Quarto
ND
588 Klee, Paul
K5 Paul Klee
A4
1987

S5825

FEB 23 '88	DATE DUE	
MAY 2 1988	OCT 19 1993	
JUN -8 1988	FEB 16 1995	
6/28		
DEC -1 1988		
MAR -5 1990		
APR 19 1990		
OCT 4 1991		

PAUL KLEE

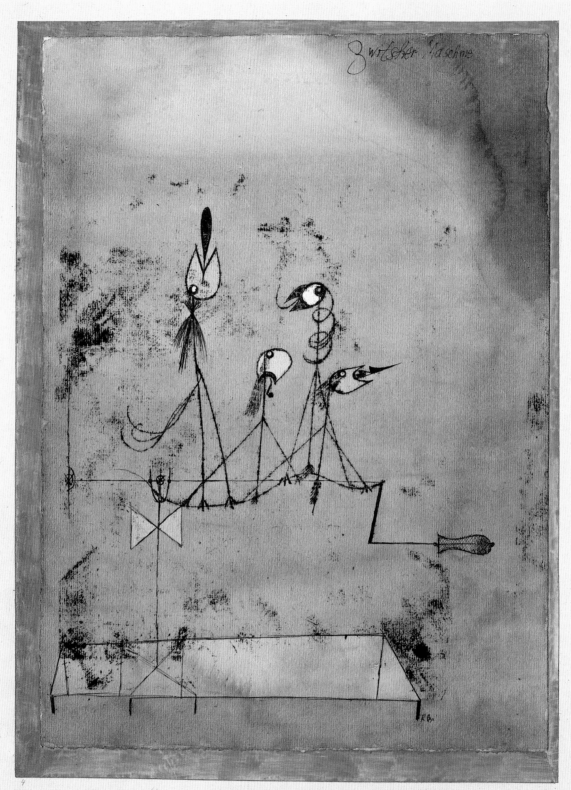

Zwitscher Maschine

4 1922/151 Die Zwitscher-Maschine

PAUL KLEE

EDITED BY CAROLYN LANCHNER

THE MUSEUM OF MODERN ART, NEW YORK

DISTRIBUTED BY NEW YORK GRAPHIC SOCIETY BOOKS/
LITTLE, BROWN AND COMPANY, BOSTON

PUBLISHED WITH THE ASSISTANCE OF THE J. PAUL GETTY TRUST

Published on the occasion of
the exhibition *Paul Klee:*

The Museum of Modern Art, New York
February 12–May 5, 1987

The Cleveland Museum of Art
June 24–August 16, 1987

Kunstmuseum Bern
Bern, Switzerland
September 25, 1987–January 3, 1988

The exhibition has been organized with the
aid of a grant from the National Endowment
for the Arts. Indemnification of foreign loans
has been provided through the Federal Coun-
cil on the Arts and the Humanities

Grateful acknowledgment is made to Editions
Gallimard, Paris, for permission to quote "Paul
Klee," by Paul Eluard, from *Capitale de la
Douleur,* © 1926, and to The Viking Press,
New York, to quote the English translation
from *The Autobiography of Surrealism*,
Copyright © Marcel Jean, 1980

Edited by Jane Fluegel
Designed by Steven Schoenfelder
Production by Tim McDonough
Composition by Trufont Typographers, Inc.,
Hicksville, New York
Printed and bound by Arnoldo Mondadori,
Verona, Italy
Distributed outside the United States and
Canada by Thames and Hudson Ltd., London

The Museum of Modern Art
11 West 53 Street
New York, New York 10019

Printed in Italy

Frontispiece:
Twittering Machine
1922 / 151
The Museum of Modern Art, New York
Purchase Fund

Contents

FOREWORD

This book is published on the occasion of the exhibition *Paul Klee*, organized by The Museum of Modern Art in close collaboration with the Kunstmuseum Bern and its Paul Klee Foundation. The continuing cooperation of our two institutions has made the realization of this project especially gratifying. Plans for this retrospective go back to the midseventies, when an exchange of exhibitions was conceived as a complementary program that would benefit the museum-going public in Switzerland and the United States.

In 1979, as a joint anniversary event celebrating the founding of the Kunstmuseum in 1879 and of The Museum of Modern Art fifty years later, we sent the exhibition *American Art from The Museum of Modern Art* to Bern. In return, the Kunstmuseum assured us of its assistance in the organization of a Paul Klee retrospective. Without the generous support of the Kunstmuseum's Klee Foundation, the present exhibition would not have been possible. We acknowledge with gratitude the cooperation of the Kunstmuseum's Director, Dr. Hans Christoph von Tavel. It has been a pleasure to work with him, and we look forward to future opportunities to continue this international collaboration.

Because the present exhibition is so much a product of discussions that took place over ten years ago between the Kunstmuseum's former Director, Dr. Hugo Wagner, and Dr. William Rubin, our Museum's Director of Painting and Sculpture, we are deeply indebted to them both for its realization. We are also most grateful to Dr. Sandor Kuthy, Deputy Director of the Kunstmuseum, who was closely involved in initiating and organizing the 1979 exhibition that served as the basis of exchange for this one. We further express our appreciation to Waldo Rasmussen, Director of The Museum of Modern Art's International Program, who coordinated the earlier exhibition, and to the Museum's International Council, which sponsored it.

That we have been able to mount this retrospective is due not only to the sympathetic cooperation of the Klee Foundation but also to the good will of Felix Klee, the artist's son. His assistance has been vital to much of the research connected with the exhibition and its accompanying book, and he is also a generous lender. We are most appreciative of his active interest and help.

We are also pleased that the exhibition is traveling to The Cleveland Museum of Art. Its showing there has been made possible by a generous grant from National City Bank of Cleveland. It is always a source of gratification when an exhibition of this interest and merit can be seen by a larger public.

The complex elements of this retrospective made its organization a costly endeavor. We are grateful for the financial support provided by the National Endowment for the Arts. The Federal Council on the Arts and the Humanities, through the Art and Artifacts Indemnity Act, provided insurance coverage for foreign loans that was essential to the realization of the exhibition.

The J. Paul Getty Trust has generously provided a grant toward the publication of this book. For this support we are most appreciative.

I should also like to thank the staff of The Museum of Modern Art, almost all of whom contribute in some degree to the realization of an exhibition of this scope. Foremost among them in this case, of course, is Carolyn Lanchner, Curator in the Department of Painting and Sculpture and Director of the Exhibition. Deeply committed to revealing and celebrating the full range of Paul Klee's genius, she has worked tirelessly and very effectively to plan and accomplish a presentation worthy of this subject. She was invaluably aided by the expertise and good judgment of Jürgen Glaesemer, Curator of the Paul Klee Foundation in Bern, who collaborated with her in the selection of works and in arranging loans from the Foundation. We owe both Ms. Lanchner and Dr. Glaesemer our warm thanks and admiration.

Finally I must express our deepest appreciation to all the private and institutional lenders to this retrospective. Without their generosity, no exhibition, however well-conceived and distinguished, could be realized. We are immensely grateful for their participation.

Richard E. Oldenburg
Director
The Museum of Modern Art, New York

8

PREFACE AND ACKNOWLEDGMENTS

A principal goal of this book and the exhibition that it accompanies is to clarify Klee's place in the history of modernism. Although Klee has been the subject of a vast literature and many exhibitions, there nonetheless persists a tendency, critical as well as popular, to see his work as peripheral to the mainstream of twentieth-century art. Yet Klee's work, in its multiplicity of styles, variety, and inventiveness, is a virtual index of the art of our century. He was the only artist of his generation who allowed his work to range freely between the figurative and the nonfigurative, the openly gestural and the tightly geometric, the wholly linear and the wholly chromatic. But the rich legacy of his art has tended to be overshadowed by the most readily grasped aspects of its appeal: its lyricism, whimsicality, and wit. In assembling for publication and for the exhibition some three hundred objects in all mediums and from all periods of the artist's career, we hope to provide the opportunity for a broader understanding and appreciation of his oeuvre.

Klee's art has opened many doors for many artists throughout the course of the century. A reexamination of his work is especially timely, for increased interest in contemporary German art has stimulated a new recognition of the importance of the German contribution to the modern movement. As we have wished the exhibition to demonstrate the depth and breadth of Klee's achievement, so we have intended the essays in this book as a contribution to a more broadly based interpretation and contextualization of Klee as artist, as human being, and as powerful presence in twentieth-century art.

The four essays that follow are written from contrasting points of view, come from mixed ideological bases, and address quite different aspects of Klee. They are linked, however, by a common effort to locate Klee's work in the cultural and historical climate of his time. Each focuses upon an area that has not previously been explored in the Klee literature. Ann Temkin has taken as her task the analysis of Klee in relation to contemporary movements and individuals, with particular emphasis on Klee's relevance to the avant-garde outside Germany. O. K. Werckmeister examines major crises in German and European history in order to treat Paul Klee's apparently private art in the context of the sociopolitical situation of his time. Jürgen Glaesemer sets Klee in the continuum of German Romanticism; while he does not discount sociopolitical factors, he nonetheless writes from the conviction that the fundamental causes of form and meaning in Klee's art are rooted in the artist's spiritual self. My own essay traces the trajectory of Klee's reputation and exposure in America to establish the historical ground for his vital importance to American Abstract Expressionism. Together these essays constitute an open-ended, discursive inquiry into the phenomenon of Paul Klee.

This book takes its place within the ongoing Klee literature, which, even as it broadens our comprehension of the artist's achievement, can never solve the mystery of Klee. It is hoped that these considerations of Klee's art will return the reader to the center of his work itself, where new possibilities will be revealed upon those sheets and canvases.

Of all the people who have contributed to the realization of this project, there are two to whom I owe far more than I can possibly express, Jürgen Glaesemer and Ann Temkin.

At the outset, Dr. Glaesemer, Curator of the Klee Foundation at the Bern Kunstmuseum and one of the world's foremost authorities on Klee, accepted an invitation to work with me on a collaborative basis. This association has been professionally invaluable as well as personally rewarding. Not only did we select the exhibition jointly, but Dr. Glaesemer has freely shared the expertise of his years of study and research, as well as contributed an essay to this book. His judgment, his faith in our endeavor, his quite remarkable sense of humor, and, not least, his friendship have sustained our efforts through what sometimes seemed nearly insuperable difficulties. Ann Temkin, too, has been a collaborator in the fullest sense. Her essay for this book was produced under the pressure of an unusually tight deadline. In addition, Ms. Temkin did a vast amount of research, compiled the bibliography, and handled the nitty-gritty of indemnity application, loan letters, and checklists with skill and accuracy. I have relied on her insights and abilities in every phase of this project from selection to installation. Without the labors, good spirits, and professional excellence of these two colleagues, neither exhibition nor book would have been possible.

I also deeply appreciate the confidence and support of William Rubin, Director of the Department of Painting and Sculpture, who entrusted me with this project. I should like as well to express my thanks to Richard E. Oldenburg, Director of the Museum, who, despite an incredibly busy schedule, always made time to assist with loan negotiations and other problems that inevitably arose.

Almost all the departments of the Museum have assisted in one way or another with the preparation of this exhibition and book. In the Department of Painting and Sculpture, I am especially grateful to Rachel Esner, who, late in the game, took on the job of curatorial assistant. In almost no time, she mastered manifold complexities of content and procedure; her abilities and professional competence have made a great contribution. I am also indebted to Marjorie Nathanson, who worked with exemplary proficiency on the exhibition in the early phases of its preparation, and to Alexandra Muzek and Joan Saunders, both of whom most expertly dealt with a vast amount of correspondence and handled a quantity of other tasks related to this project. The research Judith Cousins had previously done on Klee provided me with a rich archive of material from the beginning of this project. Her abilities and thoroughness have my admiration and I owe her a great deal. Cora Rosevear, Assistant Curator, was exceptionally sensitive to problems of loan arrangements, and has given much-appreciated assistance. Despite the heavy demands of his own schedule, Kynaston McShine, Senior Curator, has been unfailingly willing to listen to my problems, and I have valued his advice deeply.

John Elderfield, Director of the Department of Drawings, and Riva Castleman, Director of the Department of Prints and Illustrated Books, have lent to the exhibition and responded generously to requests for information and assistance. At an earlier stage, Mr. Elderfield was deeply involved in the Museum's plans for a Klee exhibition; he shared the information he had gathered with me and made numerous helpful suggestions. Beatrice Kernan, Assistant Curator of Drawings, and Wendy Weitman, Assistant Curator in the Prints Department, have, with great good will, given me valuable help. The patience and energy of Richard Palmer, Coordinator of Exhibitions, although sorely tried by the many demands of the Museum's program, have never failed, and I owe him an incalculable debt for the expertise and professionalism with which he has overseen the logistics of the exhibition's organization. Special thanks are due the Department of the Registrar, particularly Eloise Ricciardelli, Director of the Department, and Vlasta Odell and Gretchen Wold, who have been superbly attentive to the many challenges posed by the assembly of so many objects from diverse sources. The staff of the Department of Conservation deserves, as always, real gratitude for its meticulous supervision of the handling and protection of the loans entrusted to us. Its Director, Antoinette King, has been especially helpful in deciphering Klee's working methods and analyzing his complex mediums.

Jerome Neuner, Production Manager, Exhibition Program, and Kathleen Loe, Exhibition Supervisor, have been of invaluable help in devising the installation. I am also indebted to Fred Coxen of the same department for his assistance. For their active interest and energetic efforts to assure the broadest dissemination of information regarding the exhibition, I am deeply grateful to Jeanne Collins, Director of Public Information, and Jessica Schwartz, Associate Director. Philip Yenawine, Director of Education, Emily Kies, Associate Educator, and Melissa Coley, Public Programs Assistant, have aided in the

preparation of exhibition texts, related lectures, and brochures. James Faris, Director of Graphics, and Joseph Finocchiaro, Senior Designer, have also contributed their talents to these matters. I also wish to thank John Limpert, Jr., Director of Development, Chuck Tebo, Consultant, and Lacy Doyle, Grants Officer, for their many and valued efforts on behalf of this project. Waldo Rasmussen, Director of the International Program, has taken time from his own endeavors to advance the exhibition, for which he has my real gratitude. Beverly Wolff, Secretary and General Counsel of the Museum, provided essential help with a crucial loan negotiation, for which I cannot sufficiently thank her. Others who have contributed in a multitude of ways are Laurie Arbeiter, Alistair Duguid, Rose Kolmetz, Melanie Monios, and James Snyder.

The preparation of this book has been a separate task and one that was made extremely difficult because of the unforeseeable time constraints under which it was produced. I have received understanding and superb efficiency from everyone connected with this publication, and I am more grateful than I can say. Louise Chinn, Acting Director of Publications and Retail Operations, has supervised the project in collaboration with Harriet Bee, Managing Editor. It was my great good fortune to work once again with Jane Fluegel, who, with consummate skill and rare sensitivity, edited this complex book. She contributed countless improvements and her sense of humor provided real relief amid the myriad tensions of deadlines. Renate Franciscono supplied us with a superb translation of Jürgen Glaesemer's text; she has my admiring respect and gratitude. Both Tim McDonough, Production Manager, and Steven Schoenfelder, the designer of this book, exercised their abilities and imaginative talents to overcome the problems of our tight schedule. They were a pleasure to work with; they each have my admiration and thanks. I am indebted to Nancy Kranz, Book Distribution and Foreign Rights Manager, who has made much appreciated contributions, as well as to Lori Anne Salem and Maura Walsh. Richard Tooke, Supervisor of Rights and Reproductions, and Mikki Carpenter, Archivist, have also played important roles, as have Kate Keller, Chief Fine Arts Photographer, and Mali Olatunji, Fine Arts Photographer.

Many friends, museum colleagues, and others have been generous in offering assistance. Felix Klee, the artist's son, is not only a generous lender, but he also opened his archives to me. Mr. Klee, his wife Livia, and his son Alexander received me in Bern with the greatest kindness. The experience of coming to know them was an event itself in the mounting of this exhibition.

Two friends and very generous lenders to whom I am especially grateful are Christian Geelhaar, Director of the Kunstmuseum Basel, and William S. Lieberman, Chairman of the Department of 20th Century Art, The Metropolitan Museum of Art, New York. Dr. Geelhaar, an internationally recognized Klee scholar, spent many hours discussing the exhibition and book with me; I have greatly valued his counsel. Mr. Lieberman made extraordinary and deeply appreciated efforts to make available works from the recent Berggruen donation to the Metropolitan. In this connection, I should also like to express my gratitude to Heinz Berggruen, from whose extraordinary perspicaciousness in collecting we are benefiting, and who has generously given of his time to help us in a variety of other ways.

Both Ernst Beyeler and Eleanore Saidenberg interrupted their own work to assist us in securing U.S. Government Indemnification for foreign loans and helped us solve many other problems as well. I am immensely grateful to them both. For their valued assistance in a variety of ways I should like to thank Walter Bareiss, Vivian Barnett, Prinz Franz von Bayern, Albert Elsen, Stefan Frey, Agnes Gund, Gerd Hatje, Marie-Françoise Haenggli, Robert Herbert, Philip Johnson, Stephen M. Kellen, Francis Kloeppel, Robert Motherwell, Claudia Neugebauer, Linda Nochlin, Kenneth Noland, Richard Pommer, Frank Porter, Sabine Rewald, Robert Rosenblum, Roger Shattuck, Thomas Schulte, Cherie Summers, Nicholas Fox Weber, and Richard Zeisler.

I owe a very special debt to my friends Susan Jackson and George Sugarman, who not only made available to me their time and talents, but who provided indispensable personal support. They have my warmest gratitude.

Carolyn Lanchner
Curator of Painting and Sculpture
The Museum of Modern Art

KLEE AND
THE AVANT-GARDE
1912–1940

ANN TEMKIN

O bouches l'homme est à la recherche d'un nouveau langage
Auquel le grammairien d'aucune langue n'aura rien à dire.

O mouths man is in search of a new language
About which no grammarian of any tongue could speak.[1]

—Guillaume Apollinaire

Apollinaire's words voice the project of an international avant-garde that came of age during the second decade of this century. The prior generation had lifted art's obligation to imitative representation, and the possibilities seemed vast. If language had once dictated the form of literature, now literature would structure language; if man's world had shaped his painting, now painting was to remodel the world. Myriad manifestos, exhibitions, journals, and performances charted new territory for the human imagination.

Seldom do we associate Paul Klee with this flurry of activity. The collaborative enterprise and café leisure so central to our concept of the avant-garde held little appeal for an artist who preferred to see himself as "a cosmic point of reference."[2] Klee produced a great deal of his work in relative isolation and carefully cultivated an image of autonomy that his biographers have faithfully echoed. He shared with most great artists a distaste for the labels of "isms," and it is his work that has escaped most cleanly such classification.

Yet Klee's aura of remove need not prevent us from situating him within the avant-garde of his day. Indeed, the posture of the outsider strikes at the very heart of the avant-garde phenomenon: it was only by defining themselves as "outsiders" from mainstream culture that the avant-garde had invented, and continually renewed, an exclusive group of "insiders." Paul Klee was above all a true insider's man. Although by the mid-twenties he had achieved considerable popular renown, it was among his fellow artists that Klee found his strongest audience. From his first mature work in the teens to his ultimate elaboration of a powerful personal language in the

thirties, his art occupied a vital place in the avant-garde for which Apollinaire serves as spokesman.

Klee's career had begun with an unusually long period of self-imposed apprenticeship. After study in Munich from 1899 until 1901, and a tour of Italy during 1901–02, he had worked alone in his native town of Bern, Switzerland. In 1906, at the age of twenty-seven, he married and settled in Munich. Klee's natural skills as a draftsman did not extend to painting, and he spent the next five years there slowly coming to terms with the work first of the Impressionists and then of van Gogh, Cézanne, and Matisse: "I wanted to know all these things, so as not to bypass any out of ignorance, and to assimilate some parts, no matter how small, of each domain that was to be given up."[3] When Klee wrote this in the spring of 1911, he knew himself to be on the verge of finding an independent voice. That winter, he allied himself with the artists of the *Blaue Reiter* (Blue Rider), and thereby announced his entry into the avant-garde.

The *Blaue Reiter* was not a movement but simply a loose circle of artists united by Wassily Kandinsky and Franz Marc. Kandinsky's belief in the spiritual essence underlying all the arts formed the basis of the group's philosophy. Its formal activities were confined to two exhibitions and to the publication in 1912 of the *Blaue Reiter Almanac*. Klee sent seventeen drawings to the second exhibition in February 1912, and was represented in the *Almanac* with a small illustration of one of his wash drawings.[4] Yet this period held far greater importance for Klee than such facts would indicate. The *Blaue Reiter* provided the ambience that brought a decisive end to Klee's novitiate. The work of Kandinsky, Marc, and August Macke eloquently affirmed his own ideal of an art that possessed "inner" rather than "material" necessity. Klee regarded Kandinsky, his elder by thirteen years, as both ally and teacher;[5] his friendship with Marc was to be among the most meaningful of his life.

Munich now became a place where one could study the art recently made in France, Italy, and

13

Russia. This exposure motivated Klee to visit Paris in April 1912, and there he received a more extensive introduction to the work of the Fauves and Cubists. Klee visited Robert Delaunay, whose painting would also come to hold lasting value for his own.[6] Back in Munich, Klee found that the *Blaue Reiter* affiliation quickly widened his opportunities for exhibitions, if not for sales. In 1913, the art impresario Herwarth Walden welcomed Klee into the orbit of his Galerie Der Sturm in Berlin.[7]

The outbreak of war in August 1914 abruptly undid the fruitful milieu of the *Blaue Reiter*. Macke and Marc were drafted that fall, and the traffic necessary to the group's activity came to a halt. By then, however, Klee had received his start in an international artistic community. Not long after Klee's quiet entry into the *Blaue Reiter*, his work became the subject of an outspoken enthusiasm on the part of his peers. In a brief span of time, Klee's position in the avant-garde shifted from apprentice to master.

KLEE AND DADA

Klee's work seemed to open the way to the Elysian fields we saw stretched out before us.[8]
—Hans Richter

A prevailing image of the Dadaists as a noisy bunch of agitators seems to hold little room for the harmonious art of Paul Klee. Nonetheless, it was the members of the Dada circle in Zürich who first recognized in Klee the importance he soon would acquire. Under the aegis of Hugo Ball, this early phase of Dada had a decidedly pacific and even spiritualistic flavor. Ball came to Zürich directly from Munich, and his thought closely echoed the utopian mysticism of Kandinsky, whom he had known well.[9] Ball initiated Dada with the founding of the Cabaret Voltaire in February 1916. The name explains a lot about the club: it lived under the spirit of the Enlightenment philosopher who revealed as ridiculous an insistent faith in the sense and justice of a world gone mad. Like Voltaire's Candide, the generation facing maturity during World War I could not accept the concept of this as "the best of all possible worlds."

Klee was already sympathetic to the message from "Father Voltaire."[10] He had first read *Candide* in 1906, and five years later had begun to illustrate the tale (p. 128). Klee matched in his ink drawings "the exquisitely spare and exact expression"[11] he admired in Voltaire's prose style. His laconic, if witty, figures handily refute the ebullient optimism of Pangloss; not until the post-Surrealist work of Giacometti would wiry line again so eloquently convey the human condition within an absurd universe. Candide's response to such a universe—simply to cultivate one's own garden—seemed correct both to Klee and to the Zürich Dadaists. According to Ball, the cabaret's sole purpose "was to draw attention, across the barriers of war and nationalism, to the few independent spirits who live for other ideals."[12]

The habitués of the Cabaret Voltaire were primarily poets and writers, but they conceived of the cabaret as a home for performance, music, and painting, as well. Their displays of visual art depended on whatever modern works they managed to beg or borrow. Expressionist, Cubist, and Futurist pictures were imported on the strength of the cabaret members' acquisitions and contacts abroad.

Ball had a particular reverence for Klee, and his work became highly prominent when Dada headquarters moved from the cabaret to Galerie Dada (fig. 1). The gallery's two inaugural exhibitions, in March and April 1917, featured the work of the Sturm artists, and both included that of Klee. On March 31, the art critic Waldemar Jollos gave a lecture on Klee, of which no record remains. Jollos went on to organize a special one-week-long exhibition of Klee's work in May. Marcel Janco described the show as an extraordinary success, "the great event of the Galerie Dada." He termed Klee's art a revelation for them all: "In his beautiful work we saw the reflection of all our efforts to interpret the soul of primitive man, to plunge into the unconscious and the instinctive power of creation, to discover the child's pure and direct sources of creativity."[13]

Janco's remarks indicate the great influence the *Blaue Reiter* philosophy had had upon Zürich Dada. That aesthetic accounts for the constant presence of primitive art at the gallery and for the effect of the primitive on the work of the artists there. The *Blaue Reiter* focus on a work's inherent authenticity had pulled into the realm of art a vast body of objects outside the bounds previously defined by our tradition. The bronze statue and the varnished and gilt-framed canvas no longer served as guarantors of authentic art; instead, they signaled the counterfeit. The work of children, asylum patients, and folk artists revealed true eloquence in sculptures of dough and portraits in finger paint. Accordingly, professional artists shed the trappings of what once had been considered fine art. This liberation owed a great debt to the example of Cubist collage, which had introduced to the picture plane miscellaneous items from daily life. It did not matter that the Cubists' motivations were more formal than ethical. The Germans interpreted collage—and Cubism in general—as a more soulful project than it was to its makers in Paris.

Klee's materials and techniques do indeed suggest an element of craft allied more closely to the folk artist than to the professional. Beginning in 1914, he devised combinations of paints, glues, fabrics, and papers that defy present analysis, despite the recipelike notations he made in his oeuvre catalogue.[14] Oils and watercolors were painted on grounds that had been richly built up with plaster, chalk, and encaustic. Supports included the finest handmade paper and linen, but also wrapping paper, cotton remnants, and, during his military duty, aircraft canvas. Like Kandinsky, Klee earlier had experimented with painting on glass, a Bavarian folk tradition remarked in the *Blaue Reiter Almanac*. Klee never used the medium of collage as a bearer of content, as the Cubists did with the word play of their *papiers collés*. However, he

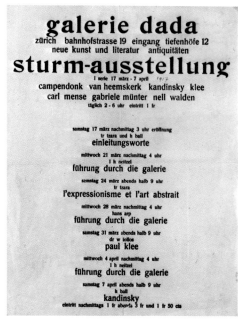

Fig. 1. *Sturm-Ausstellung*. Exhibition announcement, Galerie Dada, Zürich, 1917. 10½ × 25¼ in. (27 × 21 cm). Kunsthaus Zürich

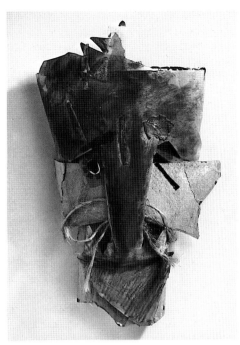

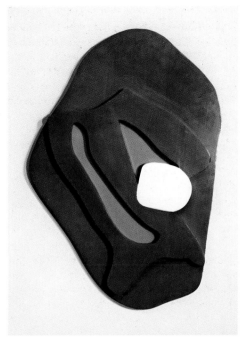

Fig. 2. Marcel Janco (1895–1984). *Mask*, 1919. Cardboard, twine, gouache, and pastel, 17¾ × 8⅝ × 2 in. (45 × 22 × 5 cm). Centre Georges Pompidou, Paris, Musée National d'Art Moderne

Fig. 3. Jean (Hans) Arp (1887–1966). *Enak's Tears (Terrestrial Forms)*, 1917. Painted wood relief, 34 × 23⅛ × 2⅜ in. (86.3 × 58.5 × 6 cm). The Museum of Modern Art, New York, Purchase Fund

often superimposed sheets and strips of paper to affect the size and texture of his compositions, and he made judicious use of scissors to reduce or rearrange them. Klee mounted his works on paper on simple cardboard mats, while the oils were housed in rudimentary wooden frames he made himself.

Klee's gift for drawing magical effects from humble materials set the tone for the art made and exhibited at the Galerie Dada in 1917. Jollos's Klee exhibition took place simultaneously with one of *Graphik, Broderie, Relief*, which included African and children's art alongside that of Klee and the Dadaists. The exhibition's concentration on graphics, embroidery, and reliefs indicates the Dadaists' disregard for the traditional Western biases of high art. Sophie Taeuber-Arp created exquisite abstractions in brightly colored yarns, while Marcel Janco made fantastic masks (fig. 2) from the inspired use of cardboard, crayon, cloth, and twine. Hans Arp blurred the boundaries of painting and sculpture in mounted reliefs (fig. 3) of crudely painted wood. These were made possible by Cubist precedents, but their biomorphic forms were far removed from the Cubist order. Arp extended the primitivist thinking of his peers to an explicit declaration of nature as his model.[15]

Nature played a dominant role in Klee's own aesthetic. His closeness to nature is central not only to the subjects of his work, but to his concept of the working process. In 1923 Klee would plainly state his grounds in "Ways of Nature Study": "The artist is a man, himself nature and a part of nature in natural space."[16] His wonderful figures formed from tile polished in the River Lech (fig. 4) literally bring nature into his art, but its presence is felt in every composition. Ball's observation in his diary in 1917 indicates that he profoundly understood Klee's microcosmic vision of the universe: "In an age of the colossus

he falls in love with a green leaf, a star, a butterfly's wing, and since the heavens and all infinity are reflected in them, he paints those in too."[17]

Klee's work, and that of Kandinsky, held the greatest importance for the Zürich Dadaists in its development of an abstract formal language that aimed toward symbolic expression rather

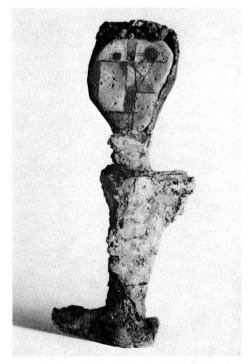

Fig. 4. Paul Klee (1879–1940). *Head Made from a Piece of Tile Polished by the Lech, Larger, Bust More Elaborate (Kopf aus einem im Lech geschliffenen Ziegelstück, grösser, Büste, ausgearbeiteter)*, 1919 / 34. Plaster, reinforced with sticks, and tile painted with watercolor and India ink, 12 × 5⅜ × 2⅝ in. (30.5 × 13.5 × 6.5 cm). Kunstmuseum Bern, Paul Klee Stiftung

than material description. The painters' ability to reject the dictates of resemblance directly related to the poets' aim to shake off a syntax and vocabulary chained to literal meaning. The apparently nonsensical poetry of Dada sought for letters and sounds the same renaissance that the painting of Klee and Kandinsky had provided for line and color. This achievement was central to the Dadaists' iconoclasm. They saw language as the shaper of history; a reform of language had to precede societal change. Current habits of usage seemed damaged beyond repair, and Hugo Ball was prompted to wonder whether "sign language was the true language of paradise."[18]

This question, again reminiscent of the *Blaue Reiter*, suggests why the recent work of Paul Klee would have prompted Ball's great admiration. The painting *Carpet of Memory* (1914; fig. 5) provides the best example with which to explore this. It is one of the first works that realized Klee's desire to go beyond description of visible reality and instead to incarnate the world of the artist's mind. *Carpet of Memory* followed shortly upon a trip Klee made to Tunisia in April 1914, in the company of August Macke and Louis Moilliet. The trip was profoundly important to Klee, for it was during this time that he crystallized the formal powers he knew were necessary to the invention of a personal voice. The landscape watercolors he made "after nature" in Tunisia (pp. 134–35) supply the pictorial basis for *Carpet of Memory*: a graphic scaffolding indebted to Analytical Cubism joining squares of translucent color that can be traced to the paintings of Windows (fig. 6) of Delaunay. Now, however, the colors and lines sink and float in a deep, amorphous space, formed by a thick ground of tan plaster applied on muslin.[19]

The image no longer reads as a naturalistic landscape; nor do we take it for a portrait of a carpet. The lush uneven texture does recall the soft pile of an antique rug, the muslin edges its frayed borders, the Xs and circles its knots and designs. But the title invokes far richer resonances. Like a worn carpet that bears witness to the people's lives it has shared, this work materializes the imagination of its creator. Without the more explicit nostalgic imagery of Marc Chagall's *I and the Village* (1911; fig. 7), Klee's painting expresses the same desire to render visible the spirit of a place and time remembered. Klee said a great deal about his art and his time when he described himself in 1915 as "abstract with memories."[20] For Klee's work acknowledged that the act of "seeing" not only consists of immediate optical sensations, but also involves associations of feelings, things, and events that have long since filtered, unnamed, into our imagination. *Carpet of Memory* refuses to fix visual experience in a single time or space, or in a single scene or idea. Without needing to know the referents, we accept meaning in its hovering signs.

During the second decade of the century, the desire to rejuvenate their respective art forms prompted the artists of the avant-garde to focus fresh attention on the most basic elements of

Fig. 5. Paul Klee. *Carpet of Memory (Teppich der Erinnerung)*, 1914 / 193. Oil over linen with chalk and oil ground, mounted on cardboard, 15¾ × 20½ in. (40.2 × 51.8 cm). Kunstmuseum Bern, Paul Klee Stiftung

Fig. 6. Robert Delaunay (1885–1941). *Windows*, 1912. Encaustic on canvas, 31½ × 27⅝ in. (79.9 × 70 cm). The Museum of Modern Art, New York, The Sidney and Harriet Janis Collection (fractional gift)

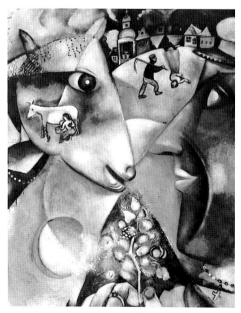

Fig. 7. Marc Chagall (1887–1985). *I and the Village*, 1911. Oil on canvas, 75⅝ × 59⅝ in. (192.1 × 151.4 cm). The Museum of Modern Art, New York, Mrs. Simon Guggenheim Fund

their formal mediums and vocabulary. It also provoked a different, but integrally related, strategy: the deliberate confounding of the boundaries between the verbal and plastic arts. The long-standing segregation of the various art forms seemed to artists of the day as arbitrary as conventions of pictorial space or poetic meter. Indeed, when the avant-garde looked outside post-Renaissance Western culture—to Oriental, medieval, and folk art—they confronted strong traditions in which the roles of images and words were inextricable.

By the time of World War I, both the painters and poets of Western Europe had begun to trespass beyond their respective frontiers. Numbers and letters appeared on Cubist paintings; thereafter, collage fully incorporated text as an integral part of the experience of a picture. The Futurists' extremely influential *parole in libertà* (free-word poetry) exploited the sizes and colors of typography to endow the letters of their poems with visual expression. Apollinaire's *calligrammes* disposed the lines of a poem in a visual image of the objects described by the text. In "Heart Crown and Mirror" (fig. 8), the letters of the poet's name form his image in the "mirror" that encloses them.[21]

Klee was a vital participant in this exploration of the verbal possibilities of plastic art and the plastic possibilities of poetics. His titles long had figured as essential components of the style and meaning of his work. Their inscription on the mats of his works on paper invites the viewer to combine the experiences of reading and looking. Klee understood that poetic expression could also stem from the forms of individual letters, apart from the context of words; thus we find them set in the midst of such works as *Composition with Windows* (1919; p. 153).[22]

Klee's first attempt to fuse fully the concept of poem and painting was a cycle of six watercolors

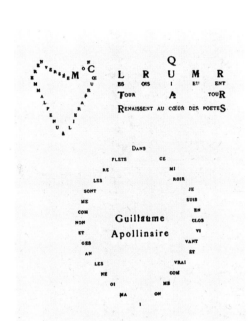

Fig. 8. Guillaume Apollinaire (1880–1918). "Heart Crown and Mirror" ("Coeur Couronne et Miroir"). *Calligramme*, 1914

Fig. 9. Paul Klee. *Once Emerged from the Gray of Night . . . (Einst dem Grau der Nacht enttaucht . . .),* 1918 / 17. Watercolor and pen drawing in India ink over pencil on paper, cut into two parts, with strip of silver paper between, mounted on cardboard, 8⅞ × 6¼ in. (22.6 × 15.8 cm). Kunstmuseum Bern, Paul Klee Stiftung

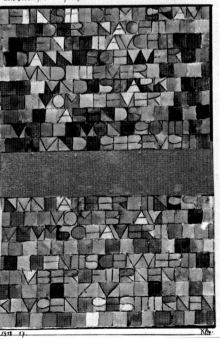

of 1916 based on Chinese poetry, which enjoyed a high regard among Westerners during the teens.[23] A Chinese poem derives its meaning not only from the words of the text but from their disposition on the page and the rhythmic and textural quality of the calligraphy. The verbal and visual are united further in those characters of the language that derive from the image of the object or action they signify. Klee's watercolors, without using the Chinese characters themselves, sought an equivalent marriage of poetic and pictorial space.

Klee's most beautiful endeavor in this direction is the painting *Once Emerged from the Gray of Night . . .* (1918; fig. 9). The structure of the poem—whose source is unknown—determines the structure of the composition. A wall of regularly spaced color squares provides the basis of the image. Then, the black ink lines of the arabic letters delineate the subdivisions of color within the squares: small triangles, circles, and odd shapes appear as tesserae in a mosaic. The upper and lower registers of the composition—divided by a strip of silver paper—correspond to the two stanzas of the poem. The text also dictates the color scheme of the painting: from beginning to end an emergence from gray to sparkling blue.

The conjunction of painting and poetry speaks directly to a central axiom of Klee's aesthetic: the insistence that "space is a temporal concept."[24] In his poem pictures, the presence of text explicitly introduces into the process of beholding a temporal quality. At first glance we see a flickering mosaic, but then as the letters emerge from the colored pattern, we progress—reading—through the page. In fact, it was a distinction between space and time that had long sustained the divorce of painting and poetry in Western tradition. The enormously influential writings of the eighteenth-century critic Gotthold Lessing maintained that the factor of time dictated the arts' different roles: painting must be confined to static representation, for we perceive it with one glance or gaze, whereas the dynamic potential of poetry stems from our process of reading in time. This dichotomy held strong sway in the Western tradition until the beginning of this century.

Klee lent no credence to Lessing's *Laocoön,* "on which we squandered study time when we were young."[25] In 1912 he had first seen the paintings in which the Futurists responded to Lessing by trying to depict the act of motion.[26] Klee eventually devised a far more profound solution to the challenge. His mature work was governed by the idea that the process of beholding takes place over time, just as does the process of creation. As we shall see, he constructed his pictures so as to require the viewer's eye to meander gradually through the pictorial space. Klee's explicit conjunction of poetry and painting forms a critical point in this development.

The exploration of the intersection of poetry and painting provides a strong link between the work of Klee and that of Kurt Schwitters. Schwitters's invention of Merz in 1919 depended closely on the lessons he had learned from his

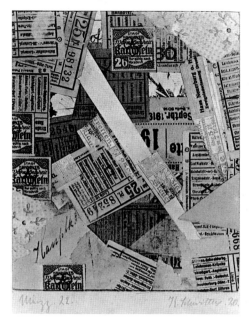

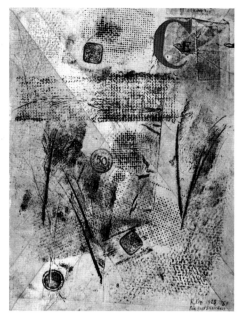

Fig. 10. Kurt Schwitters (1887–1948). *Merz 22*, 1920. Collage of railroad and bus tickets, wallpaper, ration stamps, 6⅝ × 5⅜ in. (16.8 × 13.6 cm). The Museum of Modern Art, New York, Katherine S. Dreier Bequest

Fig. 12. Paul Klee. *"C" for Schwitters ("C" für Schwitters)*, 1923 / 161. Oil transfer drawing and watercolor, 11⅜ × 8¾ in. (27.9 × 22.2 cm). Private collection, Milan

Fig. 11. Paul Klee. *Striding Figure (Ausschreitende Figur)*, 1915 / 75. Pen and ink on newsprint, mounted on cardboard, 10 × 6½ in. (25.4 × 16.5 cm). Kunstmuseum Bern, Paul Klee Stiftung

poetic activity. It had proved to him that a work of art is built upon combinations of basic elements: "A logically consistent poem evaluates letters and groups of letters against each other."[27] In the same way, Schwitters decided, a painter might "evaluate object against object by sticking or nailing them down side by side."[28] In every Merz (fig. 10) elements of different materials, scale, and significative purpose are equalized as they unite to create a single pictorial structure.

Schwitters's work was shown alongside that

of Klee at Der Sturm in January 1919. The drawings on exhibition preceded the invention of Merz, but already they suggested that Schwitters's Merz activity, like so much of German and American Dada, would differ from Klee's work in its accommodation of the urban and industrial environment.[29] In the teens Klee did not as a rule admit into his work the physical presence of printed imagery or typeface: *Striding Figure* (1915; fig. 11), drawn on a handbill, is the rare exception. The city street and the establishments that line it seem foreign to a world of the *tiergarten*, the *nördliche wald*, and the *bergdorf*. Schwitters's forays for ticket stubs, receipts, and used stamps find their counterpart in Klee's hunts for precious pebbles, shells, and pine cones. Yet the two sorts of romance are not as far apart as they first may seem. Schwitters's love for the artifacts of city life gives his work a spirit closer than any other to the love for nature evident in Klee's work. A gift Klee made to Schwitters in 1923 testifies to his affectionate respect for this artist. In the oil transfer drawing *"C" for Schwitters* (1923; fig. 12), the meticulously rendered stamps and coins masquerade as collage elements and offer a marvelous example of pseudo-Merz.

The art of Merz, like that of Klee, did not seek overtly to effect political change. In this attitude Schwitters stood closer to Klee than to his fellow German Dadaists. For Klee and for Schwitters, the conjunction of poetry and painting suited their respective pictorial goals. For the Dadaists in Berlin, the grafting of verbal and visual means formed their most potent tool of sociopolitical attack. In general, the irony of Dada became more pointed in its final phase. Klee's work was not as pertinent to the later Dadaists, although he aimed his wit at many of the same targets. A drawing such as *Metaphysical Transplant* (1920; fig. 13) gently ridicules the clumsy mechanics of man's sexuality, but it does not take on the mor-

18

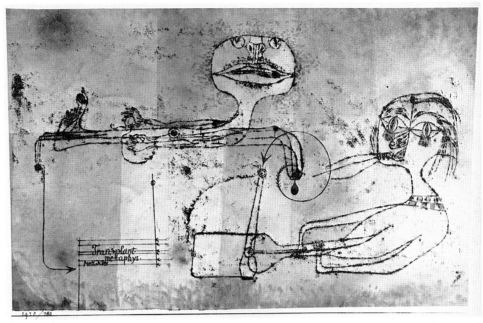

Fig. 13. Paul Klee. *Metaphysical Transplant (Transplantation metaphysisch)*, 1920 / 180. Watercolor over oil transfer drawing on paper, mounted on cardboard, 10¾ × 17¼ in. (27.3 × 43.8 cm). Collection Helen Keeler Burke, Illinois

dant bite of the *Amorous Display* (1917; fig. 14) staged by Francis Picabia. And when Klee called forth his skill for caricature, as in *The Great Kaiser, Armed for Battle* (1921; p. 164), it was hardly with a venom for which the *photomonteur* John Heartfield could have found respect. Nonetheless, in 1919 Tristan Tzara still saw fit to represent Klee's work in the *Dada Anthologie*, which he issued from Zürich to an international audience.[30] And for Max Ernst, as for the Dadaists in Zürich, Klee's pictorial iconoclasm was recommendation enough to claim him for the Dada debut in Cologne.

This event, the *Bulletin D* exhibition, was organized by Ernst with Johannes Baargeld in the fall of 1919, and it formed the most sensational context in which Klee's art had yet appeared.[31] The catalog's inflammatory texts targeted any and all aesthetic objects: "Cézanne ist chewing gum." The visitors found the work of Ernst, Baargeld, Arp, Klee, and others displayed next to art made by children and folk painters, African sculpture, and found objects such as a piano hammer ("Die vollkommenste Plastik hingegen ist der Klavierhammer").

At the time of the *Bulletin D* exhibition, Ernst was a Dada neophyte. His previous work fit into the Expressionist idiom of Der Sturm, with fantasy landscapes closely related to those of Chagall and Klee. In the summer of 1919, after seeing Klee's work at Hans Goltz's gallery in Munich, Ernst sought out the artist and returned to Cologne with an armload of works for the projected exhibition.[32]

Ernst's visit to Munich is usually remarked as a turning point in his work for reasons other than his acquaintance with Klee. In the sort of fortuitous encounter that Giorgio de Chirico seemed to demand of his admirers, Ernst's discovery of the Italian artist occurred during this same visit to Goltz's shop.[33] De Chirico's work inspired Ernst's first venture into a Dada idiom:

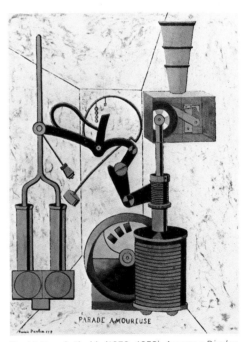

Fig. 14. Francis Picabia (1879–1953). *Amorous Display*, 1917. Oil on board, 37⅝ × 28⅜ in. (95.6 × 72.7 cm). Morton G. Neumann Family Collection, Chicago

the bizarre incongruities of the lithographs *Fiat modes: pereat ars* (fig. 15). These images echo work such as de Chirico's *The Seer* (1915; fig. 16) in their portrayals of inexplicable events and personages in a seemingly veristic space; they declare that an apparent obedience to rules of perspective by no means ensures that a picture obey the rules of this world. De Chirico decisively proved that what we call illusionistic space is truly no more than that.

Klee, too, would use the license provided by de Chirico to subvert an accepted pictorial language by means of itself. During the twenties, he would create a variety of perspective pictures, all of which meticulously diagram a "realistic" pictorial space. The transversals remain in

place to allay any doubts. But if these diagrammatic conventions once allowed us to accept a volumed space ready for flesh-and-blood people, this is no longer the case in Klee's *Room Perspective with Inhabitants* (1921; p. 162). As if automatic, the diagramming cannot be stopped: the people also become mere figments of pictorial convention. The black smudges from Klee's oil transfer technique reinforce the uneasiness that results when our confident expectations of science have been frustrated. In the *Perspective with Open Door* (1923; fig. 17), the tall black opening that looms at the back of the meticulously constructed room asserts what is implicit in all the ghostly chambers. This picture diagrams the fact that the intelligence is but the vestibule of our true personality.

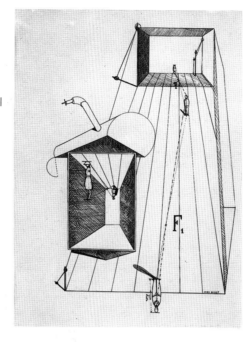

KLEE AND THE SURREALISTS

And so, on that day . . . I came to know animals of soul, birds of intelligence, fish of heart, plants of dream.[34]

—René Crevel

As Dada was transplanted to Paris in the early twenties, a number of the future Surrealists brought with them a close familiarity with Klee's art. Arp and Tzara in Zürich and Ernst in Germany had met him personally and had exhibited his work. Yet we find the poet and critic Louis Aragon responsible for the first reference to Klee published in Paris. In the November 1922 issue of *Littérature*, a journal that bridged the way from Dada to Surrealism, Aragon's "Letter from Berlin" briefly alluded to Klee: "In Weimar there flourishes a plant that resembles a witch's tooth. Here it's not yet realized that the younger generation is going to prefer Paul Klee to his predecessors."[35]

The distance between Weimar and Paris loomed far greater in spirit than in kilometers, and the inclusion of a *Bauhausmeister* in a Surrealist exhibition now seems a superb feat of Lautréamontesque incongruity. Klee's arrival at the Bauhaus in 1921 had initiated a decade of rigorous exploration of the fundamental principles of his art. His theoretical investigations of pictorial form and space would fill thousands of pages of notes and diagrams. Yet, as distinct from the activity of his Constructivist colleagues at the Bauhaus, Klee's theoretical work remained at the service of an art purely pictorial and unrelentingly individualist.[36] In Paris, the Surrealists' fascination with the poetry of Klee's painting overcame what would have been a real distaste for the theory and pedagogy so integral to his work. As the poet René Crevel admitted: "The painter gifted with poetry can find in the driest geometry the ladders he needs for his deep diving."[37] In the early twenties Klee's art became a key inspiration to the young artists with whom André Breton founded a new movement.

Surrealism inherited from Dada many of its cultural attitudes and poetic practices, but the Dadaist legacy contained no coherent concept

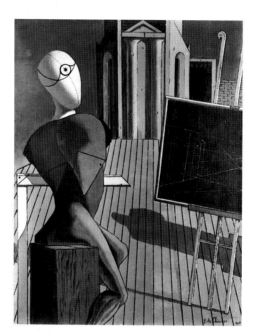

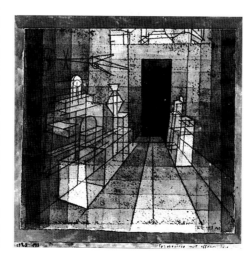

Fig. 15. Max Ernst (1891–1976). Plate from *Fiat modes: pereat ars* ("Let There be Fashion: Down with Art"), 1919. Lithograph, printed in black, sheet 17⅛ × 12 in. (43.5 × 30.5 cm). The Museum of Modern Art, New York, Purchase Fund

Fig. 16. Giorgio de Chirico (1888–1978). *The Seer*, 1915. Oil on canvas, 35¼ × 27⅝ in. (89 × 70.1 cm). The Museum of Modern Art, New York, James Thrall Soby Bequest

Fig. 17. Paul Klee. *Perspective with Open Door (Perspektive mit offener Türe)*, 1923 / 143. Oil transfer drawing and watercolor on paper, mounted on cardboard, 10¼ × 10⅝ in. (26 × 27 cm). Collection Rosengart, Lucerne

Fig. 18. Marcel Duchamp (1887–1968) and Man Ray (1890–1976). *Dust Breeding (Voici le domaine de Rrose Sélavy)*, 1920. Photograph. Published in *Littérature* (Paris), October 1, 1922

of visual style. Initially, Breton elected to his cause independent predecessors, much as the Dadaists in Zürich first filled their gallery with the work of Sturm artists. A famous footnote to the Manifesto of Surrealism enumerates painters whose work Breton found compatible with Surrealist goals. He was liberal in his choices, including among them Paolo Uccello and the principal stars of the Paris avant-garde, as well as de Chirico and Klee.[38] Breton emphasized, however, that these artists did not fully define a true Surrealist painting. By the time of the first Surrealist exhibition in November 1925, he had found new recruits to shape a much firmer roster. Klee, Picasso, de Chirico, Man Ray, and André Masson remained, joined by Arp, Ernst, Joan Miró, and Pierre Roy.[39]

As has often been recounted, the possibility of a Surrealist painting had not gone unchallenged. Pierre Naville, first editor with Benjamin Péret of *La Révolution Surréaliste*, firmly opposed any concept of the aesthetic. Accordingly, he designed the journal after *Nature*, a nineteenth-century science magazine, rather than as a typical journal of fine arts. In the third issue of this magazine, which appeared in April 1925, he published his notorious disavowal of the possibility of a Surrealist painting.

The story is not so simple, however. It is this very issue of *La Révolution Surréaliste* that publicly welcomed Paul Klee into the Surrealist orbit. Antonin Artaud, the primary voice of the third issue, admired Klee's work and included reproductions of four watercolors by Klee among the texts. These carefully placed illustrations, together with several by Masson and one by de Chirico, offered a strong argument for how one indeed might conceive a Surrealist art. Ultimate-

ly, the third issue of *La Révolution Surréaliste* reads as a field for the internecine battle over the viability of a Surrealist painting. The prominent place of Klee's work in the magazine squarely situates it within that debate.

This issue begins with a section of "Rêves," dreams recounted by several children and by Surrealist poets. This material testifies to the central role that the dream occupied in the Surrealist aesthetic; Breton approvingly noted in his manifesto the sign that Saint-Pol-Roux put on his door while asleep: "Poet at work."[40] At the end of this selection of dream narratives we find an illustration of Klee's *Castle of the Faithful* (1924; p. 207). Banded lines, spread murallike across the sheet, mark the portals and crenellations of a majestic edifice beneath a starry sky. A luscious blue, indifferent to material distinctions, grounds the entire scene. It is not only in dreams that we can conjure other civilizations, nor need we express them only in words. These delicate white lines incised in watercolor remind us how quickly the frost on a windowpane can create a fairy-tale world; and how easily *Dust Breeding* (1920; fig. 18) on Duchamp's Large Glass can construct a domain for Rrose Sélavy.

André Breton had a particular fondness for the image of the castle. He used it frequently to house the wanderings of the Surrealist imagination, the haunts of the marvelous. The Manifesto of Surrealism presents a long description of Breton's own Castle of the Faithful, where the Surrealist writers lived "as permanent guests." ("Picasso goes hunting in the neighborhood.") Breton had only disdain for the skeptical reader. "Is he certain that this castle into which I cordially invite him is [only] an image? What if this castle really existed! My guests are there to

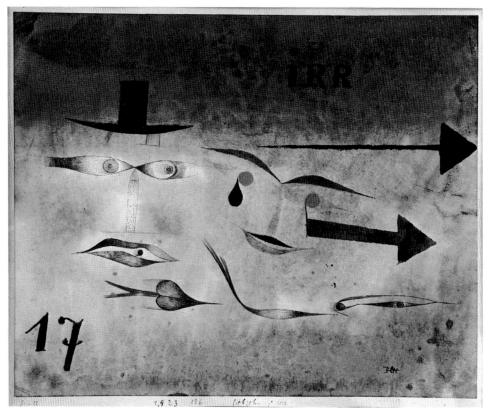

Fig. 19. Paul Klee. *17, Astray (Siebzehn, irr)*, 1923 / 136. Pen and watercolor on paper, mounted on cardboard, 8⅞ × 11¼ in. (22.5 × 28.5 cm). Kunstmuseum Basel

prove it does; their whim is the luminous road that leads to it."[41]

Artaud designed this issue of *La Révolution Surréaliste* as a sharp attack on Western culture and conventions. The lead article, written by Theodore Lessing and entitled "L'Europe et l'Asie," extols the Oriental way of life and denounces the crass logic and materialism of the West.[42] At the same time, the essay indirectly addresses the magazine's inclusion of Klee's works, one of which concludes Lessing's article. By 1925, the mythology that surrounded Klee's work emphasized the Oriental mien of the artist and his art. The first monograph on Klee, written by Leopold Zahn and published in 1920, opened with a long excerpt from the teachings of Tschuang-Tse and discussed Klee's art in the context of the Tao.[43] Subsequent writers furthered this analogy, and Klee's Bauhaus students perceived him as their Buddha in residence (see Glaesemer, fig. 15).

The description of Oriental culture in "L'Europe et l'Asie" doubles as a contemporary reading of Klee's work and illuminates the Surrealists' admiration for him. Lessing explained that Eastern art, poetry, and philosophy are inextricable from each other and from daily life itself. Oriental man allies himself with nature rather than the machine, and heroic achievements are of lesser value than the attainment of peaceful absorption into the cosmos. Correspondingly, the Orientals are indifferent to our notions of causality; their interest turns on what we would call coincidence. If Lessing's analysis amounts to simplistic romanticization, it is one that serves nicely the Surrealist agenda. It also affirms an art that does not trumpet its merits in grandiose master-

pieces, and which knows how to listen as well as to speak.

A hostility toward Western culture pervades this issue of *La Révolution Surréaliste*, the cover of which announces 1925 as the end of the Christian era.[44] Paul Eluard contributed a protest against the colonialist greed of European governments and the Church's willingness to serve as their handmaiden; the beatific creature of Klee's *An Angel Serves a Small Breakfast* (1920; p. 161) provides Eluard's piece an ironic neighbor. On page 27, however, the subject shifts to art. There we find the innocuous paragraphs that contain Pierre Naville's now famous declaration: "Everyone knows that there is no such thing as *surrealist painting*."[45] Denying any concept of taste, Naville defined his aesthetic as nothing but "the memory and the pleasure of the eyes," impossible to fix in time or space. Art is an integral part of our lives—like dressing, undressing—but, Naville claimed, never a distinct or deliberate act.

Far more prominent than this text is the large reproduction below it: Klee's watercolor *17, Astray* (1923; fig. 19). Indeed, it seems to ride on the page as a merry challenge to the statements above. In this picture, abstract signs—the number seventeen, the German word *irr*, the two arrows—inhabit and possess the same reality as that of the man and lady embodied from spermatoid forms. All swim across an aqueous space of irregular splotches and vague horizontal zones formed by repeated washings of watercolor.

This space, in particular, provides a solution to Naville's complaints. Naville protested that man's inner spirit could not be contained in formats

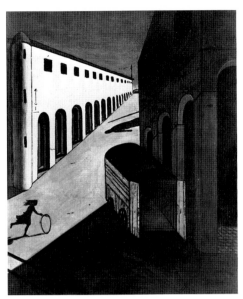

Fig. 20. Giorgio de Chirico. *The Mystery and Melancholy of a Street*, 1914. Oil on canvas, 34¼ × 18⅛ in. (87 × 71.4 cm). Private collection

"invariablement rectangulaires." His gibe specifically targeted the system of Analytical Cubism, against which Naville joined his Surrealist fellows in a classic Oedipal revolt. Naville objected to Cubism's adherence to the model of the material world. As its subjects followed in the tradition of the portrait, still life, and landscape, so its formal system echoed an external reality. The horizontals and verticals that form the scaffolding of an Analytical Cubist composition confirm the structure determined by the stretched and framed canvas. This in turn imitates the Cartesian system that Western man has imposed upon his entire environment (gridding the streets of his cities, for example).

The Surrealists believed that such order precluded the expression of man's inner mystery and natural instincts. It is here that Klee's space became such an important model for them. The wash ground of *17, Astray* overcomes the coordinates of its rectangular support to invoke a space that welcomes inexplicable phenomena. The fluid space of Klee's pictures mirrors the space of "the mind's eye," which images together all our perceptions, fantasies, calculations, and desires. In other words, Klee has conflated a physical space with a symbolic one. This is made clear by the presence of the arrows that dynamically charge the space of *17, Astray*. The arrow, an actual physical implement that goes from here to there, has been lifted onto the plane of idea. Hence, as Klee explained in his Bauhaus lectures, the arrow signifies movement, or more abstractly, the will to such movement.[46] This simple fact underlies the possibility of road signs.

It seems that the arrows in *17, Astray* doubly assume that very function in the context of the magazine page they grace. The bold black arrows structure the field of Klee's own composition. But they also propel the reader to go on, to turn the page, and to find, in fact, a second rejoinder to Naville's diatribe. Page 28 illustrates de Chirico's *The Mystery and Melancholy of a Street* (1914; fig. 20), whose veristic dream imagery offered a different avenue toward a truly Surrealist painting. Ultimately, it seems that the argument presented by these pictures triumphed over that of the text. The next issue of *La Révolution Surréaliste*, the fourth, has as its editor André Breton. Its pages are replete with illustrations and contain the first of Breton's articles on "Surrealism and Painting."

Graphic work as the expressive movement of the hand holding the recording pencil—which is essentially how I practice it—is so fundamentally different from dealing with tone and color that one can use this technique quite well in the dark, even in the blackest night.[47] —Paul Klee

As we have seen, Klee's fanciful imagery beckoned warmly to the André Breton who knew that "there are fairy tales to be written for adults."[48] But it is Klee's method that was to play a far more important role in the development of Surrealist painting. In 1924, Breton defined Surrealism as "psychic automatism," the material expression of "the actual functioning of thought."[49] Its stated goal was the direct transposition of man's inner life, without mediation imposed by convention or reason. Klee's graphic approach can be seen to have anticipated these aims. Already in 1917, Hugo Ball had announced Klee's gift for finding "the shortest path from the idea to the page."[50]

Klee's draftsmanship formed the basis of his aesthetic, and it is to this which we must look for an understanding of his relation to automatism. Klee's drawing process primarily relied neither on the exterior world nor on the preexisting format of the pictorial surface; "life drawing" played no part in his practice. Instead, with the line functioning as guide, he brought forth that which was within him. Klee's iconic self-portraits—for example *Absorption* (1919; p. 149) or, later, *Actor's Mask* (1924; p. 205)—represent the artist with his eyes knitted shut, vision directed inward rather than toward the environment. This visual conceit corroborates the romantic artist's traditional self-image as god or prophet. At the same time, however, it carries us directly to Paris in 1922—to the apartments in which the friends of André Breton and Robert Desnos sought poetic inspiration in states of trance.

A more detailed discussion of Klee's graphic technique is in order here, for the concept of "automatism" has long been clouded by vague overuse. Breton qualified Klee's art as "partial automatism,"[51] and surely Klee's drawings do not appear as frenzied scribblings. The automatic nature of Klee's drawing stems from a traditional conception of drawing as that art which is most inherently abstract. As Klee and countless others had stressed, there are no straight lines in nature; all graphic rendering is in fact invented expression, whether or not a drawing ultimately resembles something in our world.

Klee explained his personal concept of abstraction in a small fable that opens his "Creative Credo." It "talks" the reader through a drawing, using the metaphor of a journey to show how lived experience might be abstracted into a graphic record:

The first act of movement (line) takes us far beyond the dead point. After a short while we stop to get our breath (interrupted line or, if we stop several times, an articulated line). And now a glance back to see how far we have come (countermovement). We consider the road in this direction and in that (bundles of lines). A river is in the way, we use a boat (wavy motion).[52]

For didactic impact, Klee detailed a too-literal translation of experience into sign. But he also included in his example the fact that one has memories and impressions after a trip. These, much vaguer, roll together with those of our more distant past, and we record: "All sorts of lines. Spots. Dots. Smooth surfaces. Dotted surfaces, shaded surfaces. Wavy movement. Constricted, articulated movement."[53] From this we can understand Klee's ability to draw "in the blackest night," as his pen operated similarly to a seismograph that records the earth's tremors.

Drawings that document this emergence of graphic form from the workings of man's mind—*Adventure between Kurl and Kamen*

23

(1925; p. 206), for example—comprise some of Klee's most wonderful images. But all of his drawings share certain qualities that hint at their direct and unmediated formation. Most prominent, perhaps, is the prevalence of connective lines between different figures and objects, as if joined by strings of the puppets they so often depict. We read this as if the pen could not have been put down, the thought broken. In other drawings, the line seems never to articulate particular beings or things, and yet somehow it yields recognizable scenes. In works such as *Arab City* (1922; p. 165), fantasy towns materialize within networks of busy line; the spontaneous emergence of individual buildings and roads mocks all notion of modern urban planning.

Klee's sense that drawing transcribes our inner vision was of no great novelty. Although for centuries the teaching of the Academy had tried to level the very private nature of drawing, it was something that artists themselves never had ceased to acknowledge. Klee referred to more than his particular grounding in graphic art when he described his line as his "most personal possession."[54] Indeed, outside the realm of fine art, vast bodies of theory sought to dissect the disclosures believed to issue from spontaneous graphic expression. The drawings of self-described mediums were analyzed for all they might yield from the realm of the beyond. The art of the mentally ill, which Klee had admired as early as 1912, formed a fundamental diagnostic tool for the first psychiatrists.[55]

Breton was extremely well-versed in a psychiatric literature that devoted abundant attention to the graphic invention of the insane.[56] It was this that offered him the richest source for an artistic antitradition. In a romantic association of genius and madness, Breton saw the spontaneous writing and drawing of the insane as the quintessence of genuine creative activity. While the psychiatric background provided him with a model, however, it did not indicate how automatism might be attained without the license given by a diagnosis of insanity. Breton left to his painter colleagues the practical solution of that problem.

It is common art-historical hyperbole to describe as "revelation" the impact of one artist's work upon another. In the case of both André Masson and Joan Miró, the hyperbole, if that it be, rests with the artists themselves.[57] Each has declared Klee's work a decisive catalyst to his breakthrough to a Surrealist painting. A copy of Wilhelm Hausenstein's monograph on Klee provided Masson's introduction to Klee's work in 1922, and he shared it with Miró, whose studio adjoined his own.[58] The two artists would have been able to find actual works by Klee in the collections of Aragon, Breton, and Paul Eluard. It was not until October 1925, however, that they would see a full-scale exhibition of Klee's work. That occasion, at the Galerie Vavin-Raspail, Paris, seems to have been a true insider's affair. Aragon, who had first signaled Klee in *Littérature*, wrote the catalog's introduction, and Eluard contributed an homage-poem (fig. 21).[59]

By this time, Miró and Masson had already found their way to a Surrealist idiom. Their own work would appear alongside Klee's in the first exhibition of Surrealist painting, which opened at the Galerie Pierre on the day Klee's show closed.

Klee's importance to Miró and Masson is not evident in immediate comparison, for both artists had already undergone the formative period in which an artist's work truly looks like that from which he learns. As young painters working in a Cubist mode, both had been in search of an idiom more amenable to poetic and intuitive expression. Klee's work became important when they were ready not to copy but to invent truly individual voices. Klee revealed to them the possibility of a line that conjured rather than described, that traveled through space as the trace of images in our minds rather than of objects in our physical world. The words of Henri Michaux, who put to work his discovery of Klee slightly later, most beautifully express Klee's appeal to the young Parisians: "On n'avait jusque-là jamais laissé rêver une ligne"—"never before had a line been allowed to dream."[60]

A look at the early Surrealist work of Miró and Masson suggests how such a line became useful to their individual aims. Masson's automatist drawings differ immediately from those of Klee in the obvious speed with which they were executed.[61] For Masson, rapidity guarded against the intervention of reason, the temptation to exercise the eye of the trained artist. His final addition of descriptive details suggested by the lines and his bestowal of a title lifts the automatism into poetry: in *Furious Suns* (1925; fig. 22), eyes, breasts, teeth, and orifices whirl together in nebular passion. Masson's lines appear charged with energies from the darkest depths of man's unconscious. In contrast, Klee's work maintains a commitment to represent the balance between the wild and tame; if he depicts the barbarians, the Greeks are there too.

Miró's lyrical and often humorous line bears more immediate affinity to that of Klee. The painting *Le Renversement* (1924; fig. 23) demonstrates the diagrammatic line that navigates a space in which modeling has become irrelevant. As in *17, Astray* (fig. 19), laws of gravity do not apply to this material space; nor do those which separate resemblance from sign. The arcs of the mustache on the running man are weightier than those of his body, while the lines that describe the mountains simultaneously serve to diagram the man's motion. This abstract line enabled Miró, like Klee, to sever the boundary between verbal and visual signification. The weightless lines that write the words AH! and HOO! occupy the same realm as those that describe the peasant or his horse. As is made explicit by Klee in the *Vocal Fabric of the Singer Rosa Silber* (1922; p. 173), letters permit an aural component to the viewing of the picture, further collapsing together the experience of painting and poetry.[62]

In all these pictures, it is the drawing that bears the heaviest burden of meaning and first exacts the empathy of the viewer. Fully developed paintings, both for Klee and for the

PAUL KLEE

Sur la pente fatale, le voyageur profite
De la faveur du jour, verglas et sans cailloux,
Et les yeux bleus d'amour, découvre sa saison
Qui porte à tous les doigts de grands astres en bague.

Sur la plage la mer a laissé ses oreilles
Et le sable creusé la place d'un beau crime.
Le supplice est plus dur aux bourreaux qu'aux victimes,
Les couteaux sont des signes et les balles des larmes.

On the fatal slope, the traveler profits
From the day's good will, sleet and no pebbles,
And his eyes blue with love, he discovers his season
Which wears on each finger big stars set on rings.

The sea has left its ears on the beach
And the sand has marked the place of a beautiful crime.
The torture is harder on tormentors than on victims,
Knives are signs, and bullets, tears.

—Paul Eluard

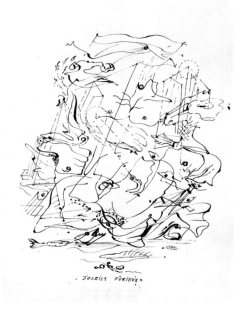

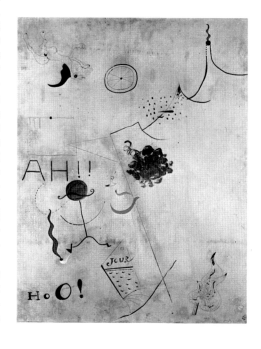

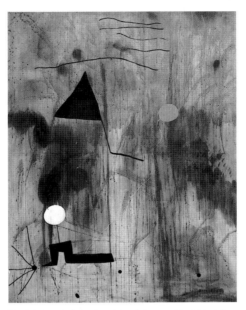

Fig. 24. Joan Miró. *The Birth of the World*, 1925. Oil on
canvas, 98¾ × 78¾ in. (250.8 × 200 cm). The Mu-
seum of Modern Art, New York; Acquired through an
anonymous fund, the Mr. and Mrs. Joseph Slifka and
Armand G. Erpf Funds, and by gift of the artist

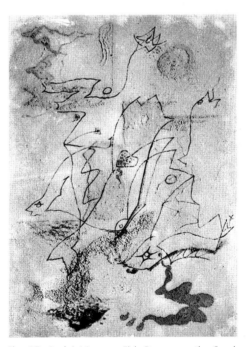

Fig. 25. André Masson. *Fish Drawn on the Sand*,
1926–27. Oil and sand, 39⅜ × 28¾ in. (97.8 × 71.4
cm). Kunstmuseum Bern, Hermann und Margrit Rupf
Stiftung

Surrealist "automatists," depended on the in-
vention of a color technique that would host
and enhance an independent graphic poetry.
Such a technique did not need to involve a truly
automatic application of color. Rather, it simply
demanded a mobile field compatible with a dy-
namic line and the pictorialization of the process
of time that governed "automatic" creation.

The temporal process of creation is empha-
sized even in those paintings by Klee that are
most systematic and nonobjective in appear-
ance, the compositions of colored stripes or col-
ored squares. As these surfaces generate a
warm vibrant light that builds from a cool dark
ground, they take as their subject their own
evolution. The title *Eros* (1923; p. 191) implies
this in the general sense of the creative power of
love and in its more specific reference to the
Greek creation myth in which Eros is born of
Night and Chaos.

The oil transfer drawings that Klee made at
the Weimar Bauhaus, for example *Twittering
Machine* (1922; p. 172), also invite the viewer to
share the temporal process of their creation.
This process comprised repeated layers of glaz-
ing, each of which had to dry before the next
was applied. Ultimately, the subtle chromatic
gradations and their varying opacities lead the
eye to circulate through space in a manner ex-
actly counter to the directed gaze encouraged
by the perspectival devices of naturalistic pic-
torial space. The random spots and smudges
born of the initial transfer of the drawing rein-
force the aura of decentralization. As a result,
the drawing seems to emerge from the sur-
rounding space despite the fact that it actually
was applied beforehand.[63]

The pictorialization of genesis is shared by the
fields of Miró's much larger oil paintings, and in
The Birth of the World (1925; fig. 24), is con-
firmed by the title.[64] The erratic application of
sizing to the canvas caused the paint to take
irregularly to the surface and thus to vary the
behavior of reflected light. The glazes were
brushed, poured, spilled, and sprayed to be-
come a rich atmosphere that would inspire the
cursive drawing and opaque symbols upon it.
Masson used sand to prompt and to symbolize
an evolutionary process of painting—and
again, evolution itself. Works such as *Fish Drawn
on the Sand* (1926–27; fig. 25) were begun by
pouring sand onto a canvas that had been
spread with patterns of glue. Sand rivulets and
clusters that clung to the adhesive would then
catalyze graphic composition in paint (straight
from the tube), charcoal, or pencil. We are used
to remarking that an artist covers his tracks;
Masson designed these works in sand precisely
as tracks.

All these techniques share Klee's emphasis on
the two-stage process of composition, in which
the emergence of form precedes associative
elaborations. Max Ernst fulfilled the same aim
with his invention of *frottage*, which he defined
as a technique for "the intensification of the
irritability of the mind's faculties."[65] The *frottage*
process consisted of rubbing black lead on a
sheet of paper that had been placed over a
textural surface such as wooden planks or

Fig. 26. Max Ernst. *The Fugitive*, plate 30 from *Histoire Naturelle*, 1926. Collotype after *frottage*, printed in black, 10¼ × 16¾ in. (26 × 42.5 cm). The Museum of Modern Art, New York, Gift of James Thrall Soby

leaves. These rubbings, Ernst explained, would stimulate the artist's imagination and provoke his inner visions. The results appear in the lithographs of his *Histoire Naturelle* (fig. 26), published in 1926.

Ernst rooted his 1925 invention of *frottage* in the memory of a childhood experience. He began his autobiography by telling of a night on which he gazed at the fake mahogany panel at the foot of his bed and saw in its patternings human forms.[66] Klee was equally careful to recount in his own autobiography a strikingly similar tale:

In the restaurant run by my uncle, the fattest man in Switzerland, were tables topped with polished marble slabs, whose surface displayed a maze of petrified layers. In this labyrinth of lines one could pick out human grotesques and capture them with a pencil. I was fascinated with this pastime; my bent for the bizarre announced itself (9 years).[67]

In the two parables, Klee and Ernst associate their own work with the intensity and authenticity of the child's creativity. This stance was anchored firmly in the avant-garde tradition: Baudelaire had declared that "genius is no more than childhood recaptured at will."[68] And yet the conjoint confessions of Klee and Ernst are most important because they alert us to the exceedingly conscious nature of an assumed naïveté. Each artist devoted the utmost care, over an extended period of time, to the construction of his autobiography.[69] The decision to reclaim the supposed spontaneity of the child or naive artist was no less a conscious construct. And, in the work of Klee and Ernst, a successful evocation of an untutored approach involved a process equally intentional and carefully cultivated.

Similarly, the rhetoric of automatism advertised a rejection of professional expertise that masked what was in fact a highly complex interaction of calculation and inspiration. While the Surrealists kept silent about the element of reason in Klee's work, it matched a similar, if lesser, distortion of their own actual practice. For ex-

ample, the same Tristan Tzara who invented the sliced-newspaper poem submitted his work to prolonged and compulsive revisions. Privately, the artists realized that matters were far less simple in practice than in discourse. When Max Ernst first saw Klee's work at the Sturm gallery, he had recognized its affinity to the art of a child. But Ernst was careful to qualify this child as one "who had looked at and studied well his Picasso, Delaunay, and Macke."[70]

In 1925, the year of Klee's debut in Paris, the Bauhaus moved from Weimar to Dessau, where Gropius's International Style buildings would embody a new era of objectivism. Although Klee remained untouched by the Bauhaus's increased emphasis on mass production and communication, his work did manifest a greater interest in systematization and measurement. Rich linear studies culminated in such masterful paintings as *Variations* (1927; p. 225). The rigorous geometry of the Constructivist aesthetic—seen in László Moholy-Nagy's cover design for Klee's *Pedagogical Sketchbook* (fig. 27)—found echo in such works as *Portrait of an Acrobat* (1927; p. 228).

Yet the painter-poet who so appealed to the Surrealists by no means disappeared. A greater pictorial clarity defined imagery even more mysterious than the often anecdotal work done at Weimar. This is perhaps most true of the pictures that consist of individual elements vividly rendered but floating separately in the pictorial space. These may be representational forms (fish, dice, flowers, moons, faces), geometrical shapes (squares, cubes), or conventional signs (arrows, exclamation points). Sometimes the discrete elements coalesce into a recognizable scenario, as in *Conjuring Trick* (1927; p. 228). Often, however, their meanings meld together no more obviously than do the forms, and the juxtapositions seem to operate only on the loosest of logics. We might therefore be tempted to treat a work such as *Around the Fish*

Fig. 27. László Moholy-Nagy (1895–1946). Cover design for *Pädagogisches Skizzenbuch (Pedagogical Sketchbook)* by Paul Klee (Munich, 1925)

Fig. 28. Paul Klee. *Pastorale*, 1927. Tempera on canvas mounted on wood, 27¼ × 20⅝ in. (69.3 × 52.4 cm). The Museum of Modern Art, New York, Abby Aldrich Rockefeller Fund and exchange

Fig. 29. Henri Michaux (1899–1984). *Alphabet*, 1927. Ink on paper, 14⅛ × 10¼ in. (36 × 26 cm). Private collection

Fig. 30. Pablo Picasso (1881–1973). Illustration for Balzac's *Le Chef-d'oeuvre inconnu* (Paris), 1931. Wood engraving by Aubert after drawing of 1924, 13 × 10 in. (33 × 25.5 cm). The Museum of Modern Art, New York, The Louis E. Stern Collection

(1926; p. 217) as a rebus to be deciphered, and to display the solution like a trophy. Scholars certainly have done so. But this is to miss the point: the magic of a dream does not rest in its analysis.

Such insoluble fish share the tactics of Surrealism not only in their coy elusion of meaning. Notwithstanding the absence of glue, their structural mechanics are those of collage, a system at the heart of the Surrealist aesthetic. Collage offered a rich alternative to a descriptive language that narrates a continuous sequence of time and space, as it disrupted the relationship between objects and external reality. Under the banner of Surrealism, this method of picture-making flourished in the latter half of the twenties. In 1926 Max Ernst began to create his wondrous collage novels, and Louis Aragon wrote in 1930 that in the last few years Picasso had undergone a veritable "crise de collages."[71] The Surrealists especially appreciated the fact that the discontinuity of collage demanded the viewer's active participation in the completion of a picture. It is this principle that is so evident in Klee's work under discussion. His pictorial fields, either a warmly worked black or a haze of pale hues, literalize a space that is left for the fantasy of the observer. The perceptual work of relating the segments of the composition parallels the job we must do in fabricating their contextual connection.

The same invitation to read a painting offers itself in Klee's seemingly far different "script pictures." These paintings have their beginnings in Klee's earliest work, but first appear in their mature form in 1924 with pictures such as *Human Script* (p. 206) and *Egypt Destroyed* (p. 208). They consist in various signs arranged in horizontal bands or freely distributed on the page, usually incised in thin strokes of watercolor or oil on a richly worked ground. The script may simply be a series of designs such as crosses and stars, or it may take as its "letters" humans or flowers. Similarly, the titles may or may not evoke concrete associations; ultimately, a *Tree Nursery* (1929; p. 234) is not so different from a *Pastorale* (1927; fig. 28). What Klee's other work implies, the script pictures explicitly state. They take as their very subject the equivalence of writing and drawing, of poem and picture.

The basic sameness of "the pen that flows in writing and the pencil that runs in drawing" is fundamental to Breton's concept of automatism.[72] Testimony to his theory is explicit in the wide variety of invented scripts made under the aegis of Surrealism by artists ranging from Picasso to Henri Michaux (see *Alphabet*, 1927; fig. 29). Breton considered automatism the most reliable route for painters and poets to follow to the unconscious, and in "Artistic Genesis and Perspective of Surrealism," he explained this preference. He suggested that the fundamental reward of automatism—and automatism only—lay in its attainment of *rhythmic unity* (Breton's italics). "I maintain that automatism in writing and drawing is the only mode of expression which gives entire satisfaction to both eye and ear by achieving a *rhythmic unity*, just as recognizable in a drawing or in an automatic text as in a melody or a bird's nest."[73]

It is ironic that André Breton, who had claimed to detest music, and who had come to feel little better about the work of Klee, indirectly becomes an astute commentator on the obvious connection between the two.[74] Of course, it is precisely the element of rhythm that motivates Klee's script pictures, far beyond their superficial resemblance to a page of sheet music or the suggestion provided by titles such as *Pastorale*. The script pictures take on the ability of music to produce meaning from its own structural elements, to construct pattern and sign by means of repetition and interval, accent and rest.

Accordingly, rhythm provides a fundamental alternative to mimetic representation. Picasso

recognized this when he used his 1924 drawings of rhythmic patterns of dots and lines to illustrate Balzac's *Le Chef-d'oeuvre inconnu* (1931; fig. 30). The masterpiece of the story's title was a portrait which, after years in the making, had developed into a foot peeking out from a web of tangled lines. Balzac's portrayal of the tragic limits of the artist's quest for resemblance finds respectful sympathy in Picasso's unassuming linear inventions.

Klee's script pictures, more than any others, assert that for the viewer as well as for the artist the experience of a picture rests in "becoming" rather than "being." In these works there is no message to decode, no tune to whistle. This fact opens onto a further dimension of the script pictures: man's delight in the unknowable. Our response to them is not unlike that which we today accord an inscribed stone from Babylonia. The fascination of the cuneiform characters cannot be reconciled with the mundane fact that they provided nothing more than, say, a recipe for bread. Here we exercise a vestigial faith in the power of signs independent of any otherwise useful purpose. The same urge underlies man's unceasing attempts to "read" the stars. Miró both referred to and recreated this pastime in *The Beautiful Bird Revealing the Unknown to a Pair of Lovers* (1941; fig. 31), one of his series of Constellations.[75] Max Ernst could have found no better way to pay homage to the quest of a favorite astronomer than to compose an entire book of make-believe script. The ciphers of *Maximiliana, or the Illegal Practice of Astronomy* (1964; fig. 32) also invite us to glean shape and meaning from the vast expanse of an unknown cosmos; like Klee's scripts, they engage our readiness to explore a system that lies beyond reach.

The secret of Klee's art must remain our secret for a long time to come.[76]
—Philippe Soupault

Our perception of Surrealism, as William Rubin has observed, greatly relies on the prejudices of André Breton, personal as much as aesthetic. When Breton took over *La Révolution Surréaliste*, Klee's work never returned to its pages. It would appear that Breton had lost his early taste for Klee; the essay "Surrealism and Painting" does not mention him at all. Yet Breton's indifference should not obscure the loyalty of other Parisian admirers. Forgetting that Klee also enjoyed the devotion of a far different audience in Dessau, the French poets continued to watch over his work as the guardians of a precious treasure.

The Surrealists' esteem found testimony in the monograph on Klee published by Cahiers d'Art in 1929, which joined a short text by Will Grohmann with a selection of homages by Surrealist poets. This monograph stands as a tribute to the diplomatic skill of Christian Zervos in what must have been delicate circumstances, for the book appeared in December 1929, the same month in which Breton's Second Manifesto of Surrealism appeared.[77] By this time Breton's penchant for electing allies to his cause had yielded to a preference for excommunicating

them. The manifesto initiated Breton's campaign for political engagement, and denounced those to whom this did not appeal. Enemy lines were starkly etched. Yet the monograph on Klee unites tributes by dissidents such as Philippe Soupault and Roger Vitrac with pieces by those who remained loyal to Breton: Crevel, Eluard, and Tzara.

The Surrealists' words remain the most beautiful ever written on Klee. The Parisians made no attempt to analyze his work; rather, they used it as a departure point for their own poetry. Their texts rhapsodized upon the mystery and ineffability of Klee's universe, a "star rather than a planet."[78] Not surprisingly, Will Grohmann felt compelled to assure the readers of the magazine *Cahiers d'Art* that Klee was a man who stood "solidly on both legs" and who walked through life "with his eyes wide open."[79]

Again and again, the Surrealists praised the miniature quality of Klee's work. As poets, they deeply understood the economy of Klee's art and the advantage that finite means can lend to an infinite vision. Crevel, in a monograph published by Gallimard in 1930, interpreted smallness more specifically: he understood Klee's tiny works as a challenge to the might of bourgeois authority. As had *La Révolution Surréaliste* in 1925, Crevel enlisted Klee in a denunciation of Western logic and materialism. In a poignant Surrealist version of the homily "the meek shall inherit the earth," Crevel reminded his readers that "there will be fleas until Judgment Day," while already the museum was the only place to find a sign of the gigantic Diplodocus dinosaur.[80]

Whereas Klee had become an unwitting collaborator in a variety of poetic visions, both Eluard and Tzara sought him out in Dessau for explicit collaborations. In April 1928, Eluard sent Klee some of his poetry with the request that he illustrate a volume of his work. Klee responded with warm enthusiasm, but for reasons unknown nothing further came of this exchange.[81] In 1931 Tzara asked Klee for an engraving for his poem *L'Homme approximatif*, and this proposal was realized. Tzara provided the artist with paper from Paris, and Klee responded with an engraving (fig. 33) based on the drawing *Eye and Ear* of 1929.[82] The image presents a man's face (the bridge of his nose that of a stringed instrument) beside a configuration that forms an enormous ear. The center of the ear appears as a third eye, and the surrounding mass seems to materialize the man's mind. The image accords with an extraordinarily musical poem that forms an epic reflection on self and language: "I think of the warmth spun by the word / around this center the dream we call ourselves."[83]

Despite these individual projects, Klee's work, as of 1929, was positioned in the Paris art world at a far remove from Breton's new Surrealism. It found its place not in his *La Surréalisme au Service de la Révolution* but in *Documents*. This magazine was the brainchild of Georges Bataille, whose disdain for Surrealism's political pretentions earned him Breton's strongest vitriol. Later emphasis on the dark side of Bataille's character and literature has obscured the fundamental humanism underlying the phi-

Fig. 34. Paul Klee. *Menu without Appetite (Menu ohne Appetit)*, 1934 / 170 (S10). Pencil on paper, 8¼ × 12⅞ in. (20.9 × 32.8 cm), irregular. Private collection, Canada

Fig. 35. Pablo Picasso. *On the Beach*, July 28, 1933. Watercolor, 15⅜ × 19⅝ in. (39 × 49.8 cm). Perls Galleries, New York

Fig. 31. Joan Miró. *The Beautiful Bird Revealing the Unknown to a Pair of Lovers*, 1941. Gouache and oil wash, 18 × 15 in. (54.7 × 38.1 cm). The Museum of Modern Art, New York, Acquired through the Lillie P. Bliss Bequest

Fig. 32. Max Ernst. Leaf 10 from *Maximiliana*, 1964. Etching with aquatint in two colors, 16¹⁄₁₆ × 12 in. (40.6 × 30.4 cm). The New York Public Library, Spencer Collection

Fig. 33. Paul Klee. *L'Homme approximatif*, 1931. Etching printed in black, 7 × 5½ in. (17.8 × 13.9 cm). The Museum of Modern Art, New York, Purchase Fund

losophy of his magazine.[84] Its masthead read "Archéologie, Beaux-Arts, Ethnographie, Variétés," and it was dedicated to exploring the "obscure intelligence of things" that united non-Western, popular, and fine art.[85] One issue, for example, juxtaposed two works by Klee with an Irish illuminated manuscript and a Russian medal.[86] *Documents'* attempt to make sense of the universe of form marked an important departure from the evolutionary and colonialist bias that long had colored discussions of contemporary art's relation to the primitive. In so doing, it served as an extraordinary herald to the avant-garde agenda of the thirties, and in particular, to the place that Klee's art would occupy within it.

KLEE IN THE THIRTIES

I am my style.[87]
—Paul Klee, 1902

The splintering of the Surrealist group forecast a general rupture in the avant-garde of the thir-

ties. What had been a rapid succession of collaborations and innovations throughout the century reached an impasse between 1930 and 1935. This period has fallen between the cracks of an art history structured to recount a linear series of successes: the new styles and programs that arose as alternatives to the modernist idiom in the thirties have often been described, but less has been said of those artists who had committed decades to the development of a modernist art. The political crises of the decade threw into question the position of those who had staked their convictions and their incomes on an art autonomous to world events. Breton faced the problem in his explicit alliance of Surrealism and Communism, and he forced his associates to choose sides for or against. But for the majority of the avant-garde, the relationship between art and society could not be so baldly resolved. Their works of the decade choreograph a strange ballet of confrontation and withdrawal.

The rise of Nazism and the approach of war scattered the members of the avant-garde; in so

doing it united them in a communal exile, psychological if not physical. For Klee, these were years of particular hardship. By 1933 the Nazi offensives against "degenerate" artists sent Klee and his wife to his native city of Bern, Switzerland. This was no simple haven for Klee. The avant-garde had interpreted Rimbaud's epigram—"Je est un autre"—as a directive. Artistic realization required a self-imposed exile from one's given identity: it meant going to a different metropolis to live, speaking a new language, and usually adopting another name. For an avant-garde artist aged fifty-five, a return "home" must be read as a very particular estrangement.

Klee's unsurety during these years is apparent in his art. In 1932 he had produced among the most magnificent works of his life. They acknowledge the inspiration of Seurat, an artist whose work only recently had been brought to public prominence, and one very close to Klee in his wedding of the poetic and theoretical. A title such as *Ad Parnassum* (1932; p. 255) indicates that Klee recognized the heights he had attained. But such work was abruptly followed in 1933 by scratchy drawings—of slaves, emigrants, and murders (p. 262)—that show modernism gone haywire. Klee's continued uncertainty is reflected in the drawing *Menu without Appetite* (1934; fig. 34), which, like Picasso's *On the Beach* (1933; fig. 35), is a clear glance in the direction of Salvador Dali. This was a very rare move for Klee, who did not share Picasso's sense of license to dip freely into the group imagination. Klee's painting was sporadic and unreliable—marvelous pictures followed by failures. In 1936 he made only twenty-five.

But in this Klee stood in fine company. We find in the midthirties a collective stopping short on the part of the elder avant-garde. Artists stopped working, switched mediums, or radically altered their stylistic approach—probably each at some point. In early 1935 Picasso ceased painting altogether for twenty months. Matisse, with great success, reinvested himself in his drawing; Ernst turned to sculpture. In 1937, a troubled Miró enrolled in the life-drawing class at an art school in Paris. Sometimes work is nothing more than an alternative to paralysis. In 1934 Giacometti made what would be his last major sculpture for twelve years: *Hands Holding the Void* (fig. 36) may stand as a symbol for an avant-garde that had lost its confidence.

In his famous lecture at Jena in 1924, Klee had apologized for disobeying the command, "Don't talk, painter, paint!" But what happens when one cannot paint? Or feels the need for reevaluation? In 1935, the normally cagey Picasso authorized the publication of remarks on his painting that Zervos had recorded on a visit. In the same year Matisse wrote "On Modernism and Tradition," his first major statement since 1908. Max Ernst published "Beyond Painting" in 1936.[88] While these painters were examining their own origins, the avant-garde was doing so collectively. In the place of reporting on a new wave of styles—with the exception of the Surrealist investigations of the object—the magazines of the day reached back to the roots of painting itself.

In 1930 *Cahiers d'Art* ushered in the decade with five installments of Hans Muhlestein's essay "Des Origines de l'art et de la culture."[89] In a prefatory editorial, Christian Zervos stressed the need to understand prehistoric art if we are to understand our own. In a strained but oddly moving manner, he asked the reader's indulgence of material neither light nor entertaining. The *Cahiers* continued to devote a great deal of space to primitive art, joined in 1933 by *Minotaure*. Their inquiries attained a level of serious interrogation far beyond earlier romantic enthusiasms. Nets were cast across a vast body of cultures, all as a means to explore the essence of creation.

Klee did not join publicly in this communal self-examination. He had spent a lifetime sharing as much as he would in his writings and classroom lectures. Privately, however, he too burrowed down into the sources of his own art. We remember that World War I had prompted many calls for a new language to replace a corrupted one. Klee had devoted the intervening years to pictorial investigations that in 1937 would enable the formation of a systematic vocabulary; far beyond romantic or random invention, it would emerge from the fundamental principles of picture-making. At this point one cannot trace in Klee's work direct connections to any particular form of primitive art. The history into which Klee now would reach was his own; the Ur forms he would retrieve were those of his imagination.

The path he chose is prefigured in *Picture Album* (p. 271), an early picture of 1937 that seems literally to refer to cave paintings. Earthtone gouaches on unprimed canvas make marks that seem scratched on rough stone; the graffiti include a scaly lizard and a moon-headed woman. If this seems a retreat from modernism, we need only remember that in this very year, The Museum of Modern Art staged an exhibition titled *Prehistoric Rock Pictures*. It displayed facsimiles of the carvings found by anthropologist Leo Froebenius, who wrote the catalog essay. His concerns were not simply formal: "For it has come to pass that we modern Europeans, concentrating on the newspaper and on that which happens from one day to the next, have lost the ability to think in large dimensions. We need a change of *Lebensgefühl*, of our feeling for life."[90]

Picture Album's overt nod toward cave painting was unique in Klee's work. He thereafter evolved a grammar that would determine the character of his art for the rest of his life. The first works of 1937 place basic graphic signs on the fields of colored squares that had, in the early twenties, provided a background for works such as *Ventriloquist: Caller in the Moor* (1923; p. 186). His simple signs are confined to rudimentary Y, T, X, and L shapes and to small arcs and loops. The paintings' titles may simply provide the label of "signs," or they may confer an associative meaning, as in *Garden in the Orient* (1937; p. 272). The signs become livelier and more varied in a work such as *Legend of the Nile* (1937; p. 278), its Egyptian motif confirming the

Fig. 36. Alberto Giacometti (1901–1966). *Hands Holding the Void (The Invisible Object)*, 1934. Plaster (original cast), 61¼ in. (155.6 cm) high. Yale University Art Gallery, New Haven, Connecticut

link to hieroglyphic expression. This painting, in which we can recognize underwater life and boats on the river surface, introduces Klee's organization of his expanded vocabulary of signs into more descriptive landscape and figural compositions.

Some of Klee's signs are ancient figures: the sun, moon, heart, wheel, flag. Others are the basic geometric forms that he must have drawn thousands of times on Bauhaus blackboards. Now they appear in their own right. We are reminded of the paper cutouts Matisse made late in his life. Works such as *Composition, Black and Red* (1947; fig. 37) show that he, too, reached to the base of his art for the vocabulary that had become his own. He no longer needed explicitly to detail nudes in interiors or flowers in vases; big leafy arabesques and the waves of a woman's back sufficed.

Klee's signs are as flexible in meaning as they are in size or shape: a comb form ⊔⊔⊔ can read as a mouth, a hand, a flower, or simply as a rhythmic element. As was always true of Klee's graphic work, the process is synthetic rather than analytical: the signs generate the associations, rather than the reverse. The linear forms constitute an alphabet from which Klee could assemble his pictures. As with language, a finite number of elements can produce an infinite number of images. Ultimately, the titles that indicate landscape or figural motifs hardly matter; the images are generalized, and the distance from a physiognomy to a forest is very slight. A drawing such as *Growth Is Stirring* (1938; p. 286) makes clear why the script pictures of the twenties could equally "write" human figures, flowers, or abstract designs. It reduces the genesis of form to an essential spirit equally applicable to animals, plants, or ideas.

In a deeper sense than ever before, the language of Klee's late work had become its own subject. His paintings of the thirties, unlike those of many of his peers, largely remained within the repertory of themes that had served him for a lifetime.[91] In contrast, Max Ernst invented a wholly new subject matter for himself when he turned his skill to veristic portrayals of petrified civilizations such as *The Entire City* (1935–36; fig. 38). There was a general resurgence of mythological themes, and Picasso managed to wrestle the myth of the Minotaur into a singularly personal legend that defined an era as it served his own psychic needs.[92] The mark of trauma upon Klee's imagery was a more subtle one. While the mood of many of his works remained characteristically benign, Klee's oeuvre catalogue now would record a different vision as well. Children are frequently grieving or lost; nature may seem more demonic than beneficent; ships can be found rusting in harbor.

The notion of a monumental painting by Klee may seem a contradiction in terms. Yet the grand scale of his last works disproves this. In absolute dimensions, they tend to be much larger than ever before; a number of paintings from 1938 surpass five feet in length. But the scale of these works is felt more in relation to their impact on the surrounding environment. If a painting by Rothko can be intimate in its enormity, these works are monumental in their still-small size.

This has a great deal to do with the dramatic change in Klee's use of mediums. He retained his longtime preference for homemade combinations of varieties of oil and tempera, watercolor and gesso. But now these mixtures aim toward an effect of intensity rather than subtlety. Klee

Fig. 37. Henri Matisse (1869–1954). *Composition, Black and Red*, 1947. Paper cutout, 15¹⁵/₁₆ × 20⅞ in. (38.1 × 50.8 cm). The Wellesley College Museum, Wellesley, Massachusetts

Fig. 38. Max Ernst. *The Entire City*, 1935–36. Oil on canvas, 23¾ × 32 in. (60 × 81 cm). Kunsthaus Zürich

also began to work with mediums he had seldom used before. In 1937 he turned to pastel crayon, which allowed firm but still soft drawing upon the colored squares. Soon he invented a thick paint of pigment and paste, which he could apply firmly but freely with a brush, spatula, or palette knife. The large scale of the marks relative to the pictorial field also boldens their impression. There seems to be no space left to separate the viewer from the image; we are pitched into immediate confrontation with figures as well as landscapes.

The thickness of Klee's marks permits his sign language its quality of anonymity and allows a preference for remove that we can trace back at least to the distancing process involved in the oil transfer drawings. The grounds on which Klee painted reinforce this effect as much as they do the rudimentary nature of his marks. Heavy burlap was substituted for expensive canvas, brown wrapping for fine paper. Klee also began frequently to paint on newspaper glued on jute.

When he did paint on artist's paper, he often wet it first so that the paint would cause it to ripple and acquire an assertive substance of its own. We find the same effect at work in Miró's contemporary turn to masonite, on which he painted in tar and casein (see *Painting on Masonite*, fig. 39). The raw nature of all these supports retains a pronounced resistance to imprint. Like walls of caves or of subways, they bespeak an existence independent of the advent of the artist's mark. Accordingly, the images must assume a stronger, and even necessary, presence. They project the same immanent power of the graffiti that Brassaï photographed (fig. 40) in Paris alleyways and published in *Minotaure* in 1933. Brassaï's words can be used to explain the consequence of Klee's late work. In distinguishing the graffiti from the work of a child—made on walls rather than paper, anonymous rather than supervised—Brassaï recognized that they returned "the word 'charming' to its original sense."[93]

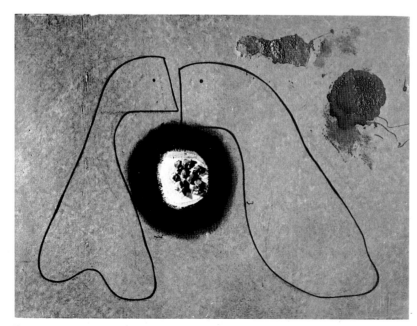

Fig. 39. Joan Miró. *Painting on Masonite*, 1936. Oil, casein, tar, and sand on masonite, 30¾ × 42½ in. (78.1 × 107.9 cm). Pierre Matisse Gallery, New York

Fig. 40. Brassaï (1899–1984). *Graffiti*, 1933. Photograph. Published in *Minotaure* (Paris), no. 3/4 (December 1933), p. 6

Fig. 41. Max Ernst, Saint-Martin d'Ardèche, 1939

This brings us back to the question that weighed so heavily in the thirties. Man yearned for art to regain its lost efficacy, a power that had been equally expressed by the penitent who knelt in a chapel of the Virgin and by the hunter who initiated his chase by drawing in mud the scene of a kill. In this sense we return to the idea of the mural, for it is not for nothing that we still speak of "writing on the wall." That legacy makes the mural a field for social interference, and even allows it the voice of a collective truth greater than that apparent to us. The Mexican muralists of the thirties knew this, as did Picasso when for the 1937 World's Fair he painted *Guernica* in a language to be understood by the many.

For Klee, such overtly propagandistic work was out of the question. Klee could no more surrender his private idiom than he could situate his creations in a nonart setting. But he did refer his own still self-contained work to an art that is engaged by its society. In the twenties his works on grounds of plaster had sought for themselves the authority of ancient documents or wall paintings. In the late thirties, the works on newspaper used this effect for more contemporary reference. Certainly, the newspaper provided the sort of rough and varied surface that Klee was seeking for a pictorial base. But it also could

stand as a metaphor for the wall on which a mural is normally painted. One can think of the news as the face of our civilization and of journalists as the architects of our history. The archaeologists of modern society, we might say, will read not its walls but its newspapers. At easy reach, Klee had found a facade on which to leave his mark in his time.

Yet the mural has a double-sided nature. On the one hand it can function as the collective voice of the people in a public forum. But it has an equal place in the private sphere, where it serves to create a personal universe for the inhabitant of the walls it covers. Goya—whose work assumed fresh relevance in the thirties—had finished his life in a panoramic nightmare of Black Paintings he frescoed on the walls of his country farmhouse. Max Ernst (fig. 41), in refuge during 1938–39 in the south of France, rebounded from his recent paintings of ruin by sculpting a fantastic menagerie to keep him company. Exiled in Lysaker, Norway, Kurt Schwitters in 1937 began to wall off the world in a Merzbau camouflaged under a hillside.

Klee had never had any impulse toward large-scale decoration. Yet in his final years he found an equivalent solution to the structuring of his environment. This is represented in the veritable outpouring of drawings he produced from 1937

33

until May 1940: a total of 1,583. Indeed, we can imagine the drawings filling his studio, as "sheet after sheet fell to the floor" in what by 1937 Lily Klee's letters described as a continuous flow.[94] They defined not only the artist's space but his remaining time: they became Klee's clock as he methodically numbered, titled, matted, and recorded in his catalog the mounting production.

Done in pencil, grease crayon, and brushed watercolor, these drawings are genuine products of the automatism Breton described in 1924. And it is here that the confounding of drawing and writing is total. Many, in fact, were made on lined writing paper. With a few quick strokes, all descriptive detail is condensed into terse sign. Musicians are one with their instruments, ships their own seas.

To see a few of these drawings in isolation is to see fragments from a lengthy frieze. Their apparent simplicity belies the enigma of the resolutely cryptic ideographs. They attain a real sense only when we see the entire proceeding, the rhythm of Klee's thought acquiring a certain communicative power beyond straightforward appearance. Themes form, sometimes in clusters, sometimes sprinkled over a long period. Often these can be traced to longstanding preoccupations. The many figures of Eidolas[95] and Angels (pp. 306, 320), en route from their earthly to celestial stations, literalize Klee's early speculations on man's condition as a creature "half-winged, half imprisoned."[96] Cumulatively, the drawings serve as a final chapter to the diary Klee had abandoned in 1918, forming for the artist what Glaesemer has described as "an uninterrupted dialogue with himself."[97]

Within the broad gamut of these drawings, one device stands out as particularly prevalent: the fragmentation of the figure into globular sections that float on the page with no relation to gravity or to each other. This scrambled structure resounds through scores of drawings, not only of people but of landscapes and buildings. The importance of this motif to Klee is reflected in *Outbreak of Fear III* (1939; fig. 42). Although Klee rarely elaborated his late drawings into colored works, this watercolor is prepared by two (*Outbreak of Fear*, p. 307). Its title confirms the mood implied by the pictorial structure. The image reads as one of Klee's puppets come apart, its pieces flattened onto the page like the cutouts of a sewing pattern. Some of its parts are discernible bits of anatomy, others merely amorphous fragments. The pale watercolor over an egg ground works to deny the possibility of any real substance within the body's forms.

The picture evinces a tender pathos, rather than a shrill rage, and yet it bears a proximity to the Weeping Women who form a postscript to *Guernica* or the *tableaux sauvages* of Miró. The Miró *Head of a Man* (1937; fig. 43) shares many of the devices by which Klee evoked an Outbreak of Fear. In both works, the figure's perimeters completely fill the pictorial field, rendering it a place of claustrophobic entrapment. Miró's head also appears severed from its body, reaching up into the painting on a long stick of a neck. An agglomeration of sickly fluids and gases takes the place of flesh and bone.

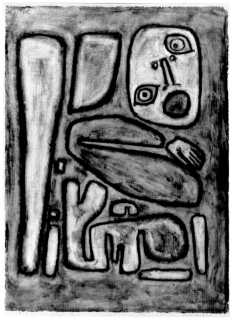

Fig. 42. Paul Klee. *Outbreak of Fear III (Angstausbruch III)*, 1939 / 124 (M 4). Watercolor over egg ground on paper, mounted on cardboard, 25 × 18⅞ in. (63.5 × 48.1 cm). Kunstmuseum Bern, Paul Klee Stiftung

Fig. 43. Joan Miró. *Head of a Man*, 1937. Gouache and India ink on black paper, 25⅝ × 19¾ in. (63.5 × 50.1 cm). Collection Richard S. Zeisler, New York

Fig. 44. Paul Klee. *Reparatur*, 1938 / 347 (Z 17). Pencil on letter paper, mounted on cardboard, 7¾ × 11¾ in. (20.9 × 29.8 cm). Kunstmuseum Bern, Paul Klee Stiftung

Fig. 45. Paul Klee. *Wandering Artist: A Poster (Wander-Artist, ein Plakat)*, 1940/273 (L 13). Colored paste on paper, mounted on cardboard, 12⅛ × 11⅜ in. (31 × 29 cm). Private collection, Switzerland

Klee and Miró each generalized their victim as an androgynous being ("head of a man" cannot account for the vagina dentata mouth on Miró's figure). Both works support readings far beyond personal cries of pain or terror. Yet the motif is also one of real immediacy, as Klee acknowledged in a drawing entitled *Reparatur* (1938; fig. 44). Here the artist, pen in hand and sporting Klee's black pipe, surveys his own scattered self in a pond of disjointed limbs and faces. The lofty title ironically punctuates the artist's situation.

Jorge Luis Borges observed that when an author dies, he becomes books. Klee was soon to become pictures; and like one of his Eidola or Angel figures—caught midway between life and death—he by the end was metamorphosing into his works. The language of the late work cannot be separated from the man himself. Klee's eyes glance from the landscapes, and his initials P and K float in the fields of signs. The artist's name homonymically situates itself within the many images in which a key (*clé*) form defines a figure or a space. As a young man, Klee again and again had portrayed himself at work in his room. Now there remain only the trappings of this personal space: the carpet, the keyhole, the cupboard. Ultimately the artist has merged with his furniture and has become his own hiding place (fig. 45).[98] But Klee's final introversion, too, would be turned outward. As his identity folded into that of his art, it also folded into the ongoing history of the avant-garde. For these late works provided a legacy with which that avant-garde was to renew itself after Klee was gone, in an abstract language that merged symbol and self.

35

Notes

The author wishes to extend warmest thanks to Carolyn Lanchner and Jürgen Glaesemer.

1. Guillaume Apollinaire, "La Victoire," in *Calligrammes* (Paris: Gallimard, 1966), p. 18. First published 1917.
2. Paul Klee, no. 1008 (1916) in *The Diaries of Paul Klee, 1898–1918*, ed. Felix Klee (Berkeley and Los Angeles: University of California Press, 1964), p. 345.
3. Klee, *Diaries*, p. 259, no. 899 (1911). On Klee's development, see Charles Werner Haxthausen, *Paul Klee: The Formative Years* (New York: Garland, 1981).
4. "Second Exhibition of the Editors of the *Blaue Reiter*," Galerie Hans Goltz, Munich, February 1912. The *Almanac* reproduced Klee's *Stonecutter* (1910 / 74). See *The Blaue Reiter Almanac*, eds. Wassily Kandinsky and Franz Marc. English edition ed. Klaus Lankheit (New York: Viking, 1974), p. 197. Klee reviewed both *Blaue Reiter* exhibitions as an arts correspondent for *Die Alpen*, a journal in Bern. Texts are reprinted in Christian Geelhaar, *Paul Klee: Schriften, Rezensionen und Aufsätze* (Cologne: DuMont, 1976).
5. For the catalog of an exhibition honoring Kandinsky's sixtieth birthday (Galerie Arnold, Dresden, 1926), Klee wrote: "Par son développement Kandinsky était mon aîné; j'aurais pu être son élève; et, en un sens, je l'étais véritablement. Il n'y avait pas un mot de lui qui ne fût pour mon travail une lumière, un encouragement, une confirmation." Reprinted in exhibition catalog *Kandinsky et Klee*, Berggruen & Cie, Paris, 1959.
6. In autumn 1912 Delaunay mailed to Klee his article "Sur la lumière," which Klee translated for publication in the journal *Der Sturm* (Berlin), vol. 3, no. 144–45 (January 1913), pp. 255–56. For a detailed analysis of Klee's assimilation of Parisian painting, see Jim M. Jordan, *Paul Klee and Cubism* (Princeton, New Jersey: Princeton University Press, 1984).
7. Walden included Klee in his historic Autumn Salon, September–November 1913. He continued to show Klee's work at Galerie Der Sturm and to illustrate it in Sturm publications throughout the teens.
8. Hans Richter, *Dada Art and Anti-Art*, trans. David Britt (New York: Abrams, 1965), p. 39.
9. As a producer at the *Kammerspiele* (intimate theaters) in Munich, Ball in 1914 had formulated a plan for a collaborative *Künstlertheater* that included Kandinsky and Klee. See Hugo Ball, *Flight Out of Time: A Dada Diary*, ed. John Elderfield, trans. Ann Raimes (New York: Viking, 1974), pp. 9–10. First published 1927.
10. Klee, *Diaries*, p. 258, no. 897 (1909).
11. Klee, *Diaries*, p. 240, no. 865 (1909). Klee's illustrations for *Candide* were published in 1920 by Kurt Wolff in Munich.
12. Hugo Ball, *Cabaret Voltaire* (Zürich), May 15, 1916.
13. "In seinem schönen Werk sahen wir den Widerschein all unserer Bemühungen, die Seele des primitiven Menschen zu deuten, ins Unbewusste und in die triebhafte Schöpfungskraft hineinzutauchen, die reinen und unmittelbaren Schaffensquellen des Kindes zu entdecken." Marcel Janco, "Schöpferische Dada," in *Dada: Monographie einer Bewegung*, eds. Willy Verkauf, Marcel Janco, Hans Bolliger (Teufen: Arthur Niggli, 1965), p. 38.
14. In early 1911 Klee began an oeuvre catalogue in which he retroactively included works dating back to 1883 and which he would maintain for the rest of his life. It detailed titles, dates, and mediums, as well as prices and sales. While he included several works from his childhood, he omitted his school drawings "because they lack creative self-sufficiency." See *Diaries*, p. 256, no. 895 (1911).
15. Arp had participated in the second *Blaue Reiter* exhibition in February 1912. Klee and he met that summer through the activity of the Swiss art association *Der moderne Bund*; Arp subsequently helped to try to find a publisher for Klee's *Candide* drawings.
16. Paul Klee, "Ways of Nature Study" (1923), in *The Thinking Eye: The Notebooks of Paul Klee*, ed. Jürg Spiller (New York and London: Wittenborn and Lund-Humphries, 1961), p. 63.
17. Ball, *Flight Out of Time*, p. 103.
18. *Ibid,*, p. 104.
19. Jürgen Glaesemer explains that Klee developed this painting from an earlier drawing that he turned sideways. See his *Paul Klee: The Colored Works in the Kunstmuseum Bern*, trans. Renate Franciscono (Bern: Kornfeld, 1979), pp. 32–33.
20. Klee, *Diaries*, p. 315, no. 952 (1915).
21. Precedents for such experiments were many. One well-known to Klee was the "Fisches Nachtgesang," from the *Galgenlieder* (1905) of the German poet Christian Morgenstern. The poem is composed entirely of dashes and arcs arranged to form a scaly fish.
22. See Kandinsky on the letter as a "being with inner life," in "On the Question of Form," *The Blaue Reiter Almanac*, p. 165.
23. For example, see Ernest Fenollosa and Ezra Pound, "The Chinese Written Character as a Medium for Poetry," *The Little Review* (New York), vol. 6, nos. 5–8 (September–December 1919). As was common among Western scholars at the time, Fenollosa exaggerated the pictographic quality of the Chinese characters. On Klee's cycle of watercolors on the Chinese poems, see Glaesemer, pp. 38–39.
24. Klee, "Creative Credo" (1920), trans. Norbert Guterman, in *The Inward Vision: Watercolors, Drawings, Writings by Paul Klee*, ed. Werner Haftmann (New York: Abrams, 1958), p. 7.
25. *Ibid.*
26. Klee, *Diaries*, p. 275, no. 916 (1913). This entry quotes Klee's remarks on a Futurist exhibition at the Galerie Thannhauser, Munich, published in *Die Alpen* (Bern), December 1912, pp. 239–40.
27. Kurt Schwitters, "Logically Consistent Poetry" (1924), reprinted in Richter, p. 148.
28. *Ibid.*, p. 149.
29. John Elderfield has observed that these whimsical drawings may reflect attention to Klee, whose works Schwitters would have known from Der Sturm and the Hanover Kestner-Gesellschaft. See his *Kurt Schwitters* (New York: Thames and Hudson, 1985), p. 47.
30. *Dada Anthologie* (Zürich), no. 4/5 (May 15, 1919). In the summer of 1919, Klee visited the Dadaists in Zürich, and saw Tzara, Arp, Eggeling, Richter, and Janco. His report to his wife suggests that their enthusiasm was infectious: "Would that we had them in Munich!" Card to Lily Klee, June 22, 1919, in *Paul Klee: Briefe an die Familie 1893–1940*, vol. 2: 1907–1940, ed. Felix Klee (Cologne: DuMont, 1979), p. 954.
31. Although originally organized for Karl Nierendorf's Gesellschaft der Künste, the Ernst and Baargeld display was segregated from Nierendorf's exhibition when shown at the Kölnischer Kunstverein; a sign announced that the two events were unrelated. The British authorities occupying Cologne ultimately confiscated the *Bulletin D* poster and catalog and forbade the projected tour. For this history and a reprint of the catalog, see *Von Dadamax zum Grüngürtel: Köln in den 20er Jahren* (Cologne: Kölnischer Kunstverein, 1975). See also Lanchner's essay in this book, p. 86.
32. For details of this visit, see Werner Spies, *Max Ernst Collagen: Inventar und Widerspruch* (Cologne: M. DuMont Schauberg, 1974), p. 35.
33. See also Glaesemer, pp. 145–46. In two paintings of 1923–24, Ernst combines a Chiricoesque setting with the painting-poem technique of Klee's *Once Emerged from the Gray of Night . . .*: see *Dans une ville pleine de mystère . . .* and *Qui est le grand malade?*, reproduced in Uwe M. Schneede, *Max Ernst* (Stuttgart: Gerd Hatje, 1972), p. 69.
34. René Crevel, in Will Grohmann, *Paul Klee* (Paris: Cahiers d'Art, 1929), p. xxiv. Excerpt from Crevel's "Merci, Paul Klee!" in *Le Centaure* (Brussels), December 1928: "Alors, ce jour-là . . . j'ai fait connaissance avec des animaux d'âme, oiseaux d'intelligence, poissons de coeur, plantes de songe."
35. Louis Aragon, "Le Dernier Eté," *Littérature*, nouvelle série no. 6 (November 1, 1922), p. 22: "C'est à Weimar que fleurit une plante qui ressemble à la dent de sorcière. On ne sait pas encore ici que la jeunesse va préférer Paul Klee à ses devanciers."
36. The creation of the Bauhaus was an example of the gentle evolution of the Dada and Expressionist climate into one of Constructivism. Walter Gropius's founding vision was one of a unity of artists and craftsmen in the project of building a new everyday environment. An extensive literature treats the development of this program and the place of Klee's work within it. See in particular Christian Geelhaar, *Paul Klee and the Bauhaus* (Bath, England: Adams and Dart, 1973) and Margaret Plant, *Paul Klee: Figures and Faces* (London: Thames and Hudson, 1978). See also the general literature on the Bauhaus: Marcel Franciscono, *Walter Gropius and the Creation of the Bauhaus at Weimar* (Urbana: University of Illinois Press, 1971) and Hans Wingler, *The Bauhaus* (Cambridge, Massachusetts: MIT Press, 1969).
37. René Crevel, *Paul Klee* (Paris: Gallimard, 1930). Translation by Alan Brown in Gert Schiff, "René Crevel as a Critic of Paul Klee," *Arts Magazine* (New York), vol. 52, no. 1 (September 1977), p. 136.
38. André Breton, "Manifesto of Surrealism," in *Manifestoes of Surrealism*, trans. Richard Seaver and Helen R. Lane (Ann Arbor: University of Michigan Press, 1972), p. 27.
39. *La Peinture surréaliste*, Galerie Pierre, Paris, November 14–25, 1925. The exhibition included two works by Klee; the catalog reproduced *Ghost Chamber* (1920/174).
40. Breton, p. 14.
41. *Ibid.*, pp. 16–17.
42. Theodore Lessing, "L'Europe et l'Asie," *La Révolution Surréaliste* (Paris), no. 3 (April 15, 1925), pp. 20–21. It is followed by Klee's *Parsimonious Words of the Miser* (present location unknown).
43. Leopold Zahn, *Paul Klee: Leben, Werk, Geist* (Potsdam: Kiepenheuer, 1920).
44. The issue included, for example, collaboratively written protests addressed to the chief doctors of insane asylums and to the administrators of European universities.
45. "Plus personne n'ignore qu'il n'y a pas de *peinture surréaliste*," in Pierre Naville, "Beaux Arts," *La Révolution Surréaliste* (Paris), no. 3 (April 15, 1925), p. 27.
46. Section 4 of Klee's *Pedagogical Sketchbook* details the evolution from actual arrow to symbolic arrow, and the significance of the latter in his philosophy of man's struggle to overcome his earthly limitations: "Revelation: that nothing that has a start can have infinity. Consolation: a bit farther than customary!—than possible? Be winged arrows, aiming at fulfillment and goal, even though you will tire without having reached the mark." Paul Klee, *Pedagogical Sketchbook*, intro. and trans. Sibyl Moholy-Nagy (London: Faber and Faber, 1984), p. 54. First German edition 1925.
47. Klee, *Diaries*, p. 307, no. 928 (1914).
48. Breton, "Manifesto of Surrealism," p. 16.
49. *Ibid.*, p. 26. The complete definition reads as follows: "SURREALISM, n. Psychic automatism in its pure state, by which one proposes to express—verbally, by means of the written word, or in any other manner—the actual functioning of thought. Dictated by thought, in the absence of any control exercised by reason, exempt from any aesthetic or moral concern."

50. Ball, *Flight Out of Time*, p. 103.
51. André Breton, "Artistic Genesis and Perspective of Surrealism," in *Art of This Century*, ed. Peggy Guggenheim (New York: Arno Press, 1968), p. 21. First published 1942.
52. Klee, "Creative Credo" (1920), in *The Thinking Eye: The Notebooks of Paul Klee*, ed. Jürg Spiller, trans. Ralph Manheim (New York: Wittenborn, 1961), p. 76.
53. *Ibid.*, p. 77.
54. Klee, *Diaries*, p. 228, no. 831 (1908).
55. Klee called attention to the art of the mentally ill in his review for *Die Alpen* (January 1912) of the first *Blaue Reiter* exhibition. After praising the art of children, he wrote: "Parallel phenomena are provided by the works of the mentally diseased; neither childish behavior nor madness are insulting words here, as they commonly are. All this is to be taken very seriously, more seriously than all the public galleries, when it comes to reforming today's art." Review excerpted by Klee in his *Diaries*, p. 266, no. 905 (1912).
56. The most important example of this literature, Hans Prinzhorn's *Bildnerei der Geisteskranken* (Berlin: Springer, 1922) was well known both to Klee and the Surrealists. See Werner Spies, "L'Art Brut avant 1967," *Revue de l'Art* (Paris), no. 1–2 (1968), pp. 123–26; Françoise Will-Levaillant, "L'Analyse des dessins d'aliénés et de médiums en France avant le Surréalisme," *Revue de l'Art* (Paris), no. 50 (1981), pp. 24–39.
57. See Lanchner's essay in this book, pp. 87–88.
58. Wilhelm Hausenstein, *Kairuan, oder eine Geschichte vom Maler Klee und von der Kunst dieses Zeitalters* (Munich: Kurt Wolff, 1921).
59. *39 aquarelles de Paul Klee*, Galerie Vavin-Raspail, Paris, October 21–November 14, 1925. Introduction by Louis Aragon reprinted in Will Grohmann, *Paul Klee* (Paris: Cahiers d'Art, 1929). Aragon perceived the obstacles facing a German artist in a strongly nationalistic postwar France. His deft solution was to remind his audience of the well-established truisms that opposed "la lourdeur des Allemands" to "la finesse des Français." In this dichotomy, Klee landed cleanly on the French side of the border.
60. Henri Michaux, "Aventure des lignes," preface to *Paul Klee* by Will Grohmann (Paris: Flinker, 1954), quoted in *Henri Michaux* (Paris: Musée National d'Art Moderne, 1978), p. 85.
61. William Rubin, "André Masson and Twentieth-Century Painting," in William Rubin and Carolyn Lanchner, *André Masson* (New York: The Museum of Modern Art, 1976), p. 21.
62. Miró probably would have known a painting very similar to *Rosa Silber*, the *Order of the High C* (1921), in the collection of Paul Eluard. See Rosalind Krauss and Margit Rowell, *Joan Miró: Magnetic Fields* (New York: The Solomon R. Guggenheim Foundation, 1972), pp. 28–29.
63. This complex process began with the transfer into oil of an independent pencil drawing. Klee placed it on a piece of tracing paper, the bottom side of which was spread with black oil or printer's ink. That in turn rested on a third sheet of paper. Using a stylus to trace the pencil drawing, Klee impressed its image onto the bottom sheet in the black oil or ink from the tracing paper. When the watercolor was applied it left the drawing intact, and apparently superior, on account of the antipathy of oil and water.
64. See William Rubin, *Miró in the Collection of The Museum of Modern Art* (New York: The Museum of Modern Art, 1973), pp. 30–33.
65. Max Ernst, *Beyond Painting and Other Writings by the Artist and His Friends*, ed. Robert Motherwell (New York: Wittenborn, Schulz, 1948), p. 8. Ernst explained that this technique allowed him to assist "as a spectator" at the birth of his work. Compare Miró's claim that a picture "suggests itself under my brush" (quoted by James Johnson Sweeney, in "Joan Miró: Comment and Interview," *Partisan Review* [New York], vol. 15, no. 2 [February 1948], p. 212). For a comparable view, see Klee's *On Modern Art* (1924), trans. Paul Findlay (London: Faber and Faber, 1948).
66. Ernst, *Beyond Painting*, p. 7.
67. Klee, *Diaries*, p. 8, no. 27.
68. Charles Baudelaire, "The Painter of Modern Life," in *Baudelaire: Selected Writings on Art & Artists*, trans. P. E. Charvet (Cambridge, England: Cambridge University Press, 1972), p. 398. First published in Paris, 1863.
69. On Klee's *Diaries*, see Christian Geelhaar, "Journal intime oder Autobiographie? Uber Klees Tagebücher," in *Paul Klee: Das Frühwerk 1883–1922* (Munich: Städtische Galerie im Lenbachhaus, 1979), pp. 246–60.
70. Ernst quoted in Patrick Waldberg, *Max Ernst* (Paris: Jean-Jacques Pauvert, 1958), p. 236. Author's translation from the French.
71. Louis Aragon, "La Peinture au défi" (1930), reprinted in *Les Collages* (Paris: Hermann, 1965), p. 67. The collage phenomenon was not limited to Paris: the same disjunctive space structures the contemporaneous photomontages of Klee's Bauhaus colleagues.
72. Breton, "Artistic Genesis and Perspective of Surrealism" (see n. 51, above), p. 20.
73. *Ibid.*, p. 21.
74. "Auditive images, in fact, are inferior to visual images not only in clarity but also in strictness, and . . . they are not destined to strengthen the idea of human greatness. So may night continue to descend upon the orchestra." André Breton, "Surrealism and Painting," in *Surrealism and Painting*, trans. Simon Watson Taylor (New York: Harper & Row, Icon, 1972), p. 1.
75. The musical quality of this series also closely relates it to the work of Klee. Miró acknowledged the inspiration he received from music while creating the Constellations, citing Bach and Mozart, two composers of great importance to Klee. Interview with Sweeney, 1948, p. 10 (see n. 65, above).
76. Philippe Soupault, in Grohmann, *Paul Klee* (1929), p. xxv: "Le secret de l'art de Klee doit rester longtemps encore notre secret."
77. Breton, "Second Manifesto of Surrealism," in *Manifestoes* (see n. 38, above), pp. 117–94. First published in *La Révolution Surréaliste* (Paris), no. 12 (December 15, 1929).
78. Soupault, p. xxv: "Une étoile plus que planète."
79. Will Grohmann, "Paul Klee," *Cahiers d'Art* (Paris), 3e année (1928), p. 296.
80. Crevel, *Paul Klee* (see n. 37, above). For comment, see Schiff, p. 136.
81. For a facsimile of Klee's reply to Eluard, see *L'Univers de Klee* (Paris: Berggruen & Cie, 1955).
82. Eberhard W. Kornfeld, *Verzeichnis des Graphischen Werkes von Paul Klee* (Bern: Kornfeld und Klipstein, 1963), no. 107.
83. "Je pense à la chaleur que tisse la parole / autour de ce noyau le rêve qu'on appelle nous." Tristan Tzara, *L'Homme approximatif* (1931), reprinted in *Oeuvres complètes*, vol. 2, ed. Henri Béhar (Paris: Flammarion, 1975), p. 82.
84. For Bataille on Klee, see *Cahiers d'Art* (Paris), 20e–21e années (1945–46), p. 52, a special Klee issue: "Klee, me semble-t-il, avait plutôt la douceur d'un vice, quelque chose de moins distant que ne l'est généralement la peinture, et que j'ai du mal à distinguer de moi-même."
85. Dawn Ades, *Dada and Surrealism Reviewed* (London: Arts Council of Great Britain, 1978), p. 230.
86. *Documents* (Paris), no. 5 (October 1929), pp. 286–87. See also Georges Limbour, "Paul Klee," *Documents*, no. 1 (April 1929), pp. 53–54.
87. Klee, *Diaries*, p. 124, no. 425 (1902).
88. "Conversation avec Picasso," *Cahiers d'Art* (Paris), 10e année, nos. 7–10 (1935), pp. 173–74. Reprinted in Dore Ashton, *Picasso on Art* (Harmondsworth, England: Penguin, 1972), pp. 7–13. Henri Matisse, "On Modernism and Tradition," *The Studio*, vol. 9, no. 50 (May 1935), pp. 236–39. Reprinted in Jack Flam, *Matisse on Art* (New York: Dutton, 1978), pp. 71–72. Max Ernst, "Au-delà de la peinture," *Cahiers d'Art* (Paris), 11e année, no. 6–7 (1936), pp. 149–84. Reprinted in Ernst, *Beyond Painting*.
89. Hans Muhlestein, "Des Origines de l'art et de la culture," *Cahiers d'Art* (Paris), 5e année (1930), pp. 57–66, 139–45, 247–49, 295–99, 532–36.
90. Leo Froebenius, essay in *Prehistoric Rock Pictures* (New York: The Museum of Modern Art, 1937), p. 28.
91. See Werckmeister's essay in this book for an interpretation of Klee's specific address of the political situation at this time.
92. Klee's own Ur-oxen (1939; p. 309) well may respond to Picasso's minotaurs, as Glaesemer has suggested in *Paul Klee: Handzeichnungen III* (Bern: Kunstmuseum Bern, 1979), p. 45. Picasso visited Klee in Bern in 1937, and as recounted by Pierre Daix, "éprouvait une très vive admiration pour le seul peintre de son époque qui, avec Miró, ait inventé un registre de signes plastiques autre que le sien." Daix, *La Vie de peintre de Pablo Picasso* (Paris: Editions du Seuil, 1977), p. 280.
93. Brassaï, "Du mur des cavernes au mur d'usine," *Minotaure* (Paris), nos. 3–4 (December 14, 1933), pp. 6–7. "Ce qu'on décele sous la transparence cristalline de la spontanéité est ici une fonction vivante, aussi impérieuse, aussi irraisonnée que la respiration ou le sommeil."
94. "Blatt für Blatt fällt zu Boden"; Lily Klee to Will Grohmann, July 8, 1937, quoted in Glaesemer, *Handzeichnungen III*, p. 27.
95. Each phantom "eidola," labeled in Greek, embodies the essential form, or *eidos*, of the identity it possessed while on earth.
96. Klee, *Pedagogical Sketchbook*, p. 54.
97. Glaesemer, *Handzeichnungen III*, p. 25.
98. "No one sees me changing. But who sees me? I am my own hiding place. . . ." Joë Bousquet, in *La Neige d'un autre âge*, quoted by Gaston Bachelard, *The Poetics of Space*, trans. Maria Jolas (Boston: Beacon, 1969), p. 88.

FROM
REVOLUTION
TO EXILE

O. K. WERCKMEISTER

In the early stages of the modernist tradition, its challenge to established culture was often linked to the radical dissidence or even revolutionary politics of Socialism and Anarchism. In 1968, Donald Drew Egbert compiled a dossier of this early history in his book *Social Radicalism and the Arts in Western Europe;* in 1973, T. J. Clark, in *The Absolute Bourgeois*, evoked the French revolution of 1848 as one of its pivotal events; and in 1983, Hans Belting pinpointed the resulting historical contradiction: "In early dreams of unity, political and aesthetic avantgardism were programmatically linked. In historical practice, the conflict between . . . aesthetic and political utopia, between artistic autonomy and political anarchy, broke out, as the history of the struggle regarding autonomous versus engaged art can show."[1]

Paul Klee's career was not exempt from such struggles. On April 12, 1919, then living in Munich, Klee responded to an invitation from the painter Fritz Schaefler to join the artists' advisory body of the second *Räterepublik*, the Council Republic of Bavaria:

The Action Committee of Revolutionary Artists may completely dispose of my artistic abilities. It is a matter of course that I regard myself as belonging here, for after all, several years before the war I was already producing in the manner that is now to be placed on a broader public base. My work and my other artistic capabilities and insights are at your disposal![2]

More than twenty years later, on July 11, 1939, Klee, now living in exile in Switzerland and having applied to its Federal government for citizenship,[3] made the following statement to the Swiss authorities who reviewed his application: "The severance of my civil service contract at Düsseldorf [in 1933] took place because of the German Revolution. Since I had nothing more to expect from the German state, I felt free of any ties to this state and entitled to a break of these relations."[4]

In the years between these two statements, the artist's attitude toward the German government had reversed itself, from cooperation to recoil; in the process, his understanding of the term "revolution," used time and again by the proponents of the modernist avant-garde,[5] had reversed from left to right. In 1919, the left-wing, nonparliamentary government of Bavaria, soon to be ousted by military intervention, seemed to offer political confirmation of the original meaning of the term; in 1933, the right-wing national government of Germany, fully legalized by a parliamentary majority, advanced the term in order to claim mass support for its swift dismantling of the democratic institutions on which modernist art had come to depend. Between these two dates, perhaps as early as 1924, the postwar revolutionary aspirations of the workers' movement had abated everywhere in Central and Western Europe. The reversal of significance in Klee's use of the term revolution was thus conditioned by historical reality, not by any vacillations on his part. The original leftist connotations of the term as used within the modern tradition had been cast in doubt for him, as for many other modern artists, by bewildering manipulations in the history of twentieth-century political ideology.[6] To trace this process through the crucial dates in Klee's career from the record of his texts and pictures is the purpose of the present essay. To integrate the process into an assessment of the political history of early-twentieth-century Europe to which Klee was subject as an artist remains a task for the future.

I

1905: THE FEBRUARY REVOLUTION IN RUSSIA

When Klee first used the term "revolutionary" in his correspondence, he applied it to himself. On December 9, 1902, he relayed to his fiancée Lily Stumpf a report from his friend Hans Bloesch

about scenes of poverty in Paris:

Bloesch shivers in Paris until the end of December, where poor devils with empty stomachs are reported to have dropped on the streets because of the cold. Probably your shows for the common people in the Hoftheater only make sense at present if the room is well heated. The rest is luxury and occurs in no republic where one thinks democratically. I am not democratic, only generally revolutionary.[7]

At the age of twenty-two, Klee voiced for the first time a principled reflection on why art ought to be justified to the common people, a matter that was to worry him intermittently throughout his career. In a democratic state, he assumed, the disparity between the "luxury" of art and the misery of the lower class would have to be resolved. However, aware of the cultural limits of his nonconformist convictions as an artist, he claimed for himself the term "revolutionary" rather than "democratic," which is both less radical and more precise. Nevertheless, even in this early stage of Klee's career, while still an art student in Munich, he sought to align himself with the "revolutionary" self-designation of the late-nineteenth-century modernist tradition, years before he began to assimilate modernist models into his art.

By 1905, when Klee had returned from a study trip to Italy and was again living at his parents' home in Bern, his social life became tied up with two people who were both more outspoken in their leftist leanings than he. With the first, Lily Stumpf, his fiancée in faraway Munich, he maintained an intense, all-encompassing correspondence. She had deliberately emancipated herself from an upper-middle-class code of values and had not only defied her father and engaged in a secret premarital sexual relationship with Klee, but, more importantly, had embarked on an intellectual, literary, and even political self-reflection that has only become apparent since Klee's letters to her were published in 1979. Stung by her father's blunt oppression, she had gone so far as to espouse August Strindberg's and Otto Weininger's critique of bourgeois sexual morality,[8] and she was in touch with Russian anarchists in Munich.[9] The second person important to Klee upon his return to Bern was Philipp Lotmar, father of Fritz Lotmar, one of two high school classmates with whom Klee had remained close, and whose house he frequently visited. Philipp Lotmar was a law professor at the University of Bern, a German Jew from Frankfurt with decidedly democratic views. He was personally acquainted with the Russian Socialist Leo Deutsch, who had been extradited from Germany at the initiative of Bismarck, and whose published memoirs about his imprisonment in Siberia Lotmar gave Klee to read.

As a result of these encounters, Klee developed what in 1919 he retrospectively called (in an autobiographical digest of his diaries known as the "Supplementary Manuscript") "an only very indirect interest in social and political questions."[10] Klee became sympathetic to Socialism but remained skeptical of its prospects for political success.[11] Despite his detachment on these grounds, he was caught up in the political debates of his friends. Their agitation

came to a head during the Russian revolution of February 1905 and its bloody suppression by the Czarist government; the news was greeted with outrage in liberal circles throughout Western Europe. Against such sentiments, Klee immediately defined his own ironic distance from the events, no matter how strongly he shared in their condemnation:

Last night at the Lotmars the talk was of Russia. Never have I seen the old man so excited; all the while he looked so magnificent that I have to be grateful to the criminals. I would never be able to take sides so wildly; it is more like me to watch with a silent smile, even if everything were blowing up. In the end I too belong to those people who die with a joke on their lips.[12]

In the following two weeks, Klee began to make the etching *Aged Phoenix* (fig. 1),[13] the next to last in the cycle of Inventions he had been working on since 1903.[14] In a letter to Lily Stumpf of February 19, 1905, he explained the project, taking a pessimistic view of Socialism:[15] "One has to imagine, for example, a revolution has just happened; they have burned inadequacy [*Unzulänglichkeit*], and it reemerges, rejuvenated, from its own ashes. That is my belief."[16] He does not say that a revolution has failed; rather that it has succeeded, but to no avail, since the prerevolutionary state of inadequacy rises like the Phoenix from its ashes. The revolution had not just succeeded in Russia, however, and thus Klee did not picture the Phoenix of inadequacy as "rejuvenated." Instead, when he reported a month later to his fiancée that he had completed the etching, he had reversed himself to depict an "aged" Phoenix before rather than after the transition. He projected the full explanatory title for the etching in his letter: "Aged Phoenix as a symbol of the inadequacy of things human (including the highest ones) in critical times."[17] And he commented: "The viewing of the image explains the epithet 'aged' to mean extremely decrepit and close to the end. . . . Here it is meant to have a funny effect, as a silent punch line."[18]

What is the "funny effect"? It must have to do with the Phoenix not looking "decrepit" at all. Here is a nude female figure with a bird's head, an iconographical descendant of the Siren, the ancient mythological hybrid of woman and bird. Poised upright, her human body is tense, muscular, and sturdy, not wrinkled or sagging, but it is organically distorted, to the point of showing only one breast, with arms and legs thinning out at the extremities. If there is weakness, it consists in her inability to move any further. She has lost one foot and must sustain herself by holding onto a long staff. It is therefore not the figure's human nature that shows signs of advanced age, but her nature as a bird. Almost all of her feathers have fallen off; a few small ones persist here and there, but only the long feathers at the extremities suggest that her arms formerly were wings and that her buttocks ended in a tail. The symbolic bird of resurrection has lost her feathers so as to reveal the ridiculously familiar female personification of Revolution depicted in countless images of the nineteenth century. Klee appears to have taken for his model Théophile Steinlen's *May 1871* (fig. 2), a lithograph origi-

Fig. 1. Paul Klee (1879–1940). *Aged Phoenix (Greiser Phoenix)*, 1905 / 36. Etching, 10⅜ × 7⁹⁄₁₆ in. (26.3 × 19.2 cm). The Museum of Modern Art, New York, Purchase Fund

Fig. 2. Théophile-Alexandre Steinlen (1859–1923). *May 1871*, 1894. Color lithograph, 9½ × 11¼ in. (24 × 28.5 cm). Published in *Le Chambard socialiste* (Paris), May 26, 1894

nally published in *Le Chambard socialiste* of May 26, 1894;[19] he matched the bent-back posture of the woman, who holds on to the banner for support, a single breast exposed. In both, the female personification of Revolution faces immediate death. Steinlen had based his political allegory on an earlier oil painting, *Louise Michel on the Barricades* (ca. 1885),[20] depicting a historic event: Louise Michel facing the guns on the barricade in the defeated uprising of the Paris Commune in Montmartre on March 18, 1871.[21] Klee's etching appears to be a mordant caricature of this heroic image of the dying female revolutionary. His figure bares not just her breast, but her whole body is bared, and the breast is revealed as the only one she has. At the top of her staff, in studied similarity to her own head, is the skull of a dead phoenix, hence a phoenix who has failed to resurrect. This aged Phoenix parades the severed head of her predecessor as a trophy that belies the myth in which she still believes, all the more ridiculous as she holds out for her own rejuvenation. The grotesque figure which cannot move personifies revolution aborted, and brandishes the proof that revolutions cannot succeed. This must have been the "funny effect" Klee had in mind.

Less than four months after completing this satirical statement of political resignation, Klee made his first trip to Paris. As he combined artistic sightseeing tours with forays into low-class popular quarters, just as he had done in Naples four years earlier,[22] he was ever mindful of the discrepancy between the high culture he was seeking out and the squalor of social inequality and poverty that had already then drawn his attention. The experience once again evoked for him the term revolution:

Another time we came in the early morning hours to Les Halles and saw prostitutes skipping rope with their men, one could think of the rococo. Yet near the walls the workers were sleeping in rows, partly sitting upright, recalling the revolution. . . . You get the impres-

sion from the crowd that it's completely indifferent to the individual human life. What is probably the case is that a place like this totally numbs you in the long run. For it is impossible to help wherever one should.[23]

Klee seems to have reenacted and recounted his reading of Hans Bloesch's Paris visit of 1902. His visual memory, as committed to the written reflections of his letter, encapsulates his tenacious if resigned awareness of the class limitations of his art. This awareness must have prompted the term revolution to have been evoked by the sight of the sleeping workers on the ground. Negatively tied to the image of their helpless inertia, it is duly counterbalanced by the sense of moral frustration on the artist's part.

1913: THE EXPRESSIONIST COUNTERCULTURE

No testimony known today would suggest that between 1906 and 1919 Klee continued to reflect on his early "interest in social and political questions." When he joined the modernist movement in 1911, it still held enough cultural nonconformism to get drawn into exasperating controversies conducted in openly political language in the public sphere of the press, books, pamphlets, and debates. Indeed, it is in this public sphere that the modernist movement was termed radical and revolutionary, no matter how remote it was from its late-nineteenth-century political radicalism or how confined it had become to mere cultural opposition.

In Germany, the revolutionary self-designation of dissident culture continued to be advanced in ever more indiscriminate, potentially Anarchist terms. Thus, in the short-lived literary journal *Revolution*, which appeared in Munich in 1913, the writer Erich Mühsam could declare:

Revolution arises whenever a state of affairs has become untenable: this state of affairs may be stabilized in the political or social conditions of a country, in an intellectual or religious culture, or in the characteristics of an individual. . . .

Destruction and elevation are identical in the revolution. All destructive pleasure is a creative pleasure (Bakunin).[24]

By 1911, the political debate in Germany about modern art was no longer waged solely in terms of a potentially radical social critique, but in terms of nationalism and internationalism, as an ideological projection of global economic policy. The latter debate became particularly vehement in the wake of the Agadir Crisis, with the two sides squaring off against one another in the publications *A Protest of German Artists* and *In the Struggle for Art*. In the same year, an anonymous author published a pamphlet entitled *Sick German Art*.[25] As Theda Shapiro has noted, he

. . . likened the modern movement (consisting, for him, of the . . . caricaturists of *Simplicissimus* as well as the Expressionists) to a vast revolution from below which aimed to destroy tradition, whose guardian, the Academy, was in the hands of the upper classes, and to replace it with rampant individualism. It was, he said, "an irruption of the unruly masses, the forces from the depths, into the aristocratic realm of Art. A revolution which, perhaps, in its own realm is scarcely

Fig. 3. Title page of *Der Sturm* (Berlin), December 1913, illustrating Klee's *Belligerent Tribe*, 1913

Fig. 4. Title page of *Simplicissimus* (Munich), April 19, 1904, illustrating Thomas Theodor Heine's *African Danger*

inferior to the French one of 1789 in force." "Art is for all, for the People, for the Proletariat!" the new culture-dictators would proclaim. And he described a grisly prospect: "The millions from below grasp the scepter; with laughter and scorn they destroy everything that might recall former subordination and slavery."[26]

Klee referred to these debates in his drawing *Belligerent Tribe* (p. 131) of 1913, which was published on the cover of the Expressionist journal *Der Sturm* in December of the same year (fig. 3). With ironic aggressiveness, the drawing represents the modernist ideal of what Klee himself had called, in his January 1912 review of the first *Blaue Reiter* exhibition, "primordial origins of art," comprising the art of children, primitives, and the insane.[27] In *Belligerent Tribe*, a tightly packed throng of savages, drawn in the childlike scheme of the diagonal cross, seems to move frontally out of the depth of the space. Composed of large and small figures, as if to distinguish between adults and children, the work portrays not just a throng of warriors, but, as the title says, an entire tribe. The appearance of the group is further varied by perspectival increases in the size of the figures from left to right, suggesting a rising and accelerating lateral movement in addition to the forward thrust. Several of the figures brandish their spears with agitation. Even their simplified faces, perceived as primitive masks, seem to grimace menacingly.

The drawing seems to derive from a caricature by Thomas Theodor Heine in *Simplicissimus* (fig. 4), a satirical journal that had impressed Klee at the beginning of his career.[28] On the title page of the issue of April 19, 1904,[29] Heine had equated the military suppression of the Herero uprisings in the German colonies of South-West Africa with repressive domestic policies in Germany itself. In a utopian reversal, he pictured the specter of Blacks from Africa bringing freedom to Germany under the title "African Danger." The caption reads: "It is high time that the government take forceful action against the Hereros,

otherwise the black beasts will end up coming to Germany and abolish slavery among us."[30] Following a leader who brandishes a red flag, a throng of Blacks armed with spears and shields advances over a huge viaduct into a building that is a composite of factory halls and prison cells. The outnumbered police try in vain to block them—and at the same time to keep a mass of white prisoners behind an already unhinged prison gate. The victorious Blacks below lead the liberated white prisoners, their social diversity clearly suggested by their attire, in a triumphal procession.

In this satirical exchange of savagery and freedom, slavery and civilization, the group in the foreground is based on the late-nineteenth-century Socialist iconography of consolidated masses marching frontally out of the picture toward the viewer, as in Steinlen's cover lithograph for the sheet music of the *Internationale* (fig. 5).[31] Heine has inserted this motif into a larger illustrative context, hence reducing its scale and deflecting it onto an angle. Steinlen's frontal scheme, which concentrates only on the group, makes a point of loosening up the common forward march by staggering the ranks and individualizing the figures' movements, as if to emphasize the spontaneity of the masses in banding together on their own. This feature distinguishes the scheme from similar frontal depictions of uniformed soldiers advancing in rank and file, as in Adolph von Menzel's illustrations for Friedrich Kugler's *History of Frederick the Great* (fig. 6),[32] which Klee may well have known, since he acknowledged having been "influenced" by Menzel's illustrations as early as 1903.[33] That Klee should have varied the composition and the movements of his throng indicates that he adopted not the uniform but the spontaneous forward march, not the militaristic but the Socialist iconography. The lateral deflection of the scheme appears in another political lithograph by Steinlen, entitled *The First of May* (fig. 7) and published in *Le*

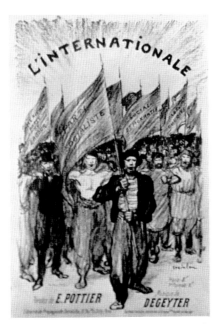

Fig. 5. Théophile-Alexandre Steinlen. Title page, sheet music of *L'Internationale*, 1895. Lithograph, 11 × 7¼ in. (28 × 18.3 cm). The Brooklyn Museum, New York, Gift of Paul Prouté

Fig. 6. Adolph von Menzel (1815–1905). *Prussian Grenadiers March with Weapons in Arms.* Published in F. Kugler's *History of Frederick the Great* (Leipzig, 1840)

Fig. 7. Théophile-Alexandre Steinlen. *The First of May*, 1894. Color lithograph, 15⅞ × 24⅝ in. (40.2 × 62.4 cm). Published in *Le Chambard socialiste* (Paris), April 28, 1894

Fig. 8. Paul Klee. *Children as Actors (Kinder als Schauspieler)*, 1913 / 101. Pen and ink, pencil on Japan paper, mounted on cardboard, 2⅝ × 6½ in. (6.6 × 16.5 cm). Kunstmuseum Bern, Paul Klee Stiftung

43

Chambard socialiste of April 28, 1894. Here an immense throng of workers, differently dressed to show its international composition, is carrying tools as weapons in a march to battle.[34] Although it cannot be proved that Klee based his drawing on this particular lithograph, the analogy suggests itself, owing to the brandished weapons and the combination of lateral and frontal movements. If he did use it, he has subjected Steinlen's Socialist iconography to a similar caricaturistic derision as in *Aged Phoenix* of 1905 (fig. 1). The comical exaggeration of the masses' expressive drive blunts both the original aggressiveness and the political resolve inherent in the iconography. The lineup of manikins drawn in the diagonal-cross scheme is a multiplication of that in his contemporary drawing *Children as Actors* (fig. 8). These drawings taken

together fuse the notions of primitivism, child-likeness, and anticultural aggression common to the avant-garde.

With his childlike image of attacking savages, Klee turned the original significance of the primitives as symbols of political liberation into a statement in the prewar art controversies in Germany. Drawing their heat from political ideologies to which the various factions in the art market appealed, these controversies came to a head in 1911 with the publication of Carl Vinnen's *A Protest of German Artists*. In an essay written in the fall of 1911 and published in the *Blaue Reiter* in early 1912, Franz Marc had characterized the modernist painters as "The Savages of Germany," defiantly appropriating the term *fauves*, advanced against Matisse and his followers in France a few years earlier:

In our epoch of the great struggle for the new art, we are fighting as "savages," albeit not organized ones, against an old, organized power. The struggle appears uneven; but in things spiritual, it is not the numbers that prevail but the strength of the ideas. The dreaded weapons of the "savages" are their *new thoughts*; they kill better than steel and break what was counted as unbreakable.[35]

Marc's revolutionary rhetoric, with its *Gedanken* ("thoughts") prevailing over weapons, is that of the German bourgeois revolution of 1848 rather than the Socialist International, but his image of the savages on the attack against entrenched culture is like that of Klee's drawing. However Klee's statement about the aggressive claims of the avant-garde is not dead serious, as is Marc's text, but appropriately self-ironical. It was printed on the cover of Herwarth Walden's journal of art and literature *Der Sturm* (Berlin) in early December 1913. This was the first work of Klee's published in that journal and his first conspicuous publication anywhere.[36] Walden probably intended the drawing as a defiant response to the storm of press debates provoked by his *Erster deutscher Herbstsalon* ("First German Autumn Salon"), Berlin, of September 20 to December 1, 1913. In the October issue of *Der Sturm*, he had reprinted a provocative collection of quotations from the press that documented and in turn fueled the debate about the exhibition. Strident examples of hostile and supportive criticisms were squared off against one another in two opposing columns of text. After Kandinsky, ever the prime target of press attacks, Klee was singled out in two comments alternately acclaiming and ridiculing the perceived childlike quality of his pictures.[37] The cultural confrontation was summed up by the following statements:

Deutsche Tageszeitung:
But here the untalented are lined up in rank and file.
Volkszeitung:
These "Youngsters" are no revolutionaries; most of them are mature and detached, although pretty eccentric.[38]

The vague, defensive evocation of the term revolutionary suggests the political limits of this debate. Klee's drawing for the cover of *Der Sturm* must have seemed an apt pictorial comment on charges such as this, at once confirming and refuting them by overstated irony in typically Expressionist defiance. Yet for all its implicit Socialist iconography, the picture carries no political significance. Walden, always keen on contesting the faintest threat of censorship to sexual and artistic freedom, was no advocate of political engagement at that time. He promoted with increasing success an Expressionist counterculture apt to accommodate Klee's non-conformity in just the artistic terms to which Klee himself had wanted to confine it all along.

Six months later, Klee had completely introverted the debative thrust of modern art into a thematic and formal principle of a dynamic but resolved agitation. In the spring or summer of 1914, shortly after his return from Tunisia, he entered a categorical statement in his diary that, if the transcription of 1921 is faithful to the original, excluded the idea of revolution from this principle:

. . . surely I know very well that good must exist in the first place, and yet cannot live without evil. Hence I would in every particular instance order the weight-relationships of both parts to a certain degree where they become bearable. Revolution I would not tolerate, but would certainly make one myself at the appropriate time.[39]

Klee's polarized sense of ethical balance apparently did not admit of any upset beyond his own control. His hypothetical claim to reserve to the artist the prerogative of waging revolution is an extreme of the term's crypto-political usage in the tradition of the avant-garde.

1919: THE MUNICH REVOLUTION

At the end of World War I, Klee was faced for the first time with the raw political reality of a revolution at home. His brief but dramatic involvement with the failed German Revolution of 1918–19 marks the high point of his political commitment to the idea.[40] Within the span of seven months, from early November 1918 to June 1919, Klee experienced in rapid succession fear, hesitation, enthusiastic acceptance, disillusion, recoil, and resignation, acting out the ambivalence of the modern artist torn between the ideology of progressive culture and the revolutionary politics of mass movements.[41]

In a letter to his wife and in his instant transcription of it in his diary, he commented on the imminent outbreak of the revolution. Writing while he was still serving as a soldier on the airfield of Gersthofen, he stressed his fear of revolution as an upset to the "ethical" principles of order and balance, which he had come to regard as fundamental for his art. He hoped that in the imminent transition to a postwar society there would be maintained a sense of "dignity." This in turn required that "the people will not act but will be an instrument. If they take matters in their own hands, ordinary things happen, blood flows, and lawsuits are brought. This would be trivial."[42] When Klee recorded the letter in his diary,[43] he exchanged the vague term "the people" for the more radical "the masses," and consequently stated even more anxiously his moral and political prescription: "But when the masses become active, what then? Then very ordinary

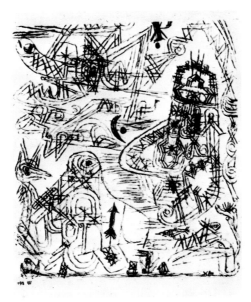

Fig. 9. Paul Klee. *Potsdamer Platz: VI. "Berlin dagegen unsere Hochburg buchte jähe Verzehnfachung seiner Bürger,"* 1919 / 15. Pen and ink on paper, mounted on cardboard, 11⅜ × 8⅝ in. (28.9 × 22 cm). Kunstmuseum Bern, Paul Klee Stiftung

Fig. 10. Paul Klee. *Cosmic Revolutionary (Kosmisch-Revolutionär),* 1918 / 181. Pen on paper, 9⅞ × 8⅝ in. (25 × 22 cm). Private collection, New York

drawings with the idea of revolution: "These drawings of Paul Klee's are full of a revolutionary paradox," he started his text. And he concluded with the exclamation: "Here's to the life-giving revolution! Here's to life-giving eroticism!!"[45] According to Corrinth's and von Sydow's facile equation of revolution and sexual license, Klee was suddenly styled a revolutionary artist.

The sixth of Klee's *Potsdamer Platz* drawings (1919; fig. 9), entitled "Yet Berlin, our citadel, recorded an abrupt decupling of her citizens," illustrates how the city attracts the prostitute population from capitals all over the world. Klee adapted it from another drawing with no reference to the text but with the explicit title *Cosmic Revolutionary* (1918; fig. 10).[46] Here the familiar ingredients of Klee's fairy-tale landscapes of 1917 and 1918 appear stirred up within a space where the location of ships, fish, birds, and stars has become indiscriminate. All are oriented toward a huge solid shape vaguely suggestive of a human profile. Klee meticulously copied the drawing for his illustration of Corrinth's story,[47] straightening out the solid shape into the image of a towering city labeled "Berlin," toward which numerous arrows suggestive of population movements are concentrically converging. Below, a little train taken from George Grosz's Berlin cityscapes of 1917[48] races across an added bridge, carrying wagonloads of prostitutes toward the city.

When Klee drew these illustrations, he may still have seen the revolution as no more than a theme for a literary grotesque suitable for adaptation to his own grotesque imagery. Yet once he had returned to Munich around Christmas 1918 and resumed his activity as Corresponding Secretary of the New Munich Secession, he was bound to notice that the revolutionary prospects of his art were much farther-reaching, and potentially more serious, than this. In the succeeding four months, he found the art policies of the three successive Council governments of Bavaria increasingly favorable to the cause of modernism. The second government even recognized as an advisory body the leftist Action Committee of Revolutionary Artists, in which Expressionist painters under the leadership of Hans Richter had come together. On April 12, 1919, Klee was formally invited to join this committee. Shedding the political hesitations he had expressed in the preceding months, he accepted enthusiastically, as his letter to Fritz Schaefler testifies. At a meeting of the Committee held in the Landtag on April 22, the same that adopted a motion by Hans Richter "to co-opt Klee into the Action Committee," an extreme program was proposed: major state-owned art monuments and collections in Munich were to be sold abroad and the proceeds were to go for social care.[49] Although the record does not show Klee's reaction to this proposal, it would have squared with his long-standing if intermittent concern about the disparity between art as a luxury and the poverty of the lower class, as he had voiced it in his very first self-designation as "revolutionary," on December 9, 1902.

The plans of the Committee came to nothing, since a few days later the Council government

things will happen, blood will flow, and, worse still: there will be lawsuits! How trivial!"[44]

However, Klee quickly discovered that the Expressionist counterculture in which he participated was being adjusted to the rhetoric of revolutionary change. During the last days of his military service at Gersthofen, or immediately after his provisional discharge, he was commissioned to illustrate a text whose subject was revolution: Curt Corrinth's *Potsdamer Platz,* a literary grotesque about a young man from the provinces who brings sexual liberation to the prostitutes of Berlin—from sexuality as paid work to sexuality as enjoyment of life. The Leipzig art historian and critic Eckart von Sydow, who seems to have played a role in this commission, wrote a preface for the special edition, where he identified the very essence of Klee's

45

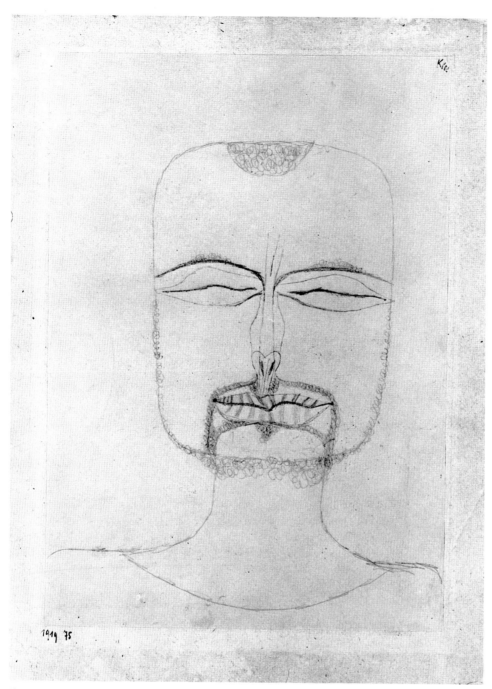

Fig. 11. Paul Klee. *Absorption (Versunkenheit)*, 1919 / 75. Pencil on notepaper, mounted on board, 10⅝ × 7¾ in. (27 × 19.5 cm). Norton Simon Museum, Pasadena, California, Galka Scheyer Blue Four Collection

was ousted through the occupation of Munich by the Freikorps troops. It was during this time, between May 1 and June 19, 1919, that Klee made the large-scale, meticulous drawing *Absorption (Versunkenheit*; fig. 11), which has traditionally been understood as a self-portrait. With its firmly closed eyes and missing ears, it seems suggestive of Klee's long-standing claim to an introspective withdrawal from the world or even to the mystic closeness to God that he had voiced in his diaries as early as 1901. Now, during the days of street fighting and mass executions in Munich, he pictured his introspection with an expression so extreme that it borders on self-mocking caricature.[50]

On June 10, 1919, on the eve of his departure for Switzerland, where he was going to escape possible prosecution from the military au-

thorities, Klee wrote a much-discussed letter to painter Alfred Kubin. He undertook a systematic reckoning with the short-lived political illusion he had shared. He couched his political judgment in familiar idealist terms: "It was a real tragedy, a shattering collapse of a movement that was fundamentally ethical, but unable to stay clean of crimes, since in its overeagerness it set off wrong."[51] Yet once again he reflected upon the discrepancy between the high culture to which his art belonged and the social concerns expressed in his letters of 1902 and 1905: "However ephemeral this communist republic appeared from the very beginning, it nevertheless offered an opportunity for an assessment of the subjective possibilities to exist in such a community. . . . Of course a pointedly individualistic art is not suitable for appreciation

by all; it is a capitalist luxury."[52] And he restated in his letter to Kubin what he had written to Lily Stumpf seventeen years earlier: "The rest is luxury and occurs in no republic where one thinks democratically."[53]

As noted above, Klee's concerns had been targeted for a radical resolution by the Action Committee of Revolutionary Artists of April 22, which, after co-opting him, demanded the sale of art works in order to obtain funds for social care. How would Klee have voted on that motion?

1920–21: After the Revolution

With the exception of one drawing of 1930,[54] there seems to be no further mention of the term revolution in the subsequent record of Klee's career, which took off rapidly in the new democratic culture of the Weimar Republic and was state-approved through his appointment to the Bauhaus in October 1920. Concurrently, when in 1919–21 he prepared a revised literary version of his diary,[55] he omitted the earlier mentions of the term. His December 9, 1902, description of himself as "generally revolutionary" may never have been entered in the diary at all; however he definitely changed the passages of February and June 1905 referring to the etching *Aged Phoenix* and his night excursion to Les Halles in Paris, recasting them in a nonrevolutionary sense, if his letters to Lily Stumpf can be taken as coming close to the original wording of his diaries.

In reevaluating the *Aged Phoenix*, Klee now compared his etching with Ovid's literary version of the myth, where the transition from death by fire to new life is replaced by organic self-regeneration: "Although Ovid does not fit [the etching], some nice things are to be read there about this bird (Metamorphoses XV 393f.). I prefer that he not be forcefully burned; in this I agree with Ovid."[56] Klee's new, nonviolent and nonrevolutionary interpretation of his etching, no longer referring to the image of death on the barricades on which he had originally based it, culminated in a nonhistorical, perpetual "rhythm of inadequacy," tragical and comical at once.[57] The historical critique of revolution of fifteen years earlier was turned into a cyclical myth of resigned rejuvenation without change.

As to his impression of Les Halles, Klee rewrote it as a merely picturesque tableau of deprivation: "The atmosphere of rotting fish, dust, tears, work, the horse on the ground, rope-skipping cocottes. . . . The sleepers on the wall."[58] The "sleepers on the wall" are no longer identified as workers and no longer recall the revolution, as they had in Klee's original passage in the letter of 1905. His explicit moral brooding over the impossibility of help has dissolved into an "atmosphere" where "tears" and "work" poetically blend with the smell of rotten fish.

These changes coincide with Klee's appointment to the Bauhaus, where Walter Gropius turned the program of the Arbeitsrat für Kunst (Working Council for Art) into that of a state institution, moving from revolutionary utopianism to social practicality.[59] It was Gropius's premise that the freedom of artistic work be guaranteed by the administrative autonomy of art institutions, which were not to be accountable to political control. As long as he belonged to the faculty, Klee was a firm supporter of that premise. In fact his resignation from the Bauhaus faculty in 1930 may have had to do with being tired of the incessant political debates that continued to be waged about the school[60] and that, particularly after Hannes Meyer's replacement as director by Ludwig Mies van der Rohe, were being carried into the school itself. By taking an appointment as a professor at the Düsseldorf Academy, a traditional state institution, Klee may have hoped to remove himself even further from the politicization of modern art in Germany, remaining oblivious to the political liabilities of its controversial installation as the official visual culture of the Weimar Republic. However, less than two years later, he found himself confronted with a much more violent political realignment of art than had occurred in 1919. And once again, the key ideological term he had to deal with was revolution.

II

1933: The Dismissal and Emigration

When Hitler's coalition government was appointed to office on January 30, 1933, Klee, like the majority of Germans, apparently refused to believe that the National Socialists would go through with the extremist policies they had announced during the years of their ascendancy in the Weimar Republic.[61] He remained aloof from those artists and intellectuals who immediately attempted to resist National Socialism in the name of freedom and democracy.[62] The democratic plurality obtained by the National Socialist party in the two elections of 1932 only confirmed his disdain for the common people, which must have hardened after many years of popular hostility to modern art. Thus, on the night of January 30, 1933, he wrote to his wife: "That the whole can ever be helped I do not believe any more. The people are too ill suited for reality, *stupid* in this respect."[63]

Klee's assessment of the political situation of January 1933 recalls his fears of and contempt for the masses poised for revolution in late October 1918. The failure of Munich's revolutionary government, to which he had briefly committed himself in April 1919, must have contributed to his assessment. And his complaint, "The people don't support us," in his speech at Jena of January 26, 1924, coming as it did after years of rightist political attacks on the Bauhaus at Weimar, suggests that even the attempt to develop a visual culture of democracy there had not brought him, as a modern artist, any closer to "the people" and their concerns.

Yet Klee's detachment from politics, sustained by now through years of resignation, seems to

have prompted him, for a short while at least, to doubt that art would actually be completely subsumed under the imminent political changes of 1933, in spite of instantaneous and continuing indications to the contrary. On February 1, two days after the installation of the new government, the National Socialist newspaper *Die Rote Erde* carried a full-page racist broadside against the Düsseldorf Academy under the headline "Art Swamp in Western Germany." It blasted the school as a haven for Jewish artists, staffed at the bidding of Klee's Jewish dealer Alfred Flechtheim, whose deliberate campaign for the Jewish corruption of German art had culminated in Klee's appointment:

And then the great *Klee* makes his entrance, already famous as a teacher of the Bauhaus at *Dessau*. He tells everyone that he has pure Arabic blood, but is a typical Galician Jew. He paints ever more madly, he bluffs and bewilders, his students are gaping with wide-open eyes and mouths, a new, unheard-of art makes its entrance in the Rhineland.[64]

The article concluded with the categorical demand to "eradicate" the whole "system." On the same day a National Socialist official replaced the Academy director.[65] Still, ten days later Klee did not let the first rumors about possible personnel changes in the faculty worry him.[66] He was attempting to assess the situation by some comparative historical studies of his own: "I am reading (in Mommsen) about Caesar, after having read about Hannibal, and at the same time [I am reading] Stendhal's *Napoleon*. Have to be a little while in the company of these kinds of geniuses. Pleasing to note that there are still other formats besides Hitler."[67]

As Klee was pondering with admiration the lives of the great dictators of the past, and found to his relief that Hitler did not measure up to them, he may still have thought, as many Germans did, that the National Socialist government was not going to last. By the end of March, party officials had searched his home in Dessau;[68] yet on April 3, Klee still hoped that he would be able to accommodate himself to the new authorities:

It was possible for me to speak with Junghanns [the new director] quite openly. It is of course my turn to be suspended; but he still has some hopes, through giving me a different assignment in the curriculum, without impairing my freedom of teaching. I am quite calm; after having been through worse things, I am preparing myself from the outset for the most negative turn of events and can hence wait and see.[69]

Even at the most critical juncture of his career as a public official, Klee was rationalizing the impending political showdown into a transitory although polarized time frame—"he still has some hopes" versus "I am preparing myself . . . for the most negative turn of events"—with Klee's cherished "calm" as a desperate, passive, fleeting synthesis, subject to "wait and see."

It was in this state of mind that Klee brooded, in a letter of April 6 to his wife in Dessau, over the indignity of documenting his Aryan descent to the authorities. Hoping he would not be required to do so, he vowed not to undertake anything on his own in this regard: "I'd rather take adversity upon me than represent the tragicomical figure of one who curries favor with those in power."[70]

Yet a few days later, he solicited legal documentation of his grandparents' "religious affiliation" at the places where they had lived.[71] This was more than a mere formality. His National Socialist opponents from the Kampfbund für deutsche Kultur (Fighting League for German Culture) had turned a detail of his biography, that his mother's ancestry was possibly rooted in North Africa, into a charge of Semitic origins. Hence the sentence in the *Rote Erde* of February 1: "He tells everyone that he has pure Arabic blood, but is a typical Galician Jew." Later in the year, Robert Böttcher, in his book *Kunst und Kunsterziehung im neuen Reich*, made clear its source: "There is the Bauhaus professor of many years, Paul Klee, who, as the Jew Hausenstein writes in his book *Kairuan*, has Saracenic blood in his veins."[72]

Indeed Hausenstein, although by no means Jewish, had in his influential monograph of 1921, interpreted Klee's trip to Tunisia of April 1914 as a profoundly meaningful return of the artist to his biological origins.[73] Klee had submitted to Hausenstein an autobiographical digest of his diaries, and Hausenstein had taken his cue from what Klee had written there about the possible Oriental ancestry of his mother: "Is half Swiss. (Basel) The other part of her descendance has not been completely clarified, it may be Oriental via Southern France."[74]

Hausenstein had thus popularized Klee's hypothetical mixed origin as a symbol of the unresolved cultural discrepancy between Europe and the Orient. Twelve years later, this speculation came to haunt the artist. No doubt in fear of yet another house search, he applied his scissors to the word "Oriental," cutting it from the original text of his autobiographical digest of his diaries (fig. 12).[75] Tragicomically, Klee's "ancestry card" only reached him by mail in Switzerland in June 1935, a year and a half after his emigration.[76]

The Prussian Ministry of Culture had not

48

Fig. 12. Paul Klee. Supplementary Manuscript, 1919, with word cut out. Kunstmuseum Bern, Paul Klee Stiftung

cared to wait that long. On April 7, 1933, the "Law for the Reconstitution of the Civil Service" was passed, which permitted the Ministry to make a clean sweep of the country's museums and academies, discharging the leading representatives of modern art regardless of their race.[77] On April 21 Klee was suspended, and sometime in the fall he was dismissed.[78] In an article entitled "Toppling Art Idols," published in the *Deutsche Kultur-Wacht*, the National Socialist art writer Robert Scholz perceived Klee's dismissal, along with that of two other artists, as "such an important step on the way toward the liberation of German art after its fourteen-year long gagging by elements of alien blood" that in a long, programmatic diatribe against modern art, he singled out Klee as an extreme case: "And that one could once regard Paul Klee as a great artist, will be, for future generations, one of the clearest examples of the complete decline of the individualist art epoch."[79]

By October 22, Klee's wife had begun to raise the possibility of leaving Düsseldorf, in part because Klee, now unemployed, could no longer afford the house he had just rented, but presumably also because of worries that he would expose himself too much if he stayed on in the city, even as a private citizen. He still thought it possible to withdraw to the countryside in order to continue working.[80] However, his business connections in Germany were no longer viable. His general sales contract with Flechtheim in Berlin, who had represented him since 1925,[81] could not be renewed. In this situation, Klee acted with dispatch. On October 21, 1933, he traveled to Paris, where on October 24 he signed, with Flechtheim's consent, a new general contract with the dealer Daniel-Henry Kahnweiler.[82] Only sometime after his return on October 27 did he finally decide to emigrate, and on December 23 he and his wife went into exile.

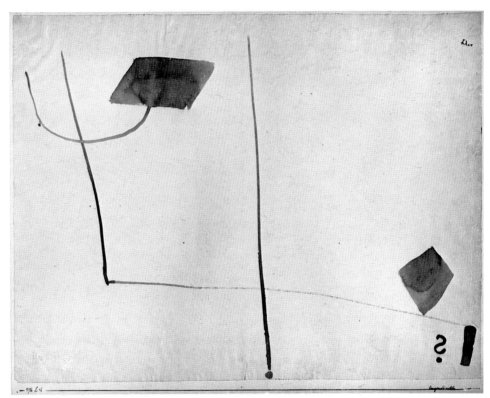

Fig. 13. Paul Klee. *Impondérable*, 1933 / 36 (L 16). Brush with black watercolor on Ingres paper, mounted on cardboard, 18½ × 24⅝ in. (47.1 × 62.5 cm). Kunstmuseum Bern, Paul Klee Stiftung

THE HISTORIC DRAWINGS OF 1933

On January 31, 1933, Klee wrote to Will Grohmann:

The year 1933 has started with new drawings made up of unabashed, supposedly straight lines. Am I therefore now feeling more of a sunny sentiment, or do the drawings come about because I am feeling more of a sunny sentiment??

A problem for more stupid art historians [than you]. Yet it is no doubt a more serious question how much happiness can reside in a few lines.

Something else: Our Hitler![83]

The "drawings made up of unabashed, supposedly straight lines" are listed under the first fifty or so numbers of Klee's oeuvre catalogue for that year.[84] They are followed by another

series of a completely different form: no straight lines, no abstraction, but comparatively realistic, figurative scenes, full of curvilinear volume and movement, made up of dense, small, and varied pencil strokes. This second group of drawings must be those Klee mentions in the same January 30 letter to his wife where he comments on the change of government (see n. 63). During these days, Klee's political self-reflections apparently entered such an acute phase that he immediately began to act them out in his work. After his account of political events, he wrote of a sudden, impulsive start of work on these new drawings:

49

Fig. 14. Paul Klee. *So to Speak (Sozusagen)*, 1933 (L 9). Brush with violet watercolor on Ingres paper, mounted on cardboard, 19⅛ × 24⅜ in. (48.6 × 61.9 cm). Kunstmuseum Bern, Paul Klee Stiftung

With these observations, then, I am sending this report to press[85] and am adding, for your eyes only, the event, *of no concern* to the public, that in recent days I was caught up in a mild drawing frenzy. However, in today's world, this is such a private matter, it will, if things continue in this way . . . take a long time until one day it will be noticed as [part of] cultural history and art history. Then perhaps no one will be able to say any more, without looking it up in the dictionary, who the great Hitler actually was.

This last train of thought belongs in the realm of the semblance of reaction artists sometimes cultivate in order, by posthumous leaps, to have been here already in the future.[86]

The suggested chronological distinction is historically crucial. The words "the year 1933 has started" in his letter to Grohmann refer to the early days of January. The words "in recent days" in his letter to Lily Klee refer to the last days of that month, that is to say, the days of the terminal government crisis of the Weimar Republic. Klee's concluding sentence in the second letter, that the artistic attitude belongs in the "realm of the semblance of reaction," is one of the most trenchant testimonies of his political self-reflection as an artist, no doubt sharpened by the recollection of his own intermittent, tentative, and disappointed political concerns since 1905. By projecting into the historical perspective of eternity the modern artist's imaginary triumph over the dictator who had just come to power, Klee retracts such a triumph into the hypothetical. His impulsive, or compulsive, work on the drawings makes his reaction a real one—yet it is at the same time only one of "semblance," bound to remain private or even secret, since under the incipient dictatorship it can no longer be aimed at any public. Klee thus circumscribed the confines of pictorial reflection and self-expression to which he was to remain subject as an

artist in exile, although he was still far from envisaging the need to emigrate. He elaborated on the term "reacting" in a further account of the compulsive drawing period on February 5, 1933, when he wrote to his wife:

Since my return from Venice I haven't worked as in the two [last] weeks. . . . The banishing of all skepticism from this process has succeeded once again. On this occasion, many things are being released which were about to become dead weight. There are several drawings that expressly deal with the shedding of dead weight, rather reactive things, yet no longer at all of the earlier, drastically reactive kind, but even so they are sublimated, or refined. *Impondérable* [fig. 13] and *So to Speak* [fig. 14] are probably the main examples of this.[87]

In surveying the "two weeks" from approximately January 20 to the date of the letter, it seems that Klee was bent on clarifying the relationship between the "happiness" of which he wrote to Grohmann and the unspecified feelings of the "drawing frenzy" of which he wrote his wife: "shedding of dead weight," "reactive things," and "skepticism," on the one hand, and "successful banishment," "sublime," and "refined" on the other.[88] The two abstract drawings Klee singled out as examples of the latter category both deal with the script of uncertainty:[89] the question mark doubting a manifest balance, the quotation marks encasing point and comma of a figure of speech. Sublimation and refinement are thematically associated with suspended judgment.

In spite of the decidedly private character of this enterprise, five or six months later, after his suspension from the Academy, Klee felt compelled to show a collection of his drawings from the first half of 1933 to at least a few confidants. The Swiss sculptor Alexander Zschokke, Klee's

former colleague at the Düsseldorf Academy, has related in a memoir how in the late summer or fall of 1933[90] Klee paid him a visit in his house on the outskirts of Düsseldorf, together with Walter Kaesbach, the dismissed director of the Academy. "Klee appeared with a large portfolio and notified us that he had drawn the National Socialist Revolution."[91] The excitement with which his former colleagues read these drawings as subversive denunciations of the new regime has puzzled later readers. Even Zschokke admitted that the first drawings Klee pulled from his portfolio—"after what one had suffered and experienced in the reality of the [1933] German revolution—radiated something funny and seemed by no means to correspond to the serious situation the artist himself was in." These were the abstract drawings from early January,[92] but none of the drawings Klee could have included, most of which must have been representational, refers overtly to National Socialist themes, in either imagery or title.[93] To be sure, after having endured a house search at Dessau as early as March, Klee could not possibly have risked compiling a series of antigovernment caricatures. Moreover, in view of his uncertain hopes for accommodation during the spring and summer of 1933, one cannot expect him to have made a politically unequivocal statement, even one obscured by the modernist sophistication of his imagery. Finally, after spending twenty-five years of his career steering his art away from visual actuality, Klee was scarcely about to engage in overt historical commentary.

What, then, was the sense of Klee's claim "that he had drawn the National Socialist Revolution"? It is not the imagery of politics but the political definition of art itself that is at issue here. For Klee, who in earlier times of political change had linked his modernist posture with his revolutionary sympathies, the drastic reorientation of cultural policy affecting the arts under the new government, which had come to power in the name of the masses, could not leave him indifferent as an artist, no matter how aloof he would remain as a citizen. All the more so since the word revolution, which he apparently chose for his pictorial comment on the National Socialist regime, was the key term, during the spring and early summer of 1933, over which that regime was waging political debates about a possible tolerance of modern art.

1933: The Political Debates about Modern Art

On April 11, the day the police raided the Bauhaus in Berlin for Communist materials and temporarily closed it, the student body submitted a memorandum to the Kampfbund für deutsche Kultur in which it was stated:

The students of the Bauhaus are well aware of the new situation created by the national revolution. . . . No doubt only the future will tell in which direction artistic creation in the new Germany will turn. . . . To cooperate in this task is . . . the duty of every German artist, of every art school and every student.[94]

Their concluding en-bloc application for admission to the Kampfbund was not acted upon, for a few days later the faculty decided to dissolve the Bauhaus. The students' initiative was part of the effort, in the spring of 1933, of a number of writers and artists to ingratiate modern art with the new authorities. At the same time Alfred Rosenberg, the chief party spokesman on matters of culture, was attempting to position the Kampfbund as the agency to assume direction of National Socialist art policies. In the ensuing debates, the term revolution was claimed and contested by both sides. Some modern artists and their defenders used it to affirm a kinship of their art with the new direction in politics. Thus, Bruno E. Werner, in his article "The Rise of Art," which appeared in the national newspaper Deutsche Allgemeine Zeitung of May 12, 1933, declared "that indeed the new art was the pioneer of the national revolution," and that the leading modern artists, Klee among them, "were consciously or unconsciously the bearers of the national revolution." And he concluded:

Clarification will now take place, and there are sufficient grounds to assume that the leading men of the new Germany know which tasks the total state has to solve here: that is, to impart to art something of its revolutionary fervor; to put it in touch with the community of people and to take the place of past dynasties and of the art-collecting upper bourgeoisie.[95]

If Klee read the national paper, which is more than likely, Werner's plea may have recalled to him, almost line for line, his own failed revolutionary aspirations as he had voiced them fourteen years earlier in his letter to Kubin. Werner's statement reads like a desperate attempt to tack the claims of an antibourgeois cultural critique, whereby modernism had been launched originally, onto a totalitarian mass movement, with disingenuous disregard for the political contradictions involved.

Rosenberg rebutted the promodernist arguments hinging on the term revolution in several speeches and articles, drawing a firm line between modernist claims and the significance of the term for the National Socialist movement. In two lead articles for the Völkische Beobachter in July—entitled, respectively, "Revolution in the Visual Arts"[96] and "Revolution as Such!"—Rosenberg launched programmatic attacks against Expressionism on the basis of his own understanding of the term. On July 15, he presided over a public rally of the Kampfbund on the subject of revolution in art, and he condemned Expressionism.[97] By this time, he was able to refer to Hitler's two speeches of July 1 and 6, in which the new chancellor declared the National Socialist revolution accomplished. And on July 14, at yet another rally of the Kampfbund in Berlin, Rosenberg delivered a speech on the theme "Revolution in the Fine Arts?"[98] Finally, in an even more programmatic article entitled "The Coming Style," published in the Völkische Beobachter of the same day, Rosenberg singled out Bauhaus art in an attack on those who were arguing for toleration of modern art in the new state under the catchword revolution. He wrote:

The press, which has remained Jewish and otherwise resists the new Germany, . . . paternalistically praises

the "revolutionary will to culture of national socialist youth." . . . It is characteristic that the "revolutionaries" in the realm of architecture are almost all adherents of the former Dessau Bauhaus. . . . It is precisely the parallelism between exalted painting and dreariest architecture which shows that the origins of feeling with the [so-called] revolutionaries is phony in and of itself.[99]

Hitler himself adopted Rosenberg's uncompromising antimodernist posture almost word for word in his own speech about cultural policy at the Party rally at Nuremberg two months later.[100] Finally, the term revolution was institutionalized in the National Socialist art administration when Joseph Goebbels, in his speech at the festive inauguration of the Reich's Chamber of Culture on November 16, 1933, in Berlin, "emphatically underlined the revolutionary character which is at the base of this fundamental reordering of all work in culture."[101]

It is clear, then, that in the months between April and July 1933, Klee was able to observe in the press and in the art world the speedy formulation of National Socialist art policies that established the new government's intransigently antimodernist posture. This process had by no means been widely foreseen, even at the moment when the new government took office on January 30, 1933. The showdown between the cultural authorities of the party and the representatives of modern art was centered on the term revolution, which both sides were using with different meanings and intentions. It happened to have been a key term in Klee's own political self-reflection as a modern artist from the beginning of his career.

KLEE'S HISTORIC THEMES OF 1933

To coordinate the chronology of art-political events in Germany during the year 1933 with the making, over the course of several months, of more than two hundred "historic" drawings by Klee would be an important task. It involves the problem of the chronological sequence and accuracy with which Klee entered his works into his oeuvre catalogue each year. It also involves the changes in his political consciousness in the course of these dramatic months, which, after all, carried him from the expectation of accommodating himself to the authorities as a teacher at the Academy to the diminished hopes of at least being tolerated as a free artist, and, finally, to the decision to emigrate, all within the span of a few months, from April to October. And furthermore Klee had already started the series during the government crisis of late January, before Hitler had come to power. These questions of historical chronology cannot yet be resolved. All that can be attempted at this stage is to discern within the entire body of drawings pictorial statements about the course or fate of modern art under the rapidly unfolding dictatorship.

It is precisely by deviating from established modern forms that these drawings are significant. Klee suddenly abandoned the various modes of stylization he had pursued thus far and drew a host of themes in a straightforwardly illustrative manner. Several of the drawings actually address the challenge to "abstract" or "Expressionist" art in the name of the unequivocal realism the new regime was putting forth. A few days before he emigrated, Klee was still uncertain about the course German art would take under the new state, for on December 8, 1933, he wrote to Alois Schardt, the former director-designate of the Nationalgalerie in Berlin and one of the unsuccessful proponents of Expressionism as a suitable art for the National Socialists: "I ask: what will the German Art sponsored by the state look like?"[102] Indeed, it took the new German art administration until 1937 to achieve a unified policy, but its hostility to modern art and insistence on realism were clear from the beginning. In a partly mimetic, partly satiric, partly argumentative way, Klee put the newly propagated realism to the test, confronting it with forms and themes of his own modernist tradition. In retrospect, it also appears as if he were methodically laying the groundwork for the style of corporeal figuration he eventually adopted in 1937, when his confrontation with National Socialist art politics was no longer direct, yet all the more painful than in 1933.

House Revolution (1933 / 94), the only drawing of 1933 bearing the word revolution in its title, cannot be located at the present time;[103] hence the inquiry cannot begin at the most obvious point. In fact *House Revolution* was the only work whose title contained the term until the panel painting *Revolution of the Viaduct* of 1937, after which the word does not recur in Klee's oeuvre. However, it is possible to single out a group of drawings in which the renewed debate between traditional and modern art appears to be at issue. In *The Work of Art* (fig. 15), two men are standing before a giant sculpture of a horse on a pedestal. The smaller man, a spectator with his hands in his coat pocket, looks up at the horse. The taller one, nude, talks down to him. The spectator is caught in the middle between the horse and the nude man, both moving toward him, but he appears to remain unconvinced. Faced with the reassertion of traditional art, to which this drawing seems to refer, Klee recalled the most antitraditional stage in his career, the years 1912 and 1913, when he transformed his figure style into expressive abstraction. In 1913 he had adapted from children's drawings the diagonal cross for the extreme schematization of figures into manikins (fig. 8).[104] Now he juxtaposed such a figure with a realistic counterpart in the drawing *Exercises at the Cross* (fig. 16), referring both to the artist's comparative exercise of drawing two types of figures in a diagonal-cross scheme and a gymnastic competition between the figures themselves.

A huge nude Atlas figure in a realistic style reminiscent of Leonardo or Dürer is immobilized, legs spread apart, bearing a horizontal weight, perhaps a pediment, above him. His smaller, surely weaker counterpart, with the diagonal cross abstractly superimposed upon his body, freely bobs in the air, out of touch with both ground and roof. The drawing seems to present an inconclusive alternative between

Fig. 15. Paul Klee. *The Work of Art (Das Kunstwerk)*, 1933 / 154 (S 14). Pencil on paper, 9½ × 7⅞ in. (24 × 20 cm). Private collection, Switzerland

Fig. 16. Paul Klee. *Exercises at the Cross (Übungen am Kreuz)*, 1933 / 108 (Qu 8). Pencil on paper, 7¼ × 8¼ in. (18.5 × 21 cm). Private collection, Switzerland

Fig. 17. Paul Klee. *Dialogue about the Concept X (Zweigespräch über den Begriff X)*, 1933 / 324 (B 4). Pencil on paper, 7⅛ × 12⅜ in. (18 × 32 cm). Private collection, Switzerland

Fig. 18. Paul Klee. *Stiff Already! (Schon Steif!)*, 1933 / 139 (R 19). Pencil on paper, 6¼ × 8¼ in. (15.8 × 21 cm). Private collection, Switzerland

functionless expressive form and subordinated, conventional form. Its composition follows Klee's long-established mode of thinking in polar opposites, and he may have conceived of the drawing as striking yet another "balance." In *Dialogue about the Concept X* (fig. 17), the debating sense of such visual thinking is made explicit. Two stylistically different figures, not quite so mutually exclusive as those in *Exercises at the Cross*, engage in a dialogue about the underlying scheme of abstraction, the unknown quantity "X." The figure on the left, conforming to that very scheme, moves its legs and arms freely in expressive excitement; the one on the right remains unaffected, defensively closing itself off and crossing its legs in ironic discomfort. In *Stiff Already!* (fig. 18) there occurs another such polar altercation. Here the simplified manikin of a child's drawing is tossed back and forth in a game between a little girl and an aged man. As the man catches it in his huge, grabbing hands, the figure becomes lifeless, though it still raises its arm stumps and opens its eyes wide in a last, frozen gesture of excitement. The drawing appears to be a succinct allegory of the impasse in which Klee had found himself since 1930, when his concept of childlike art and the ideals of untamed natural immediacy associated with it (dating from before World War I) had been called into question because they conflicted with the concept of a "professional" control of elementary forms.[105] All these satirical showdowns between abstract and realistic form appear to be focused on alternatives of artistic expression.

Sometime later in the year, Klee made the "concept X" the theme of a major painting with the confrontational title *Struck from the List* (fig. 19). In 1908, he had discarded an attempt to paint a watercolor self-portrait by penning two diagonals across the face (fig. 20). In the painting of 1933, the crossing-out itself becomes the central motif of a finished picture. As a sign, the crossed diagonals relate to the title of the paint-

ing and thus to Klee's dismissal from the Düsseldorf Academy or, more figuratively, to his deletion from the list of German artists acceptable to the government. However, the pictorial statement is not as one-sided as this. The diagonal cross is solidly integrated into the multifaceted pattern of the face made up from overlapping planes, a face pattern of which Klee produced several examples in 1933 and 1934. More specifically, with its earth colors ranging from gray to ocher, the picture appears to be a schoolbook exercise in Cubist portraiture. Within it, the concept X becomes the hallmark, or stigma, of modernism, all the more pressing since "X" denotes, as an algebraic sign, an unresolved equation. As was his habit, Klee deployed his pictorial thought in polar opposition. From the viewpoint of content, the crossing-out is a brutal, defacing slash, and the expression of the face may be perceived as sad; from the viewpoint of form, the crossing-out provides a solid structure, and the expression of the face appears defiant. The underlying idea of a convergence between face and picture, or of "the face of the picture," had long been essential for Klee's pictorial form instruction.[106]

It is probably not by chance that the firmly closed eyes of the face in *Struck from the List* recall the self-portrait *Absorption* (fig. 11) Klee had drawn in May 1919 when the Munich revolution was being crushed. The constrained physiognomic expression suggested by the straight horizontal lines is exacerbated by the tightly closed lips, curved downward as if in enforced or resigned silence. Both motifs recur in *Sees It Coming* (fig. 21), another of the historic drawings. Waving off whatever it is with no recognizable gesture of his amorphous hands, the man in this drawing of 1933 turns away as in *Struck from the List*, his eyes and mouth likewise firmly closed. However, in contrast to the reckless self-assurance of the published self-portrait *Absorption*, this clandestine depiction of an anonymous man turning away from historical reality

Fig. 19. Paul Klee. *Struck from the List (Von der Liste gestrichen)*, 1933 / 424 (G 4). Oil color on transparent waxed paper, 9½ × 8½ in. (24 × 21.5 cm). Private collection, Switzerland

Fig. 20. Paul Klee. *Self-Portrait* [reverse of *Asternam Fenster*, 1908 / 68]. Private collection, Switzerland

no longer points to any "spiritual" alternative. The closed eyes denote the opposite of what the title says, in a seemingly deliberate counterpoint that can only have been meant to be bitterly satirical.

What did Klee himself "see coming" throughout the year 1933? The historical record suggests that his attitude was indecisive, that he was swept along and into exile by the tide of events. In a letter to Grohmann of December 3, 1933, less than three weeks before his emigration, Klee reflected on "how much has happened in the negative realm for both of us. Could that be of any consolation to you? I don't know. After all, even now one can still discern nothing definitive, since the new has just started. Perhaps a year from now?"[107] The generalities in which Klee expressed himself compound the uncertainty of his perspective on the future. There is no word on the political circumstances of the "negative realm." The closed eyes are an accurate metaphor for such an attitude. The minimal certainty they assert, the only one self-reflection can provide, is stated by way of deliberate paradox. Thus in the drawing whose title proclaims *Target Recognized* (fig. 22), the man to whom the target is being pointed out likewise has his eyes closed. He points his weapon in the direction indicated by the man towering over him from behind. He is not aiming, since he cannot recognize the target by himself. The pointing man who orders him to fire blindly is actually raising his arm in the Hitler salute. For the man with the weapon to close his eyes to such a gesture may signify either blind obedience or refusal. The drawing is suggestive of the political indecisiveness with which Klee was facing the end of his career in Germany.

III

1937: KLEE IN THE EXHIBITION *DEGENERATE ART*

In the summer of 1937, Klee's prominence as an artist condemned by the National Socialist government was confirmed for all to see. On July 26, the *First Great German Art Exhibition* opened in Munich, to be followed a day later by the exhibition *Degenerate Art* (*Entartete Kunst*). This counterpointed, double presentation signaled the enforced triumph of a new, officially sanctioned German art over the modernist art sponsored by the Weimar Republic, and the National Socialist suppression of the latter was brought to a conclusion. A year later, Hitler, addressing the jubilee session of the Reich's Chamber of Art on July 9, 1938, in Munich, characterized the situation: "So at that time I reached the decision to draw a firm line and to give German art the only possible task: to compel it to stick to the path that the National Socialist revolution had assigned to the new life of Germany."[108] By the enforcement of this policy, the two alternative concepts of art polarized the consciousness of European culture, resulting in a political confrontation. As a decree by Hermann Göring of August 3, 1937, initiated the comprehensive confiscation of modern art works in all public collections of Germany, the international modernist art world began to launch express challenges to Fascism.

During the Weimar Republic, modernist art had by and large ascended to cultural supremacy, but it did so at the price of exacerbating art-political controversies. Still, when in 1933 the National Socialist government swiftly subjected modernist work to political suppression, many German modern artists were taken by surprise, as they had not conceived of their work as political in nature. It was only in 1937, when the government presented the exhibition *Degenerate Art*, a definitive survey of its political charges against what it called "art bolshevism," that even modern artists in exile were unable to ignore the political confrontation into which they had been forced, particularly since some of the most salient political connotations ascribed to modern art works in the exhibition could not be denied.

The political program of the exhibition was summarized in the official brochure:

What does the exhibition "Degenerate Art" want? . . .

It wants to expose the common root of *political* anarchy and *cultural* anarchy, and to unmask the degeneration of art as *art bolshevism* in the full sense of the word.

It wants to clarify the ideological, political, racial, and moral goals and purposes pursued by the driving forces of disintegration.[109]

The program's anti-Communist emphasis tied in with the confrontation course of German foreign policy vis-à-vis the Soviet Union at that time.

In the exhibition *Degenerate Art*, Klee was represented by seventeen works: five paintings, nine watercolors, and three prints.[110] The extent of his previous official acceptance was revealed when the ensuing confiscations of modern art in German public collections and museums unearthed no less than 102 of his works. In the topical arrangement of the show, his works were classified under the categories "confusion" and "insanity." The painting *Swamp Legend* was hung on a wall devoted to Dadaism.[111] Party officials must have read its title as an involuntary confession by the painter that he indeed came from the "art swamp," that his art belonged to what they denounced as "swamp culture." In the official guidebook (fig. 23), Klee's lithograph *The Saint of the Inner Light* was juxtaposed with a picture by a schizophrenic patient and accompanied by this comment:

Two "Saints"!!

The upper one is called *The Saint of the Inner Light* and is by *Paul Klee*.

The lower one is by a schizophrenic from an asylum. That this *Saint Magdalen with a Child* still appears more humanlike than the contraption by Paul Klee, which claimed to be taken quite seriously, is very telling.[112]

With such associations, Klee was held to the ambivalent analogy between modern art and insanity that, since the late nineteenth century, had been both a conventional reproach of anti-

Fig. 21. Paul Klee. *Sees It Coming (Sieht es kommen)*, 1933 / 387 (E 7). Pencil on paper, 16⅜ × 11⅝ in. (41.5 × 29.5 cm). Private collection, Switzerland

Fig. 22. Paul Klee. *Target Recognized (Ziel erkannt)*, 1933 / 350. Pencil on paper, mounted on cardboard; 9⅝ × 10⅞ in. (24.4 × 27.5 cm). Kunstmuseum Bern, Paul Klee Stiftung

Fig. 23. Page from *Degenerate Art (Entartete Kunst)* exhibition brochure, Munich, 1937. Top, Klee's *Saint of the Inner Light*

modernist critics and a modernist ideal of cultural renewal. Klee himself had subscribed to its modernist usage in his review for the Swiss magazine *Die Alpen* of the double exhibition of the *Neue Künstlervereinigung München* and its offshoot, the *Blaue Reiter*, held at the Thannhauser gallery, Munich, in December 1911: "For there are still primordial origins of art, as you would rather find them in the ethnographic museum or at home in the nursery. . . . Parallel phenomena are the drawings of the insane, and thus madness is no appropriate invective [against the 'new aspirations'] either."[113]

Thus, in presenting Klee's picture in the exhibition guide, the National Socialists were not gratuitously attacking his artistic position. The picture was reproduced next to a quotation from Wieland Herzfelde's article "Ethics of Insanity," restating the modernist acclamation of insanity as a call to freedom: "The crazy talk of the possessed is a higher world wisdom because it is human. . . . Why haven't we won as yet this insight into the world of the free will?"[114] The article had appeared in *Die Aktion* in April 1914. At the outbreak of World War I, this journal, edited by the left-wing writer Franz Pfemfert, had taken a resolute, albeit muffled, antiwar stand. Faced with the threat of censorship, Pfemfert had chosen to express his political opposition by the seemingly detached editorial policy of steadily reproducing works of modern art, particularly from enemy countries, thus making them the medium for a silent reassertion of his internationalist and pacifist convictions. Herzfelde had been even more deliberate. Not content with the limitations of modernist cultural opposition, in 1918 he became first a member of the Dadaist protest movement and then of the Communist party. Klee, for his part, had participated in Dada exhibitions since 1917. Thus, the political context in which his picture was placed by the National Socialist art officials was quite accurate. They were purposefully harking back to the political radicalization of modern art in World War I and its aftermath, conveniently ignoring the fact that after the consolidation of the Weimar Republic around 1924, many modern artists, Klee among them, had largely abandoned their initial radicalism to the extent that they came to be integrated into Weimar culture. It was Weimar culture as a whole that was now being held to the revolutionary political rhetoric of its beginnings.

MODERN ART TURNS ANTI-FASCIST

It is not known what news Klee received in Bern about the Munich exhibitions of 1937, and if any, how he reacted;[115] but the exhibitions coincide with a time of renewed, intensive working effort in spite of his frail health. Lily Klee's first report of the sudden resurgence of Klee's productivity after his partial recovery from his severe illness, a resurgence that was to last until May 1940, almost the very end, is addressed to Will Grohmann and is dated July 8, 1937:

[Klee] has once again one of his completely strong creative epochs. A "drawing period" also occurs. At night he sits at his desk till eleven o'clock, and one

sheet after another drops to the floor just as in old times. And yet he is still not completely cured, is constantly being checked by the doctor. . . . He is reading [Ignazio] Silone, *Fontamara*.[116]

To determine the various concerns that prompted Klee's precipitous, determined start of a new and lasting "period" in his art, and that gave it the form it took, would be a complex task. That he was reading the most celebrated anti-Fascist novel of the day, written by a prominent writer who had espoused the Popular Front, cannot be without significance. In any event, Klee was launching his new work into a modernist art scene aroused at last by the political events that had affected him. Reacting to the public suppression of modern art by the German government, international critics who supported modern art began to voice increasingly outspoken attacks on National Socialist art policies. The spectacular exhibition *Degenerate Art* drew most of their attention away from the concurrent, steadier, and therefore less dramatic suppression of modern art in the Soviet Union. The ensuing political one-sidedness of their response suited the Popular Front policies of numerous German left-wing intellectuals and artists, who from their exile in France and England took the lead in reasserting the cause of modern German culture against Hitler.

The new anti-Fascist thrust of modern art was promoted by Christian Zervos, editor of the French art journal *Cahiers d'Art*, which featured the artists of the School of Paris, as well as Klee and other foreign artists represented by Kahnweiler. In the last issue of 1936 and the first of 1937, which came out in March or April, before the exhibitions in Munich opened, Zervos had denounced the suppression of modern art in Germany in an article entitled "Reflections on the Third Reich's Effort at a Directed Aesthetics."[117] Contrary to what this title might have led one to expect, the article offered no polemical account of National Socialist art but a defense of the modernist tradition against what Zervos perceived to be the fundamental charges raised against it by the German art administration. He countered by maintaining that whatever is artistic or poetic was not to be measured by social and political concerns, at least for the present time. He exalted modern artists over the nonartistic public as initiates whose individual imaginations could not as a matter of principle be judged by social and political criteria. Negative, destructive qualities prevailed in this concept of the avant-garde. Zervos claimed the artist's prerogative was to take nothing for granted, to challenge all values, to leave all certainty behind, to move to ever newer, uncharted territories. These claims amounted in effect to a subversive ideal, proffered with a remarkable uncertainty about the contribution of modern art to contemporary culture, compared to the assurance of the earlier modern tradition, where artists such as Kandinsky, Marinetti, and Malevich, on the printed pages of their categoric texts, had laid claim to a new vision of the world, to the inauguration of a new age. For Zervos, on the contrary, every artistic advance since Cubism entailed doubt and risk. He championed a challenge of the modernist destructive mentality

55

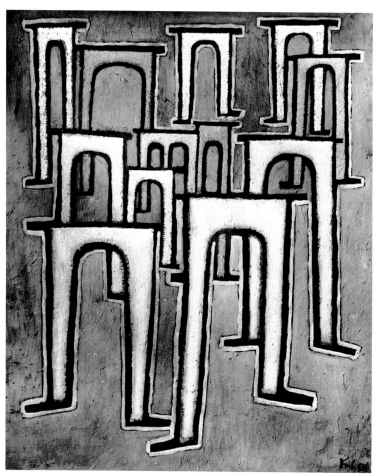

Fig. 24. Paul Klee. *Revolution of the Viaduct (Revolution des Viaduktes)*, 1937 / 153 (R 13). Oil on canvas, 23⅝ × 19⅝ in. (60 × 50 cm). Kunsthalle, Hamburg, West Germany

against a host of conservative calls for a reconsolidation of values.

The most sensitive political test of this posture was its relationship to the concerns of what Zervos called "the masses." To do justice to these concerns had been the decisive political argument of both the German and the Soviet totalitarian regimes. Hitler had claimed at the Party rally in September 1933 that now for the first time the people could determine the course of the art produced for them, and since 1932 the guided debates of the Soviet art administration had focused on the achievement of an art demanded by the proletariat itself. Zervos had come to accept at face value the National Socialist doctrine that the art it promoted was suited for the masses.[118] As a result, his article abounded in partly vengeful, partly melancholy dismissals of the people, whom he resolutely excluded from the values modern art had to offer. The separation itself was, of course, a notion of the avant-garde, but its resigned acceptance by the editor of the leading Paris art journal of the day confirmed a general retreat of the modernist tradition from the expansive self-confidence with which it had been launched. It was a far cry from earlier expectations that one day abstract art would become an art for everyone, that its immediacy of artistic expression would ensure its eventual embrace by the majority. Between 1917 and 1919, that expectation had been politically fleshed out in the concept of revolutionary art, particularly in the Soviet Union.

In Zervos's vindication of modern art, such ideals were foregone. And yet, in a utopian projection of avantgardist leadership, he desperately maintained a revolutionary perspective:

And we pose the question: shouldn't one constantly fire up the masses, ceaselessly imbue them with the idea of the revolution, an idea which teaches one to be free of fear, which reenforces the spiritual and social structures, which opens the eyes and sharpens the minds on the path toward the unknown? . . . This is how we conceive of the revolution and how we find relevancy in it.[119]

In Zervos's argument, the term revolution, drained of all political meaning, was assigned to the few in order to be dispensed to the masses, tacked onto the unspecified claims of the artist to be the guide on an expedition into the unknown. In the next two issues, the editor of *Cahiers d'Art* presented to his readers the militantly anti-Fascist attitude of Picasso, the recognized leader of modern painting. The whole summer issue was devoted to Picasso's *Guernica*, which had just been put on view in the Spanish Pavilion of the Paris World's Fair in order to decry the German bombing of the Basque town. Zervos poetically evoked Picasso's working process on the painting as a spontaneous outburst, an existential political act, a voodoolike, magical attack on Franco.[120] The lone artist was charged with providing the historic counterweight to the political disasters caused by masses and dictators alike. If Klee read the issue, he may have been reminded of his own, more tentative reaction to Hitler's ascendancy, in his letter to Will Grohmann of Janu-

56

Fig. 25. Paul Klee. *Arches of the Bridge Break Ranks (Viaducts Break Ranks) (Brückenbogen treten aus der Reihe)*, 1937 / 111 (P 11). Charcoal on cloth, mounted on paper, 16¾ × 16½ in. (42.6 × 42 cm). The Solomon R. Guggenheim Museum, New York

Fig. 26. Carl Theodor Protzen. *Bridge in the Holledau.* Exhibited 1940. Whereabouts unknown

Fig. 27. Albert Speer (1905–1981). Model for stadium at Nuremburg, Germany, 1936–37

ary 31, 1933.[121] There he had projected the historic relevancy of his drawings for a distant future when Hitler would be long forgotten; now Zervos presented Picasso as engaged in a similar contest, but one of instant actuality, and with the claim to victory, not just survival.

A posture such as this made it possible for many modern artists to reassert themselves in anti-Fascist terms without transgressing the confines of their habitually nonactivist, nonpolitical culture. Klee, who had been featured in the *Cahiers d'Art* several times in earlier years,[122] and who was well-informed about the Paris exhibitions of 1937,[123] joined this movement to some extent, adopting the large-formed, crypto-mythic figurations advanced by artists such as Jacques Lipchitz, André Masson, Max Ernst, Yves Tanguy, Joan Miró, and Henry Moore. With these artists, he participated in that new, ambivalent pictorial culture of modernism, full of a dark fascination with destiny, which historically coincided with the demise of democracy in Europe, the Great Depression, and the rise of Fascism culminating in the Spanish Civil War. It was not the point of this visual culture to devise a modernist political imagery in response to the totalitarian ones advanced by the governments of Germany, Italy, and the Soviet Union, particularly at the Paris World's Fair in the summer of 1937. But occasionally during this year, some artists did come forth with political counterimages for modernism: Lipchitz produced *Prometheus*; Ernst, *The Angel of the Home*; and Marc Chagall, *Revolution*. Klee, ever intent on keeping abreast of the modernist movement,[124] made his contribution with the painting *Revolution of the Viaduct*.

REVOLUTION OF THE VIADUCT

Klee's most protractedly elaborated picture of 1937 is *Revolution of the Viaduct* (fig. 24). It is the last version in a sequence of no less than five on a theme that must have been of particular concern to him.[125] Yet, even though it is the definitive version, it was never exhibited during Klee's lifetime.[126] Its political significance has been recognized by a succession of later commentators, who have invariably based their interpretations on the assumption that the viaduct's breakup by the individual arches going their own way has a negative meaning, and that they suggest menacing, totalitarian mass movements.[127] These commentators show a disregard for the political thoughts Klee himself might have intended to express at this particular moment, based on the history of the term revolution as he himself had reflected upon it over the years.

The composition is predicated on the contrast between the viaduct's horizontal pathway in a state of breakup, thereby rendering the intended horizontal movement impossible, and the vertically emphasized depth perspective, in which the severed individual arches, seen at various points in space, march forward from the back of the picture toward the viewer. An earlier version is called *Arches of the Bridge Break Ranks* (fig. 25). Both titles articulate the dissolu-

tion of the architecture in anthropomorphic as well as political terms. "Break Ranks" ("treten aus der Reihe") is an unequivocally military expression that likens the firm structure of the bridge to a formation of soldiers. The meaning of the term "revolution" is politically both more obvious and more uncertain, given the ideological vacillations to which it was being subjected at this point in Klee's career. For the same reason, the term is all the more conspicuous, as this is its only recurrence in Klee's oeuvre catalogue after the lost drawing *House Revolution* of 1933. And since the picture is the result of carefully advanced variations, it suggests that Klee was giving a serious review to his lifelong concern with the political idea of revolution.

The two last versions recall the neo-Roman arches and viaducts of the new National Socialist architecture, particularly in the bridges of the widely publicized highway building program (fig. 26),[128] so demonstrably aimed at an "organic" monumentalization of the German landscape. In Albert Speer's 1936–37 design for the German stadium at Nuremberg (fig. 27),[129] which was meant to hold 400,000 spectators, the series of steep arches in the exterior wall expresses the underlying ideology. The enclosure of these arches was to bring together the mass public in one embracing form; the coarse surface of the arches, made up of square, rough-hewn natural stones, suggests the individual handiwork of innumerable masons. Both Klee's pictures can be seen as formal reversals of this kind of architecture, so expressive of the National Socialist ideology of a homogeneous people's community.

The effect may be caricaturistic, but the formal procedure Klee applied to it drew on a serious, central tenet of what he had come to call "pictorial architecture." In an undated addition to his *Pictorial Form Instruction* of 1921–22, in the chapter "Subjective Theory of Space: The Migrating Viewpoint," he had drawn a fundamental aesthetic distinction between architecture and painting. This distinction derived from his concept of a dynamic viewing of the picture, whereby the eye is assumed to move along the painted surface and to continually change the perspectival vantage point, as opposed to the static buildup of architecture in corporeal space.

Conditional and [i.e., versus] free possibility of movement. One may well say, there is no purely dynamic architecture, and one must take very seriously here the slightest traces that lead beyond. One would have to take the appearance for the essence. We must therefore locate works of architecture in the purely static realm and in a static realm which inclines more or less toward the dynamic. Thus at best: in the static-dynamic intermediate realm.

In more ideal realms of art, such as painting, greater mobility, a real change from the static into the dynamic, is possible.[130]

Klee's man-centered, individualized principle of a dynamic, variable composition, which had determined his concept of "pictorial architecture" since his first Bauhaus course of 1921, carried with it connotations of self-sufficient independence.

What are we to do? Let us empathize, since we ourselves are after all buildings which have to stand on little feet and must not fall. What do we do in order

not to fall? What do we do, if we do not succeed in re-establishing stationary calm (in a small way) through a balancing shift of the weighty parts in ourselves? We move first one leg (enlargement of the base) and perhaps soon afterwards the other. And finally we walk, which facilitates the balance. We have become a form in movement and we sense an alleviation.[131]

In *Revolution of the Viaduct*, it is the application of this reasoned, humanized, abstract form procedure that breaks the National Socialist stereotype. The uniform size of individual arches required for the construction of a bridge is changed here to individual differences ranging from large to small, increasing the depth perspective as well as indicating that each one of the presumed members of the bridge is unique.[132]

The composition is grounded in the traditional iconography of the mass of workers marching frontally out of the picture, which twenty-four years earlier Klee had adapted to the avant-garde in his satirical drawing *Belligerent Tribe* (fig. 3). There is even an intriguing similarity to the viaduct on which the African mock revolution takes place in Heine's *Simplicissimus* caricature (fig. 4), Klee's source for the earlier drawing. The iconographical pedigree of the composition thus confirms the political poignancy of its title. It is as if Klee had energized his visual memory of those "workers . . . sleeping in rows, partly sitting upright, recalling the revolution," recorded in his letter to Lily Klee from Paris thirty-two years before. But what was the meaning of *Revolution of the Viaduct* in 1937, given the ideological uncertainty of the term revolution at this point in Klee's career? As recently as 1935, the iconography of Steinlen's title page for the *Internationale* had been adopted by the German-Communist artist in exile Max Lingner, working in Paris, in his brush drawing *May 1, 1935* (fig. 28) for the *Arbeiter-Illustrierte Zeitung*, suggesting the new Communist strategy of the Popular Front. Yet Klee's well-tested historic caution did not allow him such an unequivocal expression of a political allegiance; the theme had already become visually compromised two years after the inauguration of the Popular Front. For in Paris in 1937, the scheme of the forward-marching masses as the carriers of revolution had been adapted—or perverted—to the notion of Stalinist conformity in Jofan's Soviet Pavilion at the World's Fair (fig. 29). In the painting for the entrance hall, the representatives of Soviet society in festive dress appear to march forward in a perspectively staggered parade formation on an axis between the projected Palace of the Soviets, with its giant painted statue of Lenin in the background and the actual statue of Stalin placed before the canvas, as if to suggest that the figures are following him to the point of marching out of the picture. Outside, the expressive forward thrust of Jofan's architecture was personified in an extended relief covering the entire socle (fig. 30) and displaying the Soviet people moving forward with the building, as it were, tightly packed and framed by protective figures of the military. In both relief and painting, the advancing masses are being led rather than marching spontaneously. Their totalitarian

conformity, enhanced by their individualized, enthusiastic expressions of assent, historically obliterates the political distinction between Socialist and militarist iconography inherent in Menzel's and Steinlen's versions of the forward-marching scheme (figs. 6, 7).

If the negative evaluation of the theme of Klee's picture by most later commentators, who tend to perceive it as an image of totalitarian mass movements, were based on images such as these, that interpretation would be at variance with the concurrent notion of architecture as a consolidating force in National Socialist as well as Soviet ideology. Klee's conservative interpreters cannot have it both ways. An interpretation of the picture in terms of totalitarianism is inappropriate, for in the totalitarian "aestheticization of politics," as Walter Benjamin called it in 1935,[133] the masses' conformity with architecture is fundamental. Hence the care with which Klee individualized each one of the arches in size, proportion, perspectival projection, and position in space, carries the force of contradiction to the totalitarian scheme. No doubt the satirical mode in which the picture is bound to be read adds to this sense of contradiction, true to the original, historic satirical intent of Klee's works from 1905, when he was confronted with a revolution for the first time. The political significance of the picture appears to correspond to Zervos's defiant definition of the revolutionary calling of the artistic avant-garde in the name of its subversive cultural potential, rather than to the ideal of the Popular Front promoted in Lingner's drawing. Nevertheless, in devising the image, Klee was reclaiming the term from the National Socialist ideology to which he had ceded it in 1933.

1939: THE FAILED APPLICATION FOR CITIZENSHIP

After *Revolution of the Viaduct*, the term revolution never recurred in the titles of Klee's works. And in his deposition before the Swiss immigration authorities of July 1939, he finally adopted the meaning of the term as it was appropriated by the National Socialists. This represented no change of heart. It was prompted by political circumstances, for in his chosen country of exile, the original significance of the term revolution continued to be held against him.

Klee had been born in Switzerland, but as the son of a German subject, he was a German national. Thus he returned to Switzerland in 1933 as a foreign immigrant. He had not been stripped of his German citizenship, unlike those artists such as George Grosz who had been openly critical of the regime.[134] Klee soon applied for Swiss citizenship, but his application was rejected[135] on the grounds of the so-called Berlin Agreement of May 4, 1933, which stipulated that German citizens were eligible to receive the Swiss residency permit only after having lived in the country "uninterruptedly and with permission" for five years. Klee resigned himself to waiting out this period, and in due time charged his lawyer, Fritz Trüssel of Bern, to

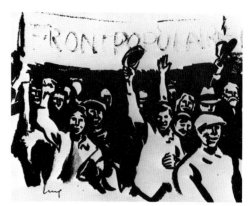

Fig. 28. Max Lingner (1888–1959). *May 1, 1935*. Published in *Arbeiter-Illustrierte Zeitung*, 1935

Fig. 29. B. Jofan. Mural, entrance hall of Soviet Pavilion, Paris World's Fair, 1937

Fig. 30. B. Jofan. Relief, Soviet Pavilion, Paris World's Fair, 1937

reapply for the Federal permit, which he did on April 24, 1939.[136] On July 11, 1939, Klee was called in and interviewed. On this occasion, he made the deposition cited earlier: "The severance of my civil service contract at Düsseldorf took place because of the German Revolution. Since I had nothing more to expect from the German state, I felt free of any ties to this state and entitled to a break of these relations."[137]

Klee was finally ready to give over the term revolution to the National Socialist dictatorship. In an irony of history, however, the original leftist significance of the term had hurt his efforts to establish himself professionally in his country of exile. In the Swiss art press and public of the thirties, a strongly conservative trend of opinion tended to associate modernist art with leftist politics. The cultural pressures the German government was able to apply abroad—even in peacetime—often found a sympathetic response, particularly since political accommodation to the National Socialist state was the announced program of the Front, the strong National Socialist party of Switzerland.

The minority position of modernist art in Switzerland was made clear in 1936. It was excluded from the huge *National Art Exhibition* at the Kunstmuseum in Bern from May 17 to July 12,[138] thus depriving Klee of the chance to be seen as a nationally significant painter in his own city. Conversely, in the deliberately oppositional show *Contemporary Problems in Swiss Painting and Sculpture*, held concurrently at the Kunsthaus Zürich from June 13 to July 22, he was prominently billed, along with Arp and Le Corbusier, as one of three leading international figures among Swiss painters of the avant-garde.[139] There was obvious political irony in the way the *Luzerner Nachrichten* characterized both exhibitions:

On June 13 the Kunsthaus Zurich opened an exhibition which was to assemble those young forces who had no business at the "National" at Bern. As everybody knows, the "National" places in the foreground the most salient Swiss characteristic, a sense of reality. Dreamers such as the surrealists and constructors such as the adherents of abstract art were "left to the left." Now the Zurich exhibition has assembled into one front these "left" ones, these revolutionaries of art.[140]

The "confrontation" between traditional and modernist art in Switzerland, in which Klee had been firmly locked into the latter side, became increasingly obdurate in the following years. Typically, the art critic of *L'Observateur de Genève* of September 15, 1937, wrote in a report about Picasso's *Guernica*: "The partisans of the artistic revolution prepare the political revolution."[141]

In this situation, the Security and Criminal Police Divisions of Bern subjected Klee's application for citizenship to a stringent assessment of the cultural and political significance of his art. They obtained an evaluation from the curator of the Kunstmuseum Bern, Conrad von Mandach, who defended Klee before the Swiss authorities against the charges that had led to his dismissal in Germany: "The reason that he is no longer recognized in Germany is that his painting lies 'beyond the tangible,' that his views are somewhat on the left, and that hence his art is evaluated as 'degenerate.' "[142]

By paraphrasing Klee's well-known sentence: "From this side I cannot be grasped at all," from Zahn's monograph of 1920,[143] the evaluator avoided taking a position on National Socialist cultural politics one way or the other. However, the charge of decadence was soon advanced against Klee by the Swiss authorities themselves. In three secret reports—dated October 31, November 4, and November 9, 1939—addressed to the Chief of Police of the Bern Canton (the reports were written in French, although the official language is German), an unnamed police sergeant presented a dossier based on his own interview with the painter, as well as on ample inquiries with others.[144] His report was laced with sarcastic, hostile comments, leaving no doubt as to what his own recommendations were. After voicing his personal opinion that Klee's ever-more bizarre extravagance might one day push him over the brink of insanity, he relayed a judgment on Klee's standing with the established art community in Switzerland:

Well-known painters of our country have found Klee's new tendency to be harmful to themselves. Should this tendency, thanks to the protection of certain competent personalities, gain a foothold in our country, it would be an insult against the true art, a deterioration of good taste and of the healthy ideas of the population.[145]

The sergeant further registered the opinion that Klee's art was being promoted by Jewish dealers for nothing but financial gain.

In spite of these reports, Federal approval of Klee's application for citizenship was granted on December 19, 1939, one day after the artist's sixtieth birthday. The next phase in the procedure was to obtain the approval of citizenship by the Community of Bern. Klee applied for it on January 15, 1940.[146] After additional inquiries, Klee's case was placed for final disposition on the agenda of the Municipal Council meeting of July 5, 1940. But since he died one week before that date, his case was not acted upon.[147]

CONCLUSION

It remains an open question whether *Revolution of the Viaduct* was merely a transitory reassertion of the claims of modernity prompted by the political confrontation of the arts in the wake of the exhibitions of 1937. It also remains an open question to what extent Klee participated in the general shift from confrontation to indecision and from indecision to pessimism that can be observed in the anti-Fascist cultural community in Western Europe in the last two years before the outbreak of World War II. In the end, the discrepancy between the picture of 1937 and the deposition of 1939 may simply testify to the discrepancy between artistic aspirations and political reality that no twentieth-century artist was spared who, like Klee, attempted to relate the two.

NOTES

I wish to thank Charles Haxthausen, Keith Holz, John Hutton, Wolfgang Kersten, Barbara McCloskey, Frances Pohl, Nancy Troy, and Joan Weinstein for their critical readings of this essay before publication; their suggestions have led to numerous corrections and additions. Some sections of parts II and III were published in a less developed form in my exhibition catalog *Paul Klee in Exile 1933–1940* (Tokyo, 1985).

FREQUENTLY CITED WORKS

Brenner, Hildegard. *Die Kunstpolitik des National-sozialismus.* Reinbek, 1963

Geelhaar, Christian, ed. *Paul Klee: Schriften, Rezensionen und Aufsätze.* Cologne, 1976.

———. "Journal intime oder Autobiographie? Über Paul Klees Tagebücher," in *Das Frühwerk* 1979 pp. 246–60

Giedion-Welcker, Carola. *Paul Klee in Selbstzeugnissen und Bilddokumenten.* Hamburg, 1961

Glaesemer, Jürgen. *Paul Klee: Die farbigen Werke im Kunstmuseum Bern.* Bern, 1976

———. *Paul Klee Handzeichnungen,* I, *Kindheit bis 1920.* Bern, 1973

———. *Paul Klee Handzeichnungen,* II, *1921–1936.* Bern, 1984

———. *Paul Klee Handzeichnungen,* III, *1937–1940.* Bern, 1979

Grohmann, Will. *Paul Klee.* Stuttgart, 1954

Haftmann, Werner. *Paul Klee: Wege bildnerischen Denkens.* Munich, 1950

Haxthausen, Charles Werner. *Paul Klee: The Formative Years.* New York and London, 1981 [dissertation of 1976, published with new introduction]

Huggler, Max. *Paul Klee: Die Malerei als Blick in den Kosmos.* Frauenfeld and Stuttgart, 1969

Kehrli, J. O. *Weshalb Paul Klees Wunsch, als Schweizer Bürger zu sterben, nicht erfüllt werden konnte* (Sonderabzug aus dem *Kleinen Bund,* no. 6 [January 5, 1962]). Bern, 1962

Klee, Paul. *Briefe an die Familie,* ed. Felix Klee. 2 vols. Cologne, 1979

———. *Tagebücher von Paul Klee, 1898–1918,* ed. Felix Klee. Cologne, 1957

Paul Klee: Das Frühwerk 1883–1922, ed. A. Zweite. Catalog. Munich, 1979

Werckmeister, O. K. *Versuche über Paul Klee.* Frankfurt, 1981

Wulf, J. *Die bildenden Künste im Dritten Reich: Eine Dokumentation.* Gütersloh, 1963

1. Hans Belting, *Das Ende der Kunstgeschichte?* (Munich, 1983), p. 22, with references.

2. "Sehr geehrter Herr Schäfler [*sic*] / Der Aktionsausschuss revolutionärer Künstler möge ganz über meine künstlerische Kraft verfügen. Dass ich mich dahin zugehörig betrachte ist ja selbstverständlich, da ich doch mehrere Jahre vor dem Krieg schon in der Art produzierte, die jetzt auf noch breitere öffentliche Basis gestellt werden soll. Mein Werk und meine sonstige künstlerische Kraft und Erkenntnis stehen zur Verfügung! / Mit bestem Gruss / Ihr Klee." Estate of Fritz Schaefler, Aachen. My thanks go to Justin Hoffmann for bringing this document to my attention. On December 2, 1918, Klee had already responded to Schaefler's request to participate in an exhibition at the I. B. Neumann gallery, Berlin; letter in Estate of Fritz Schaefler, Aachen.

3. See *Briefe,* II, p. 1286, letter to Lily Klee, Bern, April 25, 1939.

4. Kehrli, p. 6: "Die Lösung meines Dienstverhältnisses in Düsseldorf erfolgte wegen der deutschen Revolution. Da ich vom deutschen Staat nichts mehr zu erwarten hatte, fühlte ich mich frei von den Bindungen zu diesem Staat und berechtigt zu einem Abbruch dieser Beziehungen."

5. For Germany in particular, see A. C. Greenberg, *Artists and Revolution: Dada and the Bauhaus: 1917–1925* (Ann Arbor, 1979).

6. K. D. Bracher, *Zeit der Ideologien: Eine Geschichte politischen Denkens im 20. Jahrhundert* (Darmstadt, 1982), pp. 82, 90, 127–28, 130, 171, 173; for the Weimar Republic: A. Mohler, *Die Konservative Revolution in Deutschland 1918–1932: Ein Handbuch,* 2d, enlarged ed. (Darmstadt, 1972).

7. Klee, *Briefe,* I, p. 290, to Lily Stumpf, December 9, 1902: "Wir haben auch schöne Kälte. Bloesch friert in Paris bis Ende Dezember, wo arme Teufel mit leerem Magen vor Kälte auf der Strasse liegen geblieben sein sollen. Man soll über nichts klagen. Eure Volksvorstellungen im Hoftheater haben gegenwärtig wohl nur den einen Sinn, wenn der Raum gut geheizt, ist. Das übrige ist Luxus und kommt in keiner Republik vor, wo man doch demokratisch denkt. Ich bin nicht demokratisch, sondern allgemein revolutionär."

8. Klee, *Briefe,* I, p. 359, to Lily Stumpf, November 1, 1903.

9. Klee, *Briefe,* I, p. 505, to Lily Stumpf, May 21, 1905.

10. Paul Klee, Supplementary Manuscript (Kunstmuseum, Bern, Paul Klee Stiftung), p. 22: "591 nur [added with copy pencil: sehr] mittelbares Interesse für soziale u. politische Fragen." In the transcription of the digest, which he made for Wilhelm Hausenstein a short time later and which served as the basis of Hausenstein's book on Klee, the passage reads: ". . . nur bedingtes Interesse für Soziales und Politisches." As Klee was pondering the exact degree of his interest in politics, he may have inserted "very" before "indirect" into his private version in order to reaffirm the sense of artistic detachment.

11. Haxthausen 1981, pp. 103ff., is the first author to have documented and discussed these political leanings.

12. Klee, *Briefe,* I, p. 476, to Lily Stumpf, January 31, 1905: "Gestern war bei Lotmars die Rede von Russland. Den Alten habe ich noch nicht so aufgeregt gesehn; dabei sah er so prachtvoll aus, dass ich den Verbrechern dankbar sein muss. Ich könnte niemals so wild Partei ergreifen; meine Art ist, still lächelnd zuzusehen und wenn auch alles in die Luft spränge. Am Ende gehöre ich auch zu den Menschen, die mit einem Witz sterben."

13. For *Aged Phoenix* (*Greiser Phoenix*), see E. W. Kornfeld, *Paul Klee: Verzeichnis des graphischen Werkes* (Bern, 1963), no. 17. It should be pointed out that the translation "Senile Phoenix" frequently found in the English literature is mistaken. In the German language, *greis* has no connotation of mental decrepitude. Its widespread mistranslation may have to do with unconscious biases against old age prevailing in American culture.

14. This interpretation of the etching is part of a projected work on the Inventions which I have sketched out in a number of public lectures in 1984–85 under the title "Klee 1905–1906: From Socialism to Socialization."

15. Haxthausen 1981, p. 108, who, however, fails to mention the February Revolution in Russia as a motivating factor in this pessimism.

16. Klee, *Briefe,* I, p. 482, to Lily Stumpf, February 19, 1905: "Ich habe eine Allegorie der Unzulänglichkeit als auferstehender *Phoenix*; bildnerisch sehr originell. Man muss sich zum Beispiel denken, es sei eben eine Revolution gewesen, man habe die Unzulänglichkeit verbrannt, und nun steige sie verjüngt aus der eigenen Asche empor. Das ist mein Glaube. . . ." There follows an omission in the printed text.

17. Klee, *Briefe,* I, p. 489, to Lily Stumpf, March 20, 1905: "Greiser Phoenix als Symbol der Unzulänglichkeit menschlicher Dinge (auch der höchsten) in kritischen Zeiten." Haxthausen 1981, pp. 136–37, has traced these comments to a passage in Friedrich Hebbel's diary marked by Klee in his personal copy of the book.

18. *Ibid.:* "Die Anschauung des Bildes erklärt das Beiwort greis als höchst gebrechlich und dem Ende nah . . . Hier soll es als verschwiegene Pointe witzig wirken."

19. H. Gute, *A. Th. Steinlens Vermächtnis* (Berlin, 1954), p. 139.

20. P. D. Cate and Susan Gill, *Théophile-Alexandre Steinlen* (Salt Lake City, 1982), p. 46, colorplate 5.

21. *Ibid.,* p. 70.

22. For the connection, see Haxthausen 1981, pp. 105–06.

23. Klee, *Briefe,* I, p. 507, to Lily Stumpf, Paris, June 9, 1905: "Ein ander Mal kamen wir gegen Morgen durch die Hallen und sahen Huren mit ihren Männern Seil springen, man dachte ans Rokoko. An der Wand aber schliefen in Reihen, zum Teil aufrecht sitzend, die Arbeiter, an die Revolution erinnernd. . . . Von der Menge hat man den Eindruck, dass ihr das einzelne Menschenleben ganz gleichgültig sei. Es wird so sein, dass ein solcher Platz auf die Dauer total abstumpft. Denn überall zu helfen, wie man sollte, ist unmöglich. Im Winter muss alles noch viel entsetzlicher sein."

24. Erich Mühsam, "Revolution," in *Revolution,* no. 1 (October 1913), p. 2.

25. *Die kranke deutsche Kunst, Auch von einem Deutschen* (Leipzig, 1911).

26. Theda Shapiro, *Painters and Politics: The European Avant-Garde and Society, 1900–1925* (New York, 1976), pp. 117–18.

27. *Die Alpen* (Bern), no. 6 (1912), p. 302, reprinted in Geelhaar 1976, pp. 97–98; see also Werckmeister 1981, pp. 125–26.

28. Klee, *Briefe,* I, pp. 43f., 254, 319, 324, 336, 349, 478.

29. *Simplicissimus,* vol. 9, no. 4 (April 19, 1904), p. 31.

30. "Es ist höchste Zeit, dass die Regierung mit aller Macht gegen die Hereros vorgeht, sonst kommen die schwarzen Bestien schliesslich noch nach Deutschland und heben bei uns die Sklaverei auf."

31. The scheme occurs in Giuseppe Pellizza's *The Fourth Estate,* 1896–1901, Municipal Art Gallery, Milan (*Arts Magazine* [New York], vol. 53, no. 5 [1978–79], p. 134) and its model, Giuseppe Primoli's photograph *The Common People's Rally on the First of May* (*ibid.,* p. 135).

32. See illustration for F. Kugler, *Geschichte Friedrichs des Grossen* (Leipzig, 1840), in Heidi Ebertshäuser, ed., *Adolph von Menzel: Das graphische Werk,* vol. 1 (Munich, 1976), p. 381: "Preussische Grenadiere marschieren mit Gewehr im Arm."

33. Klee, *Briefe,* I, pp. 371–72, to Lily Stumpf, December 12, 1903: "Menzels Illustrationen zum 'Zerbrochenen Krug' sind von seinen bedeutendsten Arbeiten und überhaupt die bedeutendsten Illustrationen, die je gemacht worden sind. Ich sah sie nur ein Mal und habe mich schon beeinflussen lassen."

34. Cate and Gill 1982 (see n. 20), p. 72, fig. 58.

35. Franz Marc, "Die 'Wilden' Deutschlands," *Der Blaue Reiter* (1912; new edition, Munich, 1965); F. Marc, *Schriften,* ed. Klaus Lankheit (Cologne, 1978), p. 142: "In unserer Epoche des grossen Kampfes um die neue Kunst streiten wir als 'Wilde,' nicht Organisierte gegen eine alte, organisierte Macht. Der Kampf scheint ungleich; aber in geistigen Dingen siegt nie die Zahl, sondern die Stärke der Ideen. Die gefürchteten Waffen der 'Wilden' sind ihre *neuen Gedanken*; sie töten besser als Stahl und brechen, was für unzerbrechlich galt."

36. Before this, Hans Bloesch had reproduced two drawings by Klee in an article in *Die Alpen* of 1912, and one of his watercolors had been reproduced in the *Blaue Reiter* of 1911.

37. "Die Presse und der Herbstsalon," *Der Sturm* (Berlin), vol. 4, no. 182–83 (October 1913), pp. 114–15; see p. 115: *Leipziger Tageblatt:* "Paul Klee zeigt Zeichnungen, die sich in dem Tiefsinn der Kinderzeichnungen geschult haben." *Berliner Börsencourier:* "Paul Klee ist derjenige, der das Gerücht von den Max- und Moritz-Zeichnungen verursacht hat."

38. *Ibid.:* Deutsche Tageszeitung: "Hier aber sind die Talentlosen in Reih und Glied aufgestellt." *Volkszeitung:* "Diese 'Jüngsten' sind keine Revolutionäre; gereift und abgeklärt, aber reichlich ex-

zentrisch sind die Meisten."

39. *Tagebücher*, p. 311, no. 929, spring or summer 1914: ". . . ich weiss ja sehr wohl, dass das Gute in erster Linie bestehen muss, aber doch ohne das Böse nicht leben kann. Ich würde also in jedem Einzelnen die Gewichtsverhältnisse der beiden Teile ordnen, bis zu einem gewissen Grad der Erträglichkeit. Revolution würde ich nicht dulden, wohl aber zu ihrer Zeit selbst machen."

40. The following section is a short summary of chapters 5 and 6 of my forthcoming book, *Klee, War, Revolution*.

41. Haftmann 1950, pp. 54, 59, omits any mention of this period; Grohmann 1954, p. 58, passes over it with the single sentence: "Eine Ruhepause ist nötig." Neither Giedion-Welcker 1961, p. 52, nor Glaesemer, I, pp. 254ff., deals with the circumstances of Klee's career in 1919. However Glaesemer 1976, pp. 134–35, retrospectively touches on 1919 in the chapter on the years 1921–33 but confines himself to the question of whether Klee's letter to Kubin (see below, n. 51) may have been influenced by the fugitive Ernst Toller.

42. Klee, *Briefe*, II, p. 942, to Lily Klee, October 30, 1918: "Nicht das Volk wird dabei handeln, sondern Instrument sein. Wenn es selbst die Sache in die Hand nimmt, geht es gewöhnlich zu, fliesst Blut und wird processiert. Das wäre banal."

43. Geelhaar 1979, pp. 246ff, has shown that during the years between 1913 and 1921, Klee wrote a clear copy of three of his four diary notebooks, which encompassed his earliest reflections to those from the end of 1915. Only the fourth and last notebook, which covers the time of his military service from 1916 to 1918, contains the original version of the text. It was spontaneously recorded with so much intellectual assurance that Klee felt he could let it stand, even as he was bringing the other three up to the level of articulate reflection he had finally reached.

44. *Tagebücher*, pp. 405–06, no. 1130, October 30, 1918: "Wenn aber die Massen aktiv werden, was dann? Dann wird es sehr gewöhnlich zugehen, es fliesst Blut, und was noch schlimmer ist: es gibt Prozesse! Wie banal!"

45. Curt Corrinth, *Potsdamer Platz, oder die Nächte des neuen Messias: Ekstatische Visionen* (Munich, 1919), pp. 3–4.

46. *Cosmic Revolutionary* (1918 / 181), The Art Institute of Chicago; see *Das Frühwerk* 1979, p. 470, no. 359. Klee cut off a strip of the upper border and glued it to part of another drawing to form *Der Fisch* (1918 / 185), Kunstmuseum Bern, Paul Klee Stiftung (Glaesemer, I, no. 683). Glaesemer, I, p. 255, misreads the title as "komisch-revolutionär" and thus misinterprets it accordingly.

47. Glaesemer, I, p. 256, without reference to the earlier version.

48. See *Erste Grosz-Mappe*, 1, 5; and *Kleine Grosz-Mappe*, 2, 5, 14, in A. Dückers, *George Grosz: Das druckgraphische Werk* (Berlin, 1979), pl. 49–55. The motif refers to Corrinth, p. 58: "D-Züge donnerten, unablässig, Erwachende zum Paradies."

49. See Library of Congress, Washington, D.C., Reese Collection, for the minutes of this session: "Vorschlag: Klee in den Aktionsausschuss aufzunehmen, wurde angenommen." My thanks to Justin Hoffmann for providing me with a copy of this document.

50. Huggler 1969, pp. 10f., seems to have been the only author to have recognized this: "Fünf Blätter des Jahres 1919 geben die Situationen, in denen der nunmehr Vierzigjährige sich schaffend, als Künstler, mit bösem Spott ironisiert, indem er zugleich die schöpferische Tätigkeit in ihre verschiedenen Phasen zerlegt . . . ; besonders scharf ist die Ironie über die *Versunkenheit*." Huggler, however, does not so much as touch on the historical situation in which Klee found himself then.

51. "Briefe von Paul Klee an Alfred Kubin," in *Das Frühwerk* 1979, pp. 80–97; see especially p. 93: "Es war ein richtiges Trauerspiel, ein erschüt-

ternder Zusammenbruch einer im Grunde sittlichen Bewegung, die aber, im Überdrang falsch einsetzend, sich von Verbrechen nicht rein halten konnte."

52. *Ibid.*: "So wenig dauerhaft diese kommunistische Republik von Anfang an schien, so gab sie doch Gelegenheit zur Überprüfung der subjektiven Existenzmöglichkeiten in einem solchen Gemeinwesen. Natürlich eine zugespitzte individualistische Kunst ist zum Genuss durch die Gesamtheit nicht geeignet, sie ist kapitalistischer Luxus."

53. *Ibid.*; see also n. 7, above.

54. *Revolutionary Figurine* (1930 / 164), Morton G. Neumann Family Collection, Chicago. Thanks to Dr. Wolfgang Kersten of the Paul Klee Stiftung, Bern, for bringing this drawing to my attention and for checking the computerized title catalog for occurrences of the term.

55. Geelhaar 1979, p. 252; Haxthausen 1981, pp. XIIff.

56. *Tagebücher*, p. 180, no. 602, March 20, 1905: "Obwohl Ovid nicht dazu passt, ist dort manches Hübsche über diesen Vogel zu lesen (Metamorphose XV 393f.). Mir ist lieber, er wird nicht gewaltsam verbrannt, da bin ich mit Ovid eins."

57. *Ibid.*: "Ohne Tragik ist der Ausdruck auch nicht und der Gedanke, dass dieses Wesen nun bald zur Parthogenese schreiten wird, eröffnet auch keine heiteren Perspektiven. Der Rhythmus der Unzulänglichkeit mit 500jähriger Periodizität ist eine erhaben-komische Vorstellung."

58. *Tagebücher*, p. 192, no. 650, Paris, June 1905: "Valse von dem Bal de Nuit: dazu die Atmosphäre von faulenden Fischen, Staub, Tränen, Arbeit, Pferd an Boden, seilspringende Kokotten. . . . Die Schlafenden an der Wand."

59. Greenberg 1979 (see above, n. 5), pp. 173ff.

60. Barbara M. Lane, *Architecture and Politics in Germany, 1918–1945* (Cambridge, Massachusetts, 1968), pp. 69ff., 117ff., 162ff.

61. Haftmann 1950, pp. 161–62, and Grohmann 1954, pp. 77, 82, do not deal at all with the circumstances of Klee's dismissal and emigration. Grohmann (*ibid.*, pp. 286ff.) does not consider the year 1933 as a significant period for the artist's work, and does not mention the group of drawings discussed below. He says: "Auch der Übergang [*sic*] von Düsseldorf nach Bern ist also kein Einschnitt, die Kunst der letzten Lebensjahre bahnt sich seit 1932 an . . ." (p. 288). Glaesemer 1976, pp. 306–07, only touches on the year 1933 retrospectively in the section on 1934–40; but in 1984, Glaesemer, II, pp. 337ff., presents a full, detailed account.

62. Glaesemer, 1976, p. 306, concludes: "Trotz seiner Distanz zum 'Diesseitigen' besass er ein sehr klares Urteil darüber, was von den neuen Machthabern und ihren Machenschaften zu erwarten war." This is not borne out by the evidence.

63. Klee, *Briefe*, II, p. 1225, to Lily Klee, Dessau, January 30, 1933: "Dass dem Ganzen je zu helfen sei, glaube ich nicht mehr. Das Volk ist zu ungeeignet für das Dinge, *dumm* in dieser Hinsicht."

64. Hendrik, "Kunst-Sumpf in Westdeutschland: Die Flechtheim-Kaesbach-Akademie für bildende Kunst zu Düsseldorf," *Die Rote Erde*, Dortmund, February 1, 1933: "Dann hält der grosse *Klee* seinen Einzug, berühmt schon als Lehrer des Bauhauses *Dessau*. Er erzählt jedem, er habe arabisches Vollblut in sich, ist aber typischer galizischer Jude. Er malt immer toller, er blufft und verblüfft, seine Schüler reissen Augen und Maul auf, eine neue, noch unerhörte Kunst zieht in das Rheinland ein."

65. Klee, *Briefe*, II, p. 1227.

66. Klee, *Briefe*, II, p. 1230.

67. Klee, *Briefe*, II, p. 1229, to Lily Klee, Düsseldorf, February 9, 1933: ". . . ich lese nach Hannibal jetzt Caesar (in Mommsen) und zugleich Stendhal 'Napoleon.' Muss mal ein wenig in Gesellschaft solcher Art Genies gehn. Macht Freude, dass es ausser Hitler und seinen zwei Bändigern noch andere Formate gibt."

68. Felix Klee, editor's note, *Briefe*, II, p. 1233.

69. Klee, *Briefe*, II, p. 1233, to Lily Klee, Düsseldorf, April 1, 1933: "Es war mir möglich, mit Junghanns ganz aufrichtig zu sprechen. Ich bin natürlich an der Reihe, beurlaubt zu werden; aber er hat noch einige Hoffnung, durch eine andere Eingliederung meiner Person in den Lehrbetrieb, ohne dass ich in meiner Lehrfreiheit beeinträchtigt werde. Ich bin ganz ruhig, nachdem ich Schlimmeres hinter mir habe, stelle ich mich auf das Negativste zum Vornherein ein und kann dann Alles abwarten." Wolfgang Kersten has alerted me to the conceptual significance of this passage.

70. Klee, *Briefe*, II, p. 1234, to Lily Klee, April 6, 1933: "Lieber nehme ich Ungemach auf mich, als dass ich die tragikomische Figur eines sich um die Gunst der Machthaber Bemühenden darstelle."

71. See drafts in Klee's notebook, *Briefe*, II, p. 1244. Ignoring this testimony, Glaesemer, II, p. 339, asserts: "Klees kompromisslose Haltung [sc. on the issue of the Aryan Proof] führte dazu, dass er Ende 1933 die unausweichlichen Konsequenzen aus den Gegebenheiten zog und Deutschland verliess." Against this statement it must be maintained that no known testimony suggests that Klee emigrated for reasons of political or moral conscience.

72. Robert Böttcher, *Kunst und Kunsterziehung im neuen Reich* (Breslau, 1933), p. 59; quoted in Wulf 1963, p. 51.

73. See Werckmeister 1981, p. 85, with references.

74. Renée-Marie Parry Hausenstein, London: "Ist zur Hälfte Schweizerin. (Basel) Ihre übrige Abstammung ist nicht völlig geklärt, sie kann über Südfrankreich orientalisch sein."

75. Supplementary Manuscript (see above, n. 10): "Mein Vater stammt aus Thüringen, meine Mutter ist halb Französin und halb Schweizerin. Ihre französische Abstammung ist nicht völlig geklärt, sie kann über Südfrankreich [word cut out from the lower margin] sein."

76. Klee, *Briefe*, II, p. 1251.

77. Brenner 1963, p. 40.

78. Klee, *Briefe*, II, p. 1241; see also Glaesemer, II, p. 338, n. 7.

79. Robert Scholz, "Kunstgötzen stürzen," *Deutsche Kultur-Wacht*, no. 10 (1933), p. 5; quoted in Wulf 1963, p. 53.

80. Landesgalerie, Stuttgart, Grohmann Archiv, no. 7B, letter from Lily Klee to Will Grohmann, October 22, 1933: "Auch wir tragen uns mit Plänen uns völlig zu verändern. D[as] Haus können wir ausserordent[lich] kündigen u[nd] wollen u[nd] müssen es auch im Laufe d[es] Winters aufgeben. Wir gehen dann wo[h]l aufs Land u[nd] stellen zunächst unsere Möbel ein. Ich würde Sie Bitten noch nicht darüber zu sprechen, da ja von uns noch nichts unternommen wurde bis jetzt."

81. Louise A. Svendsen, *Klee at the Guggenheim Museum* (New York, 1977), p. 7.

82. "Taschenkalender Paul Klee 1933," in *Briefe*, II, p. 1240.

83. Grohmann Archiv, letter from Klee to Grohmann, January 31, 1933: "Das Jahr hat eingesetzt mit neuen Zeichnungen aus unverschämten grad sein sollenden Linien. Ob ich deswegen jetzt mehr hab Sonne im Herzen fühle, oder ob ich, weil ich m[ehr] h[ab] S[onne] im [drawing of a heart] fühle, die Zeichnungen werden?? Eine Aufgabe für dümmere Kunsthistoriker. Aber wie viel Glück in ein paar Linien liegen kann, ist schon eine ernstere Frage. / Noch etwas: Unser Hitler!"

84. For some of these drawings, see Glaesemer, II, figs. 507–20.

85. "Schliesse ich denn die Redaktion" is an ironic reference to "Redaktionsschluss," a journalism term, whose sense is suggested in the free translation.

86. Klee, *Briefe*, II, p. 1226, to Lily Klee, January 30, 1933: "Mit diesen Bemerkungen schliesse ich denn die Redaction, nur für Dich das die Öffentlichkeit *nicht berührende* Ereignis beifügend, dass ich letzte Tage einem gelinden Zeichenrappel unterlag. Aber das ist so privat in der heutigen

Welt, und wird, wenn es so weitergeht, . . . lang brauchen, bis es einmal als Culturgeschichte und Kunstgeschichte beachtet wird, und bis dann vielleicht niemand mehr, ohne im Lexikon nachzuschlagen, sagen kann, wer eigentlich der grosse Hitler war. / Dieser letztere Gedankengang gehört ins Gebiet der scheinbaren Reaction, welche Künstler manchmal pflegen, um dann in posthumen Sprüngen dereinst schon allhier zu sein."

87. Klee, Briefe, II, p. 1228, to Lily Klee, Dessau, February 5, 1933: "Seit meiner Rückkehr aus Venedig habe ich nicht mehr so gearbeitet wie in den beiden Wochen. . . . Die Bannung aller Skepsis aus diesem Prozess ist von Neuem geglückt. Dabei wird manches frei, was Ballast werden wollte. Alles abgeworfen. Da sind einige Zeichnungen, die sich ausdrücklich mit Ballastabwerfen befassen, einigermassen reactive Dinge, aber längst nicht mehr von der früheren drastisch-reactiven Art, sondern auch als solcher Charakter sublimiert, beziehungsweise raffiniert. 'Impondérable' [Glaesemer, II, no. 514] und 'sozusagen' [Glaesemer, II, no. 512] sind hiefür wohl die Hauptbeispiele. . . ."

88. Glaesemer, II, pp. 340–41, makes no chronological distinctions between the attitudes expressed in the three letters and hence believes that all in their entirety refer to the first group of abstract drawings. According to him, the group of some 150 drawings, beginning with 1933/N 16, was only started in the middle of February. Admittedly there can be no certainty on this point, but in any event the difference of three weeks involved in the alternative has to do with the degree of immediacy with which historical experience triggered Klee's response.

89. Glaesemer, II, pp. 241–42: "Die beiden Zeichnungen formulieren einen Zustand fragender Ungewissheit. . . ."

90. The exact date is uncertain; see Glaesemer, II, p. 435.

91. Alexander Zschokke, "Begegnung mit Paul Klee," Du: Schweizerische Monatszeitschrift, October 1948, pp. 74–76; idem, in Rheinischer Almanach: Jahrbuch für Kunst, Kultur und Landschaft (1954).

92. Zschokke, ibid., says that the first drawing Klee showed was a "Blatt mit ein paar wenigen geraden Bleistiftstrichen" and calls some of the drawings "völlig ungegenständlich." See Huggler 1969, pp. 144–45.

93. Glaesemer, II, pp. 337ff., published in 1984, discusses at length the questions of interpretation arising from this event. Carola Giedion-Welcker 1961, p. 95, ventured the opinion that the drawings were lost, an assumption refuted by Glaesemer, II, p. 345. She seems to have ascribed the loss to their supposedly aggressive anti-Fascism: "In his atelier at the outskirts of the city . . . house searches were getting more and more thorough, but what Klee had drawn in those last months in Germany . . . with irony, disdain, and rage, was never found. . . . As . . . Zschokke . . . relates, from those apocalyptic drawings there emanated a demonic spell, such a suggestive radiance of brutality, crudity, and discomfort, that the viewer senses the atmosphere in a direct physical fashion. To conclude from Klee's art and personality, this portfolio, missing thus far, must have been a counterpart to that other modern representation of political horror: 'Dream and Lie [of Franco]' by Picasso." ("In seinem Atelier am Stadtrand . . . begannen die Haussuchungen immer intensiver zu werden, aber das, was Klee in jenen letzten deutschen . . . Monaten mit Ironie, Abscheu und Zorn gezeichnet hatte, fand man nicht. . . . Wie . . .Zschokke . . . berichtet, ging von diesen apokalyptischen Zeichnungen eine dämonische Zauberkraft aus, ein so suggestiver Strahl von Brutalität, Roheit und Unbehagen, dass der Beschauer die Atmosphäre direkt körperlich spürte. Nach Klees Kunst und Persönlichkeit zu schliessen, muss diese Mappe, die bis heute verschollen ist, ein Gegenstück gewesen sein zu jener anderen modernen Darstellung pol-

itischen Grauens: 'Songes et Mensonges' von Picasso." Apparently the author is projecting back in time the anti-Fascist tendency of some modernist art around 1937, the date of the Picasso etching to which she compared Klee's hypothetical cycle, but such a tendency is not borne out by the record of Klee's life and art in 1933.

94. Anna Teut, Architektur im Dritten Reich, 1933–1945 (Frankfurt and Berlin, 1967), pp. 140–41.

95. Bruno E. Werner, "Der Aufstieg der Kunst," Deutsche Allgemeine Zeitung, Berlin, May 12, 1933; reprinted in Wulf 1963, pp. 83ff.

96. "Revolution in der bildenden Kunst," reprinted in Wulf 1963, pp. 46ff.; K. Wünsche's article, "Karl Hofer und die neue Kunst," in the Deutsche Kultur-Wacht of July, reprinted ibid., pp. 48ff., also hinges on the term. See also ibid., pp. 74, 105.

97. Lane 1969 (see above, n. 60), p. 180.

98. Brenner 1963, p. 69.

99. Alfred Rosenberg, "Der kommende Stil," Völkischer Beobachter, July 14, 1933; quoted in Teut 1967, p. 90.

100. Brenner 1963, p. 70.

101. As quoted in Wulf 1963, p. 104.

102. Felix Klee Archive, Bern, draft of letter to Alois Schardt, December 8, 1933, quoted by Glaesemer, II, p. 339: "Ich frage: wie wird die vom Staate protegierte deutsche Kunst aussehn?"

103. Thanks to Dr. Wolfgang Kersten of the Paul Klee Stiftung, Bern, and to Mr. Felix Klee for confirming this information.

104. Werckmeister 1981, pp. 140–41.

105. Ibid., pp. 160ff.

106. Jürg Spiller, ed., Paul Klee: Das bildnerische Denken, 3d ed. (Basel, 1971; first edition: 1956) pp. 55–56, undated lecture text.

107. Grohmann Archiv, letter from Klee to Grohmann, December 3, 1933: "Ich denke viel an Sie und Ihre Liebe Frau, und wie viel gemeinsames jetzt auf negativem Gebiet sich ereignet hat. / Ob das tröstlich für Sie ist? ich weiss es nicht. Man kann ja wol auch jetzt noch nichts definitives bemerken, weil Neues erst begonnen hat. Übers Jahr vielleicht?"

108. "Mitteilungsblatt der Reichskammer der bildenden Künste," August 1, 1938, p. 1, as quoted in Wulf 1963, p. 379: "So kam ich damals zu dem Entschluss, einen harten Strich zu ziehen und der neuen deutschen Kunst die einzig mögliche Aufgabe zu stellen: sie zu zwingen, den durch die nationalsozialistische Revolution dem neuen deutschen Leben zugewiesenen Weg ebenfalls einzuhalten."

109. Führer durch die Ausstellung Entartete Kunst, Munich, 1937, pp. 2ff.

110. The five paintings were Der goldene Fisch (Berlin), Um den Fisch (Dresden), Sumpf-Legende (Hanover), Rhythmus der Fenster (Stuttgart), and Mond über der Stadt (whereabouts unknown); see P. O. Rave, Kunstdiktatur im Dritten Reich (Hamburg, 1949), pp. 79–80.

111. Ibid., p. 57, with photographs.

112. Führer durch die Ausstellung, p. 25.

113. Die Alpen (Bern), no. 6 (1912), p. 302, reprinted in Geelhaar 1976, pp. 97–98: "Es gibt nämlich auch noch Uranfänge von Kunst, wie man sie eher im ethnographischen Museum findet oder daheim in der Kinderstube. . . . Parallele Erscheinungen sind die Zeichnungen Geisteskranker, und es ist also auch Verrücktheit kein treffendes Schimpfwort."

114. Die Aktion, 1914.

115. Grohmann 1954, p. 87, maintains with regard to the exhibition: "Klee berühren diese Dinge kaum noch, er hatte es nicht anders erwartet und ist froh, in Bern geborgen zu sein." This is consistent with his disregard for the Klees' historical situation in 1919 (see n. 41) and 1933 (see n. 61), where the evidence, unlike 1937, proves him wrong.

116. Grohmann Archiv, no. 53, letter from Lily Klee to

Grohmann: "Er hat wieder eine seiner ganz schöpferischen Epochen. Auch eine 'Zeichenperiode' tritt auf. Er sitzt Abends bis 11 Uhr u[nd] Blatt für Blatt fällt zu Boden wie einst. Seltsam. Dabei ist er [inserted: doch] noch [deleted: längst; inserted: immer] nicht wieder ganz gesund, steht dauernd unter ärztlicher Kontrolle. . . . 'Er' liest Silone, Fontamara."

117. Christian Zervos, "Réflexions sur la tentative d'esthétique dirigée du IIIe Reich," Cahiers d'Art (Paris), 11e année (1936), pp. 209–12; 12e année (1937), no. 1–3, pp. 51–61.

118. Ibid., p. 210: "Quelque sincère que puisse être à ses débuts ce regime, il se voit, en course d'application, enfermé de toutes parts par les fins même qu'il se propose, et reduit à une conception orthodoxe, restrictive, voire oppressive; et cela avec d'autant plus de vigueur qu'il cherche à se faire accepter par les masses et a leur faire sentir le pouvoir d'appel de ses verités."

119. Zervos, "Réflexions," p. 61: "Et nous posons la question: ne vaut-il pas mieux relancer constamment les masses, leur intégrer l'idée de la révolution, sans répit, idée qui desapprend la crainte, renforce les assises spirituelles et sociales, ouvre les yeux, aiguille les esprits sur la voie de l'inconnu? . . . C'est ainsi que nous entendons la révolution et que nous y trouvons matière d'intérêt."

120. Christian Zervos, "Histoire d'un tableau de Picasso," Cahiers d'Art (Paris), 12e année, no. 4–5, (1937), pp. 105–11; see also J. Bergamín, "Le Mystère Tremble: Picasso Furioso," ibid., pp. 135–40.

121. It is the example of Picasso's political commitment that Carola Giedion-Welcker (see n. 93) invokes when she assumes a similar attitude on the part of Klee in 1933.

122. Will Grohmann, "Paul Klee," Cahiers d'Art (Paris), 3e année (1928), pp. 295–302; Roger Vitrac, "A propos des oeuvres récentes de Paul Klee," Cahiers d'Art, 5e année (1930), pp. 300–06; H. Schiess, "Notes sur Klee à propos de son exposition à la Galerie Simon," Cahiers d'Art, 9e année (1934), pp. 178–84.

123. Grohmann Archiv, no. 57, postcard from Lily Klee to Grohmann, September 27, 1937: "Ein Freund von uns sandte uns Bericht aus P[aris] über die interessanten Kunstausstellungen und sandte uns auch einen Katalog de l'art intern[ational] indépendant. Obwol [sic] mit älteren Arbeiten soll 'er' sehr gut u[nd] hervorragend vertreten sein. . . . Der Schweizer Pavillon sehr schön u[nd] sachlich."

124. See "Paul Klee: Eine biographische Skizze nach eigenen Angaben des Künstlers," Der Ararat (Munich), no. 1 (1920), second special issue, pp. 1–3; quoted in Geelhaar 1976, p. 139, with regard to the years 1913–14: "Mit allen radikalen Kräften Deutschlands und Frankreichs in Fühlung stehend, festigte Klee das eigene Wollen."

125. Felix Klee, "Aufzeichnungen zum Bild 'Revolution des Viaductes' von Paul Klee," Jahrbuch der Hamburger Kunstsammlungen, vol. 12 (1967), pp. 111–20. The five versions are: Unter dem Viaduct (1937/77); Brückenbogen treten aus der Reihe (1937/111); Tiere spielen Komödie (1937/112); Seltsame Jagd (1937/152); Revolution des Viaductes, first state (1937/153), entitled, according to W. Ueberwasser, in "Paul Klees grosses Spätwerk," Werk, no. 52 (1965), p. 460: Abwanderung der Brückenbögen; and according to Felix Klee, p. 120, Abwandernde Brückenbogen. Felix Klee, p. 118, fig. 8, published a photograph that he took of this first state before the painting was completed, but does not say whether the title was conceived by his father and then changed.

126. Dr. Wolfgang Kersten of the Paul Klee Stiftung Bern, has kindly verified that the painting was first seen publicly in the memorial exhibition at the Kunsthalle Bern, November 9–December 8, 1940, when it was offered for sale at 1,500 Swiss francs.

127. Haftmann 1950, p. 170: "Threat has vanquished wit, the parable points to the times. It was in 1937 that the picture was painted, just as was Picasso's 'Guernica'; the bombs were dropping on Spain. That was the year when men and women who had not fallen for the lie of political concepts were feeling the powerlessness to counteract the resounding rebellion of the machinery of civilization. Fate urged enactment. Orders that had been joined together were stepping out of line. Things of a technique which had become unbridled were approaching in an annihilating manner, in order to trample into ruins a world grown ripe."

("Die Drohung hat den Witz besiegt, das Gleichnis deutet in die Zeit. 1937 ist das Bild gemalt, wie Picassos "Guernica,' die Bomben fielen auf Spanien. Das war das Jahr, in dem die Menschen, die der Lüge der politischen Begriffe nicht verfallen waren, die Ohnmacht fühlten, dem dröhnenden Aufstand der Zivilisationsmaschinerie entgegenzuwirken. Das Schicksal drang auf Vollzug. Die gefügten Ordnungen traten aus der Reihe. Die Dinge der zügellos gewordenen Technik rückten vernichtend an, um eine reif gewordene Welt in Trümmer zu stampfen.")

Grohmann 1954, p. 318: "The bridge-men end at the level of their hips; they have neither heads nor torsoes, are nothing but marchers; it is not excluded that Klee had been thinking of contemporary Germany."

("Die Brücken-Männer hören in der Höhe der Hüfte auf, haben weder Kopf noch Oberkörper, sind Marschierer und nichts als dies; nicht ausgeschlossen, dass Klee dabei an das damalige Deutschland gedacht hat.")

Georg Schmidt, *Die Malerei in Deutschland 1918–1955* (Konigstein i. T., 1960), p. 45, speaks of "resounding brown cohorts" ("dröhnenden braunen Kohorten") who evoke a "nightmare of violence inescapably striding toward us" ("Angsttraum unausweichlich auf uns zuschreitender Gewalttat").

R. Linnenkamp, s. v. "Klee," *Kindlers Lexikon der Malerei*, vol. 3 (Zürich, 1966), p. 634: "The function of the viaduct is to connect. Its members necessarily belong together: at the moment when they revolt they break that order which gives them meaning in the first place. Already the failure of one single element is sufficient to disable and to hopelessly corrupt the whole. . . . There is no return any more; for the mass of followers blocks up any retreat. This beginning includes its end by force of law."

("Die Funktion des Viaduktes ist Verbindung. Seine Glieder gehören notwendig zusammen; in dem Augenblick, wo sie revoltieren, brechen sie jene Ordnung, die ihnen überhaupt erst Sinn Gibt. Schon das Versagen eines einzigen Bestandteiles genügt, um das Ganze grundsätzlich zu entmachten und hoffnungslos zu korrumpieren. . . . Es gibt keine Umkehr mehr; denn jeglichen Rückzug verbaut die Masse der Gefolgschaft. Dieser Anfang beschliesst gesetzmässig sein Ende in sich.")

Huggler 1969, pp. 166 ff.: "Grohmann is describing aptly, . . . yet his conclusion 'it is not excluded that Klee had been thinking of contemporary Germany' remains insufficient. After what has been stated thus far about the artist's interest in contemporary events there can be no doubt that with *Revolution of the Viaduct* he has created a symbol which clear-sightedly represents the historical situation in just that year 1937: Spanish Civil War, Mussolini's apogee and pact with Hitler, imminent [?!] annexation of Austria and the Sudeten country."

("Grohmann beschreibt treffend, . . . doch bleibt seine Folgerung, 'nicht ausgeschlossen, dass Klee dabei an das damalige Deutschland gedacht hat' unzulänglich. Nach den bisherigen Feststellungen über die Teilnahme des Künstlers am Zeitgeschehen kann nicht zweifelhaft sein,

dass er mit *Revolution des Viaductes* ein Sinnbild geschaffen hat, das hellsichtig die historische Situation in eben dem Jahre 1937 darstellt: spanischer Bürgerkrieg, Höhepunkt Mussolinis, Pakt mit Hitler, bevorstehender [?!] Anschluss Österreichs und des Sudetenlandes.")

Felix Klee 1967 (see above, n. 125), p. 120: "The revolution appears to be victorious. For how long? But the individual is not viable in the long run, and its existence will be meaningless. The departing single arch of a bridge is headless and thoughtless, deprived of its function. . . . However, the macabre footstep of such an absurd creature is impressing the others and is gaining followers. The movement which steps out of line is to be absolutely equated with a human revolution."

("Die Revolution scheint zu siegen. Wie lange wohl? Doch das Individuum ist auf die Dauer nicht lebensfähig, und sein Dasein wird sinnlos sein. Der einzelne abwandernde Brückenbogen ist kopf- und gedankenlos, seiner Funktion beraubt. . . . Aber der makabre Fusstritt eines solch absurden Wesens imponiert den anderen und gewinnt Anhänger. Die aus der Reihe tretende Bewegung ist mit einer menschlichen Revolution absolut gleichzusetzen.")

128. G. Bussmann, ed., exhibition catalog *Kunst im 3. Reich: Dokumente der Unterwerfung*, 5th ed. (Frankfurt, 1976; first edition: 1975), p. 83, figs. 48, 49.

129. K. Arndt, G. F. Koch, and L. O. Larsson, *Albert Speer: Architektur* (Berlin, 1978), pp. 18ff.

130. This passage does not appear in the original manuscript (as published in *Paul Klee: Beiträge zur bildnerischen Formlehre*, ed. Jürgen Glaesemer [Basel and Stuttgart, 1979]), but it is reproduced in Spiller 1956 (see above, n. 106), p. 187: "Bedingte und freie Bewegungsmöglichkeit. Man kann wohl sagen, eine rein dynamische Architektur gibt es nicht, und man muss hier den leisesten nach jenseits führenden Züge wichtig nehmen. Man müsste den Schein für das Wesen nehmen. . . .

"Wir müssen daher architektonische Werke auf das rein statische Gebiet und auf ein statisches Gebiet, das sich dem Dynamischen mehr oder weniger zuneigt, verlegen. Also höchstens: auf das statisch-dynamische Zwischengebiet. Auf mehr ideellen Gebieten der Kunst, wie Malerei, ist natürlich die grössere Beweglichkeit, ein richtiger Wechsel vom Statischen ins Dynamische, möglich."

131. Klee, *Beiträge zur bildnerischen Formlehre*, p. 63: "Was tun? Fühlen wir uns ein, die wir doch selber Gebäude sind, die auf kleinem Fuss stehen müssen und nicht fallen dürfen. Was tun wir, um nicht zu fallen? Was tun wir, wenn es nicht gelang, durch abwägendes Verschieben der Gewichtsteile in uns (im Kleinen) die statische Ruhe herzustellen? Wir bewegen zunächst ein Bein (Vergrösserung der Basis) und vielleicht bald darauf das andere. Und schliesslich gehen wir, das erleichtert den Ausgleich. Wir wurden bewegte Form und empfanden eine Erleichterung."

132. Ueberwasser 1965 (see n. 125), p. 460, who offers a nonscholarly explication of some of Klee's late paintings, derives from this observation an ideological conclusion of his own, in express contradiction to the interpretations of the forward movement in terms of totalitarianism quoted above (n. 127): "There can be no question of 'brown cohorts'; even less so since it is just a lemon-colored headless man who is tripping his *brown* neighbor. The wish to trip others in the pursuit of success has generally determined the behavior of the various individuals who at any moment become competitors. . . . At that time the insight broke through in Klee that even the viaducts of great planning for humanity were being degraded into servants of the vilest business competition. Competition in each and every realm had become the decisive hallmark of human society." ("Von 'braunen

Kohorten' kann dabei keine Rede sein; schon gar nicht, wenn just ein zitronengelber Kopfloser dem *braunen* Nachbarn das Bein stellt. Beinstellen während des Jagens nach Erfolg hat überhaupt das Verhalten der verschiedenen Partikularen, die in jedem Augenblick zu 'Konkurrenten' werden, bestimmt. . . . Damals brach in Klee die Einsicht durch, dass selbst die Viadukte grosser menschheitlicher Planung zu Dienern übelster geschäftlicher Konkurrenz entwürdigt wurden. Konkurrenz auf allen und jedem Gebiete [*sic*] sei zum entscheidenden Merkmal der menschlichen Gesellschaft geworden.") The author hence perceives the architectural integrity of the viaduct as morally positive. Needless to say, there is not a trace of evidence to the effect that Klee at this time was concerned with a critique of capitalist competition.

133. Walter Benjamin, "Das Kunstwerk im Zeitalter seiner technischen Reproduzierbarkeit" (1935), in *Gesammelte Schriften*, vol. 1. (Frankfurt, 1974), pp. 469, 508.

134. The following account is derived from the apologetical pamphlet by Kehrli 1962, with additional documentation.

135. Letter from Klee to the Municipal Immigration Commission of Bern, June 28, 1939, in answer to the question why he applied as late as that: "In Beantwortung Ihres geschätzten Schreibens teile ich Ihnen mit, dass ich nach meiner Rükkehr in die Schweiz die verschiedensten Versuche gemacht habe, mein Einbürgerungsgesuch in die Wege zu leiten. Es wurde aber zurückgewiesen. Die Niederlassung erhielt ich im Mai 1939. Von diesem Zeitpunkt an beauftragte ich Herrn Fürsprech Dr. Fritz Trüssel mit der Einreichung meines Einbürgerungsgesuches." Kehrli 1962, p. 11.

136. See *Briefe*, II, p. 1286, letter from Klee to Lily Klee, Bern, April 25, 1939.

137. Kehrli 1962, p. 6.

138. W. Hugelshofer, "Zur 'Schweizer Kunst' der Zwischenkriegszeit," in exhibition catalog *Dreissiger Jahre in der Schweiz: Ein Jahrzehnt im Widerspruch* (Zurich, 1982), p. 314.

139. S. Giedion, in preface to catalog, p. 7; reproduced in exhibition catalog *1936–Eine Konfrontation* (Aarau, 1981), p. 23.

140. *Luzerner Nachrichten*, no. 140, June 16, 1936: quoted in *1936–Eine Konfrontation*, p. 33: "Am 13. Juni hat das Kunsthaus Zürich eine Ausstellung eröffnet, die jene jungen Kräfte zusammenfassen sollte, die an der 'Nationalen' in Bern nichts zu suchen hatten. Bekanntlich stellt die 'Nationale' die hervorstechendste schweizerische Eigenart, den Wirklichkeitssinn, in den Vordergrund. Träumer wie die Surrealisten und Konstrukteure wie die Anhänger der abstrakten Kunst liess sie links liegen. Diese 'linksliegenden', diese Revolutionäre der Kunst, hat nun die Zürcher Ausstellung zu einer Front versammelt."

141. Quoted in *Ein Jahrzehnt im Widerspruch* (see n. 138), p. 68: "les partisans de la révolution artistique préparent la révolution politique."

142. Kehrli 1962, p. 7: "Dass er in Deutschland nicht mehr anerkannt sei, habe seinen Grund darin, weil seine Malerei 'jenseits des Fassbaren' liege, er etwas links eingestellt sei und deswegen seine Kunst als 'entartet' taxiert werde."

143. Leopold Zahn, *Paul Klee: Leben, Werk, Geist* (Potsdam, 1920), p. 5.

144. Quoted by Meta La Roche, in "Die Schweiz, Jean Arp, Paul Klee und ein geheimer Polizeirapport," *St. Galler Tagblatt*, July 13, 1957.

145. *Ibid.*: "Bekannte Maler unseres Landes fänden Klees neue Richtung für sich selbst unheilvoll. Sollte sie dank der Protektion gewisser zuständiger Persönlichkeiten in unserem Lande Fuss fassen, wäre dies eine Beleidigung gegen die wirkliche Kunst, eine Verschlechterung des guten Geschmacks und der gesunden Ideen der Bevölkerung."

146. Kehrli 1962, p. 9.

147. Kehrli 1962, pp. 9f.

63

KLEE AND
GERMAN
ROMANTICISM

JÜRGEN GLAESEMER

Ingres is said to have given order to repose, I want to go beyond emotion to give order to movement. *The new romanticism.*

> *Diaries,* no. 941, 1914

One leaves the realm of the here and now and instead builds a realm beyond, which can be total affirmation. Abstraction.
The cool romanticism of this style without pathos is unheard of. The more terrifying this world (as it certainly is today), the more abstract the art, whereas a happy world brings forth an art of the here and now.

> *Diaries,* no. 951, 1914

Such vehement gestures point clearly to the dimension of style. Here *the distinctively crass emotional phase of romanticism* comes to life.

This gesture wants desperately to get away from the earth; the next one manages to rise above it. It rises under the dictate of buoyancy, which triumphs over gravity.

If I finally let these earth-defying forces swing especially far, up to the cosmic realm, I will get beyond the oppressive emotional style to that *Romanticism which unfolds in the All.*

The static and dynamic parts of the pictorial mechanics thus coincide very nicely with the *opposition of classic and romantic.*

> Jena, January 26, 1924

I

In the vast literature on Klee, there is scarcely a writer who has not at least touched on the connections between the artist and romanticism. Surprisingly, however, a full study of the subject has yet to be written.[1]

Younger scholars who have worked on Klee since the seventies have, in contrast to their predecessors of Will Grohmann's generation, sought to ground their studies of Klee, both as an artist and a man, in documented fact. The Klee who stands in the foreground of these studies is the disguised realist, who, with the calculation of a bookkeeper, observes all that happens around him in the spheres of art, politics, and society. O. K. Werckmeister's attempts to demystify Klee are among the most successful and stimulating of these investigations; they have brought us to a new critical understanding of Klee as an artist fully conscious of reality. These "securely" documented, and thus apparently irrefutable, investigations of Klee's political and economic actions and of his thought nevertheless also hold the danger of forcing an understanding of the man and his art into a narrow ideological scheme.

Klee's primary aim in all his art was to communicate, with every pictorial means at his disposal, the expression of *movement*—movement in the creation of form and in the idea and content of a picture—and to elicit movement in the reactions of the viewer. This concept, which was the basis of all his artistic thought and deeds, is scarcely conceivable without a romantic, idealistic point of view. We cannot follow this thinking of Klee's unless we are prepared to see the work of art, both conceptually and in its appeal to the senses, as an organically evolved whole and a reflection of natural creation and of life in all its complexity. "I want to go beyond emotion to give order to movement. The new romanticism," wrote Klee, as he sketched out his program in his diary in 1914.[2]

If today Klee's art is still capable of "moving" us, despite its decided introversion, we cannot credit this solely to the documentary evidence of his ties to reality. In the present phase of our understanding of Klee, there is a particular need, it seems to me, for a positive account of the spiritual aspects of his thought and activity, which will act as a counterweight to the important but one-sided investigations based on social and ideological critiques. A valid answer to the questions concerning the essence of his art cannot be obtained from a single approach, but lies at best—in accordance with the romantic idea of vital, all-encompassing movement—somewhere within the different, constantly changing opinions of it.

German Romanticism signifies far more than a historical style dating from about 1800: it is the expression of a *Weltanschauung*, one that survives today, constantly balancing between an expansive optimism and a sense of defeat. To attempt to convey an idea of the nature and meaning of romanticism to someone unprepared to enter into areas of perception beyond the limits of what can be grasped by reason alone is futile—as hopeless as trying to explain the expressive and communicative possibilities of music to a person who is tone deaf and unreceptive to it.

If for various readily understandable reasons one resists coming to terms with the express element of romanticism in Klee's work, then it does not seem altogether out of place to try to expose his definition of "cool romanticism," a name he himself gave his style in a deliberate effort at self-revelation. Let us for the sake of argument assume this case, which cannot be ignored in examining Klee as a romantic:

With all those fairy-tale scenes, the moonlight, sensitive flowers, animals, children, geniuses, and angels in his pictures, Klee was merely responding to a sentimental, romantic culture of sensibility found increasingly among intellectuals and aesthetes at the beginning of the twentieth century, especially during and immediately after World War I. After all, to withdraw as far as possible from the bitter realities instead of facing up to them is not an uncommon tendency of a socially privileged class in times of great crisis. It would not be difficult to document Klee's "romantic" style as at heart a shrewd, deliberate response to contemporary conditions in the art market and to the demands of his potential clientele, which came primarily from well-situated middle-class circles. Like many of his contemporaries in Germany in the first decades of the twentieth century, Klee seems to have aimed (on the pretext of creating a so-called avant-garde romanticism) at devising signals for a mode of communication meant to be understood only by a narrow circle of initiates and to serve their culture of sensibility.

Such an argument cannot be refuted merely by counterarguments. The position one takes must be based on a thorough investigation of what Klee defined as his romantic style within the context of his view of life as a whole. The above argument is presented as an open question in opposition to the following deliberations, and the reader is invited to decide between them.

Fig. 1. *Diesseitig bin ich gar nicht fassbar. . .* ("I am not at all graspable in this world. . ."). Holograph text by Klee in *Der Ararat* (Munich), 2d special issue (1920), p. 20, catalog of Klee exhibition, Galerie Goltz, Munich

||

When Klee defined his style as "cool romanticism" in 1914, he was obviously not only talking about the romantic motifs of his pictures. Like all German Romantics, he was concerned, in a much more complex context, with an individual view of the world. His most programmatic formulation of his ideas in existential terms oc-curs in this well-known aphorism:

I am not at all graspable in this world. For I live as much with the dead as with the unborn. Somewhat closer to the heart of creation than usual. But not nearly close enough.

Does warmth emanate from me? Coolness? Beyond all ardor there is nothing to discuss. I am most devout when I am furthest away. In this world some-

times a little malicious about the misfortune of others. These are merely nuances. The priests just aren't devout enough to see it. And they are a bit offended, these authorities on Scripture.

This passage does not appear in Klee's diaries; he published it in 1920 in *Ararat*, a journal put out by the Galerie Goltz of Munich on the occasion of Klee's first, large one-man show. Reproduced in the journal in facsimile (fig. 1), this handwritten passage has the unmistakable look of a program.

The question inevitably arises of whether this programmatic utterance in Klee's handwriting in what served as the catalog of his exhibition does not simply conceal an attitude: that of an artist who allowed himself the complete luxury, even during the upheavals of war, revolution, and inflation, of indulging his private imagination; who, in his extreme individualism, guarded himself as far as possible against active participation in collective events; but who nevertheless—as Klee demonstrably did—always kept sight of the realities and their importance for his career.

Is it, after all, such a luxury to get as far away as possible from active participation in everyday events, and to barricade oneself in isolation within oneself, if in the process one keeps an eye trained sharply, as Klee did, on the events of this world? To approach an answer, we must first ask what Klee really meant when he wrote that he was "not at all graspable in this world," what there is in this attitude that can be called romantic, and what the consequences were for him as a person and for his work.

A comparison of two pictures will clarify, for a start, where the perceptions of the romantics of about 1800 touch those of Klee. At first glance, Caspar David Friedrich's *Wanderer over a Sea of Fog* (ca. 1818; fig. 2)—a typical work of German Romanticism—seems to have nothing in common with Klee's watercolor *Mural from the Temple of Longing ↖ Over There ↗* (1922; fig. 3).

Surprisingly, in his many writings Klee makes not a single reference to Friedrich. He mentions Philipp Otto Runge, Friedrich's contemporary, only once—in his Bauhaus lectures—and then only as a theorist and author of the color wheel. None of this means, of course, that Klee's pictorial language does not show a profound relationship to the great works of Romantic painting—even if he never saw an original by Friedrich or Runge, which is scarcely likely.

Klee's composition is a complicated, restless construction with lines that seem to have been drawn with a ruler and compass. The objects in Friedrich's picture, instead, are immediately recognizable; a title is not even necessary. A man, seen from the back, stands like a monument atop a cliff. He gazes out over a mountain landscape covered by a sea of fog, which stretches out before him as far as the horizon. The dark silhouette of the figure, like a paper cutout, stands in marked contrast to the light background.

If we ask ourselves what idea is being expressed, the two pictures begin to look remarkably similar. Friedrich places his wanderer monumentally in the center of the picture. He stands at the point where the various horizontal and diagonal axes intersect. All parts of the composition come to focus on this wanderer who, with his back to the viewer, has turned away from the outside world. We, the viewers, thus become unobserved observers—not very different from a psychiatrist standing behind a patient on the couch. If we are willing to continue this game of role-playing, we will ask ourselves what the per-

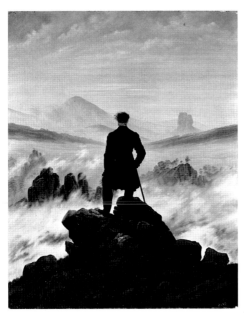

Fig. 2. Caspar David Friedrich (1774–1840). *Wanderer over a Sea of Fog*, ca. 1818. Oil on canvas, 37⅝ × 29½ in. (94.8 × 74.8 cm). Kunsthalle, Hamburg, West Germany

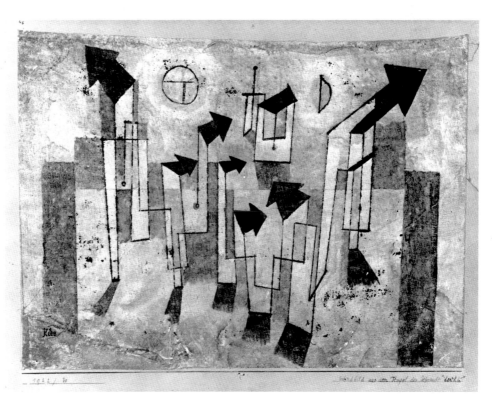

Fig. 3. Paul Klee (1879–1940). *Mural from the Temple of Longing ↖ Over There ↗ (Wandbild aus dem Tempel der Sehnsucht ↖ dorthin ↗)*, 1922 / 30. Watercolor and transfer drawing on gessoed cloth, 10½ × 14¾ in. (26.9 × 37.5 cm). The Metropolitan Museum of Art, New York, The Berggruen Klee Collection, 1984

ceptions and feelings of the figure might be; we will try to enter into the experience that moves this wanderer as he looks over the broad, fog-bound landscape.

Friedrich's setting of the scene, with its central figure seen from the back, corresponds to Klee's invitation to the viewer to find the intended meaning in his language of geometric ciphers and symbols. Klee's titles are the necessary vehicle of this meaning, and they are therefore an inseparable part of his representation, like the caption under a cartoon, which delivers the point of the joke. The title of the watercolor is *Mural from the Temple of Longing* ↖*Over There*↗ . To be absolutely sure that no one will misunderstand, Klee adds two arrows—a pedantic little joke—to serve as quotation marks around the last part of the title.

Friedrich's wanderer gazes at nature, which spreads out before him in the form of a sea of fog, just as it might have looked on the first day of creation. He stands transfixed by the infiniteness of nature; but his desire to become part of that infinitude goes against reality. The wanderer remains prudently at the edge of the abyss, his two legs and a walking stick in solid contact with the ground. His thoughts and feelings are thus in opposition to his physical existence, just as the dark, corporeal foreground is in contrast to the light, ethereal expanse of the landscape.

Students of Friedrich have assumed that in this statuelike figure of the wanderer the painter is paying homage to a friend who died in the *Freiheitskriege*, the German Wars of Liberation of 1813–15.[3] The political background of the painting is not unimportant to our understanding of the development of German Romanticism as a whole. The conclusion of the wars of independence from Napoleonic rule at the 1814–15 Congress of Vienna destroyed the hopes of the romantics for revolutionary change in Germany and for the realization of their intellectual and political ideals. It put the final seal on the romantic dilemma of powerlessness.

What does all this have to do with Klee? It is my contention that his watercolor is intended to make the very same point as Friedrich's painting. Its poetically heightened title, *Mural from the Temple of Longing* ↖*Over There*↗ , informs us that a temple has been dedicated to longing—that typically German Romantic leitmotif. *Sehnsucht* (longing) is the driving force behind German Romanticism, forging the bond between the opposite poles of earthly constraint and cosmic freedom of unrestricted movement. It is a feeling, an urge—equally alluring and tormenting—for imagined, neither clearly defined nor physically realizable goals; what is desired is inherently unattainable.

Klee's arrows symbolize thoughts and feelings filled with longing. They move weightlessly and unimpeded ↖over there↗ toward the infinity of the stars. On April 3, 1922—about the same time as he was working on the watercolor—Klee presented his thoughts on the symbolism of the arrow to his students at the Bauhaus. The passage reads like a subtle analysis of the romantic experience of life as an oscillation between the poles of ascent and fall:

The father of every force of movement or projectile, and hence of the arrow, was the thought: how can I extend my reach over there? Beyond this stream, this lake? beyond this mountain? → over there? . . . / The father is totally spirit, totally idea; in other words, totally thought. . . . / Man's ability to traverse the earthly and the supernatural in spirit as opposed to his physical impotence is the original human tragedy. The tragedy of spirituality. / The consequence of this simultaneous impotence of body and mobility of spirit is the dichotomy of human existence. Half captive, half winged, each part becomes aware of the tragedy of its incompleteness through recognition of its partner. . . . / Thought as medium between earth and cosmos. / Tragedy. Yet it is already constituted in the fact that there is a starting point, in the need to break the bonds of constraint, to become movement and not yet to be movement. So the tragedy already exists at the beginning. . . . / In parentheses: create so that you may hit the mark, so that you may head towards something, even if you should tire and not arrive anywhere![4]

Even if we set aside the particular view of the world Klee was trying to convey, we must nevertheless recognize his great talent for making

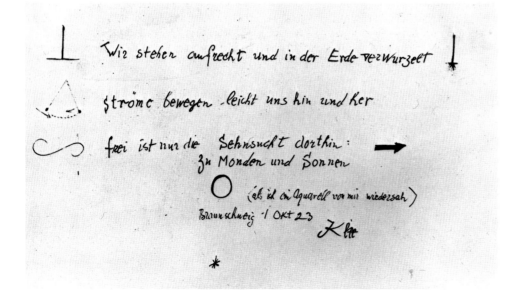

Fig. 4. Paul Klee. *Wir stehen aufrecht* . . . ("We stand erect . . ."), Braunschweig, October 1, 1923. Entry in guest book of collector Otto Ralfs, Braunschweig, Germany. India ink and pen on paper, 3½ × 6 in. (9.5 × 14.7 cm)

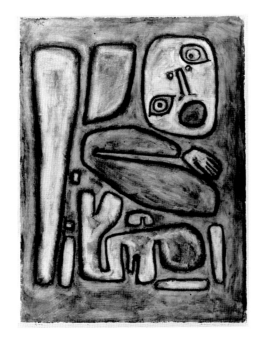

Fig. 5. Paul Klee. *Outbreak of Fear III (Angstausbruch III)*, 1939 / 124 (M 4). Watercolor over egg ground on paper, mounted on cardboard, 25 × 18⅞ in. (63.5 × 48.1 cm). Kunstmuseum Bern, Paul Klee Stiftung

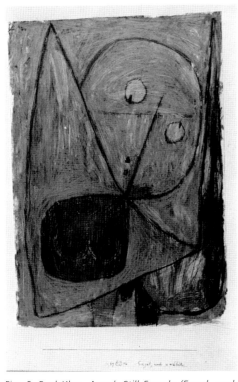

Fig. 6. Paul Klee. *Angel, Still Female (Engel, noch weiblich)*, 1939 / 1016 (CD 16). Colored lithographic crayon over blue paste on paper, mounted on cardboard, 16⅜ × 11½ in. (41.7 × 29.4 cm). Kunstmuseum Bern, Paul Klee Stiftung

complex intellectual relationships visible to the senses by the astonishingly simple means of signs or images. Those students in his Bauhaus classes who were able to analyze his lectures critically obtained a method of pictorial thinking, of reflective seeing, capable of being used in a great variety of ways. This thoroughly romantic method is the really original and creative dimension of Klee's art, one which has made him a central figure in the art of the twentieth century and still very much alive today.

To return once more to the watercolor: we possess a commentary on it that Klee himself wrote in its owner's guest book (fig. 4). Dated "Braunschweig, October 1, 1923," it summarizes in a few sentences the basic elements of the artist's romantic view of the world. This carefully written and illustrated text was meant to explain *Mural from the Temple of Longing ↖Over There↗*.[5]

Klee begins by drawing perpendicular lines and adding the words: "We stand erect and rooted in the earth." Does this not at once recall Caspar David Friedrich's *Wanderer over a Sea of Fog*? Friedrich's figure is the very epitome of erect stance in Klee's sense. In the language of *Temple of Longing*, that figure is replaced by perpendicular lines, the lower ends of which are "rooted in the earth" by broad bands of shadow.

Next, Klee draws a small pendulum with this explanation: "Currents move us lightly back and forth." Elsewhere he called this second stage "dynamic reflection." By this he meant that our freedom of movement in the physical realm of earth is an inhibited dynamic and a mere reflection of free movement. Heinrich von Kleist's essay on the marionette theater deals with the same subject.[6] Klee illustrates his ideas with the example of the pendulum. Because of gravity its every swing is opposed by a counterswing, and it is forced to return to a static condition of rest. In keeping with his remarks, the vertical lines in *Temple of Longing* seem to move gently back and forth.[7]

Finally, Klee explains his drawing of a curved line, an arrow, and a circle symbolizing the stars: "The only free longing is the longing to go over there: to moons and suns." He alludes to the many circular signs he inserted time and again in the upper parts of his pictures to symbolize the cosmic regions of "moons and suns." The motif runs through all his work. It appeals to the same romantic longing for the infinite that Friedrich visualized as a distant expanse of foggy landscape and that is reflected in the many references to infinite nature—the "blue flower," the cosmos, the stars—found in the German Romantic poetry of Jean Paul, Ludwig Tieck, Novalis, and Joseph von Eichendorff.

The essential difference between Friedrich's and Klee's pictures is therefore in their conceptual form; the content they convey is similar. Klee, in a language of symbols and signals, and with the help of titles and supplementary explanations, composes a course in the romantic perception of the world and the culture of sensibility. Yet apart from its numerous subtle decorative elements and romantic details (sun, moon), the painting lacks a sensuous realization

of the many levels of meaning addressed in it. Klee conceals the tragic disjunction in life behind intellectual constructions. But now we also gain a certain insight into what he meant when he said that he is "not graspable in this world," and in what way he covered up this attitude with his "abstract" pictorial language.

It might be objected that Klee did not experience any such tragic disjunctions but only spoke about them. It is true that conclusive proof of his sincerity, in the sense of a congruity between his experience and his artistically shaped content, is difficult to find in his early and middle periods before 1933. But his late work provides that proof. Without the heightened, almost obsessive, production of his last four years, from the onset of his illness in 1936 to his death in 1940, and without the new, undisguised humanity of his late pictures, his life's work would appear in a very different light. His final pictures and drawings make it clear that Klee's disengagement from the world was in no way a flight from reality but was rather a distancing from it.[8] In many of his late works in which the figure appears, such as *Outbreak of Fear III* (1939; fig. 5), he succeeds in expressing the threat and despair occasioned by his own impending death even while preserving the dispassionate composure he had cultivated from early on. *Angel, Still Female* (1939; fig. 6) is another easily read example. With one eye the angel gazes upward in the direction of heaven; with the other it glances suspiciously at what is left of its breasts, all that remains of its former sexual existence on earth as it goes on its way ↖over there↗. In pictures such as these, Klee still found enough humor to caricature his dying only a few months before his death.

With his concept of "cool romanticism," therefore, Klee marked out a personal position with respect both to real life and to the form of his art. From this calculated position, from the prospect afforded by distance, he tried with "cool" observation to come to terms with romantic longing as well as with earthly experiences and feelings.

Klee was not only a thinker and theorist, he was above all a creative artist. In fact, even the physical properties of his paintings and drawings bear the clear, identifying marks of romanticism. The role played by drawing as the chief bearer of content, for instance, is romantic. And so is a preference for small formats. Romantic artists often specialized in fragments, aphorisms, and short stories; in impromptus and musical *aperçus*; in sketches, drawings, and small pictures.

Even the infectious playfulness of Klee's work is an out-and-out romantic trait. His talent for discovering new means of expression was not merely an end in itself. His constant play with new forms and his startling technical experiments were a deliberate way of avoiding rigidity and overly flat statements and of creating ambiguity. In short, like all romantics, what he sought even in his forms was a ceaseless, playful activity and expansion of the mind and not the realization of an ideal in the classical sense of physical perfection.

Comparison of the romanticism of 1800 with Klee's in the first half of the twentieth century makes sense only if we grant the concept a timeless aspect, going beyond its historically limited definition. Even today, one can with reason call oneself a romantic, whereas it would hardly be appropriate to describe anyone in our time, without a hint of irony, as a "classicist" committed to the Enlightenment. Classicism is defined by each generation in new terms according to changes in ideology, and is thus as tied to historical circumstance as romantic thought, sensibility, and action are timeless.

Accordingly, the attempt to define historical Romanticism in the time of profound economic, political, and religious upheaval around 1800 can to a degree also provide a basis for understanding the romantic view of life in 1914, or even today.[9] Changes in the religious viewpoint of the middle class at the end of the eighteenth century were not the least of the causes of the Romantic temper and attitude of mind. Experience of and belief in the divine was supplanted by knowledge. Idea and reality were no longer synonymous, and as a consequence, "direct communication with heaven" broke down once and for all. The Romantics, in contrast to the followers of the Enlightenment, experienced the decline of faith as a heavy loss. They opposed scientific knowledge with the subjectivity of human sensibility. The decisive point of departure for the romantic view of life is the totality, the cosmos, the interrelationship within natural creation. The Romantic seeks to define his individuality as a living part of the all-encompassing system of nature, between the poles of present existence and the transcendent. Given the changed conditions of their society, the German Romantics, with their presentiments, their longings, and their visions, turned permanently inward. The dilemma of powerlessness left a decisive mark on the character of German Romanticism, on its ironic as well as on its tragic aspects and forms of expression.

Klee's concept of romanticism, as he defined it at the outbreak of World War I in terms of a style and an attitude toward life, was the result of a long, personal development in which both individual and external circumstances played their part. It began during his childhood in Bern. The atmosphere in which Klee grew up was imbued with the late-romantic, Biedermeier culture of the Swiss middle class (fig. 7), against whose narrowness he began to rebel during the time of his etched Inventions—that is, between 1902 and 1905. His fatalistic attitude in the struggle against his domineering father shows clearly how reluctant he was to free himself from the concept of an idyllic bourgeois family life.

During his student days in Munich, Klee wrote romantic poems in the style of folk songs and sent them to his old school friend Hans Bloesch in Bern for criticism. Here is an example of these still largely unpublished poems:

> I sank down
> In the arms of a feverish dream,
> I kissed you
> Down by the willow tree.
>
> Wild was my kiss,
> And how my temples raced!
> High above
> The storm clouds chased.
>
> Nocturnal sun
> How could such joy be true!
> Elisabeth!
> This piece is meant for you.[10]

The perfumed eroticism, the romantic surges of emotion and feeling for nature, and the roguish, ironical ending to the poem are in the style of the popular German *chansons* of the time—Heinrich Heine is their godfather.

About 1902, after returning from a trip to Rome, Klee made an about-face and confronted the heritage passed on by his family. He went not to Munich (to say nothing of Paris) but back to the provincial Biedermeier environment of Bern. The shift in his romantic tone is first noticed in his diary:

"Unfortunately the poetic in me has suffered a great change. Tender lyricism has turned to bitter satire. I protest. / If only I endure, an impudent voice in me calls out. For the truth is, the more I develop, the more brittle the great wide bourgeois world looks. / Or am I wrong about myself? Then I should never have been born.

Fig. 7. Mathilde, Ida, and Hans Klee, the artist's sister, mother, and father, August 11, 1908. Photograph by Paul Klee. Collection Felix Klee, Bern

70

Fig. 8. Paul Klee. *Comedian (Komiker)*, 1904 / 14. Etching and aquatint, 6 1/16 × 6 5/8 in. (15.3 × 16.8 cm)

Fig. 9. Paul Klee. *Hero with the Wing (Held mit dem Flügel)*, 1905 / 38. Etching, 10 × 6 1/4 in. (25.4 × 15.9 cm)

And now I can't die either! / Music has often been a comfort and will often be a comfort when necessary."[11]

These early statements set forth all the essential motifs of his lifelong disengagement from the "here and now": aloofness from the "great wide bourgeois world" and an egocentric, "impudent" reference to the "I." His path of revolt led inward. As the *Comedian* (1904; fig. 8), he did not strip off the grinning mask with the features of his father but continued to wear it on his tragically earnest face as protection. And in his etched Invention *Hero with the Wing* (1905; fig. 9), he succeeded in expressing the human condition in a form that would remain valid for

him throughout his life. The longing for a free, dynamic movement toward the infinite goes counter to reality; the hero's wing has only a limited capacity for flight. Klee commented on the etching in his diary: "The hero with the wing. A tragicomic hero, perhaps an antique Don Quixote. . . . This human being, born with only one angel's wing in contrast to divine beings, staunchly tries to fly. In doing so he breaks his arm and leg, but still manages to bear up under the banner of his idea. It was particularly important to capture the contrast between his monumental, solemn attitude and his already ruined state as a symbol of the tragicomic."[12]

71

The essential traits of Klee's romantic stance as an artist were thus already defined at the beginning of the century. The attitude embodied in the 1905 *Hero with the Wing* can be distinguished from Klee's formulation some twenty years later in *Mural from the Temple of Longing* ↖ *Over There* ↗ by its pathos, which is retained "tragicomically" in the figure's ruined condition. What is really new in Klee's definition around 1914 is not, therefore, the idea of "romanticism" but the discovery that the pathos of its basically tragic mood could be sublimated by putting it in code. Contemplation of the tragic is moved to a distance; through "abstraction" the ruined hero is made into a symbol, a marionette, a little stick figure, or a nonobjective sign charged with meaning.

Romantic inwardness was so much a part of Klee's temperament that it shows even in the way he carried himself (figs. 10–13). The dreamy yet penetrating look, the head leaning pensively on a hand in the manner of Dürer's Melancholia—this is the pose in which he repeatedly portrayed himself in the years between 1908 and 1911. Sometimes these self-portraits can be interpreted as the expression of a momentary state. In the lithograph *Absorption* (1919; fig. 14), however, inwardness becomes his very trademark. It is a self-caricature, both ironic and earnest: as if to say, I am Buddha. *Absorption* is an artistic construction as well as a mask and an identity. That sentimental schoolgirls worshiped Klee ecstatically as the "Bauhaus-Buddha" didn't seem to bother him (fig. 15). To a certain extent a mystical, religious aftertaste was unavoidable with the form of inwardness Klee was striving for.

Klee's *Weltanschauung* took meditative, inward forms of a sort that today, with the emulation of Eastern spirituality by a wider public, has profoundly affected Western culture. The spiritual movements in question have been called escapist, yet they offer a chance for our Western civilization to free itself from a blind faith in progress and to turn its gaze instead toward nature and its cyclical laws. We have disturbed this complex system of relationships without knowing and comprehending all the ramifications, and the more we press forward with details the more the whole escapes us in the disclosure of new details.

Klee's attitude toward life and his conception of art are romantic not only in his *absorption* as such. What links him closely to the Romantics of 1800 is his claim to an "inward observation of objects." As a romantic he wants to bring the "ego and the object into a resonant relationship that goes beyond optical foundations." In 1923 he summed up this idea in his essay "Ways of Nature Study" with a schematic diagram (fig. 16).[13] The center and recipient of all impulses emanating from the earth, the cosmos, and the object is the artist's "I." By his work he creates, in resonance with the universe, a "parable of God's work." In Klee's view, art, as a "parable of creation," is itself a rebirth of nature.

The new autonomy of the modern artist, his godlike self-awareness, begins with the Romanticism of 1800. However, the ability to "sense the

Fig. 10. Paul Klee. *Young Man with Pointed Beard, Resting His Head in His Hand (Junger männlicher Kopf, in Spitzbart, Hand gestützt)*, 1908 / 42. Pencil on paper, 8⅝ × 6⅝ in. (22 × 16.9 cm). Private collection, Switzerland

Fig. 11. Paul Klee. *Self-Portrait, Full Face, Head Resting in the Hand (Selbstportrait en face in die Hand gestützt)*, 1909 / 32. Watercolor on paper, 6½ × 5¼ in. (16.5 × 13.5 cm). Private collection, Switzerland

Fig. 12. Paul Klee. *Young Man Resting (Junger Mann, ausruhend)*, 1911 / 42. Brush and ink on paper, 5⅜ × 10¼ in. (13.8 × 20.2 cm). Private collection, Switzerland

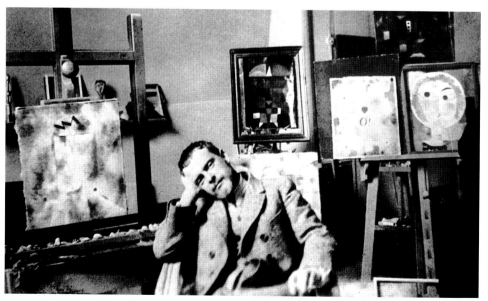

Fig. 13. Klee in his studio, Weimar Bauhaus, 1925. Photograph by Felix Klee

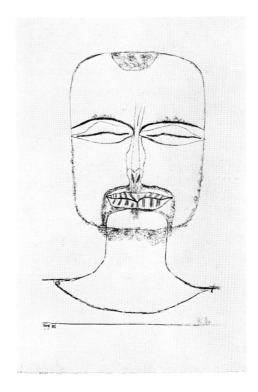

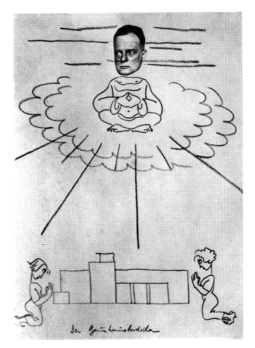

Fig. 14. Paul Klee. *Absorption: Portrait of an Expressionist (Versunkenheit: Bildnis eines Expressionisten)*, 1919 / 113. Lithograph, watercolor additions, 10 × 7 in. (25.6 × 18 cm). Private collection, Switzerland

Fig. 15. Ernst Kállai (1880–1954). *The Bauhaus Buddha: Caricature of Paul Klee*, 1930. Pencil and collage on paper. Whereabouts unknown

Fig. 16. Paul Klee. Illustration for "Ways of Nature Study," 1923. Published in *Staatliche Bauhaus Weimar 1919–1923* (Weimar and Munich, 1923), p. 25. Pen and India ink on cardboard, 13⅞ × 8¼ in. (34 × 21 cm). Kunstmuseum Bern, Paul Klee Stiftung

infinite in appearances" not only leads to soaring flight but can easily result in conflict with reality. The romantic longing of *Hero with the Wing* is brought up short by external circumstances. "What was left for the poetic spirit after this collapse of the outer world?—That into which it collapsed, the inner." This is how, as early as 1804, the great poet and theorist Jean Paul formulated the typically German conflict of romanticism.[14]

Klee's late painting *Intention* (1938; fig. 17) is a good illustration of the deliberate separation between the internal and external. It has clear elements of a self-portrait. A contour figure with head and eye divides the left half of the picture from the right. In the narrower left-hand part, a stick figure, dog, tree, and other elements, painted in a signlike shorthand, are crowded together "outside" the figure as images of the external world. The dominant color of this left side is a dull brown. In the right field "inside" the figure—that is, within the creative realm of imagining or "intention"—a dynamic play of nonobjective signs takes place over a lively, flesh-colored ground.

Fate prescribes different paths for the inwardly turned romantic: he either runs tragically aground on the rocks of external reality as a visionary individualist, or he tries to find a balance between poles as a humorist. Klee chose to look at reality with the abstracting help of humor, satire, and irony.

In this respect he has a good deal in common with Jean Paul, who was a peripheral, individualistic figure from the period of German Romanticism. Both turned their eyes toward infinity, but without losing touch with the ground under their feet. Both were aware of the abyss their romantic longing opened up before them and protected themselves against loss of balance by distancing themselves from this world, yet without losing sight of it. Both were possessed of a meticulous sense of order, cataloging their poetic ideas in almost a bureaucratic fashion— Klee, in his oeuvre catalogue; Jean Paul, with a box full of slips of paper. Their detachment from ordinary existence made them both fatalists and, to the extent that it was possible, farcical humorists. Jean Paul's comparison of the humorist with the ancient bird Merops, which flies backward—that is, with its tail pointed up— from the lower regions of this world in the direction of eternity, so that its gaze from the distance remains fastened on things below, surely applies to Klee.

Humor, satire, and caricature are at the very heart of romanticism and reach their culmination in the concept of "romantic irony." Although the term was already heatedly discussed by the Romantics and later was also a subject of much theoretical discussion, the concept remains slippery and ambiguous. Romantic irony can be defined as a form of self-knowledge. It presupposes a cool aloofness to external reality and the venture of individual intellectual freedom. The well-known definitions of romantic irony by Schlegel, Schelling, Tieck, and Novalis read like subtle descriptions of Klee's conception

73

Fig. 17. Paul Klee. *Intention (Vorhaben)*, 1938 / 126 (J 6). Colored paste on newspaper on burlap, 29½ × 44 in. (75 × 112 cm). Kunstmuseum Bern, Paul Klee Stiftung

of being as free as possible "in the here and now" without losing sight of either the real or the ideal.[15] It is curious that in the entire literature on Klee, scarcely anyone has seriously attempted to define his humor, his satire, and his irony. Yet his art is completely unthinkable without them. Grotesquerie, farce, comedy, playfulness, and the wittily unfathomable—these are the perspectives through which Klee relativized not only the external world but himself and his own activity.

Caricature as a medium is especially suited to the formal representation of distanced reflections on reality. It is one of the most important sources of Klee's art, and he directed all his intellectual and creative talent toward shaping its compositional principles into a style of his own. Klee's form of pictorial thinking could not have been achieved without the particular combination of visual and linguistic elements caricature encompassed, image and caption. As a further attraction, caricature was an altogether unacademic genre, the special quality of which—from Hogarth and Goya to Daumier and the illustrations in *Simplicissimus*—lay in the experimentation it allowed with markedly individual styles of drawing. Klee raised caricature to a broader, higher level of artistic expression by freeing it from its bondage to a momentary theme and by giving limitless extension to its pictorial possibilities. Not only his drawings but many of his paintings as well can be interpreted as subtle caricatures. Thus his *Revolution of the Viaduct* (1937; fig. 18), with its headless architectural forms constructed according to geometric rules, unmistakably caricatures mass movements, which Klee comments on without allowing his playful expression to spill over into pathos.[16] In *Everything Comes Running After!* (1940; fig. 19), painted shortly before his death, Klee depicts in a caricatural manner like that of *Revolution of the Viaduct* the constraint placed on the in-

wardly turned individual by external things. The "here and now," tripping along on little legs, pursues the figure, which has escaped to the right edge of the picture and tries to defend itself against the onslaught with an exclamation point. In works such as these Klee succeeds, with self-irony, in reaching the highest plateau of expression in the medium of caricature. During his school years, long before his etched Inventions, he had already covered the pages of his books and notebooks from edge to edge with grotesque physiognomies and witty commentaries (fig. 20). Together with his childhood drawings (p. 114), these caricatures contain the first important traces of his late style.[17]

Let us once more call to mind the image of the humorist as the strange bird Merops soaring high above, this time reversing the direction of his gaze 180 degrees. Only the direction has changed, and with the limits of ordinary reality vanished from his sight, his gaze is free to peruse the limitless expanse of infinity. This elevated view of things corresponds, in the realm of artistic creation, to Klee's concept of "abstraction." When he looks to the beyond, his abstract procedures give rise, on the one hand, to his nonobjective signs, layers of color, and compositions with squares (fig. 21). When he looks at the things of this world, on the other hand, his pictorial language remains largely figural (fig. 22). The fact that after 1912–13 Klee's figures were all transformed into stick figures, puppets, or schematic signs is by no means due to a mere aesthetic play with forms. Behind all those beings frozen into marionettes lies Klee's fatalistic conviction that with our human impotence (fig. 22) we are unconditionally subject to the laws of a higher, cosmically creative force. Even in his use of pictorial means, Klee was shifting his glance in opposite directions. Color for him tends to represent the "abstract," otherworldly side of his vision (fig. 21), whereas drawing is the means of coming to terms with the

Fig. 18. Paul Klee. *Revolution of the Viaduct (Revolution des Viaduktes)*, 1937 / 153 (R 13). Oil on canvas, 23⅝ × 19⅝ in. (60 × 50 cm). Kunsthalle, Hamburg, West Germany

anecdotal, all-too-human lower levels of this world.

"I am most devout when I am furthest away. In this world sometimes a little malicious about the misfortunes of others. These are merely nuances." Devoutness or maliciousness, longing to go "over there" or romantic irony, abstraction and color, or figural ciphers and drawing; essen-

tially the expressive qualities of these poles are distinguished for Klee only by a shift of view between the distance and the here and now. Figures such as *Angel, Still Female* (fig. 6), which look up with one eye and down with the other, dwell in Klee's own elevated domain, where alone it is possible to look in these opposing directions.

Fig. 19. Paul Klee. *Everything Comes Running After! (Alles läuft nach!)*, 1940 / 325 (G 5). Brush and black paste over colored-paste ground on paper, mounted on cardboard, 12½ × 16⅝ in. (32 × 42.4 cm). Kunstmuseum Bern, Paul Klee Stiftung

Fig. 20. Paul Klee. Caricatures in analytical-geometry notebook, 1898. Pen and India ink and pencil, 9 × 7¼ in. (23 × 18.5 cm). Collection Felix Klee, Bern

The tense polar relationship between the levels of the here and now and the beyond serves as a philosophical system determining Klee's entire pictorial thought and creation. From his youth he had as a matter of course defined appearances, in both art and life, in terms of polar opposites. In 1902, shortly after his return from Rome, he set down a scheme in his diaries that with some variation, though without essential change in perspective, would serve as the framework for his view of the world until the end of his life. The poles of the "here and now" and the transcendent were further ordered into the following pairs of antithetical concepts:

Antiquity	Christianity
Physicality	Psyche
Objective vision	Subjective vision
Worldly orientation	Spiritual orientation
Architectonic emphasis	Musical emphasis

He placed himself questioningly as the unifying median between both poles: "The third thing is to be a modest and uninformed student of the self, a tiny 'I.'"[18]

Later he added other concepts to these opposing pairs, the most important of them being statics in the terrestrial realm and dynamics as the creative expression of the transcendental. The stylistic concepts of classicism and romanticism can also be incorporated into this system as opposing artistic positions. In his Jena lecture of 1924, Klee gave a detailed description of how, in his opinion, the "static and dynamic parts of a pictorial mechanism" correspond "very nicely to the classical-romantic antithesis."[19]

Klee's own definition of his style as "cool romanticism," a romanticism taking account of reality and therefore unemotional, tells us no more than that he was trying to establish a balance for himself between these—for him—very real antitheses, knowing that a markedly dynamic—that is, plainly subjective—romanticism directed toward the beyond, and musically and intellectually ordered, could only be realized if it also included, searchingly and with awareness, its opposite number.

Klee's romantic way of thinking in polarities is distinguished by his refusal to favor one over the other. He saw the oppositions as parts of an all-embracing totality, as cooperating to form the source of all creative dynamics. Accordingly, notions such as "good" and "bad" had no moral value for him but were defined as equivalent "forces working together to create the whole."[20] It is not difficult to show direct connections between this concept and the ideas of the Romantics, for whom God was "a way of life, not merely a state of being," and who therefore believed that "an essence, namely God, must necessarily live in the bad as well as in the good."[21] Obviously, the knowledge that opposites are intimately related was not newly discovered by the Romantics. In the Taoistic princi-

Fig. 21. Paul Klee. *Fire at Evening (Feuer Abends)*, 1929 / 95 (S 5). Oil on cardboard, 13⅜ × 13¾ in. (34 × 35 cm). The Museum of Modern Art, New York, Mr. and Mrs. Joachim Jean Aberbach Fund

Fig. 22. Paul Klee. *Human Impotence (Menschliche Ohnmacht)*, 1913 / 35. Pen and India ink on paper, 7 × 3½ in. (17.8 × 9.9 cm). Kunstmuseum Bern, Paul Klee Stiftung

ple of yin and yang, the opposition between heaven and earth, light and dark, sun and shade, male and female, strong and weak, good and evil, and other entities is already conceived not as any kind of dualism but as an explicit pairing in which an implicit unity is constantly manifest.

We know that for Klee, too, artistic form resulted from the creative process of revealing the inner laws of nature; hence he called art a "parable of creation." This means that he sought not only to analyze the laws of pictorial form in his theoretical writings but to work out their inner relationships as parables for the outer forms of nature. To give an example, Klee conceived the interrelationship of statics and dynamics as the basis not only of everything existing in nature between birth and death but also of pictorial form. Thus it is that "art makes visible" the creative laws hidden behind external appearances. Polarity is Klee's key for deciphering the inner relationships between living reality and the parabolical work of art.

Despite Klee's extreme individualism, all of his work reflects an attempt to reveal the relationships between the creative, formative impulses of art and those of life, and to direct the attention of the viewer from the individual to the universal, from the particular to the archetypical. Although allusions to, and commentary on, the incomprehensible—the transcendent—constitute an essential part of his art, Klee never went so far as to make conjectures not derived from tangible reality. Characteristically, even his angels remain joined to life, beings who owe their identities to the links with their former existence. We can only obtain some notion of the full meaning of incorporeality, the void, nothingness, from our concrete impressions and experiences, as when we see for ourselves how the empty space inside a barrel—that is, the "nonexistent"—makes the object into a container and thus into something usable.

Klee, with his concept of polarity and the indissoluble bond between art and reality, was not the only late romantic among twentieth-century artists. The work of Joseph Beuys was also based on a pervasive way of thinking in

Fig. 23a. Joseph Beuys (1921–1986). *Vacuum ↔ Mass*, October 14, 1968. Action: Making of an iron chest in shape of a cubic half-cross containing 220 lb (100 kg) of fat and 100 bicycle pumps, and the showing of 20-min. segment of film *Eurasia Staff*. The action took place between 6 P.M. and midnight at Art Intermedia, Cologne.

The action addresses the question of harmonizing universal opposites. *Eurasia Staff* represents the search for a resolution of the tension between East and West, a closing of the "circle that connects Europe and Asia and puts an end to the opposition, the polarity of cultures and political systems." The bicycle pumps and fat symbolize, respectively, the positive and negative poles; they are united in a box in the form of a cubic half-cross.

Fig.23b. Joseph Beuys. *Freedom, Democracy, Socialism*, 1974. Blackboard

polarities (fig. 23), and reveals how deeply rooted Romanticism is even today in the culture of German-speaking countries. In fact Beuys drew upon the tradition and philosophy of the Romantics even more explicitly than did Klee.[22] Like Klee, he saw art as a genesis, as the making visible of a dynamic process. His idea of an all-powerful creative movement in life and in art was realized for him in the polar opposites of warm and cold, liquid and solid, active and passive, vacuum and mass, chaos and form. For Beuys, art and life were even more seamlessly—and above all more actively—knit together than they were for Klee. He never stopped arguing—against all elitist claims—for art as an integrated, comprehensible part of life. Everyone was thus an artist for Beuys. His environments, sculptures, drawings, and his many paintings covered with writing are nothing else than the energy of thought translated into form. He was a romantic utopian of the purest kind.

But the fundamental difference between Klee and Beuys, manifest in their contrasting social and political feelings and actions, is just as interesting. As early as 1921, Wilhelm Hausenstein noted in his monograph on Klee:

The idea that politics and society were a world unto themselves, or the basis for everything else, was foreign to him; indeed, antithetical. . . . Moreover, the collective was set in opposition to the personal: the personal as nothing less than the readiness to indulge in every excess of subjectivity, the personal as a despairing and thus arrogant individuality. All standards of measurement began beyond the community.[23]

In contrast with Klee, Beuys always tried to break down the barriers of exclusive individualism in his political action as an artist. In this he clearly resembles the artist whom Ludwig Marcuse, drawing on comparable examples from the nineteenth century, defined in his essay "Reaktionäre und progressive Romantik" as a progressive romantic.[24]

It is clear that in this respect Klee was not exactly a representative among the artists of his generation of a revolutionary avant-garde. The protective framework of middle-class family life gave him an important social reserve. A biting caricature of the young Klee family, made in Munich in 1908 by his friend Ernst Sonderegger (fig. 24),[25] is exceeded in its directness only by Klee's own caricatures of his wife Lily (figs. 25, 26). The Sonderegger image speaks for itself. Klee, strutting about arm in arm with his sturdy wife of two years, striking a pose with his chest out, utterly preoccupied with himself and his status as an up-and-coming bourgeois artist, asks his friend: "Well now—are you drawing much from nature?" Still, it was Sonderegger who wrote the following sincere and admiring remark to Klee in 1931: "Scarcely anyone can equal you in the way you have gained such a firm foothold in the transcendental, as if you were standing on the most solid tradition."[26]

At this point the question forces itself upon us: whether Klee's single-minded attempts to be "not at all comprehensible in this world" were not related to deep-seated repressions and an artful method of sublimating his suppressed erotic and sexual fantasies? In a diary entry of

Fig. 24. Ernst Sonderegger (1882–1956). *Well now—are you drawing much from nature?* 1908. Caricature of Paul Klee and family. Pen and India ink and watercolor on paper, 9½ × 7¾ in. (24 × 19.7 cm). Private collection, Bern

Fig. 25. Paul Klee. *Portrait of Lily*, 1908 / 59. Pencil on paper, 8⅝ × 7 in. (22 × 18 cm). Whereabouts unknown

Fig. 26. Paul Klee. *Caricature of a Young Woman, in Simple Contour (Karikatur einer jungen Frau, einfachste Konturen)*, 1908 / 40. Pencil on paper, 4⅛ × 4⅛ in. (10.5 × 10.4 cm). Kunstmuseum Bern, Paul Klee Stiftung

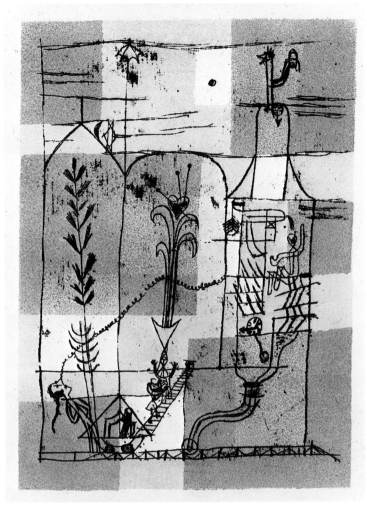

Fig. 27. Paul Klee. *Hoffmannesque Scene (Hoffmanneske Szene)*, 1921 / 123. Color lithograph, 11⅛ × 8½ in. (28.3 × 21.6 cm)

1915, he himself made this connection:

The outward conduct of an artist may reveal much about the character of his work. My schoolmate Haller loved life so passionately that he practically hunted for shattering experiences for fear of missing out on something. . . . I used to lead a restless life, until I found a natural base that allowed me to turn away from that kind of existence. We both married; he needed to put the emphasis on "beauty" and in so doing overlooked other, more important things. The result was that his marriage grew shaky. He wouldn't stop chasing after shattering experiences. The consequences for his artistic work could only be negative. . . . In contrast to him, then, I had become a kind of monk, a monk with a naturally broad base that could accommodate all natural functions. I regarded marriage as a sexual cure. My romantic inclinations were fed by the mystery of sexuality. I found that monogamy included this mystery, and that was enough.[27]

Is not Klee in his own words explaining his romantic desire as a consequence of his monastic abstinence? And was his early renunciation of the vital fulfillment of his sexuality what he meant by his so-called inner war, to which he appealed in 1914 as the reason why the actual war was of no real concern to him? In 1915 he noted thoughtfully in his diary: "Must I never lead anything but an inner life; must I forever walk along in a well-behaved, average manner?"[28]

One cannot speak of Klee as a romantic without at least touching upon the subject of music.

Even in his daily life, music was for Klee a necessary element of his well-being. That his wife was a trained pianist and that he himself regularly played music with friends until the end of his life had a decisive influence on his romantic attitude toward life, as well as on his understanding of art. Music was a reliable means for gaining access to realms of feeling, and it provided him with a measure for exploring the rules of composition and the precision of execution involved in the creation of a work of art.

There is no question in my mind that Klee arrived at his profound understanding of romanticism fundamentally by way of his musicality and his knowledge and love of music, from Bach, Mozart, and Schubert to Wagner and Offenbach. Using Beethoven's Fifth Symphony as his example, E.T.A. Hoffmann described music as "the most romantic of all the arts—one might almost say the only *purely* romantic one"; and for Jean Paul romantic expression culminated in tone and timbre, which were "beauty without limits."[29] The ideals of romanticism are more obviously embodied in music than in any other artistic genre. For the content of music is unrestricted, its expression is directed entirely toward feeling, and its dynamics are without weight. As a result, music was not only a decisive source of inspiration for Klee all his life but could "often be a comfort when necessary."[30] Important though the stimuli of painting, poetry, or

79

Fig. 28. Paul Klee. *Woe is me in the stormy wind of eternally fleeing time*, 1912 / 131. Pen and India ink on paper, 1⅝ × 7¼ in. (4.1 × 18.4 cm). Kunstmuseum Bern, Paul Klee Stiftung

past and present philosophy undoubtedly were, the final standard of perfection in art for Klee was music. Besides, no academic aftertaste clung to its inspiration.

Daily involvement with music and the resulting attempt to turn musical experience and knowledge to artistic account led empirically to romanticism in Klee's feeling, thought, and artistic creation, even without his having to immerse himself in Romantic painting, poetry, or philosophy. It is characteristic that he discovered the great German Romantic poet E.T.A. Hoffmann by way of *Tales of Hoffmann*, the work of the highly gifted operetta composer, Jacques Offenbach. The lithograph *Hoffmannesque Scene* (1921; fig. 27)—a farcical paraphrase of Hoffmann's poetic tales, the basis for Offenbach's opera libretto—is one of the few direct quotations of Romanticism in Klee's work.[31]

No one has recognized and defined the influence of music on Klee's artistic development and on his romantic idealism more clearly than Wilhelm Hausenstein in his early monograph on the artist: "It is precisely in the imperturbability of the person that its origin lies; in the shutting out of influences; in the deflection of tradition and community; in the completeness of isolation. . . . It is music that joined the painter-draftsman Klee and his idealism—this word is both permissible and essential—to tradition. Others derived what was traditional in their painting from painting."[32] This "deflection of community," this search for the "completeness of isolation," also had social consequences, of course, which in Klee's case were expressed as much in his ironically reflected flight into the bourgeois idyll as in his wanderings on the edge of the abyss of madness.

The swing back and forth between reserve and madness constitutes yet another topos of Romanticism and the history of its interpretation. After all, no less a figure than Goethe stated: "I call the classical healthy, the romantic sick," and in this context went so far as to set the notions "strong, fresh, joyous and healthy" in opposition to "weak, sickly and sick."[33] In the final analysis, such utterances always imply a deep personal dismay. The fact that the National Socialists in Germany used similar criteria when they denigrated Klee as a "degenerate artist" speaks for the sincerity of his romantic attitude. He never made a secret of his personal weaknesses, his loneliness, his fears, and his illusions. In a tiny drawing of 1912 (fig. 28), Klee added the following poem—which can also be taken as a

highly personal interpretation of Caspar David Friedrich's *Wanderer over a Sea of Fog*—to the caricature of a little stick figure with arms raised in complaint:

Woe is me in the stormy wind of eternally fleeing time
Woe is me alone ringed in by isolation
Woe is me far below on the icy ground of madness

Weh mir unter dem Sturmwind ewig fliehender Zeit
Weh mir in der Verlassenheit ringsum in der Mitte allein
Weh mir tief unten auf dem vereisten Grunde Wahn

In view of such perceptions, is not the argument that Klee's Romanticism is nothing but a "flight" from reality into a world of fantasy unnecessary? The consequence of his aloofness with respect to this world was a profound isolation. The result in his work, in contrast, was an inexhaustible wealth of inner movements and of transitions between the formal elements of artistic production and his conceptual statements. From the perspective of his "distant" point of view, in his shifts between contemplation of the here and now and longing for a transcendent existence freed from gravity, Klee created a romantic language of signs in which a circle is readily understood as a star and a reference to the cosmos, and a puppet or stick figure mirrors the whole complexity of human, earthly constraint. At the same time, the standard in Klee's inward contemplation of the object remains the given reality or the tangible idea.

Klee's vision of art as a metaphor of the Creation led him to the description of chaos and cosmos as two self-contained circular systems that approach each other and touch at some point in every process of formal creation. That point is defined by Klee as the basic element of all pictorial production, comparable to the seed from which all life grows. From the point, which is created when the pencil first touches the paper, there develops through movement a multiplicity of points; repetition and layering; lines, outlines, and surfaces; tonal gradations between black and white; and colors. In the process of giving form to art, the artist makes use of these realities as a Creator uses the laws of nature. Klee's visionary recreation of reality is finally not so very different from that of his great Bernese contemporary Adolf Wölfli, who produced his monumental pictorial, poetic, and musical work in the total isolation of a mental institution. With spontaneity and deliberation at once, Klee created a new world from within in which the outside world was mirrored.

Notes

TRANSLATOR'S NOTE: The terms *Diesseits* and *Jenseits* (lit., "this side," "that side"; adj., *diesseitig, jenseitig*) have been variously translated in this essay, the former as "the here and now," "this world," and "the terrestrial," and the latter as "the beyond," "the transcendental," and "otherworldly." In German the terms are complementary in meaning and express a dialogue that is largely lost in English, since it is impossible to retain the parallelism of form. Klee's title of his 1922 watercolor *Wandbild aus dem Tempel der Sehnsucht ↖ dorthin ↗* has been translated in this essay as *Mural from the Temple of Longing ↖Over There↗*. The owner of the picture, reproduced in figure 3 and on p. 175, translates it as *Mural from the Temple of Longing ↖Thither↗*.

1. The concepts "romanticism" and "romantic" were already applied to Klee in the first publications on the artist by Wilhelm Hausenstein, Hans Wedderkop, and Leopold Zahn in the early twenties.

 Markedly greater weight was given to the subject in German publications after World War II, however. Will Grohmann (*Paul Klee* [Stuttgart, 1954], pp. 207, 334), in emphasizing Klee's relationship to romanticism, mainly cited Novalis. Werner Haftmann, in contrast (*Paul Klee: Wege bildnerischen Denkens* [Munich, 1950], pp. 125ff.), climaxed his analysis of Klee with a general reference to the importance of romanticism to our understanding of the artist. However, Haftmann did not go beyond drawing parallels between Klee's pictorial thinking and Goethe's morphology. Carola Giedion-Welcker (*Paul Klee* [Stuttgart, 1954], pp. 47ff.) was the first to comment generally on the relationship between Klee's pictorial language of symbols and similar conceptions in the work of the Romantics, especially Runge. Max Huggler (*Paul Klee: Die Malerei als Blick in den Kosmos* [Frauenfeld and Stuttgart, 1969], pp. 239ff.), like Grohmann, chiefly drew comparisons with the texts of Novalis, but he cast doubt on Grohmann's assertion that Klee was acquainted with Novalis's poetry and showed that, at most, he could have read the "Hymnen an die Nacht" late in life. Huggler claimed that, besides romanticism, there was "a classical component at work" in Klee, but did not give a more precise definition of this concept.

 Among the writings of younger authors, the most discriminating analysis of the correlation between Klee's motifs and those of the Romantics is Hans-Ulrich Schlumpf's, in his doctoral dissertation "Das Gestirn über der Stadt, Ein Motiv im Werk von Paul Klee" (Zürich, 1969–76). Restricting himself to the single—but central—theme of "heavenly bodies above the city," Schlumpf found numerous parallels between Klee's work and the texts of Goethe, Jean Paul, Tieck, Eichendorff, and Heine. Claude Roy (*Paul Klee aux sources de la peinture* [Paris, 1963], pp. 9ff.) compiled for French readers a brief survey of some of the essential features of German Romanticism from Klee's perspective. David Burnett ("Paul Klee: The Romantic Landscape," *Art Journal* [New York], vol. 36, no. 4 [Summer 1977], pp. 322–26) was the first scholar to concentrate exclusively on the subject of Klee and Romanticism. But neither his survey of Klee nor that of the "romantic" phenomenon adequately addresses specific connections between the two and as a result his energy is largely expended on general readings of pictures. Finally, Robert Rosenblum presents a broad and informative range of pictorial comparisons in *Modern Painting and the Northern Romantic Tradition* (New York and London, 1975). However

Rosenblum understandably devotes only a brief discussion to Paul Klee, and his emphasis is essentially on Klee's romantic visions of nature.

2. *Tagebücher von Paul Klee 1898–1918*, ed. Felix Klee (Cologne: DuMont Schauberg, 1957), no. 941 (1914), p. 314.

3. H. Börsch-Supan and K. W. Jähnig, *Caspar David Friedrich* (Munich, 1973), pp. 250, 260. See also the exhibition catalog *C. D. Friedrich*, Kunsthalle Hamburg, 1974, no. 135, p. 218.

4. In facsimile edition of Klee's lecture notes, see note for April 3, 1922, in *Paul Klee: Beiträge zur bildnerischen Formlehre*, ed. Jürgen Glaesemer (Basel and Stuttgart, 1979), pp. 127, 128.

5. The watercolor was purchased soon after its completion by one of the most important contemporary collectors of Klee's work, Otto Ralfs of Braunschweig, Germany. Klee wrote the note on the occasion of a visit to Ralfs, "when I saw one of my watercolors again," as he noted at the bottom.

6. An English translation of Kleist's essay appears in Merle Armitage, ed., *5 Essays on Klee* (New York, 1950), pp. 63–81.

7. The play of meanings is carried so far in the picture that Klee even distinguishes in his linear figurations between different kinds of pendular movements. Horizontal crossbars create various linear, meandering patterns. Some are linked in an endlessly circling movement; others have cords with endings like small pendulum weights, either both pointing down or one up and one down.

8. The psychological mechanisms of Klee's "distancing" himself ("Diesseitig bin ich garnicht fassbar") were formulated by Sigmund Freud in his essay "Das Unbehagen in der Kultur" (1930), published in English as "Civilization and Its Discontents": "Another technique for fending off suffering is the employment of the displacements of libido which our mental apparatus permits. . . . The task here is that of shifting the instinctual aims in such a way that they cannot come up against frustration from the external world. In this, sublimation of the instincts lends its assistance. One gains the most if one can sufficiently heighten the yield of pleasure from the sources of psychical and intellectual work. When that is so, fate can do little against one. A satisfaction of this kind, such as an artist's joy in creating, in giving his phantasies body, or a scientist's in solving problems or discovering truths, has a special quality which we shall certainly one day be able to characterize in metapsychological terms. At present we can only say figuratively that such satisfactions seem 'finer and higher.' But their intensity is mild as compared with that derived from the sating of crude and primary instinctual impulses; it does not convulse our physical being. And the weak point of this method is that it is not applicable generally: it is accessible to only a few people. It presupposes the possession of special dispositions and gifts which are far from being common to any practical degree. And even to the few who do possess them, this method cannot give complete protection from suffering. It creates no impenetrable armour against the arrows of fortune, and it habitually fails when the source of suffering is a person's own body." Quoted in *The Complete Psychological Works of Sigmund Freud*, vol. 21 (London, 1961), pp. 79–80.

9. For a fuller definition of the historical connections and forms of artistic expression of German Romanticism in the decisive period around 1800, see Jürgen Glaesemer, "Traum und Wahrheit, Ueberlegungen zur Romantik am Material einer Ausstellung," in *Traum und Wahrheit, Deutsche Romantik aus den Museen der DDR* (Bern and Stuttgart, 1985), pp. 12–28.

10. Ich sank dahin
 In die Arme dem fiebernden Traum,
 Ich küsste dich
 Dort unten am Weidenbaum.

Wild war mein Kuss,
Und wie's in den Schläfen mir schlug!
Hoch drüber ging
Ein stürmender Wolkenzug.

Nächtliche Sonn'
Wann hätt ich geahnt solch Glück!
Elisabeth!
Dir soll es gelten dies Stück.

From Klee's letter to Hans Bloesch, Munich, March 1, 1899; Bloesch family archives, Winterthur.

11. *Tagebücher*, p. 133, no. 429 (1902).

12. *Ibid.*, pp. 172–73, no. 585 (1905).

13. "Paul Klee: Wege des Naturstudiums: Staatliches Bauhaus Weimar/München 1923," in *The Thinking Eye: The Notebooks of Paul Klee*, ed. Jürg Spiller (New York, 1961), pp. 63–68.

14. Jean Paul, *Vorschule der Aesthetik*, 5th program, para. 23 (1804).

15. On this, see *inter alia* Wilhelm Schlegel, Lyceums-Fragment 108, Athenäums-Fragment 238; Novalis, Fragmente 30. On the definition of romantic irony, see Helmut Prang, *Die romantische Ironie* (Darmstadt, 1972).

16. As Klee intended, the picture is open to various interpretations. Is this revolution of toy forms a caricature of the National Socialist revolution in Germany of the thirties, or is it, as O. K. Werckmeister subtly tries to prove in his essay in this book, the cultural revolution of the avant-garde? We may in any case rule out the possibility that Klee was caricaturing his own artistic individuality with these mechanically striding, totally world-oriented forms.

17. Shortly after his marriage in 1906, Klee, then living in Munich, even tried to find work as a caricaturist for the Munich periodical *Simplicissimus*, but his style was said to be too eccentric (*Tagebücher*, p. 219, no. 779). Only once did he succeed in having a caricature accepted by a periodical: *Concert of the Parties* (1907 / 14), published in *Der grüne Heinrich*. This humorous journal folded after a year.

18. *Tagebücher*, p. 134, no. 430 (1902).

19. Klee, lecture delivered on the occasion of an exhibition at the Jena Kunstverein, January 26, 1924. In *The Thinking Eye*, p. 92.

20. See, "Paul Klee, Creative Credo, Berlin 1920," in *The Thinking Eye*, p. 79.

21. F. W. J. Schelling, *Ueber das Wesen der menschlichen Freiheit* (1809), pp. 370–71.

22. See also Theodora Vischer, *Beuys und die Romantik* (Cologne, 1983).

23. Wilhelm Hausenstein, *Kairuan, oder eine Geschichte vom Maler Klee und von der Kunst dieses Zeitalters* (Munich, 1921), pp. 49, 50.

24. Ludwig Marcuse, "Reaktionäre und progressive Romantik," in *Begriffsbestimmung der Romantik*, ed. Helmut Prang (Darmstadt, 1968), pp. 377–85.

25. Ernst Sonderegger (1882–1956), a friend of Klee's youth, had a fund of literary knowledge that was an important inspiration for Klee during his years in Munich between 1906 and 1910. Sonderegger, an artist (primarily a draftsman and illustrator), never became successful.

26. Ernst Sonderegger in a letter to Paul Klee (La Frette, December 16, 1931); Kunstmuseum Bern, Paul Klee Stiftung.

27. *Tagebücher*, pp. 319–20, no. 958 (1915).

28. *Ibid.*, p. 324, no. 963 (1915).

29. E. T. A. Hoffmann, *Werke in 15 Bänden*, vol. 14 (Berlin, 1912), pp. 40–43; Jean Paul, *Kleine Nachschule der Vorschule der Aesthetik*, 5th program, para. 7.

30. *Tagebücher*, p. 134, no. 429 (1902).

31. Jürgen Glaesemer, "Paul Klee et Jacques Offenbach," in *Klee et la musique* (Paris, 1985), pp. 169ff.

32. Hausenstein, p. 107.

33. Johann Peter Eckermann, *Gespräche mit Goethe* (April 2, 1829).

KLEE IN AMERICA

CAROLYN LANCHNER

Paul Klee traveled little and almost certainly never considered going to America. But, as Wassily Kandinsky wrote in his 1936 birthday message to Klee: "Your art is going from country to country and over big ponds."[1] Kandinsky wrote these words as the tide of German history was accelerating the dispersal of Klee's "degenerate art" and depositing much of it on American shores. Klee's exiled art considerably enriched public and private collections in the United States, but the Nazi dictator was far from the first agent of contact between Klee and America.

Klee's American debut was modest, achieved by means of a 1911 watercolor, *House by the Brook*, published in Arthur Jerome Eddy's book *Cubists and Post-Impressionism* in the same year as the outbreak of World War I.[2] During the succeeding conflict, little European and still less German art reached America. Throughout the twenties, however, and into the next two decades, the advanced art of Europe was the most potent force on the American art scene. The influence of Picasso and the School of Paris was almost numbingly powerful, whereas Klee's art, increasingly visible during those years, was more insidious, exerting a pressure that would prove in its way as fructifying to American painting as the more obvious seductions of the Spanish master.

Acknowledged by a wide variety of commentators both in America and Europe, Klee's importance to the development of twentieth-century art, and by extension, to Post World War II American painting, has hardly gone unrecognized. An appreciation of the more profound aspects of Klee's art, as opposed to its evident popular appeal, was long the property of an elite group of amateurs, critics, and scholars, but by 1949 the situation would seem to have changed, as reflected in a review of the Klee exhibition at The Museum of Modern Art of that year: "Klee's influence has been tremendous on contemporary American art. [The exhibition] is not only a memorial to a modern master, but also to one of our adopted ancestors."[3] Yet Klee's art has remained almost an "outsider art," in what Hannah Arendt called "the lot of the unclassifiable." This is particularly true in the United States, where accounts of the New York School give a peculiar kind of short shrift to Klee, often ascribing to him mainstream importance yet withholding further commentary or confining his contribution to one of spirit.[4]

There is some reason for this near-cavalier treatment. The relevance of Klee's work to American art is far more difficult to localize than is that of Pablo Picasso, Joan Miró, or Kandinsky; nor can it be categorized within any larger movement. Yet the presence of Klee in America has a long and extensive history, and an examination of that history should reveal the ways in which his art came to be important to midcentury American painting.

The 1914 book in which Klee made his unassuming debut was dedicated "TO THAT SPIRIT, the beating of whose restless wings is heard in every land." Written with considerable knowledge of developments in European art, and, as Eddy said, out of the "ferment" of its times, the book was addressed to the sensibilities of a specifically American audience. For all Eddy's ethereal rhetoric, he aimed his conversion tactics at making art seem a challenge to the virile imagination like any other in "religion, science, politics and business." When he remarked that the 1913 Armory Show was just as inevitable as the Progressive party political convention of 1912 in Chicago, he was right on target.[5] The Bull Moose Teddy Roosevelt himself, despite his intense dislike of the European art he saw at the Armory Show, had nonetheless allowed: "There was not a touch of simpering self-satisfied conventionality . . . no stunting or dwarfing, no requirement that a man whose gifts lay in new directions should measure up or down to stereotyped and fossilized standards."[6]

Implicit in Roosevelt's remarks was a call for a native American art that could stand foot to foot with its European counterparts, and a cor-

Fig. 1. Paul Klee (1879–1940). *Hero with the Wing* (*Held mit dem Flügel*), 1905 / 38. Etching, 10 × 6¼ in. (25.4 × 15.9 cm). The Museum of Modern Art, New York, Purchase Fund

ollary assumption that the conquering of new territory for art was a suitable endeavor for individual enterprise. But in fact there was virtually no tradition in American society that conferred useful cultural value on art or its practitioners. In Europe, however, despite the tendency from the mid-nineteenth century on for art to swing ever looser on its societal moorings, it was deeply embedded in the culture.

Eddy's book, with its invocation to the spirit whose wings beat in every land, sought to arouse in the consciousness of his American readers an appreciation of the artist as hero. On the first page, Eddy cast the artist as confronting the quintessential dilemma of humanity: "As man in his loftiest flight stretches forth his hand to seize a star he drops back to earth. Perfection is unattainable." Eddy's Icaruslike image of the artist could well have been illustrated by *Hero with the Wing* (1905; fig. 1), one of the prints from Paul Klee's Invention series, the earliest suite of works in his oeuvre. The hero depicted is a pathetic figure, "tragicomic" in Klee's words—his left side earthbound, his right equipped for flight. Klee described his hero in his diary: "Perhaps a Don Quixote of ancient times. . . . The man born with only one wing, in contrast with divine creatures, makes incessant efforts to fly. In doing so, he breaks his arm and leg but persists under the banner of his idea. The contrast between his statuelike, solemn attitude and his already ruined state need especially to be captured."[7] Typically, Klee saw the humor in the absurd plight of his hero, but it was nonetheless a bleak commentary on the condition of man. The unbridgeable distance between man's imaginative freedom and his effective ability to realize his aspirations was central to Klee's thinking and held important consequences for his art.

On one hand, it produced skepticism toward collective action or theory, and on the other, the conviction that the "ego was the only reliable element in the entire matter of creative art."[8]

Such a self-aware, protoexistential view of self was unusual for an artist early in this century. As art in Europe had for some sixty years been steadily distancing itself from the concerns and ideals of its surrounding culture, so also had it come to have more faith in its own potency. This was true to such a degree that most of the movements that came into being after the beginnings of Cubism were inspired at least in part by the belief that art could be a transforming force in the shaping of a new and better society. This belief persisted in "negative" form in Dada and Surrealism. Even the "positive" denigration of painting by the Bauhaus testified to a still unextinguished hope that the aims and ideals of art would converge with those of society. Although Klee was associated with the *Blaue Reiter*, was a professor at the Bauhaus, and was at least partially annexed by both Dada and Surrealism, he was never a true believer. There was for him no sustaining umbrella of faith in any codified system outside art as, for example, theosophy served Mondrian and Kandinsky. He was, as his writings and pictures amply prove, deeply inclined to mysticism, but it was a personalized, Goethean, organicist amalgam of his own devising.

The artist, Klee felt, should hold himself aloof from "the sticky mud of the world of appearances," and except for a brief and apparently peripheral involvement in the Munich 1919 *Räterrepublik*, Klee abjured commitment to outside causes, regulating his life in logical consequence of his 1906 observation: "Democracy with its semi-civilization sincerely cherishes junk. The artist's power should be spiritual. But the power of the majority is material. When these worlds meet occasionally, it is pure coincidence."[9]

Klee's enterprise as an artist was undertaken in acute predicament, in an intensely felt awareness of the dichotomy between material existence and inner spirit. His highest imperative was his instinct as an artist; yet, like his *Hero*, he was bound to the terrestrial. In 1925 he reiterated his conception of the "ultimate human tragedy: Man's mental ability to traverse the realms of the earth and the supernatural . . . in contrast to his physical weakness . . . half winged, half captive. Thought as the medium between earth and universe. The further the journey the more grievous the tragedy of needing to become movement and not yet being it . . . the recognition that where there is a beginning there is no infinity; comfort: a bit further than usual! than possible?"[10] In such a scheme, thrust becomes the essential; for the artist, the process of form-giving must therefore be more important than the completed form. Only in passionate quest could the artist, solitary in the universe, hope to come close to the "heart of creation," his art becoming the sensitized record of his search for what Merleau-Ponty called "the secret ciphers of movement." Klee never ceased expressing his belief that "the road to form,

Fig. 2. Paul Klee. *Kettledrummer (Paukenspieler)*, 1940 / 270 (L 10). Brush and colored paste on handmade paper, mounted on cardboard, 13⅝ × 8⅜ in. (34.6 × 21.2 cm). Kunstmuseum Bern, Paul Klee Stiftung

dictated as it is by some kind of inner or outer necessity, is more important than the end of the road. . . . Form therefore, must . . . never be taken as completion, as result, as an end, but rather as genesis, as becoming, as being, but form as appearance is an evil, dangerous phantom."[11]

Klee's own appearance seems to have been irritatingly deceptive—at least to one Frenchman, who in 1929, on seeing a photograph of the Bauhaus professor, reported: "This damned portrait looks like an American."[12] This outburst of Gallic disgust now reads with a pleasant savor of irony, for the metaphysics of Klee's art is extremely close to that of American Abstract Expressionism. As William Seitz wrote in his pioneering book on the New York School: "Klee's aesthetics are at the core of Abstract Expressionism's spirit characteristics."[13] Klee's early emphasis on art as becoming, his recognition that Gotthold Lessing was no longer of much use, that painting was to be temporal and active, and his somewhat Heideggerlike view of the artist as "thrown into the world," devoid of any truth outside his own being, brought him very near to the thinking of American artists of the early forties.

To the extent that belief can be chosen, Klee elected to see man as solitary in the universe. For the American artist of the early forties, the situation was different; an adequate myth no longer existed. At the beginning of the second, world-embracing war, options were largely closed on ideas that had offered hope in the earlier part of the century. This stark position put the artist where Klee had been—wrestling alone with the terrible example of original creation. The first generation of American Abstract Expressionists found as many pictorial responses to this problem as there were artists, and many of these responses had in some measure already been formulated by Klee. His tragicomic hero of 1905 had worn many masks over the course of the years, and one of his last appearances was in the *Kettledrummer* (1940; fig. 2), painted shortly before the death Klee knew was fast approaching finally came. *Kettledrummer*'s slashing, schematic rendering puts the artist-hero at a distant remove from his first static, carefully drawn appearance. In *Kettledrummer* the shape of the thought becomes the shape of the image in a tautology of form and content that would not be seen again until the late forties in American gestural painting.

The heroism of Klee's 1905 figure and of his *Kettledrummer* is also the heroism of Barnett Newman's "First Man," who was of necessity an artist, his "first expression . . . a poetic outcry . . . of awe and anger at his tragic state, at his own self-awareness and at his own helplessness before the void,"[14] as it was also that of Clyfford Still's upright man alone on the prairie. De Kooning, who expressed the opinion that "art . . . is the forever mute part you can talk about forever," and might well consider Klee's Teutonic mysticism as a milder form of Kandinsky's "middle-European Buddhism,"[15] put the matter another way: "The attitude that nature is chaotic and that the artist puts order into it is a very

absurd point of view. . . . All that we can hope for is to put some order into ourselves. When a man ploughs his field at the right time, it means just that. Insofar as we understand the universe—if it can be understood—our doings must have some desire for order in them; but from the point of view of the universe, they must be very grotesque."[16]

In contrast with the "artistic order of rest" advocated by Ingres, Klee expressed his ordering desires by saying: "I should like to create an order out of feeling and going still further, out of motion."[17] He continued: "I begin logically with chaos . . . because at the start I may myself be chaos."[18] This interior chaos paralleled, Klee believed, "a mythical primal condition of the world from which the ordered cosmos gradually, or suddenly, takes shape by itself or by the act of a creator."[19] Consequently, he based his artistic method on the intensive study of natural laws; the nearer he could come to the formative principles of cosmic ordering, the closer he could come to emulating those principles in his own art. During his years at the Bauhaus, Klee formulated a theoretical structure for the dynamics of painting equaled, perhaps, only by the investigations of Leonardo. His analyses were in no sense meant as law but rather as working means, necessary because he could not, as he said, "deal in one blow with an entirety."[20] Klee's ambitious dream, expressed in a lecture at Jena in 1924, was for "a work of really great breadth, ranging through the whole region of element, object, meaning and style."[21] In his lifelong pursuit of that goal, Klee produced an oeuvre of great expressive power and dazzling formal invention. So varied were his experiments in pictorial form that his work, as Harold Rosenberg pointed out, "calls to mind contemporary painters and art movements seemingly irreconcilable with one another: Hans Hofmann and Dubuffet, Saul Steinberg, Baziotes and Anuszkiewicz and Ferren, Gottlieb, Franz Kline, Pollock, Op and Pop."[22] This immensely diverse work, turned through every gear of modernist pictorial expression, became a significant presence on the American art scene during the twenties.

New and seemingly radical art had been championed during the second decade of the century by such people as Eddy, Willard Huntington Wright, and above all, by Alfred Stieglitz, but to little overall effect. By 1920 Americans still regarded Cubism and all the other "isms" of modernist expression as at best a transient fad and at worst a hoax. Mostly it just didn't matter. "Art," Stieglitz observed, "is the equivalent in American society to what the appendix is to the human body."[23] For those few to whom it did matter, the propagation of advanced painting and sculpture became missionary work. Throughout the twenties Klee's art was brought before the public as part of the new gospel.

The cause of modernism had no more impassioned nor idealistic crusader than Katherine Dreier, who, with Marcel Duchamp, founded the Société Anonyme in 1920. The Société, which Dreier parenthetically subtitled "The Museum of Modern Art," was founded, according to the

typewritten fliers it distributed, "to provide a public non-commercial center for the study and promotion of MODERN ART." Dreier's taste was eclectic, her energy enormous, her manner didactic, and her faith in the modern movement as a moral, cultural, and social force absolute. Despite the association with the Société of such influential critics and collectors as Henry McBride, Christian Brinton, A. E. Gallatin, and Walter Arensberg, it received virtually no support outside of Dreier herself. It was she who kept the Société afloat against the tide of the times, and made advanced European art available to those who would take the trouble.

Dreier first showed Klee's work in a group exhibition in the early spring of 1921 and again in the winter of 1923.[24] Between these dates, in October of 1922, Dreier had visited both Klee and Kandinsky at the Bauhaus, buying works from them and making plans for one-artist shows for each. Kandinsky's was held in 1923 under the Société's auspices at Vassar College, and Klee's opened in January 1924 in newly rented galleries in the Heckscher Building on Fifty-seventh Street, New York City. The singularity of Klee's art seems to have been apparent even at this early date. Henry McBride advised his readers in the *New York Sun* that they would find in the new quarters of the Société Anonyme "a most entrancing exhibition of that strange meteor from Switzerland—Paul Klee— an isolated figure in art." Concluding McBride's review is an unacknowledged paraphrase from Dreier: "The charm of his color and the delicacy of his lines attract many to him. But what does he say? Ah, that is the question! Is it only something whimsical, or beneath the whimsicality is it something profound?"[25]

Dreier herself had had some time to ponder this leading question as she had been aware of Klee's work from at least the early fall of 1919, when she visited Herwarth Walden's Der Sturm gallery in Berlin. She then went to Cologne, where, much to the initial consternation of Max Ernst and Johannes Baargeld, she appeared uninvited at the Kunstverein to watch them install the *Bulletin D* exhibition, which included work by Klee. Ernst recalled that he and Baargeld were much peeved by the stubborn presence of this large, conventional-looking lady. They were, however, appeased when, insulting remarks having failed to drive her off, they directly asked her for an explanation, and she replied that not only was she very interested in the work they were hanging, but it would also be of interest to her friend Marcel Duchamp—indeed she would like to arrange for the shipment of the entire exhibition to America.[26] Apparently because of difficulties caused by United States Customs, she was unable to realize the project.

Had history arranged otherwise, and however its larger course might have been altered by the event, it would probably not have been Duchamp's first glimpse of Klee. According to Duchamp's friend Henri-Pierre Roché, Duchamp was one of the earliest admirers of Klee and Kandinsky, whose work he had first seen during a summer spent in Munich in 1912.[27] In any event, Dreier and Duchamp were in close accord on most artistic issues, and it is reasonable to assume that the activities of the Société Anonyme on behalf of Klee reflected a shared enthusiasm. Dreier and Duchamp gave the collection of the Société to the Yale University Art Gallery in 1941, and when nine years later the university published a catalog of it, Duchamp wrote that Klee stood out "in contemporary painting as unrelated to anyone else. On the other hand his experiments over the last thirty years have been used by other artists as a basis for new developments in the different fields of art. . . . His extreme fecundity never shows signs of repetition as is generally the case."[28]

Duchamp and Dreier's 1924 Société Anonyme Klee exhibition was the earliest significant opportunity for Americans to take some measure of that fecundity, but it was not the only indication of nascent interest. William Valentiner, a German art historian who was to become director of the Detroit Institute of Arts in 1924, had visited Klee in Weimar in 1922 and had bought four watercolors from him. In the following year, Valentiner included Klee's work in the first exhibition of contemporary German art ever held in America. To whatever extent modernist art had established a beachhead in America, it was held by French forces, and Valentiner very much hoped to claim some of that territory through his German exhibition, which opened on October 1, 1923, in the Anderson Galleries, New York. He was apparently not dissatisfied with the results, writing in his diary: "The main goal has been accomplished, I believe. German art, which for forty years . . . has not been accepted but has, instead, been pushed aside by French art, has at last arrived in America and been judged favorably."[29] He went on to note that sales from the exhibition were good and several German dealers had been encouraged to start branch offices in New York. Although Klee sold at least one watercolor, more important to him in the long run was that J. B. Neumann, who had been exhibiting his work in Berlin since the teens, established a gallery in New York in February 1924. Although Neumann did not immediately agitate on Klee's behalf, he was to become one of Klee's most dedicated and effective advocates in America.

"Courage" to mount the German exhibition had been supplied, Valentiner wrote, by "the well-known lack of prejudice and the broad understanding of American friends of art."[30] Though only a small minority was concerned with art, Valentiner was not wrong in this assessment of American attitudes. Somewhat paradoxically, the lack of any official tradition of art allowed for a more liberal and generous disposition toward the new than generally prevailed in Europe, where antagonisms were much stronger. The time had come, Valentiner believed, for German art to receive its due in the United States. While that recognition came slowly, and has never quite caught up with the early lead of Cubism and the international art of Paris, the Swiss-German Klee along with the Russian-German Kandinsky became the principal standard-bearers of German art, and were increasingly seen as among the greatest inno-

Fig. 3. Paul Klee. *Suicide on the Bridge (Der Selbstmörder auf der Brücke)*, 1913 / 100. Pen on Ingres paper. Whereabouts unknown. Published in *Broom* (Berlin), February 1923

vators of modernism.

In the early twenties Kandinsky's art was more familiar to the English-speaking art world than Klee's, as it was relatively accessible through reproduction in publications in English. Klee's only exposure had been the watercolor illustrated by Eddy in 1914. In that book alone, Kandinsky was represented by four reproductions, two of which were in color. Given Klee's extended period of development and the fact that even in his own judgment he did not reach maturity as a painter until 1914, exactly the period of Kandinsky's freest most daring work, it is more surprising that a Klee was reproduced at all than that there was a disparity in the representation of the two artists. Klee's work would become more and more available in reproduction, but its first appearance after Eddy was not until 1923, when three drawings (along with five by George Grosz) were published in the Febru-

ary issue of the American left-wing intellectual magazine *Broom*, then being printed in Berlin. Reproduced along with Klee's and Grosz's work were "primitive" Indian drawings and those of the insane together with a commentary that remarked on their conceptual similarities.[31] Klee's drawings, including *Suicide on the Bridge* (1913; fig. 3), were all of the automatist character that was just then becoming important to two young painters in Paris, Joan Miró and André Masson.

The discovery of Klee's art by Miró and Masson was an event of real consequence to the development of American painting in the early forties. It is widely and justifiably recognized that the work of both artists was instrumental in the struggle of American art to free itself from the strictures of Cubist space, and furnished, as well, the most provocative example of the uses of automatism and biomorphism. Klee's art had

a similar liberating function for Masson and, more immediately and powerfully, for Miró.

Sometime in late 1922, as Masson recalls, he found a German book full of Klee reproductions in a stall along the Paris quays. It so excited him that he lost no time in showing it to his good friend Joan Miró, whose studio adjoined Masson's on the rue Blomet. Since Masson remembers that the book was published in Munich, it can only have been Wilhelm Hausenstein's *Kairuan, oder eine Geschichte vom Maler Klee und von der Kunst dieses Zeitalters*, brought out only the year before by the Kurt Wolff Verlag of Munich.[32] The illustrations of Klee's work were a marvelous discovery for the two impoverished young artists. It came at a time when Masson was desperately looking for a way out of "the terrorism of Cubism," and Miró was searching for a way to implement his threat to "break the Cubist guitar." The fortuitous find of Hausenstein's Klee book seems to have had an almost immediate impact on Miró's art.

It cannot, of course, be argued that Miró would not have been Miró if it were not for Klee, but the dramatic changes in Miró's art between 1922 and 1924, and the form and directions those changes took, powerfully argue for the fundamental importance of Klee to Miró. The sources any artist draws on are complex; and the greater the artist, the more finally frustrating are attempts to unravel them. Yet a comparison of the Klees Miró saw in reproduction with the immediately ensuing changes in his own work supports Miró's statement, as reported by Brassaï, that: "My encounter with Klee's work was the most important event in my life."[33]

What must have startled Miró as he first looked at Klee's images was their perversion of Cubist structure to accommodate romantic landscape and fantastic signs. At any rate, this is what surfaces most immediately in Miró's work; only slightly later did he pick up on Klee's calligraphic, nondescriptive line, and finally take Klee's hints to open up a new, "poetic" pictorial space.

The initial work to manifest Klee's influence was *The Tilled Field* (1923–24; fig. 4), where, for the first time, Miró gave free reign to wholly imaginary elements. Unlike the artist's earlier landscapes, which could be identified with familiar places such as his family farm at Montroig, this one describes a region much closer to that of Klee's *Zoo* (1918; fig. 5) or *Landscape with Dove* (1918; fig. 6), both found in Hausenstein's book. The eye in the landscape, prominent in the *Zoo* and long familiar in Klee's work, made its first of many appearances in Miró's oeuvre in *Tilled Field*, and the bird-arrow in the sky, the flags flying in opposite directions, even the diagonal thrust of the object at the left pushing out of a stylized fig tree, can be explained as extrapolations not only from the two paintings, but from the varied range of images provided Miró by Hausenstein.

It would not be surprising if Miró's first experiments with ideas received from Klee were based on *Zoo* and *Landscape with Dove*, as their evident Cubist structures would have made them more accessible than such freely composed

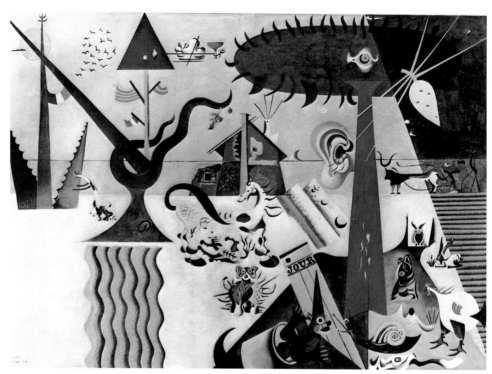

Fig. 4. Joan Miró (1893–1983). *The Tilled Field*, 1923–24. Oil on canvas, 26 × 36½ in. (66 × 92.7 cm). The Solomon R. Guggenheim Museum, New York

Fig. 5. Paul Klee. *Zoo (Tiergarten)*, 1918 / 42. Watercolor on plaster-primed wrapping paper, mounted on cardboard, 6¾ × 9⅛ in. (17.1 × 23.1 cm). Kunstmuseum Bern, Paul Klee Stiftung. Published in Wilhelm Hausenstein, *Kairuan* (Munich, 1921)

Fig. 6. Paul Klee. *Landscape with Dove (Bild mit der Taube)*, 1918 / 118. Watercolor, 7⅛ × 9⅝ in. (18 × 24.4 cm). Whereabouts unknown. Published in Wilhelm Hausenstein, *Kairuan* (Munich, 1921)

Fig. 7. Paul Klee. *Souvenir (Gedenkblatt),* n.d. Whereabouts unknown. Published in Wilhelm Hausenstein, *Kairuan* (Munich, 1921)

Fig. 8. Paul Klee. *Watercolors I and II (Aquarell I* and *Aquarell II),* n.d. Whereabouts unknown. Published in Wilhelm Hausenstein, *Kairuan* (Munich, 1921)

images (also in Hausenstein) as *Souvenir,* (fig. 7) and *Watercolors I* and *II* (fig. 8), which are much closer to Miró's mature style. Shortly after the *Tilled Field,* other Kleelike pictorial devices began to creep into *Mirómonde,* such as the frequent use of a dotted line to indicate movement, the appearance of numbers and letters that no longer refer to external reality as in Cubism but assume independent poetic weight, and an ordering of compositional elements that isolates and enlarges according to a wholly personal hierarchy.

Much later, both Hans Hofmann and Clement Greenberg were to remark on Klee's "high degree" of importance to Miró.[34] That importance does not lie in shared or similar iconography but rather in Miró's ability to assimilate Klee's liberated use of line and, perhaps above all, in Miró's absorption of Klee's solution to what he had identified as the artist's central problem: "how to enlarge space." No doubt remembering the days when Miró and he had stumbled upon Klee, Masson in his *Eulogy of Paul Klee* (1946) described Klee's space, and obliquely compared it with Cubist space by enlisting the words of another painter, Henri Michaux, who, "not without humor," said Masson, "wrote about the pictures of a school considered till now to be one of the most emancipated as regards servility to the visual, [saying] 'we know that you can't see more than ten feet into them.' With Paul Klee,

the exact contrary is the case, what he seeks is the unlimited . . . he wants to hold in check the reasonable horizon. The slight antenna of a scarab will suffice to measure the desert."[35]

Masson's sensitive reading of line as antenna and pictorial field as desert could well apply to Miró's *"Sourire de ma blonde"* (1924; fig. 9), the central motif of which strongly suggests a source in Klee's *The Eye of Eros* (1919; fig. 10), also featured in the Klee book Miró and Masson shared. In *"Sourire de ma blonde,"* line has become an independent, nonillusionist element that seems to generate itself as in *Souvenir* and many of the other illustrations in Hausenstein. The space of *"Sourire de ma blonde"* is, as in Klee, organic, weightless, and indeterminate. It is materially flatter than Cubist space, as there is less sensed differentiation between canvas surface and paint layer, and, at the same time, deeper in that it has become metaphysical, iconic with the painter's and the viewer's interior space, both sensuous and ideographic.

Although Miró had managed by the end of 1924 to see a few actual works by Klee, it is a nicety of historical irony that his initial, most telling encounter was through reproductions, just as later, in spite of not infrequent Klee and Miró exhibitions during the thirties, American artists found the most ready means of studying Miró and Klee to be through reproductions in magazines such as *Cahiers d'Art.* But even these

opportunities were relatively infrequent during the twenties. Miró, because he was working out of Paris and because of his Surrealist connections, may have had a name that was better known than Klee's, but during that decade Klee's art was more available.

The comparatively abundant presence of Klee's art in America, and its quite remarkable geographic distribution, was due in large measure to the efforts of Emmy "Galka" Scheyer, a friend of Klee, Kandinsky, Lyonel Feininger, and Alexey Jawlensky, whom she represented in the United States, from 1924 until her death in 1945, as "The Blue Four." Scheyer seems to have come up with the idea of going to the new world as a missionary on behalf of her four artists sometime during 1923. The artists themselves were quite pleased with the idea, but anxious that a name applied to all four might be taken as a token of some common school. Writing Scheyer in January 1924, Klee allowed that in the hypothetical case of a group of unknown artists from the Orient being sent to Europe, it would probably be advantageous if they could be recognized by a characteristic name, and on that basis, he and his fellow artists would consent to one provided it "in no case" end with an "ism."[36]

Without question the four artists wished to realize financial and critical success through their collaboration with Scheyer, but they all—even Feininger who was born in the United States—could not help finding the idea of sending their art to America slightly bizarre, perhaps akin to the dispatch of coded messages to receivers of doubtful literacy. In a spirit of hope and skepticism, the "four blue professors" sent their ambassador off, their declared purpose "the expulsion of bad art from the United States of America," which would be accomplished "under the leadership of the children's maid, Frau Emmy Scheyerin."[37] Elsewhere the four referred to themselves as kings and to Emmy as their foreign minister. In the voluminous correspondence later exchanged by Scheyer, Klee, and Klee's wife, Lily, there are frequent coy, almost coquettish references, mainly by Scheyer herself, to her role as nursemaid or, alternatively, minister to their kingly highnesses.

Scheyer's efforts on behalf of her artists almost equaled the energy of Katherine Dreier's more broadly based endeavors. Both women mounted exhibitions, gave lectures, and attempted to sell works by artists in whom they believed: behind their activities, however, were different motives and philosophies. Scheyer's projects were undertaken, Klee had written to Dreier in June 1923, not as a dealer, but out of love of art;[38] while this certainly gave her common cause with Dreier, she had little of the American's earnest belief in the efficacy of art to uplift society. For Scheyer, art's proper sphere was much more with the cultural and economic elite, and it was principally this world she cultivated in proselytizing for her Blue Four.

In a letter to "Kleelilein" (Scheyer's pet name for Lily Klee) and "Meister" Klee of August 30, 1924, Scheyer recounted the wonders of New York, made a first tentative suggestion that the Klees consider a visit, and described her industry

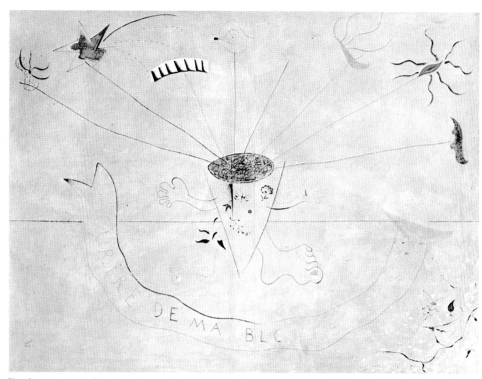

Fig. 9. Joan Miró. "*Sourire de ma blonde,*" 1924. Tempera on canvas, 34⅝ × 45¼ in. (88 × 115 cm). Whereabouts unknown

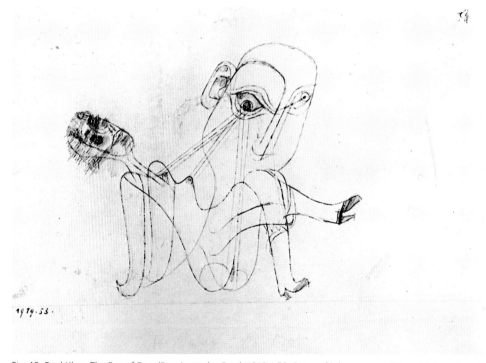

Fig. 10. Paul Klee. *The Eye of Eros (Das Auge des Eros),* 1919 / 53. Pen and ink on paper, 5⅛ × 8⅝ in. (13 × 22 cm). Morton G. Neumann Family Collection, Chicago. Published in Wilhelm Hausenstein, *Kairuan* (Munich, 1921)

in working for her "beloved Blue Four." She had, she told them, spent eight days in the library gathering the names of all the universities and art institutes in America and a thousand letters were in the process of being sent out.[39] By February of the following year she had "barely time to breathe" between the lectures she was giving and the arrangements she was making for exhibitions.

An exhibition of the Blue Four was just then taking place at the Daniel Gallery in New York. Henry McBride in the February 21 issue of the *New York Sun* commented on the "new Group of Modernists . . . [of which] Klee is the best known in the United States and after this exhibition doubtless will remain so." While he found all four "clever," it was Klee's "charm of manner" that would win. Kandinsky was undoubtedly, McBride said, "sincere and serious, but he is also forbidding"; whereas Klee was an "Ariel . . . light, dancing . . . no matter what the motif, he plays with it with astonishing agility." McBride finally fell back on the adjective "decorative," which had semipejorative currency in American criticism of all persuasions from the Armory Show to the midforties, and was applied to the whole range of modernist expression from the most baroque Picasso to the most austere Mondrian. Scheyer's own feelings about the exhibition, as she reported them in a letter to Lily, were both wary and optimistic. There was, she said, a generally favorable disposition toward Klee's work manifested in the reactions to the Daniel Gallery show, but the people who wanted to buy didn't want to pay. Yet she wrote in an addendum to Klee himself that the Americans who were looking at his work were impressed with "its quality as such," and with time something would certainly come of it in the United States.[40]

Scheyer apparently felt that the most promising territory was the West Coast. By October 1925 she had organized a Blue Four exhibition at the University of California at Los Angeles, and in the following year arranged a larger exhibition that opened in Oakland and subsequently toured to San Francisco, Los Angeles, and other West Coast cities. Between 1926 and 1930 Scheyer mainly operated out of San Francisco, finally settling in Hollywood in 1930. During those years and throughout the next decade the Blue Four were seen extensively in the West in exhibitions exclusively devoted to their work and in others of larger scope.

Although Scheyer complained frequently about her difficulties, she nonetheless enjoyed some degree of success. In a letter to Lily of late April 1930, she described her wonderful "though uncomfortable Frank Lloyd Wright house" and remarked on the good connections she had been able to make.[41] She was at the moment arranging an important four-part exhibition at Hollywood's Braxton Gallery for each of her Blue Four "kings." The catalog stated that the exhibition had been sponsored by Josef von Sternberg and Mme Galka E. Scheyer, and in its preface, Braxton, the gallery owner whom Galka characterized to Klee as "the typical dealer in the worst sense of the word," offered

this opinion: "Someday, not so far off, the canvases of Kandinsky, Feininger, Jawlensky and Klee will be collected by Americans as feverishly as are those of van Gogh, Cézanne and Matisse. In Europe, these artists . . . are commanding respectable prices for their work." The tone of this introduction is not likely to have attracted Scheyer's most significant customers for Klee's work, Walter and Louise Arensberg, whose apartment had been the center of New York Dada in the teens, and the first meeting place of Dreier and Duchamp. The Arensbergs had moved to Hollywood in 1921 and had virtually stopped collecting, but, Galka informed Klee, his work had inspired "Arnsberg" [sic] to begin again, and Klee's picture *Village Carnival* (1926; p. 221) would be in the excellent company of "wonderful Cézannes, Rousseaus, Picassos, Brancusis, Renoirs, Gauguins etc., etc., etc."[42]

While the only direct focus on Klee between his 1924 Société Anonyme exhibition and the end of the decade was provided by Scheyer's West Coast efforts, Katherine Dreier kept up her Bauhaus contacts and included Klee prominently in her most ambitious exhibitions. In 1926 she organized the German section of the Philadelphia Sesqui-Centennial, and mounted the largest and most far-reaching exhibition of international modern art to have been held in America since the Armory Show. In a letter dated March 30, 1926, Dreier told Klee about the two exhibitions, explaining early in the letter that although she had understood from Kandinsky and Galka Scheyer that she should send all of her Klee paintings to Scheyer, she had sent only twelve, as, "I found it a shame not to see you championed in the Sesqui-Centennial Exposition," and went on: "I have been invited to collect the pictures for the modern section of the great International Exhibition which will open May 1 in Philadelphia. It's the 150th jubilee of the Declaration of Independence of the U.S. . . . and I've sent a group of eleven of your paintings there, which were in my possession, and also three which belonged to me." After discussing prices, Dreier brought up the matter that was closest to her heart, advising Klee that she would be in Dessau in early May and wanted to see him and Kandinsky because, she said: "I've succeeded in interesting the big, beautiful, Brooklyn Museum in a big International Exhibition of Modern Art, and I'd be very happy if you'd lend some fresh paintings . . . this . . . is an especially great event, for our museums are very conservative, and that a museum of the significance of the Brooklyn Museum would arrange it through me is a matter of great importance."[43] Klee's response of April 16 was cordial, and he remarked that he was "pleased over our good auspices in America regarding exhibitions, museums, etc."[44]

Klee with eight works and Kandinsky with six were numerically among the best represented of the 106 artists in the *International Exhibition of Modern Art*, which ran at The Brooklyn Museum from November 19, 1926, to January 9, 1927, and subsequently was shown in somewhat abbreviated versions at the Anderson Galleries in Manhattan, the Albright Art Gallery in

Buffalo, and the Toronto Art Gallery. Although the exhibition elicited considerable press coverage, it did not receive anything like the attention the Armory Show had produced, nor did it have much immediate effect on American artists. Those who had been shocked into new explorations by the Armory exhibition had reached artistic maturity by 1926, and were, for the most part, painting in Cubist-derived figurative styles. For the next generation, the Brooklyn exhibition came too early; most of the artists who would achieve their mature styles in the forties were then too young. Even artists such as Mark Rothko, Barnett Newman, Arshile Gorky, James Brooks, and Adolph Gottlieb, who were already in New York and studying art, would have been too newly apprenticed to assimilate the advanced lessons of the exhibition. Although it failed to generate significant critical recognition or creative response, it made visible the conflicting crosscurrents of European modernism, including those coming out of Germany and Eastern Europe, and as the American debut of Mondrian and Miró symbolically set the stage for the pictorial debates of the next two decades.

Thomas Hart Benton, who three years after the Brooklyn exhibition was to become Jackson Pollock's teacher at the Art Students League, looked long and hard at the pictures in Brooklyn. The tone of his review in the January 1927 issue of *The Arts* revealed his effort at sympathetic comprehension, but he concluded finally that the artists' general preoccupation with materials and composition was not enough, and he asked at the end of his article: "Isn't it possible that to derive the greatest variety, interest and originality even in the purely substantive factors of painting, some motive power, some drive, connecting it with larger fields of human experience than those in evidence at the Brooklyn Museum is necessary?"[45] His own response was to reject abstraction in favor of meaningful subject matter; for his student Pollock and other young artists of his generation, the question prefigured a central dilemma—how to endow what Benton called the "substantive factors of painting" with power sufficient to carry the greatest weight of human content. In the endeavor to find solutions to this problem, the whole spectrum of advanced European art was to play a role, but as Greenberg was later to remark, "everybody, whether conscious of it or not, was learning from Klee."[46] The freedom of Klee's nondidactic, stylistically open-ended work, whether abstract or figurative, scrawllike or geometric, by inference or by allusion tied to universals of experience from genetic beginnings to the banal encounters of everyday life, provided a unique example. But in 1927 there was as yet no readiness for that example.

The small band of individuals who cared about art were mainly still trying to figure it all out. As the Brooklyn exhibition toured its various satellite sites, art's puzzled public could look to the new edition of Sheldon Cheney's *A Primer of Modern Art* for clarification. Although Cheney stayed fairly clear of Eddy's earlier "spiritual"

tone, he adopted a similar American vernacular address, and his attitudes were typical of contemporary, liberal, enlightened criticism. If his groupings strike the present-day reader as bizarre, such as lumping together Grosz, Klee, Heinrich Campendonk, and Marc Chagall as "Expressionists when at their best, Dadaists at their least responsible moments," it is largely because the particularities of "ismhood" within the larger notion of modern art were not as yet formulated. Cheney championed the new art, both European and American, and, like many of his fellow critics, tended to prefer the usually less abstract American versions. His attitudes vacillated on a number of points, not least of which was Paul Klee. On one page he excluded him, but not Kandinsky, from the first rank of artists "who count," granting him second-rate status along with Max Pechstein, Erich Heckel, and Hans Purrmann; on another, he compared one of Klee's "whatnots" with a watercolor by John Marin. Not surprisingly, he found the Marin much superior, but nonetheless declared that Klee, in spite of a seemingly childlike naiveté, "can put the slightest thing on his canvas or paper and it comes out a palpitating picture."[47] His last pronouncement on Klee was that he was "a man of prime importance closely associated with the Munich school," and in spite of "primitiveness of the child-art sort," his paintings and drawings "never fail to have aesthetic validity. He is counted one of the chief figures in German Expressionism today. . . . Klee and Kandinsky are both associated at present with the group that has developed in Weimar what is at present the most interesting school and experimental laboratory of the arts existent anywhere."[48] The major importance Cheney attributed to the Bauhaus was somewhat unusual, as American critics and collectors tended to focus much more on events in Paris than on anything taking place in Germany.

By 1927, however, the Bauhaus was no longer in Weimar but in Dessau, and from that city in eastern Germany we may be sure that Klee, an avid follower of the fortunes of his own art, was observing its fate in the wider world. Germany itself must have given him some satisfaction, for, even though he always seems to have been short of money, his art had attracted devoted collectors and was beginning to be acquired by museums throughout the country. Beyond its borders what would have interested him most was the headquarters of the competition, Paris. There he had cause for both gratification and disappointment. His art was deeply admired by the most advanced artists, poets, and intellectuals of the French capital. Louis Aragon had contributed an introduction and Paul Eluard a poem to the catalog of his first French one-man exhibition at the Galerie Vavin-Raspail in the fall of 1925.[49] Immediately thereafter, he, Picasso, and de Chirico were the only non-Surrealist-affiliated artists included by Eluard and Breton in the first Surrealist exhibition at the Galerie Pierre.[50] Although Breton was never to be completely happy with Klee's work, remarking at one point that he didn't like Miró because his work

reminded him too much of Klee, he nevertheless recommended to that exceptional collector Jacques Doucet that he buy a watercolor.[51] Everyone else in the nascent *bande surréaliste* seems to have had nothing but the deepest admiration for Klee's art. His reputation among the artistic and intellectual elite only grew with the years, as is reflected in the fact that Christian Zervos's *Cahiers d'Art* published the first non-German monograph on Klee in 1929, containing homages by Aragon, René Crevel, Paul Eluard, Jean Lurçat, Philippe Soupault, Tristan Tzara, and Roger Vitrac.[52] The high order of this attention was certainly not lost on Klee. Yet, as artists must also eat, he could not have failed to remark that there were few solid rewards devolving from his singular French distinction.

In retrospect Klee's early experience in France seems both remarkable and predictable: remarkable, in that French chauvinism, the idea of Paris as the center of creative energy, was so firmly entrenched that even the intellectual elite had difficulty imagining worthwhile art being produced elsewhere. Klee was the only contemporary artist living outside France accorded such peer acclaim. That there were few French collectors of Klee's work is what now seems predictable. In fact, there were few French collectors of any modernist art. With notable exceptions, such as Dutilleul and Doucet, the French were indifferent to the art being produced in their own front yard. In contrast to Germany, where there was a lively audience for modern art, and museums and collectors interested in buying it, France displayed a kind of national disdain. The Paris air that Duchamp had bottled was what had given birth to modernism and continued to sustain its growth; artists were allowed to inhale its creative elixir less by any material support they received in France than by the collecting activities of Russians, Germans, Eastern Europeans, and Americans. If French society failed in large measure to support the extraordinary art being produced on its own soil, it is littler wonder that it offered small solace to an outsider, and a German at that.

While Klee's interest in France was keen, there is almost no evidence that he had much curiosity about the United States—at least during the twenties. His chief contacts with America were through Dreier and Scheyer, and although Galka filled her letters with bits of local color, Klee's responses mostly had to do with sales, shipments, and like matters, leaving any commentaries on the imagined life of the United States to Lily. We know, however, that he read the monthly *Das Kunstblatt*, and it is reasonable to assume that J. B. Neumann's article in a 1927 issue, "Die neue deutsche Kunst in New York," would have interested him, as it dealt with matters with which he was familiar—Valentiner's German show of 1923, the Carnegie International of 1925 (in which he had participated), activities of the Société Anonyme, and those of Scheyer. If he read it, he might have been mildly entertained by the description of New York, and somewhat surprised that he had been realizing any sales at all from his American connections,

as Neumann's take on American attitudes toward German art was petulantly bleak, grimmer than the actual situation. He informed his readers:

New York is not a city, but a world to itself. It is well known that there are more Italians in New York than Rome, more *jiddische* Jews than in Palestine etc. . . . above all "more." . . . Here the life of the entire world is replayed, reproduced or imitated. After that, it's a matter of which nation. My question in the fall of 1923 . . . was, how is it going for German art? and the German exhibition of 1923 was noteworthy for having come, gone, and been forgotten. By contrast, Paris has many long-standing dealers here, Durand-Ruel, Bernheim Jeune . . . Paul Rosenberg, Brummer, and so on, and even a conservative like Durand-Ruel shows Braque, which he might not do in Paris.

The somewhat paranoid tone abates toward the end, and the author notes that the Blue Four were shown in New York and "now wander around the West with Frau G. E. Scheyer."[53] However Klee may have reacted to *Kunstblatt*'s article, he cannot have felt very positive about his prospects in America when it was written, as three years later, in May 1930, he wrote Galka Scheyer that he was no longer as displeased "with over there as I have been till now."[54] Much, in fact, had occurred in the intervening years to contribute to the expansion of Klee's reputation.

In early 1927, the Baroness Hilla von Rebay, yet another determined German woman and convinced apostle of modern art, had arrived in America. Rebay, like Dreier, was an artist herself, and had known Klee's work at least since the middle of World War I when her own work was shown with his in Berlin at Der Sturm and in Zürich in Dada-sponsored exhibitions. Rebay combined Dreier's faith in the spiritual power of art with Scheyer's social abilities, and was perhaps the most effective of the three. Within two years of her arrival in America, she had apparently interested Solomon R. Guggenheim in forming a collection that might someday become museum-worthy, and was showing Kandinsky and Klee to her wealthy friends in her Carnegie Hall studio.[55] Although Rebay's primary concern was for Kandinsky and her lover, Rudolf Bauer, and in spite of the fact that her faith was totally in abstract, or "non-objective," art, she had a lifelong commitment to Klee. By 1939 when her dream of founding a museum was realized with the opening of the Museum of Non-Objective Painting (the precursor to the present Solomon R. Guggenheim Museum), the collection boasted sixteen works by Klee.[56]

Rebay's museum was hardly the first museum of modern art in America, nor was it by any means the first to acquire and show the work of Paul Klee. Pressure for a museum devoted to contemporary art had been collecting in diffuse ways since the Armory Show. The first, noble attempt had been made by Dreier in 1920, but she had never been able to mobilize sufficient support to maintain permanent quarters. One cannot help wondering how Dreier may have felt if, in the midst of organizing her Brooklyn exhibition, she read Forbes Watson in *The Arts* celebrating the opening of the Cloisters with this pious hope: "New York having gained a

museum of medieval art, may heaven send it a museum of modern art so that folks will see what is going on in the world."[57] It is also possible that she suffered a twinge or two when A. E. Gallatin, who had been a member of the Société Anonyme in 1923, opened his Gallery of Living Art in December 1927, and in his 1930 catalog remarked that it was a "matter of surprise that hitherto no museum of this character had existed in the U.S., the most modern of all countries."[58]

If Dreier had cause for some personal bitterness in the opening of Gallatin's museum, it was nonetheless a step forward in the larger crusade to bring modernism to America. Housed in rooms of New York University at Washington Square and open weekdays from 8 A.M. to 9 P.M., the Gallery was informal and came to be regarded by many American artists as the "neighborhood museum." Its collection was very much Gallatin's personal choice, based on "thorough investigation" in which only "two distinctions" prevailed: "between pictures well-painted and the reverse."[59] Any exclusions were deliberate, even motivated by "sadistic pleasure . . . (Segonzac, late Derain)."[60] Although the collection became more broad-based over the years, it was always heavily oriented toward Cubism and the School of Paris. Of the artists represented in one of its first exhibitions at the Brummer Galleries in 1929, all were French or working in Paris except Klee and seven contemporary Americans. Although Klee was represented by only two works, he was for a considerable period the only German in the collection, which eventually admitted only Kandinsky, Wolfgang Paalen, Kurt Schwitters and Hans Hartung as additional artists with German roots. Because Gallatin's museum was so available and because it continually had Klee's work on view in a choice context of modernist masters, it was important in reinforcing Klee's presence in America, but Klee's American future was more significantly being prepared elsewhere in the late twenties.

Alfred H. Barr, Jr., a young art historian teaching at Wellesley College, was vitally interested in European modernism. During 1927–28 he made an extensive trip through Europe visiting nearly every center of artistic activity. In early December 1927 he was at the Bauhaus, where the frenetic pace of his studio visits seems to have been both exhilarating and exhausting. Jotted down in his notebook for December 7 are appointments with Gropius (also "Frau Gropius and House"), Feininger, Albers, and Klee, along with the notation: "7:45 gone mad and back to Goldenes Beugel [his hotel]," accompanied by a silly drawing of his battered self (fig. 11). Not all the pages of Barr's notebook were dated, but it would appear that he visited Klee more than once, making at one point a fascinated inventory of the idiosyncratic objects collected by the artist.[61] Later, Barr recalled:

Klee, when one talks with him, seems the opposite of eccentric, in spite of his amazing art. He lives in Dessau in a house designed by Gropius as a *machine à habiter* near the factory-like Bauhaus building. He is a smallish man with penetrating eyes, simple in speech and gently humorous. While one looks over his drawings in his studio one can hear his wife playing a Mozart sonata in the room below. Only in one corner are there curiosities, a table littered with such ornaments as shells, a snake's egg, bits of dried moss, a pine cone, a piece of coral, fragments of textiles, a couple of drawings by the children of his neighbor, Feininger. These serve to break the logical severity of the Gropius interior and Bauhaus furniture—and perhaps also serve as catalysts to Klee's creative activity.[62]

Two years after this meeting, Barr was appointed director of the newly founded Museum of Modern Art. The exhibition program he initiated testifies forcefully to his admiration for Paul Klee. The first three shows of the new museum largely established the coordinates of its interests—the first one being devoted to Cézanne, Gauguin, Seurat, and van Gogh, then only semi-established old masters of modernism; the second to living Americans; and the third to the School of Paris. The fourth exhibition, which opened in March 1930, declared the Museum's interest in both sculpture and painting on an international basis, showing the German Wilhelm Lehmbruck; the Frenchman Aristide Maillol; the American Max Weber; and the German Klee. Thus Klee was the first living European painter to receive a one-person exhibition at The Museum of Modern Art; the next European painter to be accorded the same treatment was Henri Matisse some two years later.

While there is no question that Barr was a Klee enthusiast, this early exhibition at the Museum almost certainly would not have come about without the presence of J. B. Neumann in New York and Barr's friendship with him. Neumann, who had opened a gallery in the city shortly after Valentiner's German exhibition of 1923, had shown Klee sporadically for years in Berlin—at the gallery he operated in association with Alfred Flechtheim—and even more occasionally in New York. Neumann, who would become as selfless as a dealer can be in promoting Klee's work, did not, by his own admission, fall in love with Klee at first sight. According to his unpublished memoirs, he had come to a profound appreciation of Klee's work by the midtwenties, but showed it rarely in New York because of the lack of public understanding: "The United States was," he said, "then virgin territory for Klee."[63] By 1930 he apparently felt the time had come to "launch the first major Klee exhibition in America," and so, with his partner Flechtheim, brought more than fifty works to New York with the intention of showing them in his gallery. But he realized that only a few hundred people could see the gallery exhibition whereas several thousand might see it at the Museum. When he proposed the show for the Museum, Barr seems to have accepted with alacrity.

The exhibition was extensive, including sixty-three pictures from 1919 through 1930. For the first time an American audience would see the already amazing range of Klee's work. Barr remarked in the exhibition's catalog: "Nothing is so astonishing to the student of Klee as his infinite variety," and, referring to the most abstract works such as *Variations* (1927; fig. 12), he made a telling observation: "They have little to do with Cubism for they are pure inventions

Fig. 11. Alfred H. Barr, Jr. (1902–1981). Notebook entry, Dessau, Germany, December 1927. The Museum of Modern Art Archives, Alfred H. Barr, Jr., Papers

94

rather than abstractions of things seen. . . . Here are forms which live and breathe with convincing actuality though their like has never been seen." In the very same essay, Barr found it necessary to defend Klee against charges of being "too literary," and in evident response to purist believers in abstraction, he pointed out that the means of painting, "surface texture or merely formal composition," were not large enough for Klee—that his art also insists on the right to explore imagination and dream.[64] What Barr observed in Klee, his extraordinary freedom, came from the artist's belief in the artmaking process as the vehicle of content, which not only placed at his disposal all the elements of picture-making, but mandated their exploration. Because he understood line, color, and *matière* to be themselves carriers of meaning, it made little difference whether they were employed in the service of abstraction or representation. No other artist of his time was willing to move from the completely nonfigurative to the figurative; no one else so completely demonstrated that the making of the work can be the making of its expressive power, and in this his art held the key to the dilemma of "subject" that was to become a preoccupying issue to the first generation of American Post World War II painters. Klee would certainly have accepted as applicable to painting T. S. Eliot's words about poetry: "It is not the 'greatness,' the intensity, of the emotions, the components, but the intensity of the artistic process, the pressure so to speak, under which the fusion takes place that counts."[65]

Early events at The Museum of Modern Art tended to elicit considerable press reaction, especially as contrasted with the relative apathy that had been the lot of the Société Anonyme, and the Klee exhibition was no exception. The press not only put forward divergent views on the merits of Klee's art, but it differed widely as to just who he was and how long he had been around. The critic for *Art News* sounded aggrieved that "Klee is permitted to burst upon the public almost as a complete surprise," and concluded: "We have not been able to understand why he is considered one of the most important artists working out of Paris."[66] *The Arts* reviewer felt that despite "all the years of ardent promotion," he was not worthy of being called a painter, rather "a phenomenon of interest and influence" who supported "his subtle if none too stalwart gifts upon the consoling prop of the non-visual."[67] Henry McBride, who was one of the best prepared commentators around, had some insightful as well as curious things to tell his readers in the *New York Sun*. (Present-day readers should be cautioned, however, that when McBride was writing, "Cubism" was used to describe almost all art with a tendency toward the abstract.) With Kiplingesque gusto, McBride pronounced: "When Cubism came up like thunder out of China across the bay, and the subject became a mere starting point for artists, no one left it so far behind him as did Klee, the German," and he went on to point out the many painters who vacillated between it and " 'straight' " painting, but "Not so Klee. He seems to have been born a Cubist. It is difficult to think

of him as anything else and if you don't mind my being slightly paradoxical, he is not so much a Cubist, either. That is to say, he slips as lightly away from solid forms as he does from all the other prosaic facts of earth." McBride's article concluded with a reprimand to his audience. "If Weber's work [the American painter, Max Weber, with whom Klee was exhibiting at the Modern] is not up to Klee's, then that," admonished McBride, is "your fault, gentle reader. It's because Weber has led a much more difficult life in America than Klee has led in Germany."[68]

McBride's reprimand came out of his exasperation with the relative indifference of Americans to art, but it also reflected his recognition of the outwardly flourishing support of painting and sculpture in Germany. Despite the fact that the Depression of 1929 had greatly increased popular support of the National Socialist party, the institutions and collectors of Germany were in 1930 the most enlightened benefactors of current art in Europe. Flora Turkel-Deri's "Berlin Letter" published in the May 3, 1930, issue of *Art News* typifies the activity and optimism of the moment. She reported on the formation of a new periodical, *Museum der Gegenwart*, which would describe "to a wide circle of readers the very lively activities of our modern museums," on a new modern annex to the Nationalgalerie, and on the organization of a society of collectors of contemporary art, which by donating works to the Nationalgalerie, would enable that institution "to benefit by the initiative and purchasing power of a number of private art collectors" thus "greatly aiding the cause of contemporary art." In the same letter she made some lengthy observations on an exhibition of fifty Klee drawings installed on the upper floor of the new modern annex, characterizing Klee as the artist "who has aroused almost more controversy than any of the German modernists."[69]

If Klee's lament, "the people are not with us," delivered in his Jena lecture of 1924 was still true in 1930, he had, nonetheless, as Turkel-Deri's account implies, reached a wide audience and achieved considerable public recognition. Barr's 1930 Museum of Modern Art Klee catalog tabulated the museums holding his work; it listed twelve German institutions, three Swiss, two American, and one Russian. In spite of the ominous rumblings of the right—evident to at least one of Klee's friends, the art historian Carl Einstein, who had written Klee in 1929: "The Klee Capital must be made larger . . . are things still looking so amazingly reactionary in Germany?"[70]—Klee's future at the beginning of the century's fourth decade appeared to be in Germany. Since Klee was regarded as the standard-bearer of German art, his fortunes in other countries were followed with interest. A certain wary optimism informed Will Grohmann's *Cicerone* article "Paul Klee in New York," which read: "After two big French exhibitions, the 'Museum of Modern Art' allows its first German show. Again it is Paul Klee who sets the pace." After describing the extent of the exhibition and the excellence of the catalog, he ended: "It would be good fortune if Klee's success would come to the rest of Germany."[71] Although Amer-

Fig. 12. Paul Klee. *Variations (Variationen [progressives Motiv])*, 1927 / 299 (Omega 9). Oil and watercolor on canvas, 16 × 15¾ in. (40.6 × 40 cm). The Metropolitan Museum of Art, New York, The Berggruen Klee Collection, 1984

95

ican interest in German art was only slowly widening, Klee was, as Grohmann pointed out, in the forefront—sometimes with somewhat singular distinction. In the issue of the 1930 *Vanity Fair* devoted to its nominees for the year's Hall of Fame, Klee's photograph was sandwiched between those of Henry Luce and Knute Rockne.[72]

Soon after the close of the Modern's Klee exhibition, the show *Modern German Art* opened on April 18, 1930, at the Harvard Society for Contemporary Art, Cambridge, Massachusetts, and Klee was the most prominently featured artist. The catalog demonstrated that its assemblers were enthusiasts whose eyes were good and whose confusion was considerable. After informing its readers in an introduction titled "Historical Background" that Klee, Kandinsky, and Marc had come together in the Blue Rider in 1903 (1911 is correct), it shifted the date in its individual discussion of Klee to 1906, and in a sympathetically written commentary deduced from "his affinity with primitive ornament" and "lunatic scratchings," that he was "an automatic paleolith."

Of the ten works by Klee in the Harvard exhibition, four were borrowed from Valentiner, five from Neumann, and one from Jere Abbott, Associate Director of The Museum of Modern Art. This list of lenders may be taken as a symbol of the past and future progress of Klee's art in America at the beginning of the decade of political turmoil that would usher in World War II. As Valentiner in the early twenties had been one of the first to bring Klee before an American public, so Neumann and The Museum of Modern Art would be instrumental in the vast increase in his exposure during the thirties. Between 1931 and 1935, there was not one year in which Klee's work did not figure prominently in an important group show, and, after Neumann's 1935 Klee exhibition, every succeeding year saw at least one and often several ambitious shows devoted exclusively to Klee.

During the winter and spring of 1931, Klee was to be seen in the Société Anonyme's *International Exhibition Illustrating the Most Recent Development in Abstract Art* at the Buffalo Fine Arts Academy after an initial showing at the New School in New York City; in the Harvard Society for Contemporary Art's *Bauhaus* show, a version of which went to The Arts Club of Chicago; in *The Blue Four* at the California Palace of the Legion of Honor, San Francisco; and in *German Painting and Sculpture* at The Museum of Modern Art. These exhibitions testify to an expanded American interest in the modern movement, and, in the clairvoyant light of hindsight, are replete with historical ironies. The American situation as it seemed at the time is assessed with considerable accuracy in the 1933 book *The Arts in American Life*. Its authors, Frederick P. Keppel and R. L. Duffus wrote: "It must be admitted that for the overwhelming majority of the American people the fine arts of painting and sculpture, in their non-commercial, non-industrial forms, do not exist"; nonetheless they observed that "the growth in attendance at museums and exhibitions . . . has been striking."

They further commented on the social position of the artist who "both ignores the public and craves its approval," and on the attitude that the neglect and misunderstanding encountered by artists is held to "reflect adversely upon the cultural attainments of the people." Finally they questioned whether "the American public is gradually being converted to the new in art and is this conversion, if taking place, adding to the number of those who are interested in pure painting and sculpture?"[73]

The authors of the above attempted no answer. One might, however, read a type of response in some of Diego Rivera's remarks in the catalog introduction to the 1931 San Francisco Blue Four exhibition, which he cosponsored with Galka Scheyer. Undoubtedly thinking of a radical political as well as artistic conversion in America, Rivera wrote: "There are in Europe today expressions of art which are not decadent but which are on the contrary anticipated [*sic*] works destined for a better organized world." Their authors, he continued, are men like the Blue Four, "whose work contains all the science of great masters and all the freshness and genius of children. The artist-public of America should be especially interested in their work . . . in America an epoch of rapid development is beginning with great possibilities for art."[74]

Lincoln Kirstein's soberly written introduction to the Harvard Bauhaus catalog understandably made no reference to the present or future state of art in America. Rather, it detailed the political dissension at the Bauhaus that had already been a factor in Klee's move to the Academy in Düsseldorf and indicated its strong anti-Communist direction under Ludwig Mies van der Rohe. About Klee, Kirstein wrote that he "has been traduced by sensationalists. He is not obsessed by insanity at all." Kirstein was at least in part referring to the common notion of Klee as a Surrealist. Typical of this attitude was the characterization of Klee in the Braxton Gallery catalog of its Blue Four exhibition the year before as the "father of surrealism,"[75] as well as popular press commentary that in May 1931 had elicited a letter to the *New York Times* from Hilla Rebay objecting to Klee's classification as a Surrealist, somewhat murkily clarifying his position as "an intuitive painter who created masterpieces."[76]

Dreier, who explained modern art in her catalog introduction to the Société Anonyme exhibition as that which tends toward the abstract or toward greater simplification, would certainly have agreed with Kirstein and Rebay in seeing Klee as outside Surrealism's burgeoning illustrative proclivities. Her New School exhibition put Klee in the company of thirty-six other artists (representing ten countries and including, along with her old European favorites, the young émigrés Arshile Gorky and John Graham). Convinced as ever of art's inevitable progress and liberating spiritual power, Dreier spoke of America in her lectures accompanying the exhibition as "the nation of the future because of its power, vitality, and facility to shed the past more rapidly than Europe." If it lagged behind Europe, then it was because of its devotion to materialism, and American artists should bond together against

Fig. 13. Paul Klee. *Maid of Saxony (Mädchen aus Sachsen)*, 1922/132. Oil, and oil-primed muslin on gold foil, on painted board, 14¼ × 8⅝ in. (36 × 22.8 cm). Norton Simon Museum, Pasadena, California, Galka Scheyer Blue Four Collection

Fig. 14. Pablo Picasso (1881–1973). *Seated Woman*, 1927. Oil on wood, 51⅛ × 38¼ in. (129.9 × 97.1 cm). The Museum of Modern Art, New York, Gift of James Thrall Soby

this malevolent influence. As an example to America, she most enthusiastically pointed to Germany, where government at all levels supported the most advanced art schools.[77]

For all that Dreier felt that Barr's new museum (which had, in her view, usurped its very name from its original usage by the Société Anonyme in 1920) was regressive in having shown nineteenth-century art and overly biased toward the School of Paris, she cannot have failed to see that Barr shared her views about German support of the arts. Although Barr noted in the opening sentence of the catalog introduction to *German Painting and Sculpture* that "in matters of art Germany, France, England, Italy, America and other countries assume the paradoxical position of standing with their backs toward one another and their faces toward Paris," he was quick to point out that "however much modern German art is admired or misunderstood abroad, it is certainly supported publicly and privately in Germany with extraordinary generosity."[78] He then devoted several paragraphs to this phenomenon, as well as reserving a separate section for the topic "Modern Art in German Museums," and observed that "most surprising is the alert attitude of German museums toward modern art."[79] Appended to this section was a list of over *fifty* (italicized in Barr's text) museums whose holdings included advanced painting and sculpture.

In the newly founded German magazine *Museum der Gegenwart*, Barr had the opportunity to address a German audience directly. Reporting on the Modern's exhibition, he wrote that Klee particularly had made a deep impression on artists and collectors. Many visitors, Barr observed, who had been indignant over Klee's work when it was shown the previous year at the Museum, now found it marvelous.[80] It had

apparently not quite lost its power to shock, however; in the sampling of American reviews Barr appended to the article, there was a statement by Milton S. Fox of the *Cleveland Sunday News* that of all the artists in the exhibition, Klee had provoked the most vehement controversy.[81] In the exhibition catalog Barr had particularly singled out *Maid of Saxony* (there titled *Ma*; 1922; fig. 13) calling it "one of the finest Klees in color . . . similar in conception to much of Picasso's work of some five years later, specifically the now famous *Seated Woman* [1927; fig. 14]."[82] He did so again in *Museum der Gegenwart*, declaring that it and the two watercolors lent by the Nationalgalerie in Berlin had been public favorites. Neither Barr nor his German readers could have suspected that within eight years *Twittering Machine* (1922; p. 172), one of those watercolors lent by Berlin, would be part of the permanent collection of The Museum of Modern Art. Nor could they have guessed that 1931, the very year of the article, when Klee had one-person exhibitions in Düsseldorf, Hanover, and Berlin, would mark the end of Klee's exposure in Germany for seventeen years and the beginning of nearly two decades that would bring a proliferation of Klee exhibitions to the United States.

Only two years after this article was published, Barr was writing from Germany of the dismissal from their posts of German museum directors "who bought and hung too modern pictures," and, he said, this was also "the fate of the pictures themselves." This policy, he continued, "has now rendered the progressive painter particularly vulnerable. For example, Paul Klee and Oskar Moll have been removed from the Düsseldorf Academy."[83] Indeed, by the time Barr unsuccessfully attempted to publish his reports in the still politically isolationist United States, Klee had already

decided to return to his childhood home of Bern, Switzerland.[84] Along with other members of what the Nazi propaganda machine characterized as a "dictatorship" of art historians, museum directors, dealers, and, "to their shame, a large number of artists" engaged in bringing about "a so-called international art language," Klee was obliged to flee Germany.[85] Although Klee was by nature and conviction not particularly gregarious—neither a joiner nor politically involved—his sudden forced removal to Bern and its circumstances were deeply shocking. His distress at events in Germany was profound, and his sense of isolation in the provincial city of Bern, after years spent in international centers of artistic activity, nearly absolute. Such proto-art-brut works as *Ragged Ghost* (1933; fig. 15), in all probability a half-humorous self-portrait, in stark contrast to the exquisitely executed, majestic paintings of the previous year's divisionist series, which had culminated in *Ad Parnassum* (1932; p. 255), directly expressed both Klee's own troubles and his wider anxieties.[86]

In Bern, virtually the only contact Klee had with other artists was through occasional visits and letters. A considerable correspondence, mainly sustained by Lily, was carried on with the Klees' former Bauhaus neighbors the Kandinskys, who were by this time in Paris. Lily and Nina Kandinsky wrote of domestic problems, financial difficulties, and their fears of war—Lily offering the opinion that what was needed in European politics was "a few clever women."[87] When Klee and Kandinsky wrote, it was more often of professional problems and old friends. One of their exchanges is especially interesting because it sets out Klee's view of his position so clearly, and, indeed, now reads very poignantly, as we know he spent the last five, immensely productive years of his life suffering from a fatal illness. Concluding an explanation to Kandinsky of his reasons for not wishing to do anything further to help the French magazine *Cahiers d'Art* out of financial problems, Klee wrote: "I hope you have your health back. We need health—together with a minimum of material support—in order to create. I have no optimism except in creativity, and if it has to take place in total isolation, then basically it makes no difference."[88]

Other letters generally dealt with matters not quite so fundamental. Writing to Klee on December 16, 1934, Kandinsky congratulated him on the appearance of Will Grohmann's monograph on Klee's drawings, which, as it turned out, was less an occasion for celebration than it seemed. The book was almost immediately suppressed by the Nazis, and relatively few copies were put into circulation. In fact, it would only reach a wide public in 1944 when it was reprinted in English by Curt Valentin. In the same letter Kandinsky remarked on what a special pleasure it was "in these wicked times" to hear from old friends and how happy they had been to receive Lily's letters; he went on to tell Klee that they had also heard from the Arps, whose good fortune was matched only by that of Anni and Josef Albers. They had been, said Kandinsky, "brilliantly rewarded for all the evil experiences

of the last years."[89]

Josef Albers had, by then, been teaching at the recently founded Black Mountain College in North Carolina for nearly a year. His wife Anni Albers was Jewish, so his situation in Germany had been even more difficult than Klee's. Through the American architect Philip Johnson, one of whose earliest enthusiasms as a collector was for Paul Klee, Albers's emigration to the United States had been facilitated, and the post at Black Mountain College obtained. Albers remained at Black Mountain until 1949, when he left to become Chairman of the Department of Design at Yale University. As a professor at the Bauhaus, and before that as a student, Albers had developed a deep admiration for both Klee and Kandinsky. His teaching in America had a profound influence on several generations of artists and very much reflected ideas he had first encountered through Klee and Kandinsky. Painters as diverse as de Kooning, Kenneth Noland, and Robert Rauschenburg were to hear him repeat the importance of the Klee/Kandinsky–derived concept: "Art is concerned with the how not the what . . . the performance—how it is done—that is the content of art."[90]

It is somewhat ironic that Albers would not have been appointed to Black Mountain if Katherine Dreier had had her way. When her nephew, Theodore Dreier, cofounder of the college, asked her advice, she opposed the choice, preferring Werner Drewes, who had also been a student of Klee's. She seems, however, to have amended her opinion rather quickly, as by 1934 she was quite close to Albers—working with him, Drewes, Burgoyne Diller, Gorky, John Graham, Harry Holtzman, and Paul Outerbridge on a project for an album of abstract prints.

Although Dreier's print project fell through, the call she had issued three years before for artists to bond together against materialism was being heeded in a multiplicity of ways. Artists, traditionally on the fringes of American society, found the Depression-caused collapse of that society to be both a leveler and a force toward communal activity. As the plumber, the bricklayer, and everyone else became unemployed, the marginal became mainstream. Artists, like other manual laborers, banded together to form the Unemployed Artists Group, later the Artists' Union, and in 1935 the Roosevelt Administration responded by giving them jobs "at plumbers' wages" on the Federal Art Project of the Works Progress Administration. The story of the formation of close-knit artist groups, and of the unprecedented sense of community gained during the thirties, is well-known and has been recounted elsewhere, but it was in this context that most of the young artists who came to be known as Abstract Expressionists were forming and testing their ideas. All of them came to reject American Social Realism and Regionalist painting; none of them was happy with the dogma and lack of human content of Geometric Abstraction; all of them were looking at advanced European art.

Speaking of the period in early 1935 when Gottlieb and Rothko cofounded a group called "The Ten," Joseph Solman, one of its members,

Fig. 15. Paul Klee. *Ragged Ghost (Lumpengespenst)*, 1933 / 465 (J 5). Colored paste over watercolor on paper, mounted on cardboard, 18⅞ × 13 in. (48 × 33.1 cm). Kunstmuseum Bern, Paul Klee Stiftung

Fig. 16. Paul Klee. *Abstract Trio (Abstractes Terzeit)*, 1923 / 88. Watercolor and ink transfer drawing on wove paper, bordered with gouache and ink, mounted on cardboard, 12⅝ × 19¾ in. (32 × 50.2 cm). The Metropolitan Museum of Art, New York, The Berggruen Klee Collection, 1984

Fig. 17. Mark Rothko (1903–1970). Untitled, 1944. Watercolor on paper, 27 × 40½ in. (68.5 × 102.8 cm). The Mark Rothko Estate

recalled: "We all admired Picasso, Matisse, Klee, and the German Expressionists, many of whose works we first became acquainted with at J. B. Neumann's New Art Circle and later [at] Paul Rosenberg and of course at The Museum of Modern Art."[91] Solman may have cited J. B. Neumann first because almost coincidental with the formation of The Ten was the opening at Neumann's of a large Klee retrospective, the first since the Modern's of five years before and the earliest in a cluster of twenty Klee exhibitions that would take place in the United States—most of them in New York—between 1935 and the retrospective Klee would again have at the Modern in 1941. Although ideas picked up from Klee do not surface in the work of either Gottlieb or Rothko as early as 1935, they begin to do so some three to four years later. With hindsight we can see a parallel in the delicate automatist calligraphy and translucent ground of Klee's *Abstract Trio* (1923; fig. 16), which was in Neumann's exhibition with such later Rothko watercolors as an untitled work of 1944 (fig. 17).[92]

Although Gottlieb and Rothko rarely saw eye to eye with contemporary criticism, on the occasion of the New Art Circle Klee exhibition they may have been in agreement with Margaret Breuning of the *New York Post*, whose comments were reprinted in *Art Digest* along with a reproduction of *Abstract Trio*. Breuning called Klee "an isolated, intense painter" whose works "reveal . . . power to express in abstract patterning strange echoes of emotion and experience. He seems able to fuse this emotional content with a play of color so that the whole painting is an orchestration of one motif."[93]

Meanwhile Klee's work was not being neglected on the West Coast. In a letter dated July 29, 1935, Galka Scheyer wrote the Klees about an exhibition that would open two days later in Hollywood and subsequently travel to Oakland and San Francisco.[94] Scheyer described the Hollywood gallery where the show was to open as being run not by a dealer but by an artist, which means that she was probably referring to the Stanley Rose Gallery, run by the painter Lorser Feitelson. By October when the exhibition reached Oakland, where Klee was billed as "one of the most celebrated ultra-moderns," the Stanley Rose Gallery had been taken over by Howard Putzel, a somewhat enigmatic young man who was to be of major importance to the developing artists of the New York School in the early forties. During the two years Putzel remained in Hollywood, he often showed the work of Klee along with that of Miró, Masson, Salvador Dali, Yves Tanguy, Stanley William Hayter, and others; he also gave Klee a solo exhibition in November and December of 1937. There has been some question of where Putzel obtained the pictures for his exhibitions, and it may be that Scheyer was a source, despite the competition she apparently felt with Putzel. Not only does she seem to have been involved with the Stanley Rose Klee exhibition, but she had kept up her contacts with the Arensbergs who knew Putzel well through both his gallery and their mutual close friend, Marcel Duchamp.

Scheyer's correspondence with the Klees dur-

99

ing this time abounded with discussions of prices and sales, but it also evinced Scheyer's concern for the welfare of her European friends. For years Scheyer had been suggesting that the Klees visit America; in 1935, however, probably prompted by Lily's description of Klee's poor health as well as the alarming political situation in Europe, she stepped up her efforts to persuade them. Perhaps thinking that the prospect of professional activity would make the idea more appealing, she wrote them on October 28, 1935, that a professor from Mills College, whom she described as having "revered Klee's work for years," had suggested that Klee might be interested in teaching a summer course.[95] Although radical developments in Europe may have made Klee slightly less aloof toward America, his health was far worse than Scheyer imagined and nothing came of the proposal. The professor in question, "Salmonie" in Scheyer's often eccentric orthography, was the Orientalist Alfred Salmony, a recent refugee from Nazi Germany with whom Ad Reinhardt was to study at the Institute of Fine Arts of New York University in 1944. If Salmony's efforts to bring Klee to American failed, it is nonetheless likely that he brought Klee's spirit and the example of his art to discussions of Oriental and Western art.

Klee's own feeling of kinship with Oriental art is readily apparent throughout his work, as, for example, in *Collection of Signs, Southern* (1924; fig. 18), shown in Neumann's 1935 exhibition. Klee's occasionally expressed idea that he had something of the Orient within himself did not come solely from his admiration for the effects or techniques of Asian and Islamic art, but from the attraction that philosophies predicated on the unity of opposites would inevitably exert on this artist who wished his work to reflect nature "in its complementary oneness." Similar aspirations were at the heart of the creative efforts of Abstract Expressionism; as Gottlieb noted when speaking of Gorky, "what he felt . . . was a sense of polarity, . . . that opposites could exist simultaneously within a body, within a painting or within an entire art."[96]

"Art," Klee declared, "is a likeness of creation," and as such should grasp the object, whether man, animal, tree, landscape, or the world, within the totality of cosmic flux. This belief was at the core of what William Seitz called Klee's "naturalism," which was, he said, "very closely related . . . to the New York painters' organicism," defined by Seitz "as the highest possible regard, sometimes amounting to deification, of the creative powers of both man and nature."[97] For Klee, as similarly for the Americans, this psychic identification with the creative process itself imposed the moral imperative to reject formalism in favor of the "powers that do the forming." While most of the Americans found their mature styles in nonrepresentational modes, it was not out of a programmatic rejection of figuration, but issued from an intensive search to body forth the transient energies of the world. As Klee put it, "the formal element must blend with one's philosophy of the universe."

Abstraction for Klee was, as Jürgen Glaese-mer has pointed out, "a requirement imposed on the process of creating a picture,"[98] but it had nothing at all to do with "abstracting because of the possibilities of making comparisons with natural objects"; rather, it had to do with the manipulation through pictorial relationships of opposing concepts, "light to dark, color to light and dark color, color to color, long to short, broad to narrow, sharp to dull, left to right, above, below, behind in front . . . if outside concepts such as 'catdog' show up within the scope of the pictorial . . . they are permissible. Only the substantial blurring resulting from outside concepts is forbidden."[99]

Klee's fundamental, vastly ambitious drive was to get at the form-giving principles of nature, to make an art that would mirror the structure, complexity, and randomness of the world. Like Blake, Leibniz, and Goethe, he was fascinated with the idea of self-similarity, that "a kind of formula for man, earth, fire, water, air and all the circling forces might be found"; yet, as Leo Steinberg remarked, he was always aware that there was "no one immutable reality available to detached contemplation."[100] If his minute analyses of nature led him to the notion that things might wear their irregularity in surprisingly orderly patterns, he nevertheless realized he could only "find parts . . . not the whole." Wallace Stevens had something of the same notion when he wrote: "It was when the trees were leafless first in November / And their blackness became apparent, that one first knew the eccentric to be the base of design."[101] For Klee, as later for the Americans, there could be no Euclidean simplicity in the expression of whatever unity might be out there. Most Americans were to find formal solutions to their expressive dilemma in monumental, signature styles. Klee, however, practically plotted the chart of modernism. "In miniature," Seitz remarked, "almost every formal solution and technical innovation of modern art can be found in his watercolors and oils."[102] Like another mystic, Ralph Waldo Emerson, Klee believed that "Every hose fits every hydrant in the transmission of the heavenly waters."[103]

The unique diversity of Klee's art was acknowledged by Barr in the catalog of his enormously influential 1936 exhibition *Cubism and Abstract Art*.[104] Although Barr pointed out in his preface that European abstraction had long been available in America, particularly through the efforts of Stieglitz, Eddy, and Dreier, he nonetheless felt a sorting-out process was necessary, and Klee showed up under three different classifications: Abstract Expressionism in Germany; Abstract Dadaism; and Abstract Tendencies in Surrealist Art. At the end of the year, in another exhibition, *Fantastic Art, Dada, Surrealism*, which had almost as much impact on the New York art world as the Cubism show, Barr showed twenty Klees in the section headed 20th Century Pioneers.[105]

Without doubt, most of the painters who would later make history as the New York School saw Barr's two exhibitions. And all who saw them would have been interested in what *Art Front*, the publication of the Artists' Union, had

Fig. 18. Paul Klee. *Collection of Signs, Southern (Zeichensammlung, Südlich)*, 1924 / 214. Watercolor and ink, 12¼ × 18⅜ in. (31.1 × 46.7 cm). Washington University Gallery of Art, St. Louis

100

Fig. 21. Paul Klee. *Rehearsal with Props (Stelleprobe)*, 1934 / 156 (R 16). Zulu pencil and colored paste on untreated cotton, 9⅞ × 5½ in. (25 × 14 cm). Whereabouts unknown

Fig. 22. Matta (born 1912). *Eronisme*, 1943. Oil on canvas, 23¾ × 31½ in. (60 × 80 cm). Private collection, Paris

terms with every phase of European twentieth-century art, was a brilliant and articulate theoretician, empathetic to "the chaps" who came to work with him—in short, the perfect foil for discussion and practice.

In the interchange of ideas at Hayter's, Klee's works occupied a significant place. Hayter has spoken of the "tremendous interest" of Motherwell and Rothko in Klee,[118] and in a recent interview, a question about the possible influence of Klee on Pollock elicited this response:

Paul Klee without any doubt. I thought at one time that Paul Klee was a major influence, as he was both in the case of Motherwell and in the case of Mark Rothko, surely. And Bill Baziotes who was with us quite a lot. There was a time when Pollock was quite obviously understanding some of the implications of Paul Klee. I think that is rather important because Klee was a man who covered an enormous amount of territory from point of idea. He also made suggestions in slight things which you could follow and go farther with, which would challenge you and propose things to you. Perhaps more so than people like Matisse and Picasso who took a thing and more or less terminated it, destroyed it if you like. Very beautiful, but very destructive.[119]

Hayter's point is well taken, for deeply as the Americans admired Picasso, they often found his weight as oppressive as Miró and Masson had earlier. Picasso's art is physical, tied to the world of sensory experience, even autobiographic, and never, except when specifically conceived as decoration, nonfigurative. What enables one to speak of the artists of the New York School as a group, despite their very different mature styles, derives from their common drive to create tragic, metaphysical art, of, as Pollock said, "organic intensity—energy and motion made visible—memories arrested in space."[120] It is this which links them most closely with Klee, who spoke of being "abstract with memories," and whose aim was to create an art of "cosmic world feeling" able to express his Bergsonian sense of duration—"the present as the invisible progress of the past gnawing into the future."

The Picasso-Klee dialectic, especially in relation to the New York School, is so often set up that a brief digression touching but one of its many aspects may be in order.[121] In a comparison of Klee's *Room Perspective with Inhabitants* (1921; fig. 19) with Picasso's *Artist's Salon, rue la Boétie* (1919; fig. 20), the similarity of motifs is immediately apparent. In Klee's watercolor it is the painter's family apartment in Weimar; its inhabitants, the painter himself and his wife and child. Picasso's drawing shows the painter's parlor in Paris peopled by his wife Olga, Jean Cocteau, Erik Satie, and Clive Bell. Both artists have deliberately, with conscious humor, subverted traditional perspective, but for different ends. Picasso's drawing is a dialogue with the visible—among other things a demonstration of the artist's power to cause his guests to assume a precarious perch on his parquet floor. Klee's watercolor engages the invisible in a negation of the integrity of matter. The comfortable living room becomes a kind of domestic wind tunnel to eternity, its inhabitants and their objects dematerialized in the flux of time and space. Both works play with illusions of recessive space; but the coordinates of Picasso's organization are felt to be stable, whereas those of Klee one senses as shifting. In such later works as *Rehearsal with Props* (1934; fig. 21), space as a field of forces is more abstractly stated by Klee. In small format, such Klees are very close to some paintings by Matta—for instance *Eronisme* (1943; fig. 22)—who spoke of the spaces of his own pictures as "non-Euclidean . . . where

103

all the ordinates and coordinates are moving in themselves because the references of the 'wall' of the space are constantly changing. They are not parallel to a Euclidean cube to which most previous painting has referred." Matta went on to explain how this kind of space applied to Pollock, "who gave a picture of the world in a series of moves and shocks, actions and repulsions. Some of my pictures," Matta observed, "might be thought of as details that could be placed in a square inch of his pictures."[122]

Specific resemblances between Klee's art and that of the first group of Abstract Expressionists are few (with the exception of Gottlieb) and largely limited to the first half of the forties, when the Americans were groping toward their mature styles. Yet Klee's conceptual base, in close coincidence with theirs, led him to formal solutions that anticipated many of their own. Klee's frequent use of an equally weighted compositional structure, which was later to be a distinctive characteristic of mature Abstract Expressionism, was remarked as early as 1938 by Robert Goldwater in *Primitivism and Modern Painting*. Goldwater found "characteristic" of Klee his "use of a close all-over pattern made up either of dots or a minute linear scheme which the eye cannot follow in detail and designed in such a way that the eye has equal and yet exact demands on its attention from the whole picture surface, thereby creating a tremendous strain."[123] Among Goldwater's illustrations was *Picture Album* (1937; fig. 23), whose primitivistic imagery as well as its structure would have interested artists such as Gottlieb, Rothko, Newman, and Pollock.

The "allover" method of composition was, as Goldwater remarked, characteristic of Klee, but it assumed many forms; he might as well have illustrated *Sacred Islands* (1926; p. 224) or *Variations* (fig. 12), both of which were first seen in New York in 1930. Only in the last three years of his life did Klee work with anything like uniformity of style. His pictures became larger, line lost its character as edge or contour to become both structure and sign, and the allover composition dominated. Pictures of this type, among them *Heroic Roses* (1938; fig. 24), on view at Nierendorf's in the early forties, were less available in New York prior to the end of the war than they were to become thereafter, when their kinship with the maturing styles of the gestural side of Abstract Expressionism would become evident. In the survey "Six Opinions on What Is Sublime in Art" published in *The Tiger's Eye* of December 1948 (whose respondents included Motherwell and Newman), A. D. B. Sylvester chose Klee as his subject, writing: "In a late Klee every point of arrival at once becomes a point of departure. The journey is unending. . . . Composition is distributed equably anywhere [*sic*], content absorbs experience from everywhere—both as agglomeration of distinct memories and as elucidation of common, germinal elements and movements of the remembered physical world."[124] Two years after Sylvester's appraisal of Klee, Jackson Pollock would say of a negative response to his work: "There was a reviewer a while back who wrote that my pictures didn't

have any beginning or any end. He didn't mean it as a compliment, but it was. It was a fine compliment."[125]

Opportunities to see Klee's work during the forties were abundant. The decade opened with the big Willard-Valentin exhibition, and in the following year The Museum of Modern Art held a memorial retrospective that subsequently traveled throughout the country. In New York, Nierendorf was "blanketing the waterfront" in the 1941–42 season with five successive one-man shows with such apparent success that Rosamond Frost reported at the end of the fifth, in the June–July 1942 issue of *Art News*: "Attendance broke records, catalogues had to be reprinted up to four times, for to begin to know Klee is comparable to embarking on the opium habit." In her long review, Frost touched on many points that had relevance to artists then in New York. The early imagery of Baziotes, Stamos, Newman, and Rothko was full of allusions to genetic beginnings and biological growth that were very close to much of Klee. Frost described *The Fruit* (1932; fig. 25) in words that expressed the aspirations of many of the New York painters: "His message is profound, even metaphysical, expressing ideas attempted only in poetry. Take *The Fruit* with . . . its hidden core of light, and its intricate life-thread which travels from the blossom through the seed and on to the next planting." Without naming it, Frost caught the automatist character of Klee's line, calling it "the most interesting and varied in modern art. Sometimes . . . [it] has no end coming back on itself after turnings and wanderings . . . the eye unconsciously goes after it, makes a pilgrimage through the picture."[126] Mark Tobey, by then working in his "white writing" technique, had already picked up on possibilities offered by Klee's line; and it is not difficult to imagine that it was beginning to register with Jackson Pollock as well.[127]

Indeed, in the winter of 1942, Klee's automatist method of getting a picture started was brought to Pollock's attention by Robert Motherwell at Matta's instigation. Matta's "Oedipal relation to the Surrealists" brought him to the idea of getting together a group of American artists who might "make a manifestation" that would show up the Surrealists. Although the proposed group project never came off, Motherwell and Baziotes met with Pollock, de Kooning, Jerome Kamrowski, and Peter Busa to explain "the whole Surrealist thing in general and the theory of automatism in particular." Motherwell later recalled his astonishment at how "intently" Pollock listened as he explained the way "Klee and Masson made their things," even inviting him back to continue the discussion.[128] How Pollock later used the idea of automatism is history. One might, taking liberties with the spirit of Paul Klee, find in Pollock's achievement a realization of what Klee in 1902 felt should have been the endeavor of Michelangelo, who, he said, "should have baroquised the Gothic . . . such a transformer is lacking."[129]

The principle of automatism was very much in evidence in New York toward the end of 1942 with the nearly simultaneous openings of the

Fig. 23. Paul Klee. *Picture Album (Bilderbogen)*, 1937 / 133 (Qu 13). Oil on canvas, 23¼ × 22 in. (59 × 56 cm). The Phillips Collection, Washington, D.C.

Fig. 24. Paul Klee. *Heroic Roses (Heroische Rosen)*, 1938 / 139 (J 19). Oil on burlap, 26¾ × 20½ in. (68 × 52 cm). Kunstsammlung Nordrhein-Westfalen, Düsseldorf

Fig. 25. Paul Klee. *The Fruit (Die Frucht)*, 1932 / 44. Oil on burlap, 22 × 28 in. (55.8 × 71.1 cm). Collection Marianne Lohan, Chicago

exhibition *First Papers of Surrealism* at the Whitelaw Reid mansion and of Peggy Guggenheim's new gallery, Art of This Century. Klee's work was to be found in both places, and was, in fact, a special feature of Frederick Kiesler's "automatic method of showing paintings" in his installation at Guggenheim's gallery. As described by Edgar Kaufmann, Jr., Kiesler's Klee machine was part of a "violent hanging," in which works by Klee were mounted on a mechanized belt. "By pressing a button," Kaufmann said, "the visitor operates it. Each Klee appears and halts a short while before the next one rolls in with a clangor and grind. . . . Harried in time and space, the visitor . . . feels as if subway doors were forever just closing on what the artist was about to say to him."[130] If Kaufmann was annoyed by the installation, it held certain advantages for others, as Emily Genauer reported in the *New York World-Telegram*, "the machine which rotates the pictures by Klee allows you ten seconds in which to study each one. For most Klees that's just about right too."[131]

Genauer's opinion notwithstanding, some of those revolving Klees would have struck a responsive chord in Gottlieb, Newman, Rothko, and Pollock. Klee's *Male and Female Plant* (1921; fig. 26), in particular, is an image very near to the concerns of the New York painters. Its blurred and spotted surface combines with tentacled plant "machinery" in a fusion of sexuality and generation that suggests the beginnings of life. Indeed, it is close to much of their early work, such as Newman's *The Blessing* (1944; fig. 27). Klee's *The Magic Garden* (1926; fig. 28), also a "ten second" painting, does not immediately bring to mind the work of any of the Americans, yet its scratched, densely layered surface, simultaneously asserting the flatness of the support while suggesting depths of time in which imagery is both buried and disclosed, held implications for the future work of at least Rothko and

Pollock. Another rotating picture was *Flat Landscape* (1924; fig. 29), its subtly graded horizontals of red, rust-red, and red-violet prefiguring, although in small format, Rothko's mature work. According to Kenneth Noland, Rothko and Gottlieb had first become interested in Klee's color through Milton Avery and were aware of its various uses in Klee by the time of the Art of This Century exhibition.[132]

The Klees displayed on what Kiesler called his "paternoster" were on more or less permanent view. They were part of Guggenheim's own collection and would have been especially familiar to the Americans for whom the gallery played an important role. Guggenheim's assistant was Howard Putzel, who in the previous decade had recognized Klee on the West Coast. On Putzel's advice Guggenheim put Pollock under contract and became Rothko's representative.[133] Baziotes, Hofmann, Motherwell, Pollock, Rothko, Richard Pousette-Dart, and Clyfford Still had their first one-man shows under Guggenheim's aegis. Since she was married to Max Ernst, her gallery became a meeting place for the Surrealist emigrés, as well as for the New York artists.

While the Americans were interested in the Surrealist premise that the probing of dream and the unconscious was the means to a deeper projection of reality, they were put off by Surrealism's illusionist, academic side. Nor could they accept what seemed Surrealism's antithesis, "pure" geometric abstraction. They needed a mediating principle. In 1944 Sidney Janis defined the problem while softening its edges when he wrote: "Although Abstraction and Surrealism are considered counter-movements in twentieth-century painting, especially by the painters themselves, tendencies in both parallel each other and at times overlap so that there is a fusion of elements from each."[134] The polarities of what Janis called "these apparently antipodal" modes were symbolized in New York by

105

Fig. 26. Paul Klee. *Male and Female Plant (Weibliche und männliche Pflanze)*, 1921 / 76. Oil transfer drawing with watercolor on paper, 8¾ × 6½ in. (22.2 × 16.5 cm). Collection Mr. and Mrs. Daniel Saidenberg, New York

Fig. 27. Barnett Newman (1905–1970). *The Blessing*, 1944. Oil crayon and wax crayon, 25½ × 19⅜ in. (64.8 × 49.2 cm). Collection Mrs. Barnett Newman

Fig. 29. Paul Klee. *Flat Landscape (Ebene Landschaft)*, 1924 / 134. Gouache on Ingres paper, mounted on cardboard, 7¼ × 10½ in. (18.5 × 27 cm). Private collection

Fig. 28. Paul Klee. *The Magic Garden (Zaubergarten)*, 1926 / 141. Oil on gypsum-plaster-filled wire mesh, mounted in wood frame, 20½ × 16⅝ in. (50.2 × 42 cm). Peggy Guggenheim Collection, Venice, The Solomon R. Guggenheim Foundation

the physical presence of the Surrealists and Mondrian. Klee's presence was only virtual, but it was widespread and constant, bracketing the decade. After the flurry of Klee exhibitions at the beginning of the forties, he was to be seen in at least one solo exhibition per year from 1943 until his third and largest retrospective at The Museum of Modern Art in 1949. Not only was his work on nearly constant view at Nierendorf's, but in the midforties it was the subject of a great many publications: in 1944, the translation of his *Pedagogical Sketch Book* and a catalog of his graphic work prefaced by James Thrall Soby; in 1945, an expanded edition of the Modern's 1941 catalog, a translation of Grohmann's 1934 drawings book, and a Klee issue of *Cahiers d'Art*. And there were many more.

Sidney Janis reported on the impact of Klee's presence in 1944 in words that bring back Greenberg's remark: "Whether they were conscious of it or not everyone was learning from Paul Klee." Janis who had gone all over America researching his book *Abstract and Surrealist Art in America*, found that "a realization emerges perhaps a little unexpectedly . . . if there is any artist after Picasso, the character of whose work runs through twentieth-century American painting . . . like a recurring theme, it is Klee."[135] Motherwell recently recalled that Janis had told him much the same thing. It "makes sense," Motherwell reflected, "because Klee can be admired equally by one with an 'abstract' orientation and by someone else with a 'Surrealist' orientation. Moreover, he fitted perfectly the idea that automatism was the road to one's personal iconography, without, at the same time (as some of the official Surrealists did) ignoring 'painterly' considerations."[136]

For artists who found their mature styles after the period Motherwell refers to, Surrealism was less an issue. By the late forties its emigré propo-

nents had returned to Europe, and its useful ideas had been assimilated into advanced American painting. Klee, however, was as visible a presence as he had been earlier in the decade, but now his late, larger-scaled gestural work with its prominent use of heavy black line was far more available than it had been during the war. The visual parallel between Klee's work of this type and the painting of Franz Kline is obvious, but the claim that the impact on Kline of

Fig. 30. Paul Klee. *Injured (Verletzt)*, 1940 / 316 (H 16). Black paste on paper, mounted on cardboard, 16⅜ × 11⅝ in. (41.7 × 29.5 cm). Kunstmuseum Bern, Paul Klee Stiftung

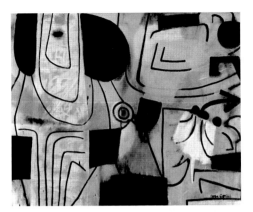

Fig. 31. Adolph Gottlieb (1903–1974). *Figurations of Clangor*, 1951. Oil, gouache, and tempera on unsized burlap, 48 × 60 in. (121.9 × 152.4 cm). © 1980 Adolph and Esther Gottlieb Foundation, Inc., New York

Fig. 32. Paul Klee. *Red Vest (Rote Weste)*, 1938. Colored paste on burlap, 25½ × 17 in. (65 × 43 cm). Kunstsammlung Nordrhein-Westfalen, Düsseldorf

Fig. 33. Kenneth Noland (born 1924). *Red Space × Vibrations = Combustion*, 1951–52. Oil on board, 30½ × 21½ in. (77.4 × 54.6 cm). Collection Harry and Christa Noland

The Museum of Modern Art's 1949–50 Klee exhibition "was immediate and decisive"[137] should perhaps be viewed with skepticism.[138] It is, however, inarguable that Kline's stylistic shift between 1947 and 1950 was coincidental not only with the Modern's exhibition but also with several important exhibitions at Nierendorf's and at Valentin's Buchholz Gallery. And a comparison of Klee's *Injured* (1940; fig. 30) and *Kettledrummer* (fig. 2), both in the 1949 exhibition, with Kline's black-and-white bar style of 1950 is persuasive.

Another link to Klee in Kline's shift to abstraction came through Bradley Walker Tomlin, whose influence has been cited as important to Kline during 1949.[139] Tomlin, whose first one-man show in New York was at the Anderson Galleries in 1923, had probably known Klee's work longer than any other New York painter, although he did not begin to incorporate distinctly Kleelike calligraphy and glyphs into his painting until his own conversion to abstraction around 1947. The plot thickens if we consider that Gottlieb believed Tomlin's use of abstract, cryptic signs and motifs such as letters, arrows, and crosses to have been borrowed from him; there is little question that Klee's use of the same symbols had been a source for Gottlieb himself.

To a degree Gottlieb's art provides a formal bridge between the color-field and gestural sides of New York painting. Klee, whose own work ran the gamut between these extremes, is less subsumed in Gottlieb's mature painting than in that of any of the other "first generation" Americans. Perhaps the range of Gottlieb's stylistic accommodations accounts for the fact that Klee-related elements appeared in his art throughout his career as, for instance, in *Figurations of Clangor* (1951; fig. 31), the composition of which is close to such late Klees then in New York as *Red Vest* (1938; fig. 32).[140]

The implications of Klee's art extend well beyond those it held for painters who reached artistic maturity around 1950. Echoes of it resonate in the work of such diverse artists as Cy Twombly, Jasper Johns, and even Sol LeWitt. Kenneth Noland freely acknowledges that Klee's work was an important source, and much of Noland's early work, such as *Red Space × Vibrations = Combustion* (1951–52; fig. 33) bears this out.[141] Noland was particularly interested in Klee's color, which he has called "a fantastic language" with a range "the others didn't have." More unexpectedly, he singled out Klee's space as a remarkable aspect of his art; "in Klee there is a projection of size that's larger than it is small. . . . It's an enormous space."[142]

It is beyond the scope of this essay to comprehend in any detail the interaction of Klee and American art after midcentury; however, an observation Noland made about his desire to get back to the United States in 1948 after a year spent studying in Paris is relevant: "They [the French]," he said, "knew about Picasso very much and about Matisse and Miró, but they knew nothing about Paul Klee or Mondrian. And over here we had known about Mondrian and Klee and assumed that they were of equal stature with the so-called French School of

Painting."[143] Noland's observation is affirmed by the French critic Michel Seuphor, writing for the 1951 publication *Modern Artists in America*, edited by Robert Motherwell and Ad Reinhardt:

I said earlier that young American painting made its entry into the world only a few years ago. However, it has had a long pre-history that is also a long and serious education . . . the influence of Marcel Duchamp has been predominant ever since the exhibition at the Armory in 1913. In 1920 Katherine Dreier collaborated with Duchamp and Man Ray in founding the Société Anonyme, a prodigious collection that at present contains the works of all the painters who have won distinction in abstract art between 1910 and 1945 . . . at about the same time [1920 sic] A. E. Gallatin began the collection . . . The Museum of Living Art . . . now in Philadelphia. A third collection which cannot be slighted is the one sponsored by the Guggenheim Foundation (The Museum of Non-Objective Painting) directed by Hilla Rebay. . . . Last in chronological order, but already tending to surpass the others in importance, is the collection of the Museum of Modern Art. . . . To give an example of America's discernment . . . I need only say that each of these four museums has owned for a long time important canvasses by Mondrian, a painter absent from the Museums of France.[144]

Mondrian was Seuphor's particular passion, but his remarks would have been equally accurate had he used the example of Klee. By midcentury the vision of collectors and enthusiasts combined with the course of history had made of America the functional "Klee capital" of the world.

Abstract Expressionism was the product of a long, complex generative process, but there can be no doubt that Klee's art played a role in its evolution. John Ferren, one of the participants in that process, described some of its particulars: "It was an art of the individual, lonely and in rebellion . . . a question of finding . . . your own answers. . . . We discovered a simple thing, yet far reaching in its effects. 'The search is the discovery.' Picasso had said 'I don't search. I find.' We lacked the confidence for such an arrogant remark. We discovered instead that searching was itself a way of art."[145] Klee's self-interrogatory art, constantly seeking new formal solutions to carry the fullest weight of meaning, was a living example of art as search.

Klee's explorations of pictorial form were always undertaken to achieve the greatest expressive content, yet his art stands as a somewhat ironic paradigm of the principle that holds modernism to be capable of meaningful content only as the product of vigilant, formal self-criticism. If the paradigmatic emphasis seems off, Klee nonetheless vastly extended the competence of the means of painting to recapitulate the physical and spiritual drama of human existence. His immensely rich art put him at the source from which "many different minds and temperaments" could draw. In 1949, Barr excoriated those who dogmatically asserted that one style was better than another, declaring in homage to Paul Klee that no one kind of art provided "the only funicular up Parnassus."[146]

Notes

1. Letter of December 12, 1936, in "Kandinsky und Klee: Aus dem Briefwechsel der beiden Künstler und ihrer Frauen—1912–1914," *Berner Kunstmitteilungen* (Bern), nos. 234–36 (December 1984–February 1985), ed. Dr. Sandor Kuthy with notices by Stefan Frey, p. 17.
2. Arthur Jerome Eddy, *Cubists and Post-Impressionism* (Chicago: A. C. McClurg, 1914), p. 88. The title of the watercolor may have been mistranslated, as Klee recorded it in his oeuvre catalogue as *Haus bei der Brücke* (*House by the Bridge*).
3. Henry A. LaFarge, "Klee: The Old Magician in a New U.S. Look," *Art News* (New York), vol. 48, no. 2 (April 1949), p. 42.
4. A notable exception is Andrew Kagan, in "Paul Klee's Influence on American Painting," Part I, *Arts Magazine* (New York), vol. 49, no. 10 (June 1975), pp. 54–59, and Part II, *Arts Magazine*, vol. 50, no. 1 (September 1975), pp. 84–90.
5. Eddy, p. 4.
6. Cited by Rudi Blesh, in *Modern Art U.S.A.* (New York: Knopf, 1956), p. 56. In 1913 Klee's work, still in a developmental stage, was insufficiently known to have been included in the Armory Show.
7. *The Diaries of Paul Klee, 1898–1918*, edited and with an introduction by Felix Klee (Berkeley and Los Angeles: University of California Press, 1964), Diary III, no. 585, p. 162. First German edition: *Tagebücher von Paul Klee*, edited by Felix Klee (Cologne: M. DuMont Schauberg, 1957).
8. *Diaries*, p. 318, III, no. 961.
9. *Diaries*, p. 194, III, no. 747. See essay by O. K. Werckmeister, in this book for Klee's involvement with the *Räterepublik*.
10. *Pädagogisches Skizzenbuch* (Munich: Langen, 1925), IIII. 37, p. 44, as translated by Renate Franciscono, in Jürgen Glaesemer, *Paul Klee: The Colored Works in the Kunstmuseum Bern* (Bern: Kornfeld, 1979), p. 150. See also *Paul Klee Pedagogical Sketch Book*, translated by Sibyl Peech (New York: Nierendorf, 1944), IIII.37.
11. Cited in Glaesemer, p. 135.
12. Marc Seize, "Paul Klee," *L'Art d'Aujourd'hui* (Paris: Albert Morancé, 1929), p. 18.
13. William Seitz, *Abstract Expressionist Painting in America* (Cambridge, Massachusetts, and London: Harvard University Press, 1983), p. 159. Seitz's book was written in 1955 as a doctoral dissertation for Princeton University and was available on microfilm and in typescript prior to its publication in 1983.
14. Barnett Newman, "The First Man Was an Artist," *The Tiger's Eye* (New York), no. 1 (October 1947), p. 59.
15. "What Abstract Art Means to Me," *Museum of Modern Art Bulletin* (New York), vol. 18, no. 3 (Spring 1951), p. 4.
16. "The Renaissance and Order," *Trans/formation* (New York), vol. 1, no. 2 (1951), p. 87.
17. *Diaries*, p. 310, III, no. 941. In German: "Ingres soll die Ruhe geordnet haben, ich möchte über das Pathos hinaus die Bewegung ordnen" *Tagebücher*, p. 314).
18. *Diaries*, p. 176, III, no. 633.
19. As cited in Glaesemer, pp. 132–33.
20. Glaesemer, p. 135.
21. Paul Klee, *On Modern Art*, translated by Paul Findlay, with introduction by Herbert Read (London: Faber and Faber, 1948), p. 54. Prepared for a lecture delivered at the opening of an exhibition at the museum in Jena, East Germany, 1924. First published as *Uber die moderne Kunst* (Bern-Bümpliz: Benteli, 1945).
22. Harold Rosenberg, "Art as Thinking," in *Artworks and Packages* (Chicago and London: University of Chicago Press, 1982), p. 44. First edition: New York: Horizon Press, 1969.
23. Cited in *Commemorating the 50th Anniversary of The Forum Exhibition of Modern American Painters: March 1916*, ACA Heritage Gallery, New York, March 14–April 9, 1966, n.p.
24. Société Anonyme (S.A.) Exhibition 14, March 15–April 12, 1921, and S.A. 22, February 5–22, 1923. For a complete list of exhibitions sponsored by the Société Anonyme, see *The Société Anonyme and the Dreier Bequest: A Catalogue Raisonné*, edited by Robert L. Herbert, Eleanor S. Apter, and Elise K. Kenney (New Haven, Connecticut) and London: Yale University Press, 1984), pp. 776–79.
25. Henry McBride, "Notes and Activities in the World of Art," *New York Sun*, January 13, 1924.
26. Max Ernst, *Ecritures* (Paris: Gallimard, 1970), pp. 38–39.
27. "Souvenirs of Marcel Duchamp," in Robert Lebel, *Marcel Duchamp*, translated by George Heard Hamilton (New York: Grove Press, 1959), p. 85. French edition: *Sur Marcel Duchamp* (Paris: Trianon Press, 1959).
28. *Collection of the Société Anonyme: Museum of Modern Art 1920*, edited by George Heard Hamilton (New Haven, Connecticut: Yale University Art Gallery, 1950), p. 101.
29. Cited in Margaret Sterne, *The Passionate Eye: The Life of William R. Valentiner* (Detroit: Wayne State University Press, 1980), pp. 143–44.
30. Cited in Sterne, p. 144.
31. With "Comment" by Ladislas Medgyes, *Broom*, vol. 4, no. 3 (February 1923), pp. 171, 179, 181, 212–13.
32. Conversation with the author, January 1975.
33. Cited in *Brassaï: The Artists of My Life*, translated by Richard Miller (New York: Viking, 1982), p. 143. Miró gave conflicting dates and accounts of the events surrounding his discovery of the work of Paul Klee. Clement Greenberg, in *Joan Miró* (New York: Quadrangle, 1948), pp. 27–28, reports: "I would have conjectured that Klee had already exerted some influence on the mood and calligraphy of the *Tilled Field* though Miró himself has assured me that Klee's art did not come into his ken until he had finished the pictures he began in 1923." In *Ceçi est la couleur de mes rêves, entretiens avec Georges Raillard* (Paris: Seuil, 1977), p. 68, Raillard quotes Miró as saying his first encounter with Klee's work was in 1923 after he had seen reproductions. In Brassaï's citation, no date is given; however, Miró relates his encounter with Klee to his move (in late 1922) into the studio next to Masson's. In this account Miró remembered seeing actual works by Klee immediately after seeing reproductions. This, however, runs counter to his earlier recollections and is at odds with Masson's emphatically stated account that they saw work by Klee a considerable time after finding Hausenstein's book.
34. Hans Hofmann, "The Digest Interviews Hans Hofmann," *The Art Digest* (New York), vol. 19, no. 13 (April 1, 1945), p. 52. Greenberg, *Joan Miró*, pp. 27–28.
35. André Masson, "Eloge de Paul Klee," *Fontaine* (Paris), no. 53 (June 1946), pp. 105–08. Reprinted in André Masson, *Le Plaisir de peindre* (Paris, 1950) and in English translation as "Homage to Paul Klee," in *Partisan Review* (New York), vol. 14, no. 1 (January–February 1947), pp. 59–61, and as *Eulogy of Paul Klee* (New York: Curt Valentin, 1950).
36. Letter, K. 1924–1, in Galka Scheyer Blue Four Archive, Norton Simon Museum, Pasadena, California.
37. Scheyer Archive, K. 1924–4. Undated letter from Paul Klee to Galka Scheyer.
38. Archives of the Société Anonyme, incorporating the papers of Katherine S. Dreier, Collection of American Literature, The Beinecke Rare Book and Manuscript Library, Yale University, New Haven, Connecticut.
39. Scheyer Archive, K. 1924–12.
40. Scheyer Archive, K. 1925–2.
41. Scheyer Archive, K. 1930–3. The date of the letter can be read as "April 22 nd 30" or "April 28 nd 30."
42. Scheyer Archive, K. 1930–2.
43. Société Anonyme Archives, letter, Dreier to Klee, March 30, 1926.
44. Société Anonyme Archives, letter, Klee to Dreier, April 16, 1926.
45. Thomas Hart Benton, "New York Exhibitions," *The Arts* (New York), vol. 11, no. 1 (January 1927), p. 49.
46. Clement Greenberg, "The Late Thirties in New York," *Art and Culture* (Boston: Beacon, 1961), p. 232.
47. Sheldon Cheney, *A Primer of Modern Art* (New York: Boni and Liveright, 1927), pp. 70, 86, 170, 171, 172. First printing, January 1924.
48. Cheney, p. 201.
49. *39 aquarelles de Paul Klee*, Galerie Vavin-Raspail, Paris, October 21–November 14, 1925.
50. *La Peinture surréaliste*, Galerie Pierre, Paris, November 14–25, 1925. Other artists were Hans Arp, Max Ernst, André Masson, Joan Miró, Man Ray, and Pierre Roy.
51. François Chapon, *Mystère et splendeurs de Jacques Doucet* (Paris: J.-C. Lattès, 1984), pp. 289, 295.
52. Will Grohmann, *Paul Klee* (Paris: Cahiers d'Art, 1929).
53. *Das Kunstblatt*, vol. 11, no. 10 (1927), p. 379.
54. Scheyer Archive, K. 1930–5.
55. Joan M. Lukach, *Hilla Rebay: In Search of the Spirit in Art* (New York: Braziller, 1983), p. 54.
56. According to Lukach, p. 41, because of lack of space, "the 'objective' paintings by the 'precursors' to the non-objective [Rebay assigned Klee to this category] remained in the Guggenheim suite at The Plaza Hotel where they were available to the interested viewer." The records of The Solomon R. Guggenheim Museum do not reveal when Klee's work was first put on view in the museum itself.
57. Forbes Watson, "Editorial," *The Arts* (New York), vol. 9, no. 5 (1926), p. 240.
58. *Gallery of Living Art* (Paris: Horizons de France, 1930), n.p.
59. *Ibid.*
60. Jacques Mauny, in Preface, *Ibid.*
61. Alfred H. Barr, Jr., Papers, The Museum of Modern Art Archives, New York.
62. In exhibition catalog *Paul Klee*, The Museum of Modern Art, New York, March 13–April 2, 1930, p. 8.
63. Manuscript dated 1958 in the files of The Museum of Modern Art, p. K3.
64. *Paul Klee*, 1930, p. 9.
65. "Tradition and the Individual Talent" (1919), in *Selected Prose of T. S. Eliot*, edited and with an introduction by Frank Kermode (New York: Harcourt Brace Jovanovich / Farrar, Straus and Giroux, 1975), p. 41.
66. "Modern Museum Shows Weber, Klee, Maillol, Lehmbruck," *Art News* (New York), vol. 28, no. 24 (March 15, 1930), p. 11.
67. Forbes Watson, "In the Galleries," *The Arts* (New York), vol. 16, no. 8 (April 1930), p. 568.
68. Henry McBride, *New York Sun*, March 15, 1930.
69. Flora Turkel-Deri, "Berlin Letter," *Art News* (New York), vol. 28, no. 31 (May 3, 1930), p. 14.
70. Undated letter in files of Paul Klee Stiftung, Kunstmuseum Bern, Switzerland.
71. Will Grohmann, "Paul Klee in New York," *Der Cicerone* (Leipzig), no. 22 (1930), p. 11.
72. Facsimile reproduced in *Vanity Fair: A Cavalcade of the 1920's and 1930's*, edited by Cleveland Amory and Frederic Bradlee (New York: Viking, 1960), pp. 186–87.
73. Frederick P. Keppel and R. L. Duffus, *The Arts in American Life* (New York and London: McGraw Hill, 1933), pp. 120–22.
74. *Blue Four*, California Palace of the Legion of Honor, San Francisco, n.p. (Kandinsky and Feininger, April 8–22; Jawlensky and Klee, April 23–May 8, 1931).
75. *Paul Klee*, Braxton Gallery, Hollywood, California,

The second digit is typed over so that it reads as both an "8" and a "2."

109

May 1–15, 1930, p. 13.

76. Cited in Lukach, p. 83.

77. As reported in *The Société Anonyme and the Dreier Bequest at Yale*, p. 17.

78. *German Painting and Sculpture*, The Museum of Modern Art, New York, March 13–April 26, 1931, p. 7.

79. *German Painting and Sculpture*, p. 15.

80. Alfred H. Barr, Jr., "Die wirkung der deutschen Ausstellung in New York," *Museum der Gegenwart* (Berlin), no. 2 (1931), p. 60.

81. "Deutschen Ausstellung in New York," p. 66.

82. *German Painting and Sculpture*, p. 27.

83. Alfred H. Barr, Jr., "1933: The Battle Band for German Culture," *Magazine of Art* (Washington, D.C.), Special Issue Devoted to Art in the Third Reich, vol. 38, no. 6 (October 1945), p. 218. This is one of four articles Barr wrote in Ascona, Switzerland, in May 1933 after four months in Stuttgart.

84. Although one of Barr's four articles (see n. 83) was published in *Hound and Horn* in 1934 ("Notes on the Film: Nationalism in German Films"), at the time Barr was unable to find a publisher for the other three, which, according to Jacques Barzun in the above-cited issue of *Magazine of Art* (p. 211), "accumulated bored rejection slips from our best magazines."

85. Professor Waldschmidt of the Kampfbund für deutsche Kultur, cited in Barr, "The Battle Band," p. 218. O. K. Werckmeister, translates this as "Fighting League for German Culture."

86. For an interpretation and discussion of Klee's art and state of mind in 1933, see Werckmeister's essay in this book.

87. "Kandinsky und Klee: Briefwechsel" (see n. 1, above), p. 14, letter no. 39, February 1935.

88. *Ibid.*, letter no. 40, February 1935.

89. *Ibid.*, letter no. 37, December 16, 1934.

90. Cited in Martin Duberman, *Black Mountain: An Exploration in Community* (New York: Dutton, 1972), p. 60. Duberman's source is the manuscript in the Black Mountain Archives, Raleigh, North Carolina, of Albers's lecture "The Meaning of Art," delivered at Black Mountain College, May 6, 1940. See also Josef Albers, *Interaction of Color*, rev. ed. (New Haven, Connecticut, and London: Yale University Press, 1975), p. 5.

91. Letter from Solman to Diane Waldman, November 15, 1977; cited in *Mark Rothko, 1903–1970: A Retrospective* (New York: The Solomon R. Guggenheim Museum, 1978), p. 31.

92. This type of "surrealist" Rothko watercolor has not infrequently been compared with works by Miró. Robert Rosenblum ("Notes on Rothko's Surrealist Years," in exhibition catalog *Mark Rothko*, The Pace Gallery, New York, April 24–May 30, 1981, pp. 7–8) specifically compares work of Rothko's Surrealist period with Miró's *The Family* (1924; reproduced by William Rubin, in *Miró in the Collection of The Museum of Modern Art* [New York, 1973], p. 29), which itself almost certainly has a source in Klee (see John Elderfield, *The Modern Drawing* [New York: The Museum of Modern Art, 1983], pp. 154, 182). Rosenblum singles out *The Family* as "atypically clouded by visible ghosts. For Rothko, this shadowy sense of after-image and atmosphere must have been compatible with his own evocations of a filmy, submarine environment whose dimly discernible inhabitants might vanish in the strong sunlight which customarily floods Miró's art." By contrast, Klee's ink-transfer watercolors of the early twenties, such as *Abstract Trio* (fig. 16), *Male and Female Plant* (fig. 26), and *Twittering Machine* (p. 172), which were well known in New York, are characterized by aqueous, filmy grounds. It is also to be remarked that in its quality and sensibility, Rothko's line is closer to Klee's than Miró's.

93. "Sincerity, Incredible Fantasy in Klee's Art," *The Art Digest* (New York), vol. 9, no. 12 (March 15, 1935), p. 13.

94. Scheyer Archive, K. 1935–4.

95. Scheyer Archive, K. 1935–7.

96. Quoted in *Selected Paintings by the late Arshile Gorky*, Samuel Kootz Gallery, New York, March 28–April 24, 1950.

97. Seitz, p. 152.

98. Glaesemer (see above, n. 10), p. 32.

99. Cited in Glaesemer, p. 32.

100. Leo Steinberg, "The Eye Is a Part of the Mind," *Other Criteria: Confrontations with Twentieth Century Art* (New York: Oxford University Press, 1972), p. 289.

101. "Like Decorations in a Nigger Cemetery (for Arthur Powell)," *The Collected Poems of Wallace Stevens* (New York: Knopf, 1977), p. 151.

102. Seitz, p. 159.

103. *Ralph Waldo Emerson: Complete Works*, vol. 3 (New York: AMS Press, 1968), p. 20.

104. *Cubism and Abstract Art*, The Museum of Modern Art, New York, March 2–April 19, 1936.

105. *Fantastic Art, Dada, Surrealism*, The Museum of Modern Art, New York, December 7, 1936–April 19, 1937.

106. Charmion von Wiegand, "The Surrealists," *Art Front* (New York), January 1937, p. 13.

107. Letter of April 6, 1938, Duncan Phillips Archive, The Phillips Collection, Washington, D.C.

108. Curt Valentin Archive, The Museum of Modern Art, New York.

109. Letter, Paul Klee Stiftung, Bern.

110. Valentin Archive. *Around the Fish* entered the collection of The Museum of Modern Art in 1939 and *Vocal Fabric*, in 1955.

111. Jeannette Lowe, "Of the Mortal Klee: Memorial View of the Wittiest Surrealist," *Art News* (New York), vol. 39, no. 2 (October 12, 1940), pp. 12, 15–16.

112. "A Conversation with Clement Greenberg," *Art Monthly* (New York), no. 73 (February 1984), p. 5.

113. Clement Greenberg, "On Paul Klee 1879–1940," *Partisan Review* (New York), vol. 8, no. 3 (May–June 1941), pp. 225, 228.

114. *Magazine of Art* (Washington, D.C.), vol. 39, no. 4 (April 1946), pp. 127–30.

115. Cited by Francis V. O'Connor, in "The Life of Jackson Pollock, 1912–1956: A Documentary Chronology," *Jackson Pollock: A Catalogue of Paintings, Drawings, and Other Works*, vol. 4, edited by Francis Valentine O'Connor and Eugene Victor Thaw (New Haven, Connecticut, and London: Yale University Press, 1978), p. 251.

116. Cited in Jacob Kainen, "An Interview with Stanley William Hayter," *Arts Magazine* (New York), vol. 60, no. 5 (January 1986), p. 65.

117. *Picasso: Forty Years of His Art*, November 15, 1939–January 7, 1940; *Joan Miró*, November 18, 1941–January 11, 1942.

118. Interview with the author and Ann Temkin, December 5, 1985.

119. Cited in Kainen, p. 66.

120. Cited in O'Connor, vol. 4, D 90, p. 253.

121. In addition to Hayter's comments above (n. 116), he told the author (n. 118), that he found Klee's influence to have been "even greater" than Picasso's. Cited above (n. 113) is one of several instances of Greenberg's comparing Klee and Picasso (usually to the detriment of Klee's quality but not to his influence). Sidney Janis's comments are on page 106, above. Others, *inter alia*, who have made the comparison with at least an oblique reference to midcentury American painting are A. D. B. Sylvester (in "Auguries of Experience," *The Tiger's Eye* [New York], vol. 1, no. 6 [December 1948], p. 49), who wrote: "Klee's method of composition is dramatically opposed to that of the Renaissance and therefore Picasso"; James Thrall Soby (in an unpublished letter of April 18, 1950, files of The Museum of Modern Art), who stated: "Klee seems to me one of the few very great artists our century has produced, and whose influence on younger painters of talent is perhaps greater than that of any other contemporary master except possibly Picasso." Mark Tobey (according to Selden Rodman, in *Conversations with Artists* [New York: Devin-Adair, 1957], p. 18), asserted:

"Picasso and Klee are the greatest artists of our age because they are the *freest*. There's most variety, most scope in their work. They never stop inventing. They don't make art that seals itself in one invention. . . . Miró, for example, good as he is, has wound up with a predictable style. We've now come to expect the crosses and free forms, and there they are, every time. I can never be sure what Klee or Picasso will do next." Lazlo Glozer made an extended comparison of Klee and Picasso in "Der Weltkrieg und die Moderne, Panorama 1939," in *Westkunst: Zeitgenössische Kunst seit 1939* (Cologne: DuMont, 1981), pp. 24–30, observing: "Both are in different ways major figures of the century." Glozer went on to say that Klee "also had more influence on the generation after the war, on the artists," and that "the range of the modern is represented by the extreme poles of Picasso and Klee." Evidently without reference to American painting, Alfred H. Barr, Jr., made the comparison in 1941 (exhibition catalog *Paul Klee*, The Museum of Modern Art, New York, June 30–July 27, p. 6), writing: "Not even Picasso approaches him in sheer inventiveness. In quality of imagination also he can hold his own with Picasso; but Picasso of course is incomparably more powerful. Picasso's pictures often roar or stomp or pound; Klee's whisper a soliloquy—lyric, intimate, incalculably sensitive."

122. In Max Kozloff, "An Interview with Matta," *Artforum* (Los Angeles), vol. 4, no. 1 (September 1965), p. 26. Klee's and Matta's spatial renderings are compared by William S. Rubin in *Dada and Surrealist Art* (New York: Abrams, 1968), p. 332, to that of Miró, whose *Painting* (1933; reproduced *ibid.*, p. 333), Rubin observes, suggests "an illusionistic atmospheric space much like Klee's and adumbrating certain of Matta's effects in 1944."

123. Robert Goldwater, *Primitivism and Modern Painting* (New York: Harper, 1938), p. 155.

124. Sylvester, "Auguries of Experience," p. 49.

125. Cited in O'Connor, vol. 4, D 85, p. 297.

126. Rosamond Frost, "Klee: Pigeons Come Home to Roost," *Art News* (New York), vol. 41, no. 8 (June–July 1942), pp. 24–25.

127. For a discussion of Klee and Tobey, see Kagan (n. 4, above), Part I, pp. 56–57. The relevance of Klee's work to Tobey's has been pointed out by many commentators, among them Greenberg, who referred to both Morris Graves and Tobey as "products of the Klee school" (*Horizon* [New York], vol. 16, no. 93 [October 1947], p. 25). Tobey himself has commented on Klee: "Anyway, I don't resemble anyone but have some kin [ship] to Klee" (letter to Marian Willard, May 1958, in exhibition catalog *Mark Tobey*, Musée des Arts Décoratifs, Paris, 1961). Tobey had probably seen Klee's work as early as the late twenties when he was living in Seattle and Scheyer's Blue Four exhibitions were touring the West Coast.

128. "Concerning the Beginnings of the New York School: 1939–1943: An Interview with Robert Motherwell Conducted by Sidney Simon in New York in January 1967," *Art International* (Lugano), vol. 12, no. 6 (Summer 1967), p. 21.

129. *Diaries*, p. 112, II (Italian Diary), no. 406.

130. Edgar Kaufmann, Jr., "The Violent Art of Hanging Pictures," *Magazine of Art* (Washington, D.C.), vol. 39, no. 3 (March 1946), p. 109.

131. "Surrealist Paintings Hung Surrealistically," *New York World-Telegram*, October 24, 1942.

132. Interview with the author and Ann Temkin, November 14, 1985.

133. Irving Sandler, *The Triumph of American Painting: A History of Abstract Expressionism* (New York and Washington: Praeger, 1970), p. 33.

134. Sidney Janis, in the exhibition catalog *Abstract and Surrealist Art in the United States*, published by The San Francisco Museum of Art, 1944, p. 16. The exhibition traveled to Cincinnati, Denver, Seattle, Santa Barbara, and San Francisco during 1944.

135. *Idem.*

136. Letter to the author, November 14, 1985.

137. Kagan (n. 4), Part II, p. 84.

138. Harry F. Gaugh, in the exhibition catalog *The Vital Gesture: Franz Kline*, Cincinnati Art Museum, November 27, 1985–March 2, 1986, p. 97, discounts Kagan's assertion (n. 137) that Klee had an immediate impact on Kline at the time of The Museum of Modern Art 1949–50 exhibition. It is unlikely that Kline would have known Klee's *The Cupboard*, as is conjectured by Gaugh and implied by Kagan, as the picture was not in the Modern's exhibition.

139. Gaugh, pp. 85–86.

140. For a discussion of Gottlieb and Klee, see Kagan, Part II, pp. 85–87. References to the possible influence of Klee on Gottlieb are to be found throughout the Gottlieb literature.

141. For a discussion of Klee and Noland, see Diane Waldman, in exhibition catalog *Kenneth Noland: A Retrospective*, The Solomon R. Guggenheim Museum, New York, April 15–June 19, 1977, pp. 12–16. See also Kagan, Part II, pp. 87–88.

142. Interview, November 14, 1985.

143. Cited in Waldman, p. 13.

144. Michel Seuphor, "Paris New York 1951," *Modern Artists in America*, edited by Robert Motherwell and Ad Reinhardt, First Series (New York: Wittenborn Schultz, 1952), p. 119.

145. "Epitaph for an Avant-Garde," *Arts Magazine* (New York), vol. 33, no. 2 (November 1958), p. 25.

146. Response to questions posed by Robert Goldwater, in "A Symposium. The State of American Art," *Magazine of Art* (Washington, D.C.), vol. 42, no. 1 (January 1949), p. 85.

PLATES

German titles are the artist's. Dates are followed by the inventory number that Klee assigned to each of his works. All titles, dates, and inventory numbers were recorded in the artist's oeuvre catalogue, now in the Paul Klee Stiftung of the Kunstmuseum Bern. Klee began this detailed listing of his production in 1911, retroactively included works dating back to 1883, and maintained it through May 1940. In the dimensions, height precedes width.

114 **Untitled (Family Outing)**
Ohne Titel (Familienspazierfahrt)
1883 / N
Pencil on paper, 11⅛ x 7¼ in.
(28.2 x 18.4 cm)
Private collection, Switzerland

Child's Drawing, Representing Five Sisters
Kinderzeichnung, fünf Geschwister darstellend
ca. 1885
Pencil and colored grease crayon on paper, mounted on cardboard,
6⅛ x 5½ in. (15.6 x 14 cm), irregular
Private collection, Switzerland

Clock with Roman Numerals
Uhr mit römischen Zahlen
1884 / 16
Pencil and colored crayon on paper, mounted on cardboard, 4⅞ x 7 in.
(12.5 x 18 cm)
Kunstmuseum Bern, Paul Klee Stiftung

Lady with Parasol
Dame mit Sonnenschirm
1883–85 / 15
Pencil on paper, mounted on cardboard with two other childhood drawings,
4⅜ x 3¼ in. (11.2 x 8.2 cm), irregular
Kunstmuseum Bern, Paul Klee Stiftung

**Self-Portrait with the White Cap,
after Nature**
Selbstportrait mit der weissen
Sportmütze, nach Natur
1899 / 1
Pencil on paper, 5½ x 4¾ in.
(14 x 12 cm)
Private collection, Switzerland

A Notorious Masculine Woman
Ein berüchtigtes Mannweib
From the studies and sketches at Knirr's,
Munich
1899
Pencil on paper, 12¾ x 8¼ in.
(32.5 x 21 cm)
Kunstmuseum Bern, Paul Klee Stiftung

Virgin in a Tree
Jungfrau im Baum
Invention 3
1903 / 2
Etching, 9⁵⁄₁₆ x 11¹¹⁄₁₆ in.
(28.7 x 29.7 cm)
The Museum of Modern Art, New York
Purchase Fund

**Two Men Meet, Each Believing the
Other to Be of Higher Rank**
Zwei Männer, einander in höherer
Stellung vermutend, begegnen sich
Invention 6
1903 / 5
Etching, 4⁵⁄₈ x 8⁷⁄₈ in. (11.7 x 22.6 cm)
The Museum of Modern Art, New York
Gift of Mme Paul Klee

Female and Animal
Weib und Tier
Invention 1, second version
1904 / 13
Etching, 7⅞ x 8⅞ in. (20 x 22.8 cm)
Kunstmuseum Bern, Paul Klee Stiftung

Comedian
Komiker
Invention 4
1904 / 14
Etching and aquatint, 6¹⁄₁₆ x 6⅝ in.
(15.3 x 16.8 cm)
The Museum of Modern Art, New York
Purchase Fund

118

Hero with the Wing
Held mit dem Flügel
1905 / 7
Pencil on paper, 9⅜ x 4⅞ in.
(24 x 12.5 cm)
Collection E. W. K., Bern

Hero with the Wing
Held mit dem Flügel
Invention 2
1905 / 38
Etching, 10 x 6¼ in. (25.4 x 15.9 cm)
The Museum of Modern Art, New York
Purchase Fund

Aged Phoenix
Greiser Phoenix
Invention 9
1905 / 36
Etching, 10⅜ x 7⁹⁄₁₆ in. (26.3 x 19.2 cm)
The Museum of Modern Art, New York
Purchase Fund

Portrait of a Pregnant Woman
Bildnis einer schwangeren Frau
1907 / 25
Charcoal and watercolor on paper,
9½ x 13¼ in. (24.3 x 33.9 cm)
The Brooklyn Museum, New York
Museum Collection Fund

Musical Tea Party
Musikalische Theegesellschaft
1907 / 20
Ink on glass, 6⅝ x 10 in. (17 x 25.5 cm)
Isidore Ducasse Fine Arts, Inc.,
New York

**Young Man with Pointed Beard,
Resting His Head in His Hand**
Junger männlicher Kopf, in Spitzbart,
Hand gestützt
1908 / 42
Pencil on paper, mounted on cardboard,
8⅝ x 6⅝ in. (22 x 16.9 cm)
Private collection, Switzerland

122

Clock on the Sideboard
by Candlelight
Uhr auf der Kredenz, bei Kerzenlicht
1908 / 69
Watercolor on paper, 7⅜ x 8⅛ in.
(18.7 x 20.7 cm)
Private collection, Switzerland

**Self-Portrait, Full Face, Head Resting
in the Hand**
Selbstportrait en face in die Hand
gestützt
1909 / 32
Watercolor on paper, 6½ x 5¼ in.
(16.5 x 13.5 cm)
Private collection, Switzerland

Glance in a Bedroom
Blick in eine Schlafkammer
1908 / 70
Watercolor on paper, 11¾ x 9¼ in.
(30 x 23.6 cm)
Kunstmuseum Basel

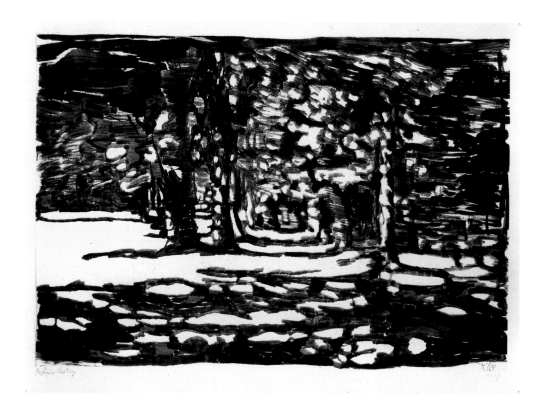

Self-Portrait: Drawing for a Woodcut
Selbst: Zeichnung zu einem Holzschnitt
1909 / 39
Ink on paper, 5¼ x 5⅝ in.
(13.3 x 14.5 cm)
Private collection, Switzerland

Well-Tended Woodland Path, Waldegg near Bern
Gepflegter Waldweg, Waldegg bei Bern
1909 / 62
India ink on linen, 6⅞ x 10⅛ in.
(17.5 x 25.7 cm)
Private collection, Switzerland

Furniture Caricature
Karikatur eines Möbels
1910 / 15
Pen and ink on paper, mounted on
cardboard, 8⅞ x 10⅜ in.
(22.5 x 26.3 cm)
Kunstmuseum Bern, Paul Klee Stiftung

Interior (Sideboard)
Interieur (Kredenz)
1910 / 14
Pen and ink on paper, mounted on
cardboard, 8¾ x 10¼ in.
(22.3 x 26.2 cm)
Private collection, Freiburg,
West Germany

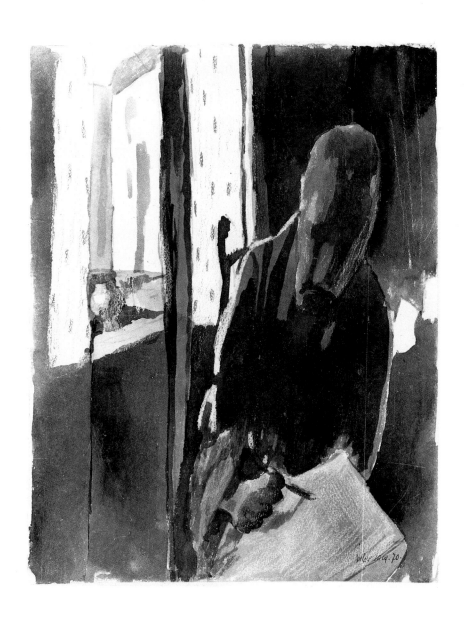

Draftsman at the Window
Der Zeichner am Fenster
1909 / 70
Watercolor and colored crayon on
paper, 11¾ x 9¼ in. (30 x 23.5 cm)
Private collection, Switzerland

Girl with Jugs
Mädchen mit Krügen
1910 / 120
Oil on cardboard, 13¾ x 11 in.
(35 x 28 cm)
Private collection, Switzerland

Top:
Candide, Chapter 5: "Quelle peut-être la raison suffisante de ce phénomène?"
1911 / 81
Pen and ink on paper, mounted on cardboard, 5⅜ x 8¾ in.
(13.7 x 22.2 cm)
Kunstmuseum Bern, Paul Klee Stiftung

Bottom left:
Candide, Chapter 9: "Il le perce d'outre en outre"
1911 / 62
Pen and ink on paper, mounted on cardboard, 5⅞ x 9⅞ in. (15 x 25.2 cm)
Kunstmuseum Bern, Paul Klee Stiftung

Bottom right:
Candide, Chapter 13: "Et ordonna au capitaine Candide d'aller faire la revue de sa compagnie"
1912 / 39
Pen and ink on paper, mounted on cardboard, 7⅜ x 9¾ in.
(18.8 x 24.7 cm)
Kunstmuseum Bern, Paul Klee Stiftung

Young Man Resting
Junger Mann, ausruhend
1911 / 42
Brush and ink on paper, mounted on
cardboard, 5⅜ x 10¼ in.
(13.8 x 26.2 cm)
Private collection, Switzerland

Youthful Self-Portrait
Jugendliches Selbstportrait
1910 / 76
Pen and brush and black watercolor on
paper, mounted on cardboard,
6⅞ x 6¼ in. (17.5 x 15.9 cm)
Private collection, Switzerland

Cunning Enticement
Listige Werbung
1913 / 56
Pen and ink on paper, mounted on
cardboard, 5⅝ x 6⅜ in.
(14.4 x 16.4 cm)
Kunstmuseum Bern, Paul Klee Stiftung

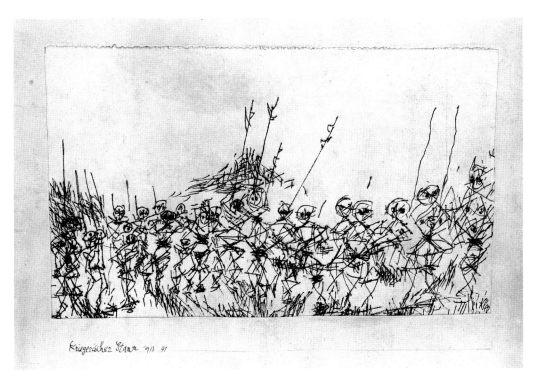

The Fleeing Policemen
Die fliehenden Polizisten
1913 / 55
Pen and ink on paper, mounted on
cardboard, 7⅝ x 6⅛ in.
(19.6 x 15.5 cm)
Kunstmuseum Bern, Paul Klee Stiftung

Belligerent Tribe
Kriegerischer Stamm
1913 / 41
Pen and ink on paper, mounted on
cardboard, 5⅝ x 9⅞ in.
(14.3 x 25.1 cm)
Staatsgalerie Stuttgart
Graphische Sammlung

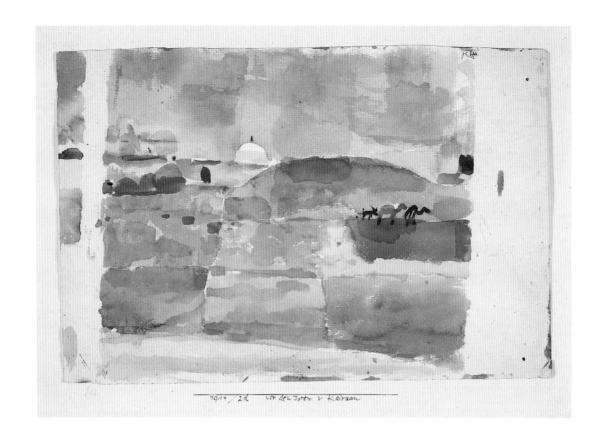

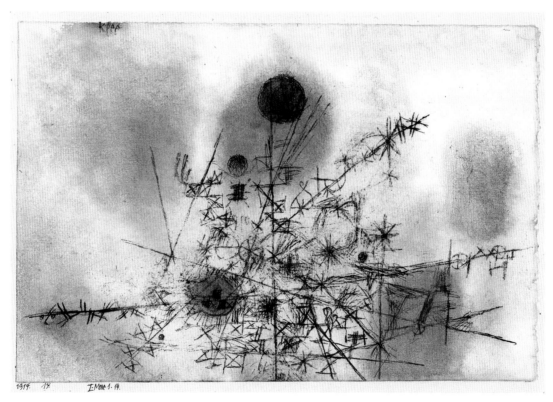

**Before the Gates of Kairouan
(Original Version from Nature)**
Vor den Toren von Kairuan
(ursprüngliche Fassung vor der Natur)
1914 / 216
Watercolor on paper, mounted on
cardboard, 8⅛ x 12⅜ in.
(20.7 x 31.5 cm)
Kunstmuseum Bern, Paul Klee Stiftung

Genesis of the Stars (1 Moses 1.14)
Genesis der Gestirne (I Moses 1.14)
1914 / 14
Pen and watercolor on paper, mounted
on cardboard, 6⅜ x 9½ in.
(16.2 x 24.2 cm)
Private collection, Munich

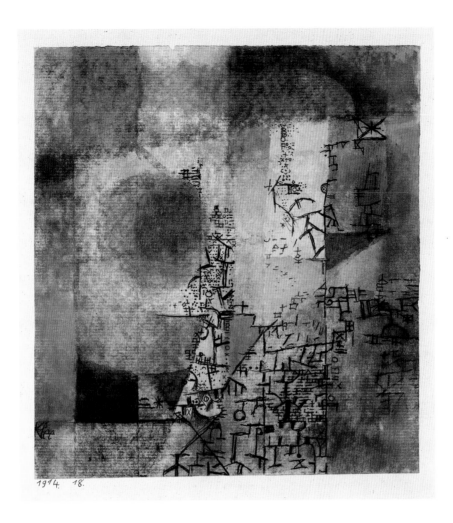

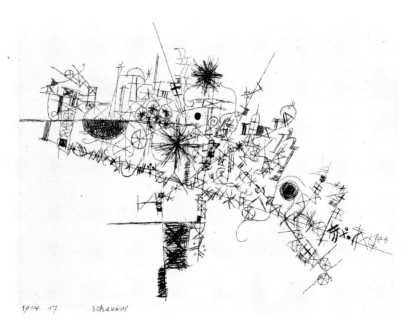

Untitled
Ohne Titel
1914 / 18
Watercolor and pen on paper, mounted
on cardboard, 6⅝ x 6¼ in.
(17 x 15.8 cm)
Kunstmuseum Basel

Seesaw
Schaukel
1914 / 17
Pen and ink on paper, 5⅞ x 8¼ in.
(15.2 x 21.2 cm)
Graphische Sammlung Albertina,
Vienna, Alfred Kubin Stiftung

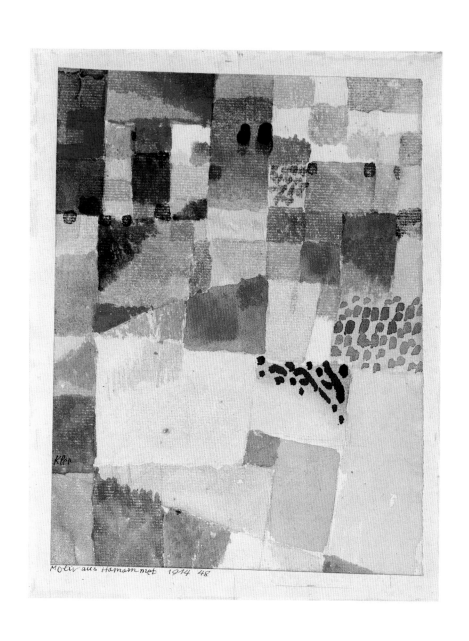

134

Motif from Hamamet
Motiv aus Hammamet
1914 / 48
Watercolor on paper, mounted on
cardboard, 7⅞ x 6⅛ in.
(20.2 x 15.7 cm)
Kunstmuseum Basel

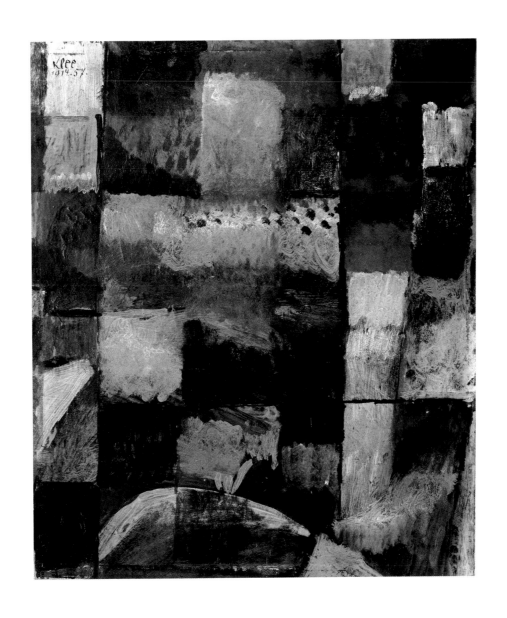

On a Motif from Hamamet
Über ein Motiv aus Hammamet
1914 / 57
Oil on cardboard, 10⅝ x 8⅝ in.
(27 x 22 cm)
Kunstmuseum Basel

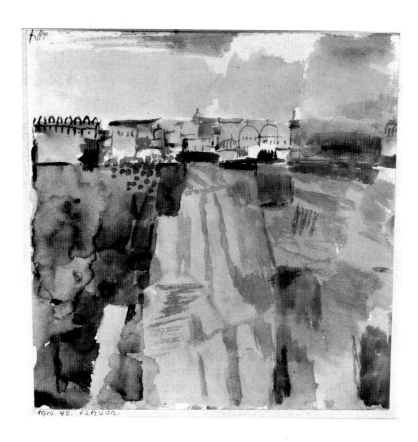

Kairouan (Farewell)
Kairuan (Abschied)
1914 / 42
Watercolor on paper, mounted on
cardboard, 8⅞ x 9⅛ in.
(22.6 x 23.2 cm)
Ulmer Museum, Ulm, West Germany
Stiftung Sammlung Kurt Fried

Beach of St. Germain near Tunis
Badestrand St. Germain bei Tunis
1914 / 215
Watercolor on paper, mounted on
cardboard, 8½ x 10⅝ in. (21.7 x 27 cm)
Ulmer Museum, Ulm, West Germany
Extended loan from the state of Baden-
Württemberg, West Germany

Garden in St. Germain, European Quarter of Tunis
Garten in der tunesischen Europäerkolonie St. Germain
1914 / 213
Watercolor on laid paper, mounted on cardboard, 8½ x 10¾ in.
(21.6 x 27.3 cm)
The Metropolitan Museum of Art, New York, The Berggruen Klee Collection, 1984

137

1914 / 217 St.germain b Tunis (landeinwärts)

St. Germain near Tunis (Inland)
St. Germain bei Tunis (landeinwärts)
1914 / 217
Watercolor on paper, mounted on
cardboard, 8½ x 12¾ in.
(21.6 x 32.4 cm)
Centre Georges Pompidou, Paris
Musée National d'Art Moderne
Succession Kandinsky

Föhn Wind: In Franz Marc's Garden
Föhn, im Marc'schen Garten
1915 / 102
Watercolor on paper, mounted on
cardboard, 7⅞ x 5⅞ in. (20 x 15 cm)
Städtische Galerie im Lenbachhaus,
Munich

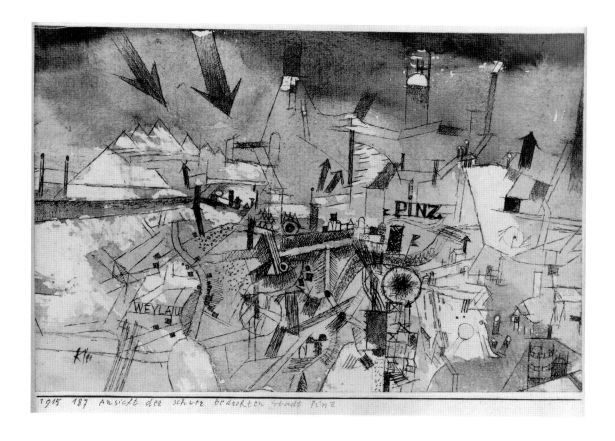

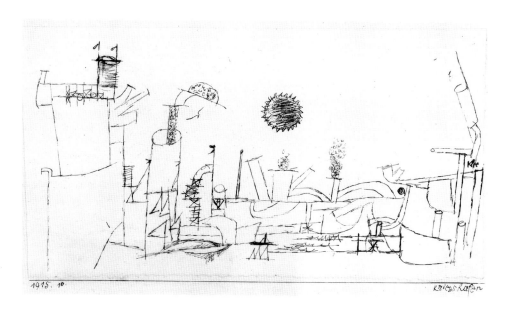

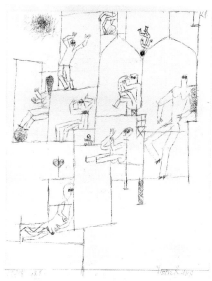

View of the Severely Threatened City of Pinz
Ansicht der schwer bedrohten Stadt Pinz
1915 / 187
Watercolor and pen on paper, mounted on cardboard, 5½ x 8½ in.
(14 x 21.7 cm)
Private collection, West Germany

Naval Station
Kriegshafen
1915 / 10
Pen on paper, mounted on cardboard, 4⅛ x 7⅞ in. (10.5 x 20 cm)
Private collection, Switzerland

Madhouse
Irrenhaus
1915 / 121
Pen on paper, mounted on cardboard, 6⅝ x 5⅛ in. (16.8 x 13 cm)
Private collection, Bern

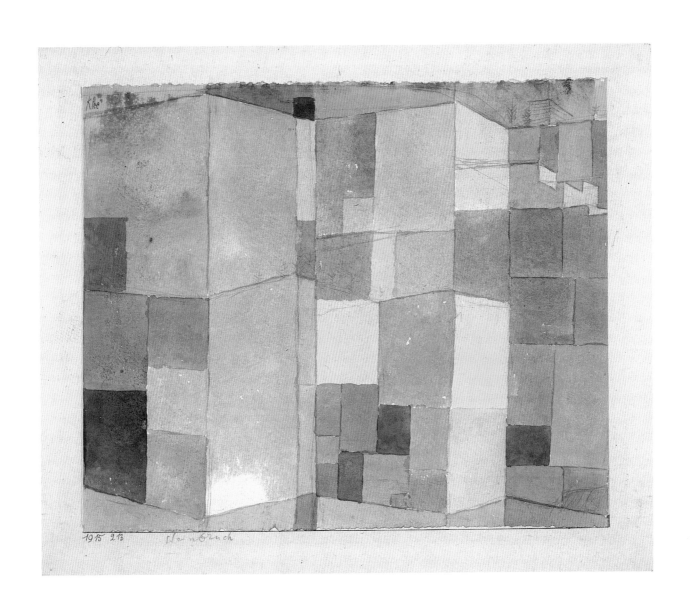

Quarry at Ostermundigen
Steinbruch Ostermundigen
1915 / 213
Watercolor over pencil on paper,
mounted on cardboard, 7⅞ x 9⅝ in.
(20.2 x 24.6 cm)
Kunstmuseum Bern, Paul Klee Stiftung

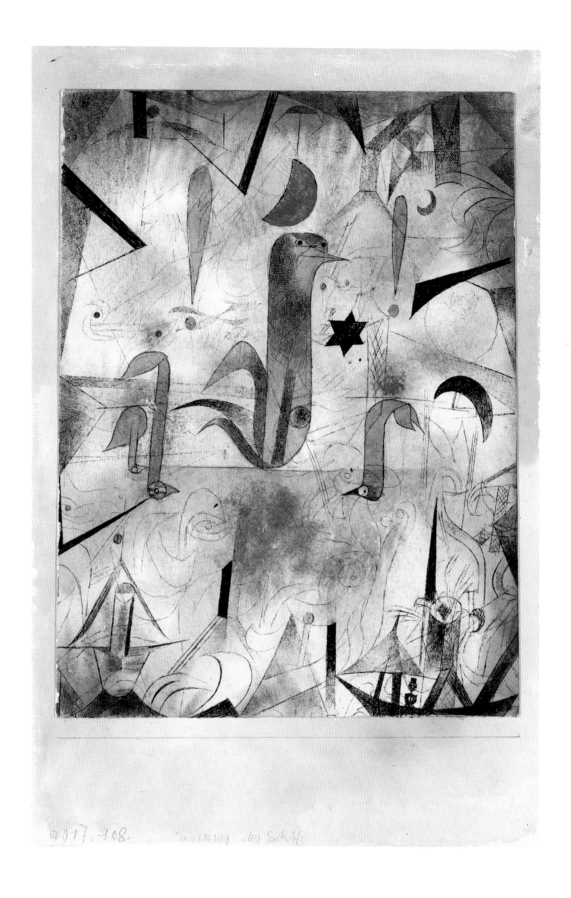

142

Warning of the Ships
Warnung der Schiffe
1917 / 108
Pen and watercolor on paper, mounted
on cardboard, 9½ x 6⅜ in.
(24.2 x 16.4 cm), irregular
Staatsgalerie Stuttgart
Graphische Sammlung

Top left:
Astral Automatons
Astrale Automaten
1918 / 171
Watercolor and pen on paper, mounted
on cardboard, 8⅞ x 7⅞ in.
(22.5 x 20.3 cm)
Private collection, Australia

Bottom left:
Irma Rossa, the Animal Tamer
Irma Rossa die Bändigerin
1918 / 162
Watercolor and pen on paper, mounted
on cardboard, 7⅜ x 9 in.
(18.8 x 22.9 cm)
Sprengel Museum Hannover

Right:
Fatal Bassoon Solo
Fatales Fagott Solo
1918 / 172
Pen and ink on paper, 11⅜ x 8⅝ in.
(29 x 22 cm)
Collection Mr. and Mrs. Daniel
Saidenberg, New York

1917 47

144

With the Egg
Mit dem Ei
1917 / 47
Watercolor on paper, mounted on
cardboard, 9⅛ x 5⅞ in.
(23.3 x 14.9 cm)
Private collection, West Germany

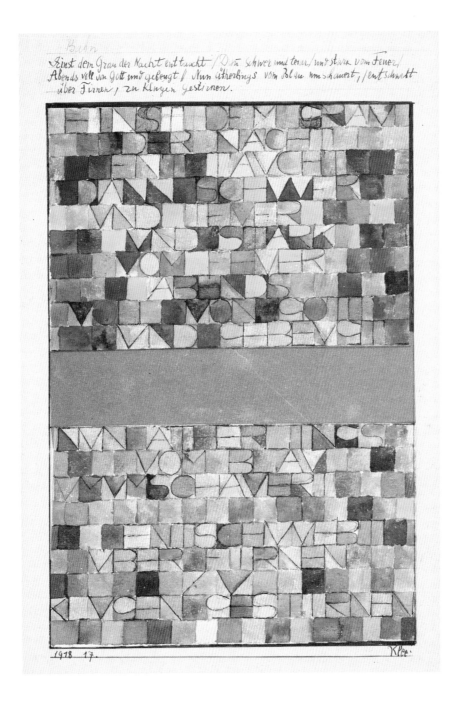

Once Emerged from the Gray of Night . . .

Einst dem Grau der Nacht enttaucht . . .
1918 / 17
Watercolor and pen drawing in India ink
over pencil on paper, cut into two parts
with strip of silver paper between,
mounted on cardboard, 8⅞ x 6¼ in.
(22.6 x 15.8 cm)
Kunstmuseum Bern, Paul Klee Stiftung

Souvenir (of Gersthofen)
Gedenkblatt (an Gersthofen)
1918 / 196
Pen and watercolor on paper, mounted
on cardboard, 11¼ x 8¼ in.
(28.5 x 21 cm)
Private collection, Switzerland

Inscription
Inschrift
1918 / 207
Pen on paper, mounted on cardboard,
8¼ x 2⅞ in. (21 x 7.5 cm)
Private collection, Switzerland

1919. 78.

Artist Pondering
Abwägender Künstler
1919 / 73
Tracing on paper, mounted on
cardboard, 7⅞ x 6½ in. (20 x 16.5 cm)
Private collection, Switzerland

**Constructed in Color with Black
Graphic Elements**
Farbig gebaut mit schwarz-graphischem
Gegenständlichem
1919 / 62
Watercolor on paper with chalk ground,
in two parts, 9 x 12⅛ in. (23 x 31 cm)
Private collection, New York

The Eye of Eros
Das Auge des Eros
1919 / 53
Pen and ink on paper, mounted on
cardboard, 5⅛ x 8⅝ in. (13 x 22 cm)
Morton G. Neumann Family Collection,
Chicago

**Absorption: Portrait of an
Expressionist**
Versunkenheit: Bildnis eines
Expressionisten
1919 / 113
Lithograph with watercolor on paper,
10 x 7 in. (25.6 x 18 cm)
Private collection, Switzerland

150

Black Magician
Schwarzmagier
1920 / 13
Watercolor over oil transfer on chalk-
primed paper, mounted on cardboard,
14½ x 10 in. (37 x 25.5 cm)
Bayerische Staatsgemäldesammlungen,
Munich, Extended loan from private
collection

The Bavarian Don Giovanni
Der bayerische Don Giovanni
1919 / 116
Watercolor on paper, 8⅞ x 8⅜ in.
(22.5 x 21.3 cm)
The Solomon R. Guggenheim Museum,
New York

151

152

Rocky Landscape (with Palms and Fir Trees)
Felsenlandschaft (mit Palmen und Tannen)
1919 / 155
Oil on cardboard, 16½ x 20¼ in.
(42 x 51.5 cm)
Private collection, Switzerland

**Composition with Windows
(Composition with a B')**
Komposition mit Fenstern (Komposition
mit dem B')
1919 / 156
Oil over pen and India ink, varnished, on
cardboard, 19¾ x 15 in. (50.4 x 38.3 cm)
Kunstmuseum Bern, Paul Klee Stiftung

Baroque Portrait
Barockbildnis
1920 / 9
Watercolor and gouache on paper,
10⅛ x 7 in. (25.9 x 17.8 cm)
Collection Carl Djerassi, promised
gift to San Francisco Museum of
Modern Art

View from a Window
Fensterausblick
1920 / 27
Oil on paper with lacquer ground,
16¼ x 12⅞ in. (41.5 x 32.7 cm)
Private collection, Munich

156

Sea Landscape with Heavenly Body
Seelandschaft mit dem Himmelskörper
1920 / 166
Pen and ink on paper in two parts,
mounted on cardboard, 5 x 11 in.
(12.7 x 28.1 cm)
Kunstmuseum Bern, Paul Klee Stiftung

The Way from Unklaich to China
Der Weg von Unklaich nach China
1920 / 153
Pen and ink on paper, mounted on
cardboard, 7¼ x 11⅛ in.
(18.6 x 28.2 cm)
Kunstmuseum Bern, Paul Klee Stiftung

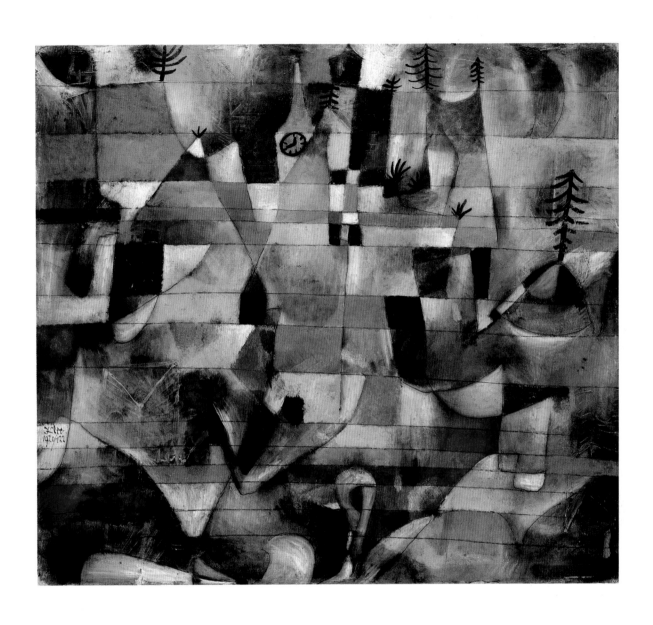

Landscape and Yellow Church Tower
Landschaft und gelben Kirchturm
1920 / 122
Oil on cardboard, 18⅞ x 21¼ in.
(48.2 x 54 cm)
Bayerische Staatsgemäldesammlungen,
Munich

Moribundus
1919 / 203
Watercolor over oil transfer drawing on
paper, mounted on cardboard,
8½ x 11 in. (21.7 x 28 cm)
Collection Rosengart, Lucerne

Pisch, the Tormented
Pisch, der Gequälte
1918 / 137
Pen and ink on paper, mounted on
cardboard, 7⅝ x 11¼ in.
(19.4 x 28.5 cm)
Graphische Sammlung Albertina,
Vienna, Alfred Kubin Stiftung

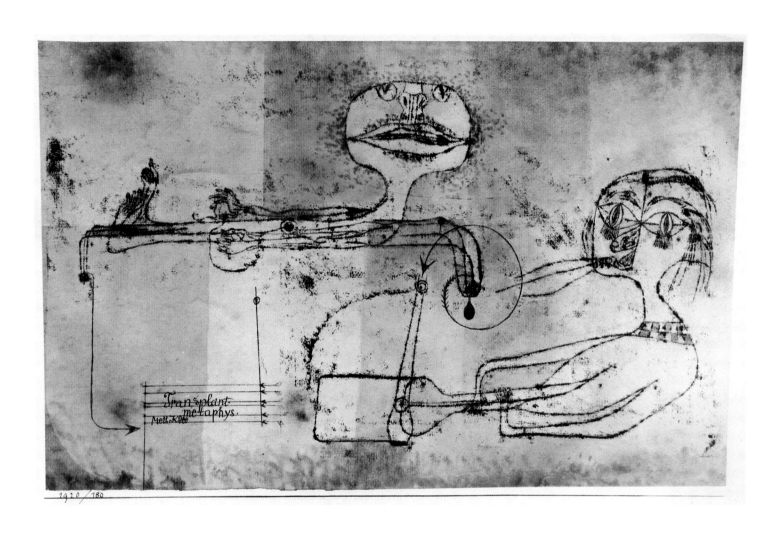

Metaphysical Transplant
Transplantation metaphysisch
1920 / 180
Watercolor over oil transfer drawing on
paper, mounted on cardboard,
10¾ x 17¼ in. (27.3 x 43.8 cm)
Collection Helen Keeler Burke, Illinois

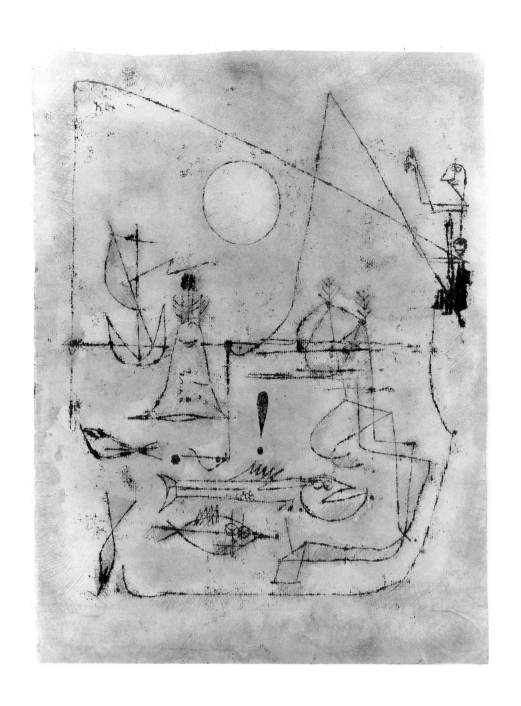

160

They're Biting
Sie beissen an
1920 / 6
Watercolor and oil transfer drawing on
paper, 12¼ x 9¼ in. (31.1 x 23.5 cm)
The Trustees of the Tate Gallery, London

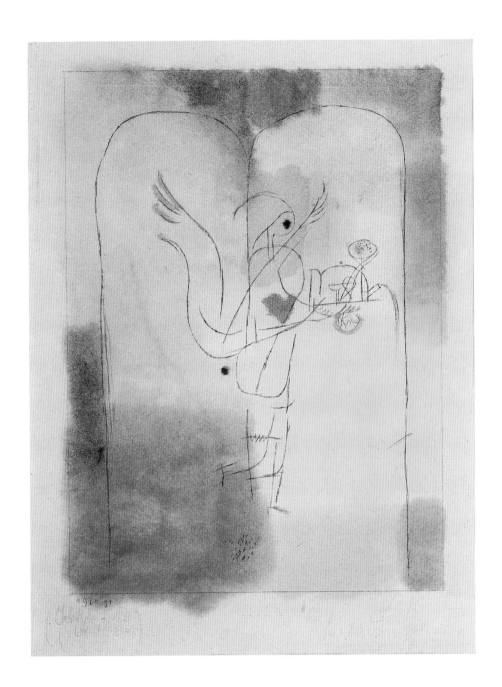

An Angel Serves a Small Breakfast
Ein Genius serviert ein kleines Frühstück
1920 / 91
Lithograph, with watercolor additions,
7¾ x 5¾ in. (19.8 x 14.6 cm)
Sprengel Museum Hannover

An Angel Serves a Small Breakfast
Ein Genius serviert ein kleines Frühstück
1915 / 29
Pen and ink on paper, 12⅞ x 9⅝ in.
(33 x 24.5 cm)
Collection E. W. K., Bern

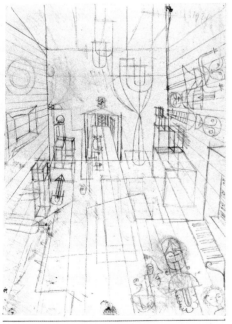

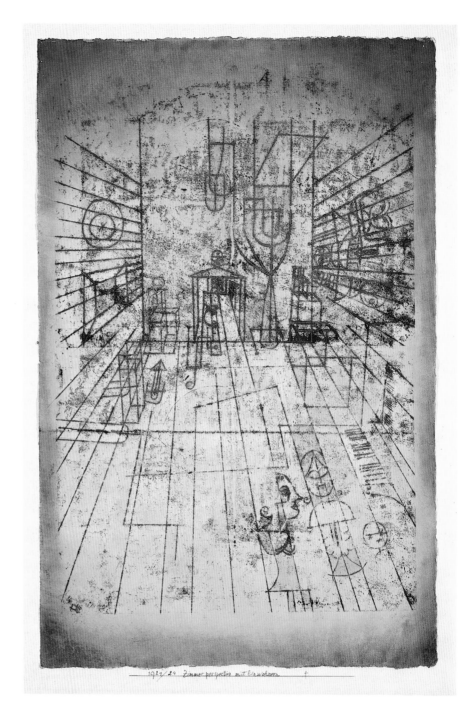

Drawing for "Room Perspective with Inhabitants"
Zeichnung zur "Zimmerperspektive mit Einwohnern"
1921 / 168
Pencil on paper, mounted on cardboard,
13¼ x 9¾ in. (33.8 x 25 cm), irregular
Kunstmuseum Bern, Paul Klee Stiftung

Room Perspective with Inhabitants
Zimmerperspektive mit Einwohnern
1921 / 24
Watercolor over oil transfer drawing on
paper, mounted on cardboard,
19 x 12½ in. (48.5 x 31.7 cm)
Kunstmuseum Bern, Paul Klee Stiftung

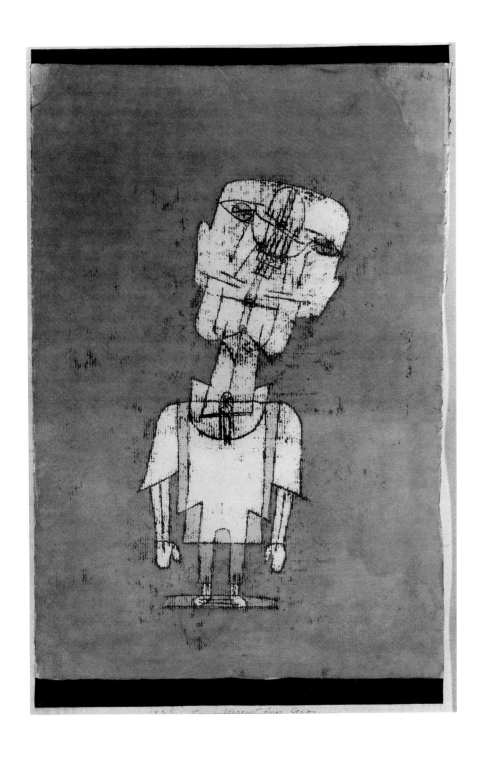

Ghost of a Genius
Gespenst eines Genies
1922 / 10
Watercolor and oil transfer drawing on
paper, mounted on cardboard,
20⅞ x 13⅜ in. (53 x 34 cm)
Scottish National Gallery of Modern Art,
Edinburgh

163

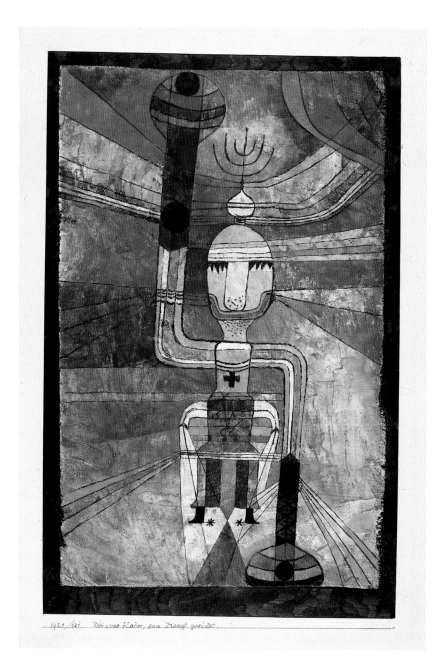

The Great Kaiser, Armed for Battle
Der grosse Kaiser, zum Kampf gerüstet
1921 / 131
Watercolor and oil transfer drawing on
plaster-primed canvas, mounted on
cardboard, 17⅛ x 11⅛ in.
(43.5 x 28.2 cm)
Private collection, Switzerland

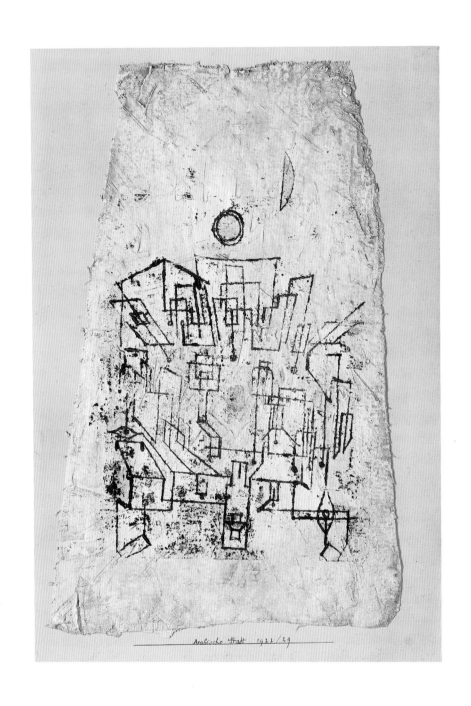

Arab City
Arabische Stadt
1922 / 29
Watercolor and oil transfer drawing on
plaster-primed gauze, mounted on
cardboard, 12½ x 7⅞ in.
(31.7 x 20.3 cm)
Private collection

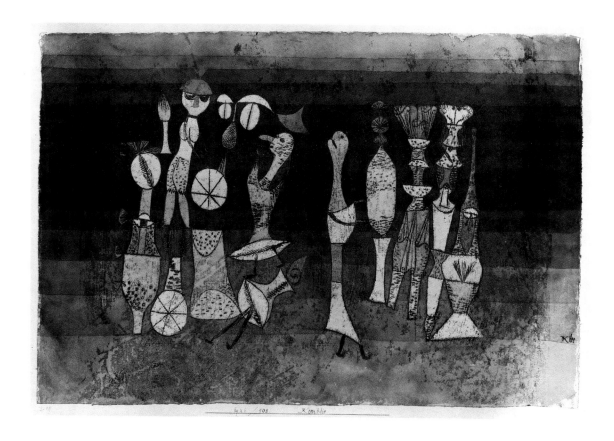

166

Comedy
Komödie
1921 / 108
Watercolor and oil transfer drawing on
paper, mounted on cardboard,
12 x 17⅞ in. (30.5 x 45.5 cm)
The Trustees of the Tate Gallery, London

Study for "Comedy"
Komödie
1921 / 109
Pen and ink on paper, mounted on
cardboard, 8¾ x 6¼ in.
(22.3 x 15.8 cm), irregular
Private collection, Canada

Tale à la Hoffmann
Hoffmanneske Geschichte
1921 / 18
Watercolor and oil transfer drawing on
laid paper, bordered with metallic foil,
mounted on cardboard, 12¼ x 9½ in.
(31.1 x 24.1 cm)
The Metropolitan Museum of Art,
New York, The Berggruen
Klee Collection, 1984

168

Green, Violet against Orange
Grün, Violett, gegen Orange
1922 / 71
Watercolor on paper, mounted on
cardboard, 10⅜ x 6⅛ in.
(26.4 x 15.5 cm)
Private collection, New York

Fugue in Red
Fuge in Rot
1921 / 69
Watercolor on paper, mounted on
cardboard, 9½ x 14⅝ in.
(24.3 x 37.2 cm)
Private collection, Switzerland

Crystal Gradation
Kristall-Stufung
1921 / 88
Watercolor on paper, mounted on
cardboard, 9⅝ x 12⅜ in.
(24.5 x 31.5 cm)
Kunstmuseum Basel

Night Feast
Nächtliches Fest
1921 / 176
Oil on paper, mounted on cardboard,
19⅝ x 24 in. (50 x 61 cm)
The Solomon R. Guggenheim Museum,
New York

Rose Wind
Rosenwind
1922 / 39
Oil on paper, mounted on cardboard,
16½ x 19 in. (42 x 48.5 cm)
Private collection, Switzerland

God of the Northern Woods
Der Gott des nördlichen Waldes
1922 / 32
Oil and pen-and-India-ink drawing on
canvas, mounted on cardboard,
21 x 16¼ in. (53.5 x 41.4 cm)
Kunstmuseum Bern, Paul Klee Stiftung

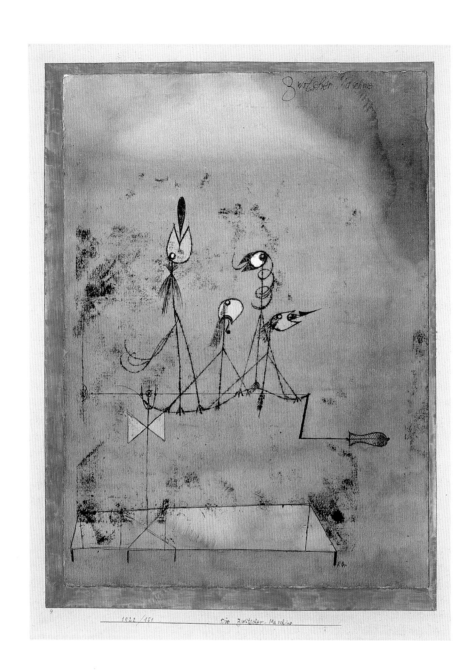

172

Twittering Machine
Zwitscher Maschine
1922 / 151
Watercolor and pen and ink on oil
transfer drawing on paper, mounted on
cardboard, 25¼ x 19 in.
(63.8 x 48.1 cm)
The Museum of Modern Art, New York
Purchase Fund

Vocal Fabric of the Singer Rosa Silber
Das Vokaltuch der Kammersängerin
Rosa Silber
1922 / 126
Gouache and plaster on canvas,
20¼ x 16⅜ in. (51.5 x 41.7 cm),
irregular
The Museum of Modern Art, New York
Gift of Mr. and Mrs. Stanley Resor

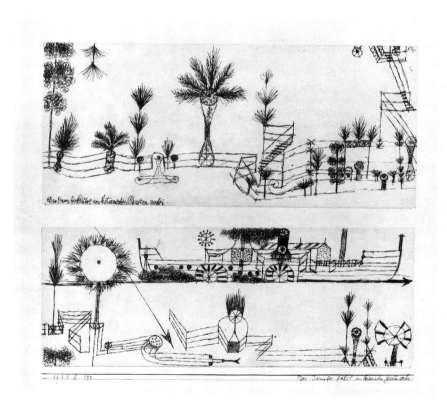

Tropical Gardening
Tropische Garten Kultur
1923 / 55
Watercolor and oil transfer drawing on paper, mounted on paper, 7⅞ x 19¼ in. (20 x 48.9 cm)
The Solomon R. Guggenheim Museum, New York, Gift of Solomon R. Guggenheim, 1937

The Steamboat Passes the Botanical Garden
Der Dampfer fährt am botanischen Garten vorbei
1921 / 199
Pen and black ink on paper, in two parts, mounted on cardboard,
4⅝ x 11⅜ in. and 4 x 11¼ in. (11.9 x 28.9 cm and 10.4 x 28.8 cm)
Kunstmuseum Bern, Paul Klee Stiftung

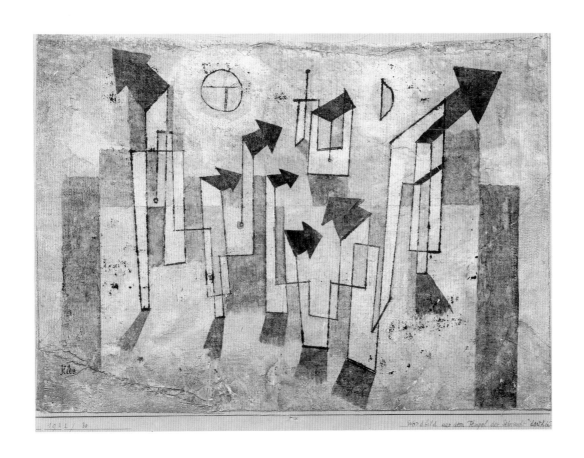

Mural from the Temple of Longing
↖ **Thither** ↗
Wandbild aus dem Tempel der
Sehnsucht ↖ dorthin ↗
1922 / 30
Watercolor, transfer drawing on gessoed
cloth, mounted on cardboard,
10⅝ x 14⅜ in. (27 x 36.5 cm)
The Metropolitan Museum of Art,
New York, The Berggruen
Klee Collection, 1984

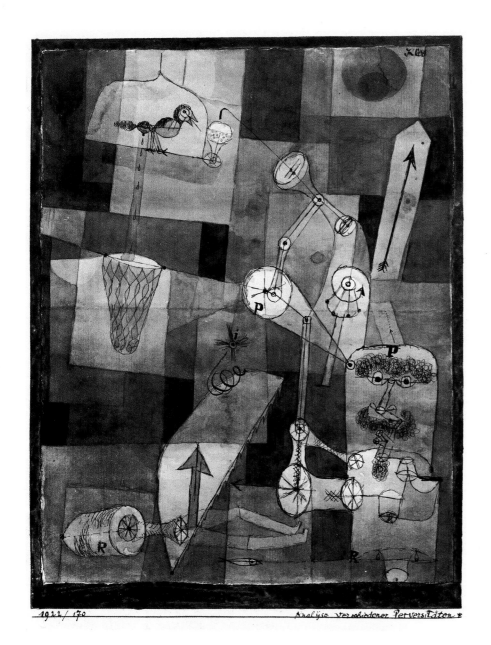

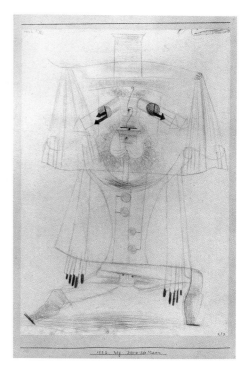

Analysis of Diverse Perversities
Analyse verschiedener Perversitaten
1922 / 170
Pen and ink drawing and watercolor on
paper, mounted on cardboard,
12⅛ x 9⅜ in. (31 x 24 cm)
Centre Georges Pompidou, Paris
Musée National d'Art Moderne

The Wild Man
Der wilde Mann
1922 / 209
Colored pencil on paper, mounted on
cardboard, 15¾ x 11 in. (40 x 28 cm)
Collection Mr. and Mrs. James Foster,
Chicago

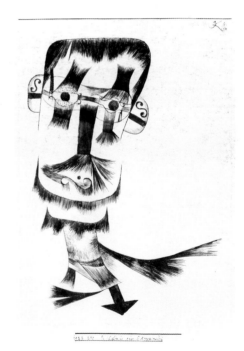

Window Display for Lingerie
Schaufenster für Damenunterkleidung
1922 / 125
Pen and black ink and watercolor on
two sheets of laid paper bordered with
black ink, mounted on cardboard,
16½ x 10⅝ in. (41.9 x 27 cm)
The Metropolitan Museum of Art,
New York, The Berggruen
Klee Collection, 1984

Portrait of an Expressionist
Bildnis eines Expressionisten
1922 / 240
Pencil on paper, mounted on cardboard,
12⅛ x 8¾ in. (31 x 22.2 cm)
Private collection, Washington, D.C.

178

Separation in the Evening
Scheidung Abends
1922 / 79
Watercolor on paper, mounted on
cardboard, 13⅛ x 9¼ in.
(33.5 x 23.5 cm)
Private collection, Switzerland

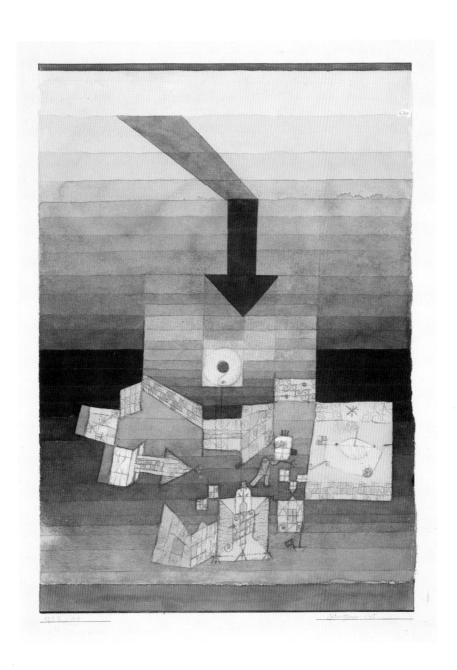

Stricken Place
Betroffener Ort
1922 / 109
Watercolor and pen and India ink over
pencil on paper, mounted on cardboard,
12⅞ x 9 in. (32.8 x 23.1 cm)
Kunstmuseum Bern, Paul Klee Stiftung

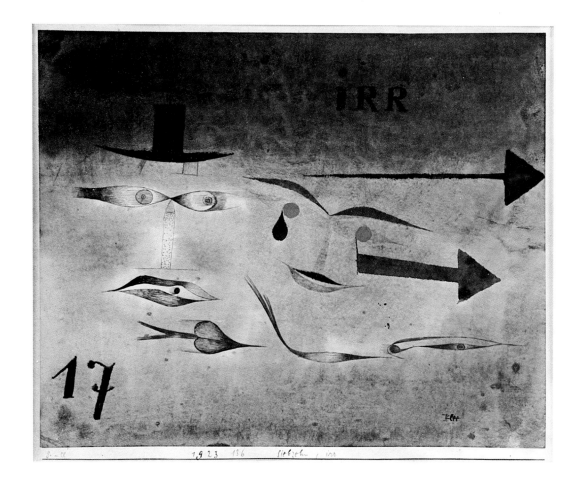

17, Astray
Siebzehn, irr
1923 / 136
Pen and watercolor on paper, mounted
on cardboard, 8⅞ x 11¼ in.
(22.5 x 28.5 cm)
Kunstmuseum Basel

Classic-Dynamic Scherzo "217"
Klassisch-dynamisches Scherzo "217"
1923 / 187
Pen with black ink and pencil on paper,
mounted on cardboard, 11¼ x 8½ in.
(28.7 x 21.7 cm)
Kunstmuseum Bern, Paul Klee Stiftung

The Tightrope Walker
Der Seiltänzer
1923 / 121
Watercolor over oil transfer drawing and
pencil on paper, mounted on cardboard,
19⅛ x 12⅜ in. (48.7 x 32.2 cm)
Kunstmuseum Bern, Paul Klee Stiftung

Landscape with Yellow Birds
Landschaft mit gelben Vögeln
1923 / 32
Watercolor and gouache on paper,
13⅞ x 17¼ in. (35.5 x 44 cm)
Private collection, Switzerland

Assyrian Game
Assyrisches Spiel
1923 / 79
Oil on cardboard, 14½ x 20 in.
(37 x 51 cm)
Private collection, Switzerland

184

Actor
Schauspieler
1923 / 27
Oil on packing paper, mounted on
cardboard, 18¼ x 9¾ in.
(46.5 x 25 cm)
Private collection, Switzerland

Child on the Stairway
Kind an der Freitreppe
1923 / 65
Oil on paper, mounted on cardboard,
9⅝ x 7 in. (24.5 x 18 cm)
Private collection, Switzerland

185

186

Ventriloquist: Caller in the Moor
Bauchredner und Rufer im Moor
1923 / 103
Watercolor and oil transfer drawing on
laid paper bordered with black and blue
ink, mounted on cardboard,
15¼ x 10⅞ in. (38.7 x 27.6 cm)
The Metropolitan Museum of Art,
New York, The Berggruen
Klee Collection, 1984

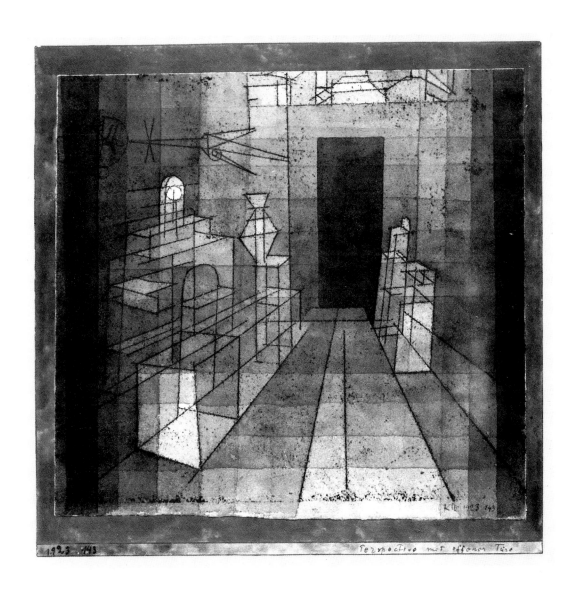

Perspective with Open Door
Perspektive mit offener Türe
1923 / 143
Oil transfer drawing and watercolor on
paper, mounted on cardboard,
10¼ x 10⅝ in. (26 x 27 cm)
Collection Rosengart, Lucerne

187

The Window
Das Fenster
1922 / 140
Oil on cardboard, 22¾ x 15¼ in.
(57.8 x 38.7 cm)
Stephen Hahn, Inc., New York

Architecture
Architektur
1923 / 62
Oil on cardboard, 22⅜ x 14¾ in.
(57 x 37.5 cm)
Staatliche Museen Preussischer
Kulturbesitz, Nationalgalerie, Berlin

190

Double Tent
Doppelzelt
1923 / 114
Watercolor on paper, mounted on
cardboard, 19⅞ x 12½ in.
(50.6 x 31.8 cm)
Collection Rosengart, Lucerne

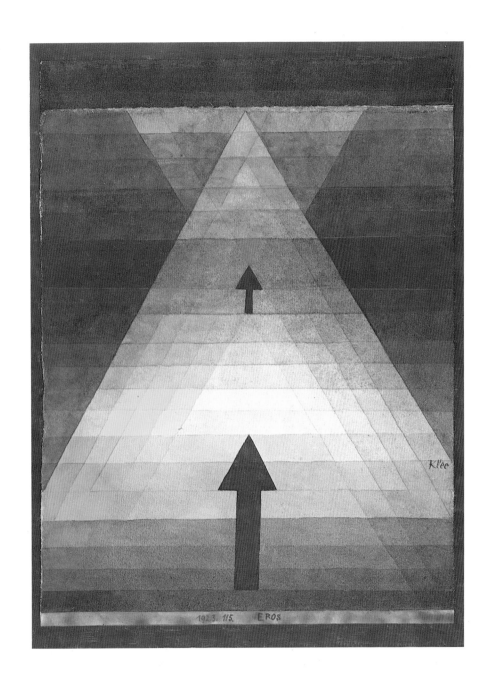

Eros
1923 / 115
Watercolor on paper, mounted on
cardboard, 13⅛ x 9⅝ in.
(33.3 x 24.5 cm)
Collection Rosengart, Lucerne

192

**Harmony of Rectangles in Red,
Yellow, Blue, White, and Black**
Harmonie aus Vierecken mit Rot, Gelb,
Blau, Weiss, und Schwarz
1923 / 238
Oil on cardboard with black ground,
27⅜ x 19⅞ in. (69.7 x 50.6 cm)
Kunstmuseum Bern, Paul Klee Stiftung

North Sea Picture (from Baltrum)
Nordseebild (aus Baltrum)
1923 / 246
Watercolor and brush drawing over
pencil on paper, mounted on cardboard,
12 x 18½ in. (30.7 x 47.1 cm)
Kunstmuseum Bern, Paul Klee Stiftung

North Sea Picture (from Baltrum)
Nordseebild (aus Baltrum)
1923 / 242
Watercolor on paper, mounted on
cardboard, 9¾ x 12⅜ in.
(24.7 x 31.5 cm)
Kunstmuseum Bern, Paul Klee Stiftung

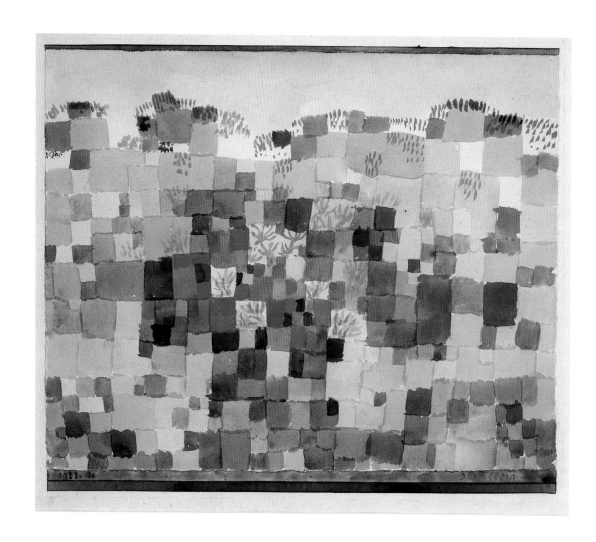

Dune Flora
Dünenflora
1923 / 184
Watercolor on paper, mounted on
cardboard, 10 x 11⅞ in.
(25.4 x 30.2 cm)
Collection Mr. and Mrs. Daniel
Saidenberg, New York

Salon Tunisien
1918 / 6
Watercolor on paper, 8⅞ x 11¼ in.
(22.5 x 28.5 cm)
Private collection, Frankfurt, West
Germany

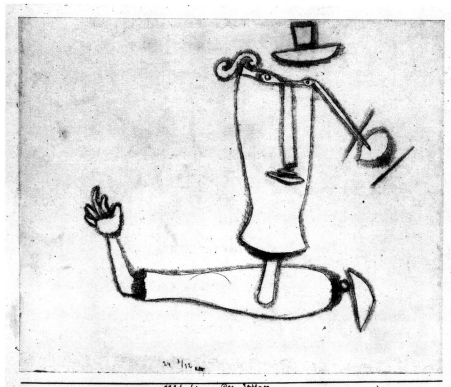

The Draftsman
Der Zeichner
1924 / 61
Pencil on paper, mounted on cardboard,
8⅞ x 11⅛ in. (22.5 x 28.4 cm)
Kunstmuseum Bern, Paul Klee Stiftung

Cosmic Flora
Kosmische Flora
1923 / 176
Brush drawing in watercolor on tinted-
chalk ground on paper, mounted on
cardboard, 10⅝ x 14⅜ in.
(27.2 x 36.6 cm)
Kunstmuseum Bern, Paul Klee Stiftung

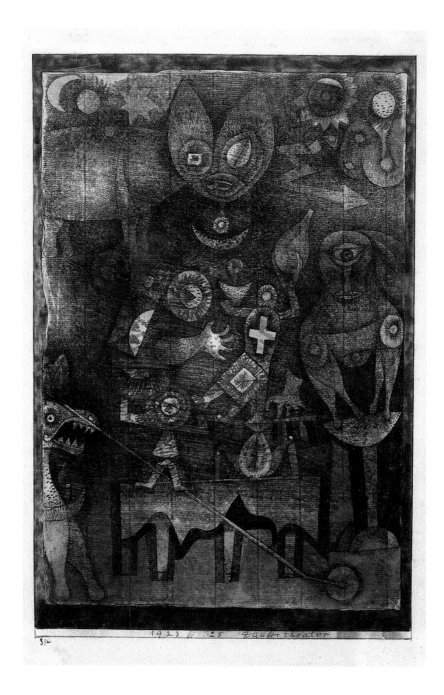

198

Magic Theater
Zaubertheater
1923 / 25
Pen and brush drawing in India ink,
painted with watercolor, on paper,
mounted on cardboard, 13¼ x 8⅞ in.
(33.6 x 22.8 cm)
Kunstmuseum Bern, Paul Klee Stiftung

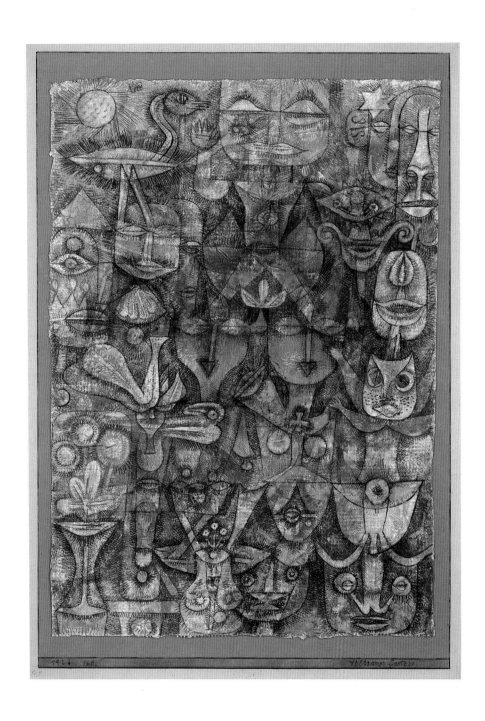

Strange Garden
Seltsamer Garten
1923 / 160
Watercolor on gessoed cloth bordered
with red and green gouache and black
ink, mounted on cardboard,
15¾ x 11⅜ in. (40 x 28.9 cm)
The Metropolitan Museum of Art,
New York, The Berggruen
Klee Collection, 1984

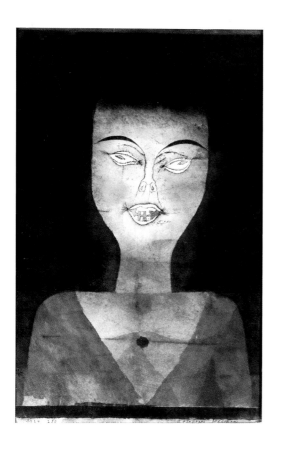

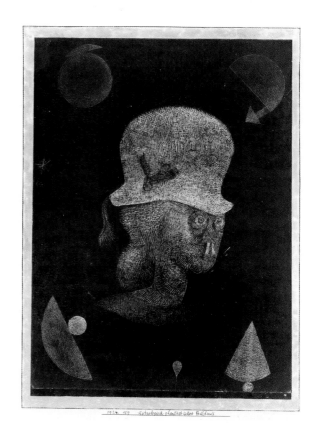

Possessed Girl
Besessenes Mädchen
1924 / 250
Oil and watercolor on paper, mounted
on cardboard, 17 x 11⅜ in.
(43.2 x 29 cm)
Collection Beyeler, Basel

Astrological Fantasy Portrait
Astrologisch-phantastisches Bildnis
1924 / 159
Gouache on laid paper bordered with
black ink and gray gouache, mounted
on cardboard, 12⅜ x 9⅜ in.
(31.4 x 23.8 cm)
The Metropolitan Museum of Art,
New York, The Berggruen
Klee Collection, 1984

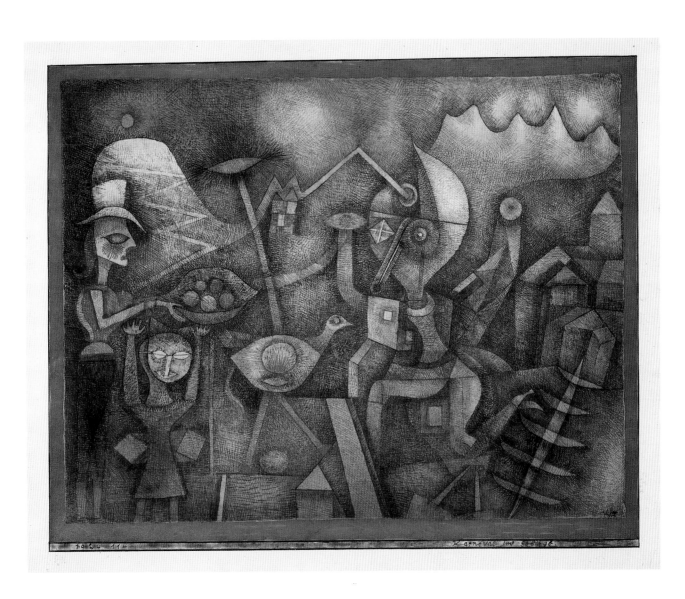

Carnival in the Mountains
Karneval im Gebirge
1924 / 114
Brush drawing in watercolor over tinted-
paste ground on paper, mounted on
cardboard, 10⅜ x 13 in.
(26.5 x 33.1 cm)
Kunstmuseum Bern, Paul Klee Stiftung

Steamboat
Dampfschiff
1924 / 118
Oil on paper, mounted on cardboard,
11⅞ x 14⅝ in. (30 x 37 cm)
Private collection

Danceplay of the Red Skirts
Tanzspiel der Rotröcke
1924 / 119
Oil on paper on cardboard,
13¾ x 17¼ in. (35 x 44 cm)
Private collection

In Memory of an All-Girl Band
Zur Erinnerung an eine Damenkapelle
1925 / 103 (A 3)
Pen and black ink and pencil on laid
paper bordered with metallic paint and
black ink, mounted on cardboard,
7⅝ x 9⅝ in. (19.4 x 24.4 cm)
The Metropolitan Museum of Art,
New York, The Berggruen
Klee Collection, 1984

Demonry
Daemonie
1925 / 204 (U 4)
Pen and black ink on paper, mounted
on cardboard, 9⅞ x 21¾ in.
(25.1 x 55.4 cm), irregular
Kunstmuseum Bern, Paul Klee Stiftung

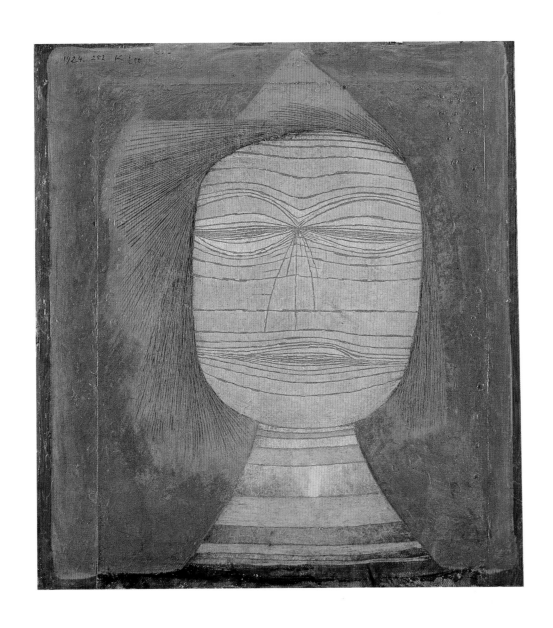

Actor's Mask
Schauspielermaske
1924 / 252
Oil on canvas mounted on board,
14⅜ x 13¼ in. (36.7 x 33.8 cm)
The Museum of Modern Art, New York
The Sidney and Harriet Janis Collection
Fractional gift

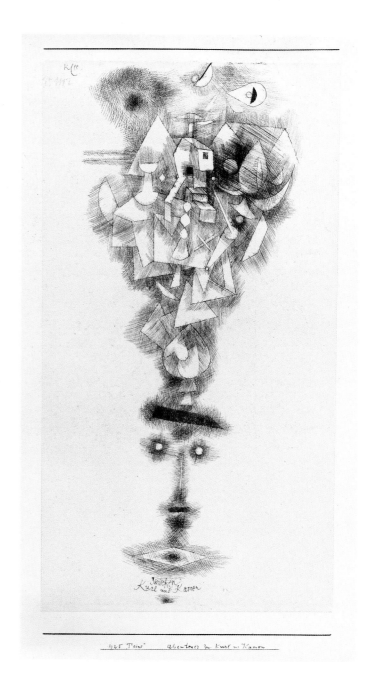

Human Script
Menschenschrift
1924 / 92
Pen and ink on paper, mounted
on cardboard, 8¼ x 5¾ in.
(21 x 14.6 cm)
Milwaukee Art Museum
Gift of Mrs. Edward R. Wehr

Adventure between Kurl and Kamen
Abenteuer zwischen Kurl und Kamen
1925 / 191 (T 1)
Pen and ink on paper, mounted on
cardboard, 12⅛ x 6⅝ in. (30.8 x 17 cm)
Collection Ian Woodner, New York

Castle of the Faithful
Burg der Gläubigen
1924 / 133
Watercolor on paper, mounted on
cardboard, 9 x 12¾ in. (23 x 32.5 cm)
Collection Rosengart, Lucerne

208

Ur-Clock-Plants
Uhr-Pflanzen
1924 / 261
Oil transfer drawing, sprayed, on paper
with chalk ground, 18⅛ x 12 in.
(46 x 30.5 cm)
Musées Royaux des Beaux-Arts de
Belgique, Brussels

Egypt Destroyed
Zerstörtes Aegypten
1924 / 178
Watercolor and India ink on paper,
mounted on cardboard, 4¾ x 11⅛ in.
(12 x 28.4 cm)
Collection Rosengart, Lucerne

Letter Picture
Buchstabenbild
1924 / 116
Watercolor and pasted papers on
cardboard, 5⅞ x 12¾ in.
(15.2 x 32.4 cm)
Private collection, Switzerland

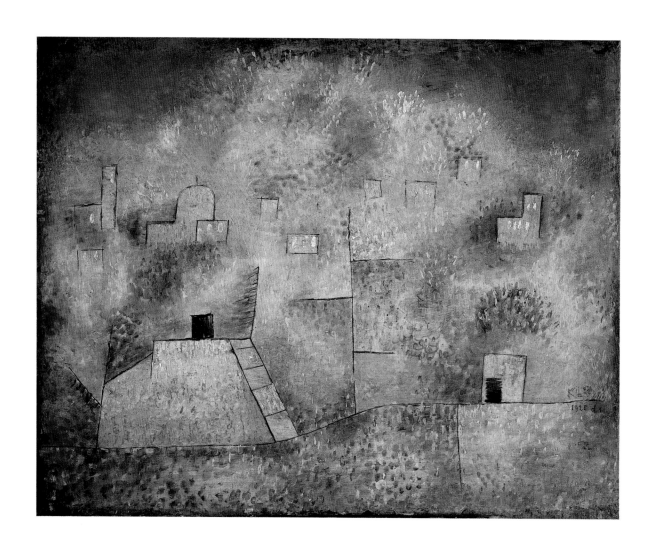

210

Oriental Garden
Orientalischer Lustgarten
1925 / 131
Oil on cardboard, 15¾ x 20½ in.
(40 x 52.1 cm)
The Metropolitan Museum of Art,
New York, The Berggruen
Klee Collection, 1984

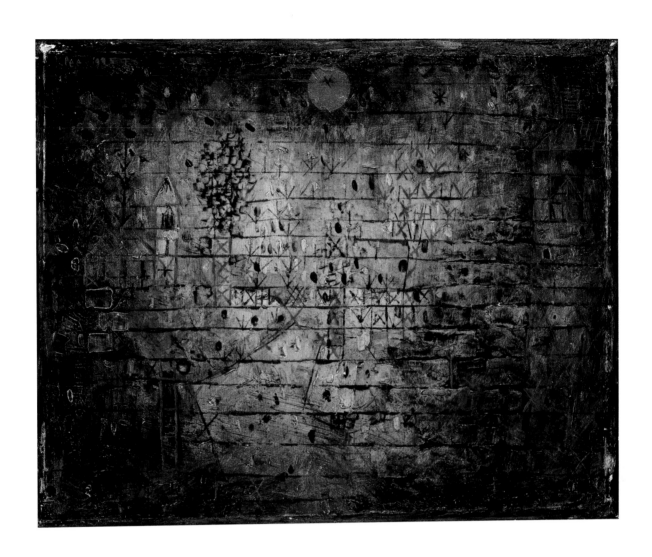

Garden Vision
Garten Vision
1925 / 196 (T 6)
Oil on cardboard, 9⅜ x 11¾ in.
(24 x 30 cm)
Private collection, Switzerland

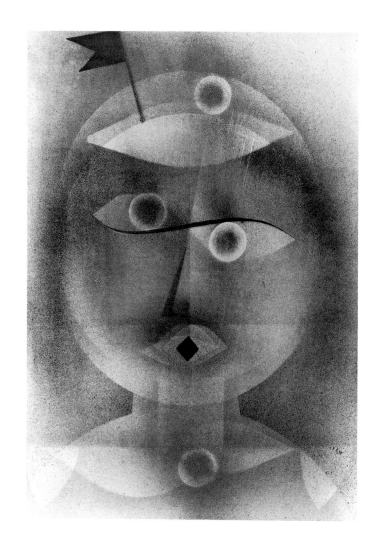

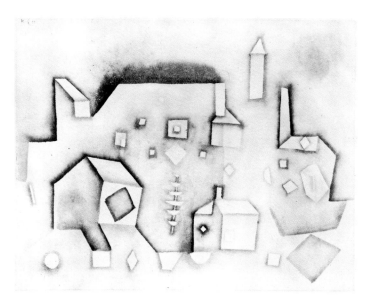

The Mask with the Little Flag
Die Maske mit dem Fähnchen
1925 / 220
Watercolor sprayed over stencils on
chalk-primed paper, 25½ x 19½ in.
(65 x 49.5 cm)
Bayerische Staatsgemäldesammlungen,
Munich

A Village as a Play in Relief
Ein Dorf als Reliefspiel
1925 / 140 (E null)
Watercolor sprayed over stencils on
paper, 9⅜ x 12⅜ in. (23.9 x 31.4 cm)
Morton G. Neumann Family Collection,
Chicago

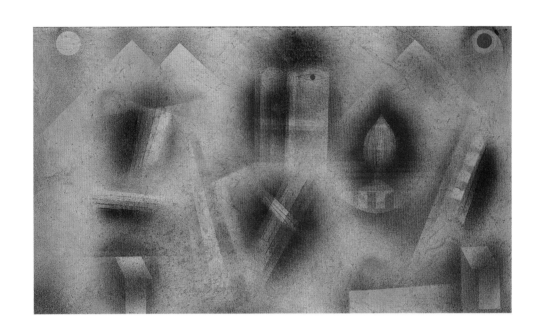

Still Life with Fragments
Stilleben mit Fragmenten
1925 / 211 (V 1)
Oil on cardboard, 16¼ x 28¼ in.
(41.2 x 71.8 cm)
Collection Richard S. Zeisler, New York

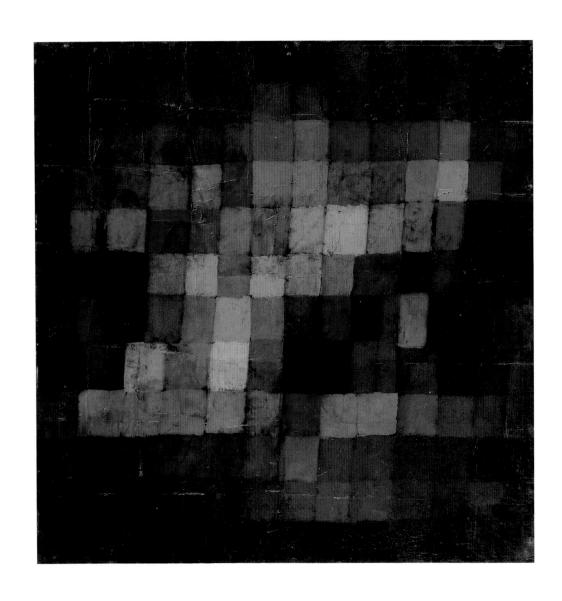

214

Ancient Sound
Alter Klang
1925 / 236 (X 6)
Oil on pasteboard, 14⅞ x 14⅞ in.
(38 x 38 cm)
Kunstmuseum Basel

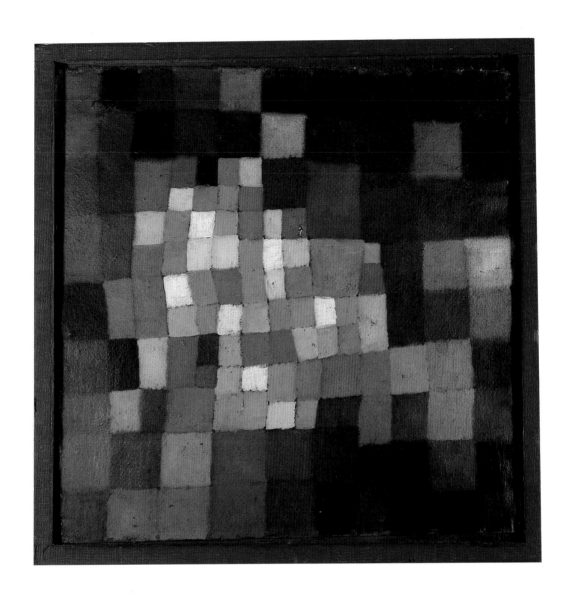

**Abstraction with Reference to a
Flowering Tree**
Abstract mit Bezug auf einen blühenden
Baum
1925 / 119 (B 9)
Oil on cardboard, 15⅛ x 15⅜ in.
(38.5 x 39 cm)
Private collection, Switzerland

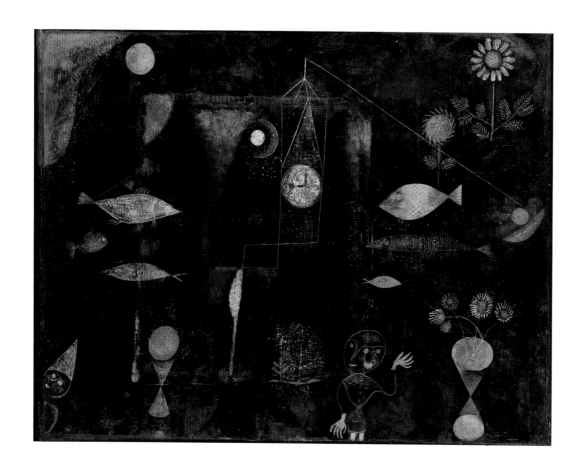

Fish Magic
Fischzauber
1925 / 85 (R 5)
Oil and watercolor on muslin,
mounted on board, 30½ x 38¾ in.
(77.5 x 98.4 cm)
Philadelphia Museum of Art
The Louise and Walter Arensberg
Collection

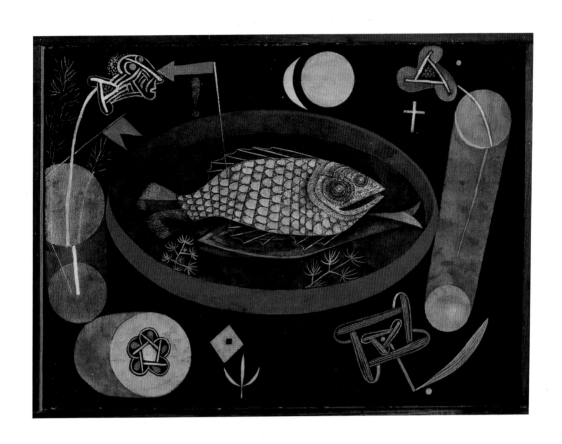

Around the Fish
Um den Fisch
1926 / 124 (C 4)
Oil on canvas, 18⅜ x 25⅛ in.
(46.7 x 63.8 cm)
The Museum of Modern Art, New York
Abby Aldrich Rockefeller Fund

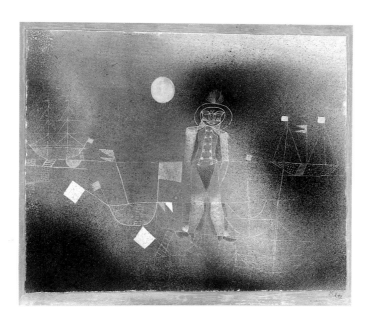

Bird Wandering Off
Abwandernder Vogel
1926 / 218 (V 8)
Gouache sprayed and hand-applied on
wove paper bordered with gray
gouache, mounted on cardboard,
14¾ x 18⅝ in. (37.5 x 47.3 cm)
The Metropolitan Museum of Art,
New York, The Berggruen
Klee Collection, 1984

Sea Adventurer
Abenteurer zur See
1927 / 5
Watercolor on paper, mounted on
cardboard, 9⅞ x 12¾ in.
(25.1 x 32.4 cm)
Private collection, Switzerland

Dune Landscape
Dünenbild
1926 / 115
Oil and tempera on paper, mounted on
wood, 12½ x 10 in. (32 x 25 cm)
Private collection

220

Florentine Villa District
"Florentinisches" Villen Viertel
1926 / 223 (W 3)
Oil on cardboard, 19½ x 14⅜ in.
(49.5 x 36.5 cm)
Centre Georges Pompidou, Paris
Musée National d'Art Moderne

Village Carnival
Dorf Carnaval
1926 / 135 (D 5)
Oil on cloth mounted on masonite,
21⅝ x 17¼ in. (55 x 43.8 cm)
Philadelphia Museum of Art
The Louise and Walter Arensberg
Collection

221

Castle to Be Built in the Woods
Schloss im Wald zu bauen
1926 / 2
Watercolor on paper, mounted on
cardboard, 10⅜ x 15⅝ in.
(26.5 x 39.7 cm)
Staatsgalerie Stuttgart

Palace, Partly Destroyed
Palast, teilweise zerstört
1926 / 119 (B 9)
Watercolor and ink on paper, mounted
on cardboard, 18¼ x 12 in.
(46.4 x 30.5 cm)
The Denver Art Museum
Charles Francis Hendrie Memorial
Collection

A Garden for Orpheus
Ein Garten für Orpheus
1926 / 3
Pen and black ink on paper, mounted
on cardboard, 18½ x 12¾ in.
(47 x 32.5 cm), irregular
Kunstmuseum Bern, Paul Klee Stiftung

Sacred Islands
Heilige Inseln
1926 / 6
Pen and ink and watercolor on board,
18⅝ x 12⅜ in. (47 x 31.3 cm)
The Museum of Modern Art, New York
Gift of Philip Johnson

Variations
Variationen (progressives Motiv)
1927 / 299 (Omega 9)
Oil and watercolor on canvas,
16 x 15¾ in. (40.6 x 40 cm)
The Metropolitan Museum of Art,
New York, The Berggruen
Klee Collection, 1984

Stage Site
Bühnenbauplatz
1928 / 44 (N 4)
Pen and ink on paper, mounted on
cardboard, 12⅛ x 11¾ in. (31 x 30 cm)
Private collection, West Germany

Ships in the Lock
Schiffe in der Schleuse
1928 / 40 (M 10)
Pen and black ink on paper, mounted
on cardboard, 11⅞ x 17⅞ in.
(30.3 x 45.5 cm), irregular
Kunstmuseum Bern, Paul Klee Stiftung

Clouds over BOR
Gewölk über BOR
1928 / 155 (F 5)
Watercolor and pen on paper, mounted
on cardboard, 12⅛ x 18 in.
(30.8 x 45.8 cm)
Private collection, Switzerland

Portrait of an Acrobat
Artistenbildnis
1927 / 13 (K 3)
Oil and collage on cardboard over wood
with painted plaster border,
24⅞ x 15¾ in. (63.2 x 40 cm)
The Museum of Modern Art, New York
Mrs. Simon Guggenheim Fund

Conjuring Trick
Zauberkunststück
1927 / 297 (Omega 7)
Oil and watercolor on cardboard,
19½ x 16⅝ in. (49.5 x 42.2 cm)
Philadelphia Museum of Art
The Louise and Walter Arensberg
Collection

Clown
1929 / 133 (D 3)
Oil on canvas, 26⅜ x 19⅝ in.
(67 x 50 cm)
Private collection, St. Louis

229

230

Still Life (Jars, Fruit, Easter Egg, and Curtains)
Stilleben (Töpfe, Frucht, Osterei, und Gardinen)
1927 / 18 (K 8)
Oil on plaster, 17¾ x 25¼ in.
(45.1 x 64.1 cm)
The Metropolitan Museum of Art,
New York, The Berggruen
Klee Collection, 1984

Colorful Meal
Bunte Mahlzeit
1928 / 29 (L 9)
Oil and watercolor on canvas,
33 x 26⅜ in. (84 x 67 cm)
Private collection, U.S.A.

She Bellows, We Play
Sie brüllt, wir spielen
1928 / 70 (P 10)
Oil on canvas, 17⅛ x 22¼ in.
(43.5 x 56.5 cm)
Kunstmuseum Bern, Paul Klee Stiftung

Cat and Bird
Katze und Vogel
1928 / 73 (Qu 3)
Oil and ink on gessoed canvas,
mounted on wood, 15 x 20⅞ in.
(38.1 x 53.2 cm)
The Museum of Modern Art, New York
Gift of Sidney Janis, and gift of Suzy
Prudden Sussman and Joan H. Meijer
in memory of F. H. Hirschland

233

234

Tree Nursery
Junge Pflanzung
1929 / 98 (S 8)
Oil on incised gesso panel,
16⅞ x 20½ in. (43 x 52 cm)
The Phillips Collection,
Washington, D.C.

Arrow in the Garden
Pfeil in Garten
1929 / 27 (S 7)
Oil and tempera on canvas,
27½ x 19⅝ in. (70 x 50 cm)
Centre Georges Pompidou, Paris
Musée National d'Art Moderne
Gift of Louise and Michel Leiris

236

Monument in Fertile Country
Monument im Fruchtland
1929 / 41 (N 1)
Watercolor over pencil on paper,
mounted on cardboard, 17⅞ x 12⅛ in.
(45.7 x 30.8 cm)
Kunstmuseum Bern, Paul Klee Stiftung

Highroad and Byroads
Hauptweg und Nebenwege
1929 / 90 (R 10)
Oil on canvas, 32⅞ x 26½ in.
(83.7 x 67.5 cm)
Museum Ludwig, Cologne

238

In the Current Six Thresholds
In der Strömung sechs Schwellen
1929 / 92 (S 2)
Oil and tempera on canvas,
17⅛ x 17⅛ in. (43.5 x 43.5 cm)
The Solomon R. Guggenheim Museum,
New York

Fire at Evening
Feuer Abends
1929 / 95 (S 5)
Oil on cardboard, 13⅜ x 13¾ in.
(34 x 35 cm)
The Museum of Modern Art, New York
Mr. and Mrs. Joachim Jean Aberbach Fund

Color Table (on Major Gray)
Farbtafel (auf maiorem Grau)
1930 / 83 (R 3)
Pastels combined with paste on paper,
mounted on cardboard, 14¾ x 11⅞ in.
(37.7 x 30.4 cm)
Kunstmuseum Bern, Paul Klee Stiftung

Individualized Measurement of Strata
Individualisierte Höhenmessung der
Lagen
1930 / 82 (R 2)
Pastels combined with paste on paper,
mounted on cardboard, 18⅜ x 13⅝ in.
(46.8 x 34.8 cm)
Kunstmuseum Bern, Paul Klee Stiftung

Rhythmical
Rhythmisches
1930 / 203 (E 3)
Oil on canvas, 27⅛ x 19⅝ in.
(69 x 50 cm)
Centre Georges Pompidou, Paris
Musée National d'Art Moderne

242

Polyphonically Enclosed White
Polyphon gefasstes Weiss
1930 / 140 (X 10)
Watercolor and pen and India ink on
paper, mounted on cardboard,
13⅛ x 9⅝ in. (33.3 x 24.5 cm)
Kunstmuseum Bern, Paul Klee Stiftung

Vegetal-Strange
Pflanzlich-seltsam
1929 / 317 (3 H 17)
Brush drawing in water-based paint over
watercolor, partly sprayed, on paper,
mounted on cardboard, 13 x 10 in.
(33.1 x 25.6 cm)
Kunstmuseum Bern, Paul Klee Stiftung

Romantic Park
Romantischer Park
1930 / 280 (Oe 10)
Oil on cardboard, 12⅞ x 19⅝ in.
(33 x 49.8 cm)
Collection Rosengart, Lucerne

Ad marginem
1930 / 210 (E 10)
Watercolor and India ink on pasteboard,
17⅛ x 12⅞ in. (43.5 x 33 cm)
Kunstmuseum Basel

245

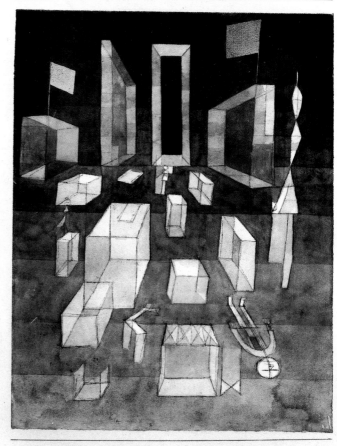

Moving Furniture
Möbelrücken
1929 / 184 (J 4)
Pen and watercolor on paper, mounted
on cardboard, 18⅛ x 11¾ in.
(46 x 30 cm)
Private collection, London

Uncomposed in Space
Nichtcomponiertes im Raum
1929 / 124 (C 4)
Watercolor and pen on paper, mounted
on cardboard, 12½ x 9¾ in.
(32 x 25 cm)
Private collection, Switzerland

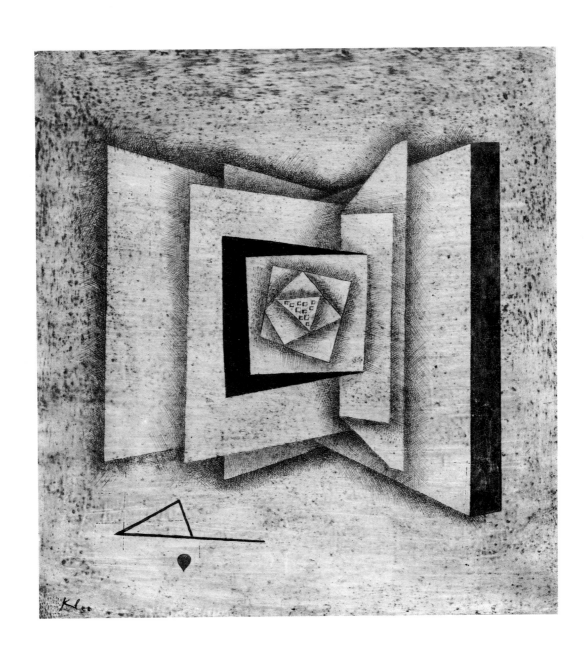

Open Book
Offenes Buch
1930 / 206 (E 6)
Gouache over white lacquer on canvas,
17⅞ x 16¾ in. (45.7 x 42.5 cm)
The Solomon R. Guggenheim Museum,
New York

248

Steerable Grandfather
Lenkbarer Grossvater
1930 / 252 (J 2)
Pen and black ink on paper, mounted
on cardboard, 23¾ x 18¼ in.
(60.3 x 46.5 cm), irregular
Kunstmuseum Bern, Paul Klee Stiftung

Family Outing / Tempo II
Familienspaziergang / Tempo II
1930 / 260 (J 10)
Pen and colored inks on paper, mounted
on cardboard, 15¾ x 22⅝ in.
(40.1 x 57.5 cm), irregular
Kunstmuseum Bern, Paul Klee Stiftung

**Vertical and Horizontal Planes
in the Studio**
Vertical und Horizontal-Flächen im
Atelier
1931 / 41 (L 1)
Pen and colored inks on paper, mounted
on cardboard, 15½ x 24⅛ in.
(39.5 x 61.4 cm), irregular
Kunstmuseum Bern, Paul Klee Stiftung

Model l06 (Expanded)
Modell 106 (erweitert)
1931 / 199 (T 19)
Pen and colored inks on paper, mounted
on cardboard, 18⅛ x 24⅝ in.
(46.2 x 62.7 cm)
Kunstmuseum Bern, Paul Klee Stiftung

250

Flight from Oneself (First State)
Flucht vor sich (erstes Stadium)
1931 / 25 (K 5)
Pen and colored inks on paper, mounted
on cardboard, 16⅝ x 22⅞ in.
(42.2 x 58.2 cm), irregular
Kunstmuseum Bern, Paul Klee Stiftung

Colorful Life Outside
Draussen buntes Leben
1931 / 160 (R 20)
Watercolor on paper, mounted on
cardboard, 12¼ x 19⅛ in.
(31.3 x 48.8 cm)
Private collection, Switzerland

All in Twilight
Der Ganze dämmernd
1932 / 4
Watercolor on paper, 15¾ x 12⅜ in.
(40 x 31.7 cm)
Private collection, New York

252

Classical Coast
Klassische Küste
1931 / 285 (Y 5)
Oil on canvas, 31⅞ x 27⅛ in.
(81 x 69 cm)
Private collection, U.S.A.

Castle Garden
Schlossgarten
1931 / 152 (R 12)
Oil on canvas, 26⅜ x 21⅝ in.
(67.2 x 54.9 cm)
The Museum of Modern Art, New York
Sidney and Harriet Janis Collection Fund

254

Polyphony
Polyphonie
1932 / 273 (X 13)
Oil on canvas, 26⅛ x 41¾ in.
(106 x 66.5 cm)
Kunstmuseum Basel
Emanuel Hoffman Stiftung

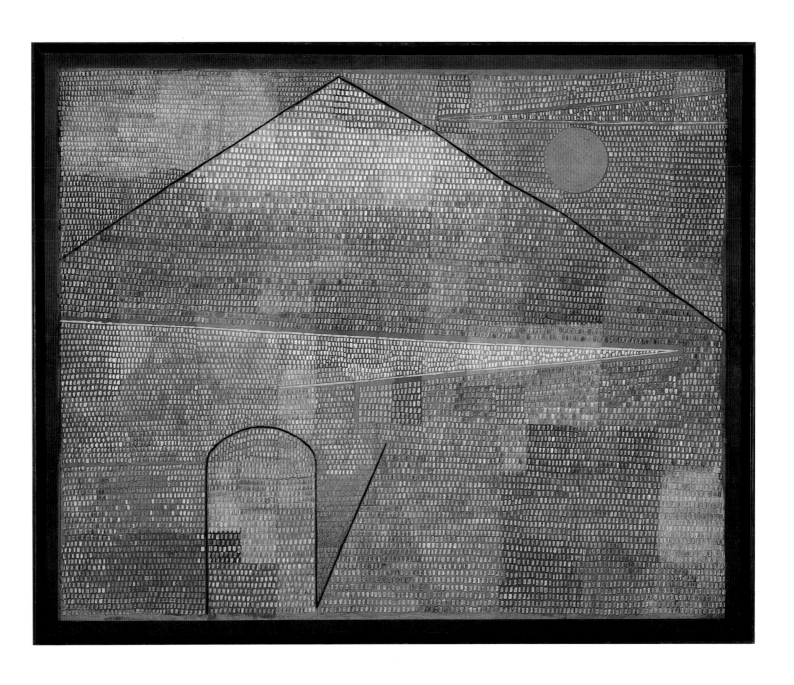

Ad Parnassum
1932 / 274 (X 14)
Oil on canvas, 39⅜ x 49⅝ in.
(100 x 126 cm)
Kunstmuseum Bern, Society of Friends
of the Kunstmuseum Bern

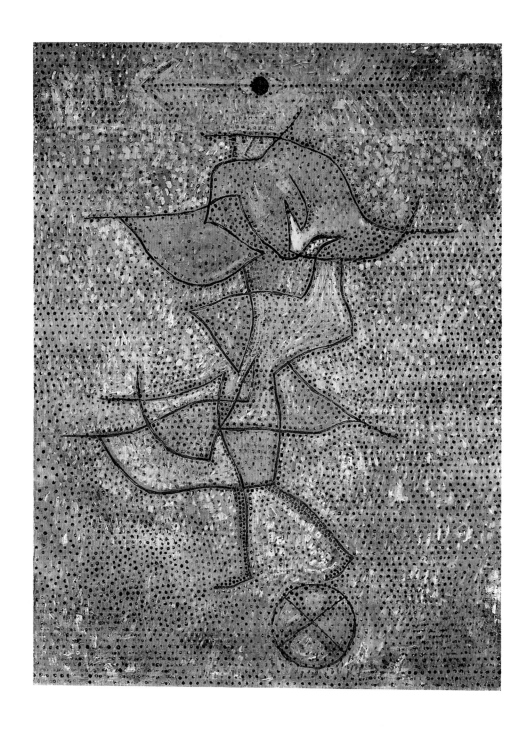

256

Diana
1931 / 287 (Y 7)
Oil on canvas, 31½ x 23⅝ in.
(80 x 60 cm)
Private collection, St. Louis

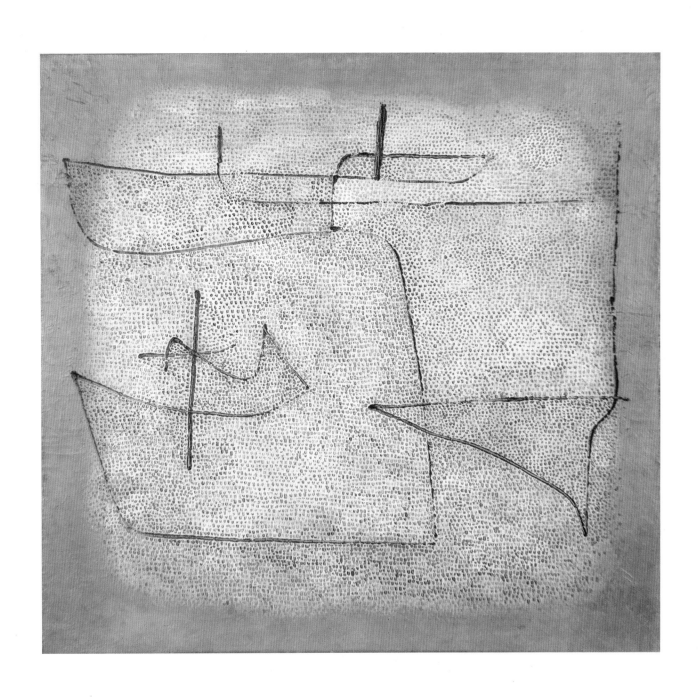

Anchored
Vor Anker
1932 / 22 (K 2)
Oil on canvas, 36½ x 43½ in.
(92.7 x 110.5 cm)
Private collection, U.S.A.

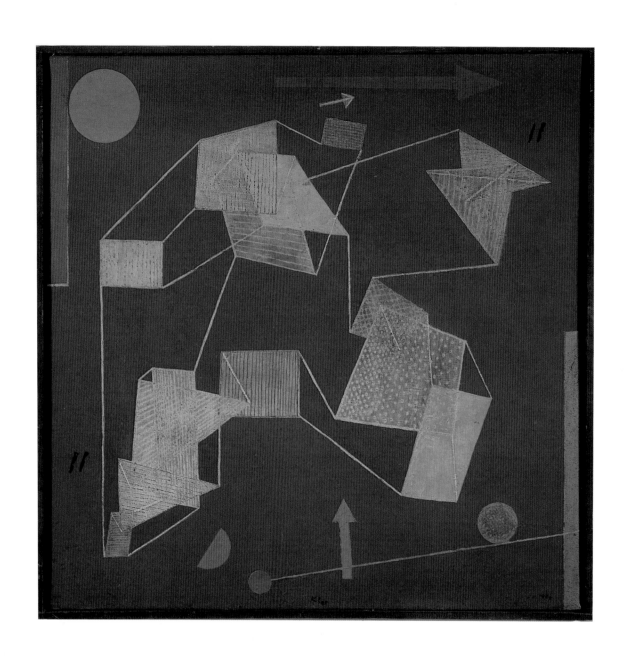

Uplift and Way (Sail Flight)
Auftrieb und Weg (Segelflug)
1932 / 190
Oil on canvas, 35⅜ x 35¾ in.
(90 x 91 cm)
Private collection, Switzerland

Commotion in the Studio
Bewegung in der Werkstatt
1932 / 312 (Z 12)
Brush and ink over crayon on paper,
mounted on cardboard, 12⅝ x 16⅞ in.
(32.2 x 42.8 cm)
Kunstmuseum Bern, Paul Klee Stiftung

Signs Intensifying Themselves
Zeichen verdichten sich
1932 / 121 (qu 1)
Brush and blue ink on paper, mounted
on cardboard, 12⅜ x 19 in.
(31.4 x 48.5 cm)
Kunstmuseum Bern, Paul Klee Stiftung

Arab Song
Arabisches Lied
1932 / 283 (Y 3)
Gouache on burlap, 35¾ x 25⅛ in.
(91 x 64 cm)
The Phillips Collection,
Washington, D.C.

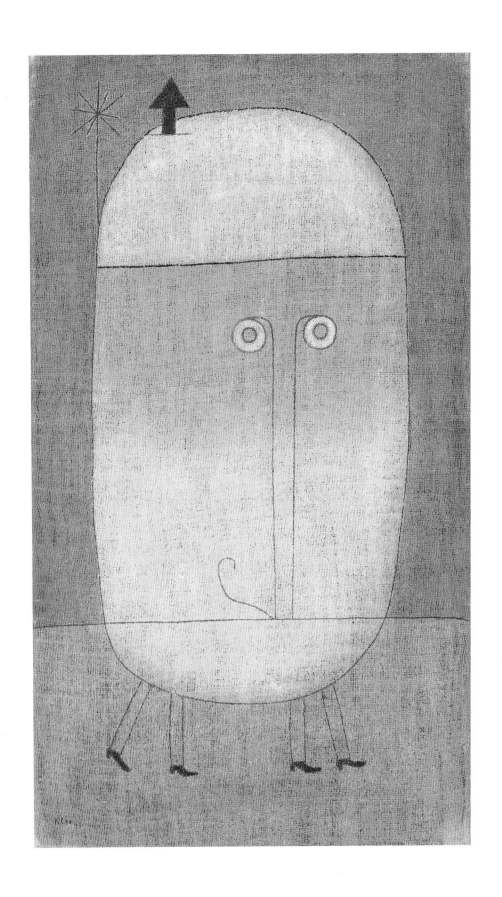

Mask of Fear
Maske Furcht
1932 / 286 (Y 6)
Oil on burlap, 39½ x 22½ in.
(100.4 x 57.1 cm)
The Museum of Modern Art, New York
Nelson A. Rockefeller Fund

Top:
Be They Cursed!
Fluch ihnen!
1933 / 157 (S 17)
Black crayon on paper, mounted on cardboard, 10⅞ x 8¼ in.
(27.6 x 20.9 cm)
Kunstmuseum Bern, Paul Klee Stiftung

Bottom left:
Emigrating
Auswandern
1933 / 181 (U 1)
Black crayon on paper, mounted on cardboard, 12⅞ x 8¼ in.
(32.9 x 21.0 cm)
Kunstmuseum Bern, Paul Klee Stiftung

Bottom right:
Double Murder
Doppelmord
1933 / 211 (V 11)
Black crayon on paper, mounted on cardboard, 12⅞ x 8¼ in.
(32.9 x 20.9 cm)
Kunstmuseum Bern, Paul Klee Stiftung

Shame
Schande
1933 / 15 (K 15)
Brush and ink on paper, mounted on
cardboard, 24⅝ x 18½ in.
(62.6 x 47.2 cm)
Kunstmuseum Bern, Paul Klee Stiftung

**Brush, Plate, Cups, Bowls (First
Version)**
Pinsel, Teller, Tassen, Schalen (I. Fassung)
1933 / 8 (K 8)
Watercolor on paper, mounted on
cardboard, 19 x 24⅞ in.
(48.4 x 63.4 cm), irregular
Kunstmuseum Bern, Paul Klee Stiftung

264

Mountain Village (Autumnal)
Bergdorf (herbstlich)
1934 / 209 (U 9)
Oil on primed canvas, mounted on
plywood, 28⅛ x 21⅜ in.
(71.5 x 54.4 cm)
Collection Rosengart, Lucerne

Blossoming
Blühendes
1934 / 199 (T 19)
Oil on canvas, 31⅞ x 31½ in.
(81 x 80 cm)
Kunstmuseum Winterthur, Switzerland

The Way Out Discovered
Der gefundene Ausweg
1935 / 98 (N 18)
Watercolor and charcoal on paper,
12½ x 18⅞ in. (32 x 48 cm)
Private collection, Switzerland

Planting according to Rules
Nach Regeln zu pflanzen
1935 / 91 (N 11)
Watercolor on paper, mounted on
cardboard, 10⅛ x 14½ in.
(25.8 x 36.9 cm)
Kunstmuseum Bern
Hermann und Margrit Rupf Stiftung

Menu without Appetite
Menu ohne Appetit
1934 / 170 (S 10)
Pencil on paper, mounted on cardboard,
8¼ x 12⅞ in. (20.9 x 32.8 cm),
irregular
Private collection, Canada

The Helpless Ones
Die Ratlosen
1936 / 23 (K 3)
Watercolor on canvas, mounted on
plywood, 9¾ x 21¼ in. (25 x 54 cm)
Private collection, Switzerland

New Harmony
Neue Harmonie
1936 / 24 (K 4)
Oil on canvas, 36⅞ x 26⅛ in.
(93.6 x 66.3 cm)
The Solomon R. Guggenheim Museum,
New York

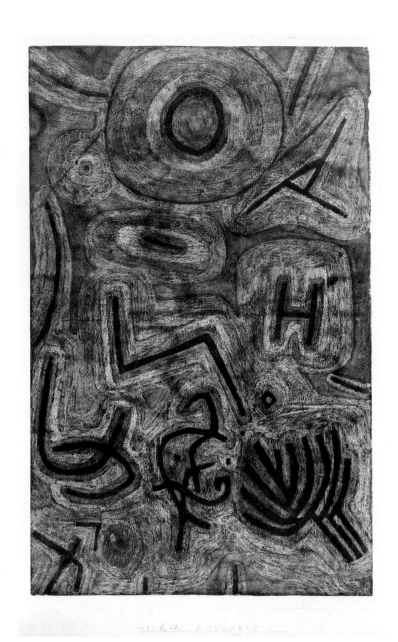

270

Catharsis
Katharsis
1937 / 40 (K 20)
Colored pencil over paste ground on
paper, mounted on cardboard,
19⅛ x 12⅝ in. (48.8 x 32.3 cm)
Kunstmuseum Bern, Paul Klee Stiftung

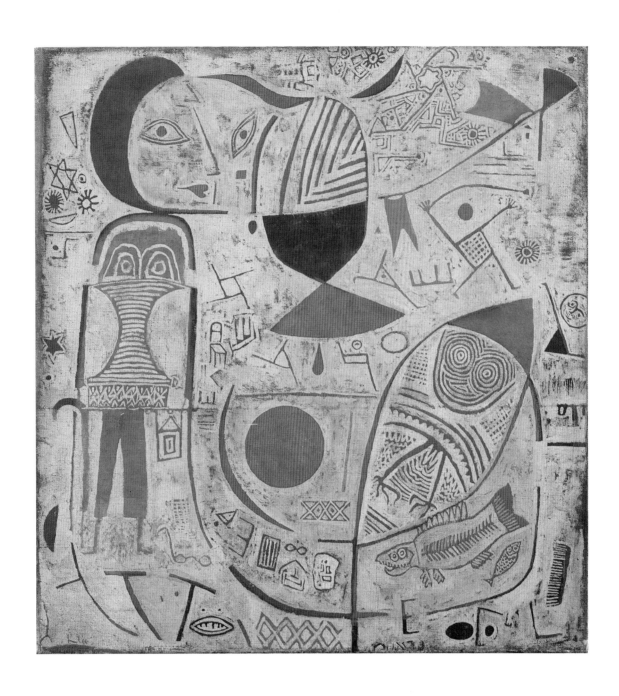

Picture Album
Bilderbogen
1937 / 133 (Qu 13)
Oil on canvas, 23¼ x 22 in.
(59 x 56 cm)
The Phillips Collection,
Washington, D.C.

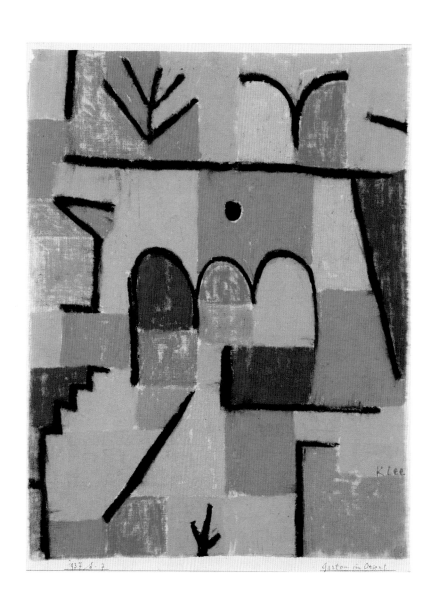

272

Garden in the Orient
Garten im Orient
1937 / 167 (S 7)
Pastel on canvas, 14⅛ x 11⅛ in.
(36.1 x 28.2 cm)
Collection Mr. and Mrs. James W.
Alsdorf, Chicago

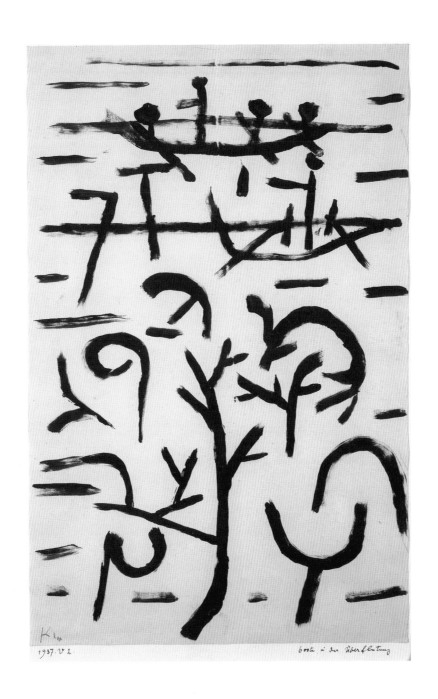

Boats in the Flood
Boote in der Überflutung
1937 / 222 (V 2)
Gouache and colored paste on
cardboard, 19½ x 12¾ in.
(49.5 x 32.5 cm)
Collection Beyeler, Basel

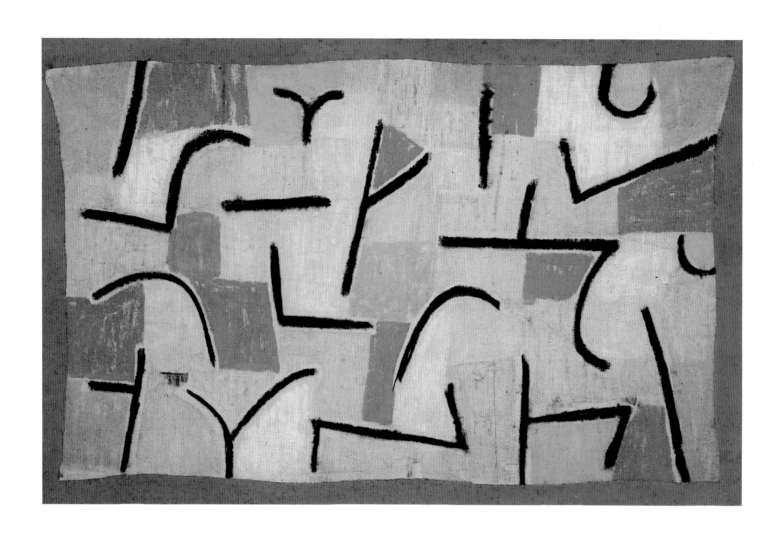

Landscape near Hades
Landschaft gegen den Hades
1937 / 209 (U 9)
Pastel on canvas on burlap,
18⅜ x 28¾ in. (46.9 x 73.1 cm)
Munson-Williams-Proctor Institute
Museum of Art, Utica, New York

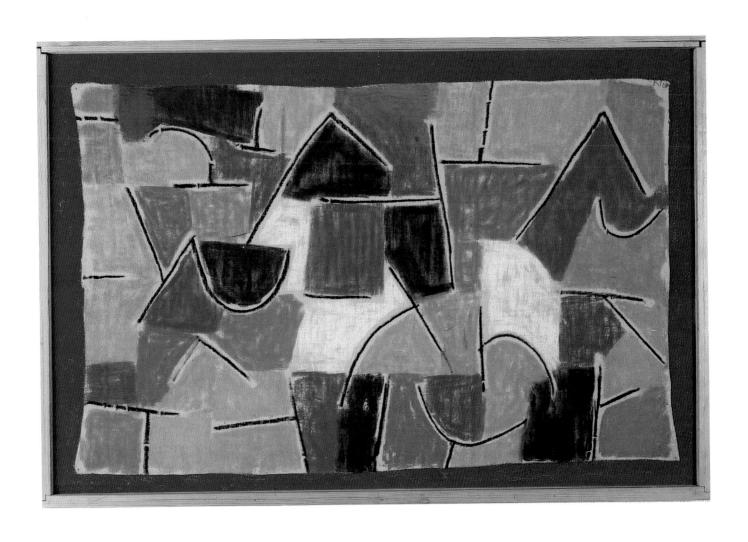

Blue Night
Blaue Nacht
1937 / 208 (U 8)
Tempera and pastel on canvas on
burlap, 19¾ x 30 in. (50.3 x 76.4 cm)
Kunstmuseum Basel

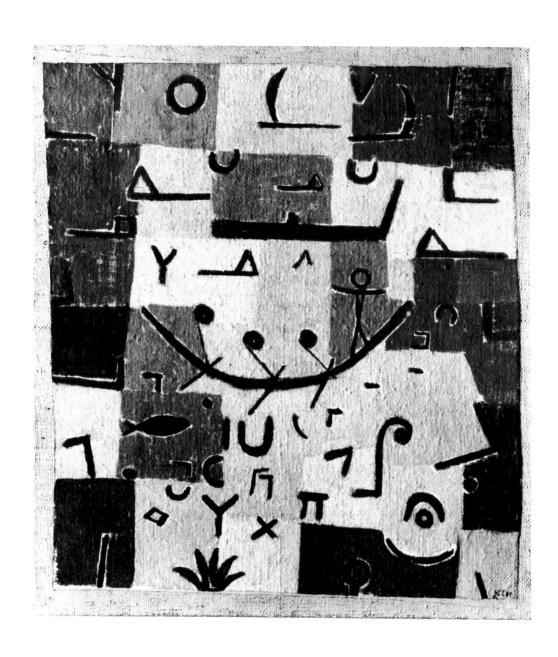

278

Legend of the Nile
Legende vom Nil
1937 / 215 (U 15)
Pastel on cotton on burlap,
27⅛ x 24 in. (69 x 61 cm)
Kunstmuseum Bern
Hermann und Margrit Rupf Stiftung

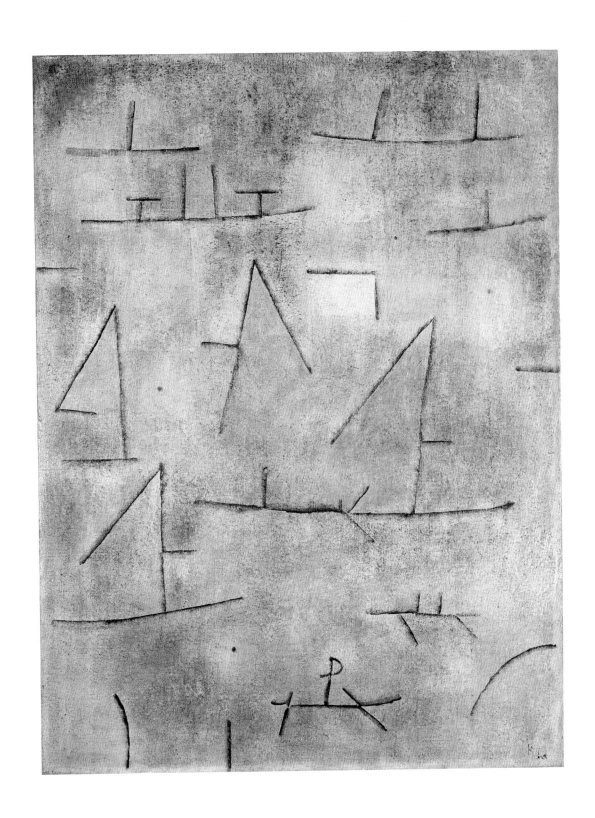

Harbor with Sailboats
Hafen mit Segelschiffen
1937 / 151 (R 11)
Oil on canvas, 31½ x 23⅝ in.
(80 x 60 cm)
Centre Georges Pompidou, Paris
Musée National d'Art Moderne

Indian
Indianisch
1937 / 181 (T 1)
Pastel on paper, 18⅞ x 12⅞ in.
(48 x 33 cm)
Private collection

Landscape with Two Who Are Lost
Landschaft mit den beiden Verirrten
1938 / 36 (D 16)
Colored paste on paper, mounted on
cardboard, 12½ x 19 in. (32 x 48.5 cm)
Kunstmuseum Basel

Rusting Ships
Rostende Schiffe
1938 / 127 (J 7)
Colored paste on newspaper on burlap,
21⅝ x 53½ in. (55 x 136 cm)
Private collection, Switzerland

Rich Harbor
Reicher Hafen
1938 / 147 (K 7)
Tempera on paper and canvas,
29¾ x 64⅞ in. (75.5 x 165 cm)
Kunstmuseum Basel

283

284

Heroic Strokes of the Bow
Heroische Bogenstriche
1938 / 1 (1)
Tempera on paper on cloth with gesso
backing, 28¾ x 20¾ in. (73 x 52.7 cm)
The Museum of Modern Art, New York
Nelson A. Rockefeller Bequest

The Gray One and the Coast
Der Graue und die Küste
1938 / 125 (J 5)
Colored paste on burlap,
40⅞ x 27½ in. (104 x 70 cm)
Private collection, Switzerland

Growth Is Stirring
Wachstum regt sich
1938 / 78 (F 18)
Colored paste on newspaper, mounted
on cardboard, 12⅞ x 19 in.
(33 x 48.5 cm)
Private collection, Switzerland

Intention
Vorhaben
1938 / 126 (J 6)
Colored paste on newspaper on burlap,
29½ x 44 in. (75 x 112 cm)
Kunstmuseum Bern, Paul Klee Stiftung

287

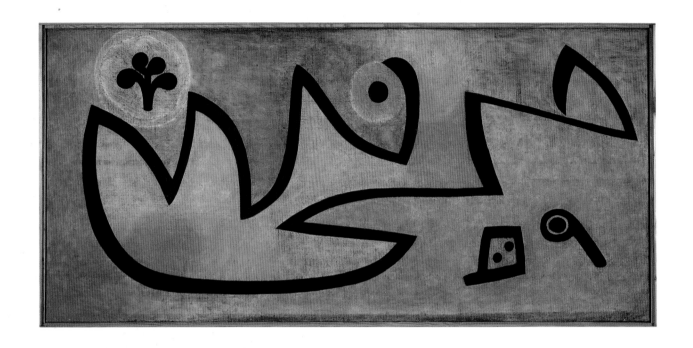

288

Fire Source
Feuer Quelle
1938 / 132 J 12
Oil on newspaper on burlap,
27⅜ x 58⅞ in. (69.5 x 149.5 cm)
Private collection, Switzerland

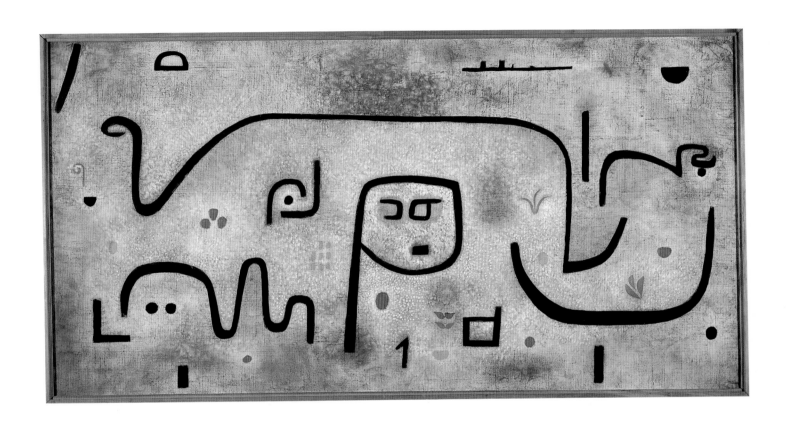

Insula Dulcamara
1938 / 481 (C 1)
Oil and black paste on newspaper,
mounted on burlap, 34⅝ x 69¼ in.
(88 x 176 cm)
Kunstmuseum Bern, Paul Klee Stiftung

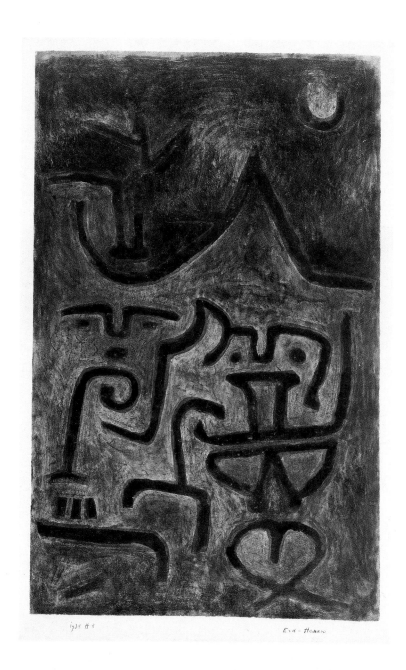

Earth Witches
Erd-Hexen
1938 / 108 (H 8)
Watercolor and oil, varnished, on paper,
mounted on cardboard, 19 x 12¼ in.
(48.5 x 31.2 cm)
Kunstmuseum Bern, Paul Klee Stiftung

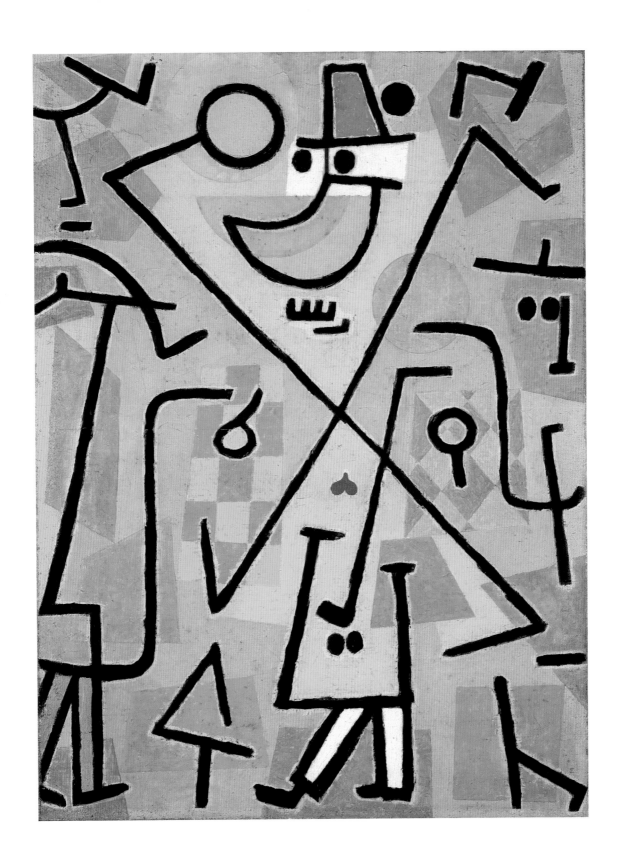

Capriccio in February
Capriccio im Februar
1938 / 128 (J 8)
Oil on newspaper on burlap,
39⅜ x 29¼ in. (100 x 74.3 cm)
Morton G. Neumann Family Collection,
Chicago

Pomona, Overripe (Slightly Inclined)
Pomona, überreif (leicht geneigt)
1938 / 134 (J 14)
Oil on newspaper on burlap,
26¾ x 20½ in. (68 x 52 cm)
Kunstmuseum Bern, Paul Klee Stiftung

The Key (Broken Key)
Der Schlüssel (Zerbrochener Schlüssel)
1938 / 136 (J 16)
Oil on burlap, 19¾ x 26⅛ in.
(50.4 x 66.4 cm)
Sprengel Museum Hannover

ABC for a Wall Painter
ABC für Wandmaler
1938 / 320 (T 20)
Oil and watercolor on burlap,
22 x 14⅞ in. (56 x 37.8 cm)
Collection Rosengart, Lucerne

"So May It Secretly Begin"
"So Fang Es Heimlich an"
1938 / 189 (M 9)
Water-based paint on paper, mounted
on cardboard, 19 x 24¾ in.
(48.3 x 62.8 cm)
Kunstmuseum Bern, Paul Klee Stiftung

The Timid Brute
Der furchtsame Grausame
1938 / 138 (J 18)
Oil and gouache on canvas,
22¼ x 29 in. (56.5 x 73.6 cm)
Private collection, New York

Protected Children
Geschützte Kinder
1939 / 345 (Y 5)
Oil on burlap, 29⅝ x 39½ in.
(75.2 x 100.4 cm)
Private collection, U.S.A.

Flowers in Stone
Blumen in Stein
1939 / 638 (GG 18)
Oil on cardboard, 19½ x 15⅝ in.
(49.6 x 39.8 cm)
Stiftung Sammlung Bernhard Sprengel,
Hanover

Underwater Garden
Unterwasser-Garten
1939 / 746 (NN 6)
Oil on canvas, 40⅞ x 33 in.
(104 x 84 cm), irregular
Private collection

Gigantic Plants
Riesen-Pflanzen
1940 / 266 (L 6)
Colored paste on paper, mounted on
cardboard, 18⅞ x 24⅝ in.
(48 x 62.5 cm)
Private collection, Switzerland

At the Hunter Tree
Zum Jägerbaum
1939 / 557 (CC 17)
Oil on canvas, 39⅜ x 31½ in.
(100 x 80 cm)
Kunsthaus Zürich

Luna of the Barbarians
Luna der Barbaren
1939 / 284 (v 4)
Gouache on paper, mounted on board,
12¾ x 8¼ in. (32.5 x 21 cm)
Private collection, Philadelphia

Mephisto as Pallas
Mephisto als Pallas
1939 / 855 (UU 15)
Watercolor and tempera on paper,
mounted on cardboard, 19 x 12⅛ in.
(48.4 x 30.9 cm)
Ulmer Museum, Ulm, West Germany

304 **As I Rode on the Ass**
Als ich auf dem Esel ritt
1940 / 313
Black paste on paper, mounted on
cardboard, 11½ x 16⅛ in. (29 x 41 cm)
Private collection, Switzerland

The Snake Goddess and Her Foe
Die Schlangengöttin und ihr Feind
1940 / 317 (H 17)
Colored paste on paper, mounted on
cardboard, 13⅜ x 20⅞ in. (34 x 53 cm)
Private collection, Switzerland

Injured
Verletzt
1940 / 316 (H 16)
Black paste on paper, mounted on
cardboard, 16⅜ x 11⅝ in.
(41.7 x 29.5 cm)
Kunstmuseum Bern, Paul Klee Stiftung

Dancing Fruit
Tanzende Früchte
1940 / 312 (H 12)
Black paste on paper, mounted on
cardboard, 11⅝ x 16⅜ in.
(29.5 x 41.8 cm)
Kunstmuseum Bern
Hermann und Margrit Rupf Stiftung

Destroyed Labyrinth
Zerstörtes Labyrinth
1939 / 346 (Y 6)
Oil and water-based paint, varnished, on
paper with oil ground, mounted on
burlap, 21¼ x 27½ in. (54 x 70 cm)
Kunstmuseum Bern, Paul Klee Stiftung

306 **Eidola: Erstwhile Musician**
Eidola: weiland Musiker
1940 / 81 (V 1)
Black crayon on paper, mounted on
cardboard, 11⅝ x 8¼ in. (29.7 x 21 cm)
Kunstmuseum Bern, Paul Klee Stiftung

Eidola: Erstwhile Harpist
Eidola: weiland Harfner
1940 / 100 (V 20)
Black crayon on paper, mounted on
cardboard, 11⅝ x 8¼ in. (29.7 x 21 cm)
Kunstmuseum Bern, Paul Klee Stiftung

**Eidola: KNAYHPOE, Erstwhile
Kettledrummer**
Eidola: KNAYHPOE, weiland Pauker
1940 / 102 (U 2)
Black crayon on paper, mounted on
cardboard, 11⅝ x 8¼ in. (29.7 x 21 cm)
Kunstmuseum Bern, Paul Klee Stiftung

Eidola: Erstwhile Pianist
Eidola: weiland Pianist
1940 / 104 (U 4)
Black crayon on paper, mounted on
cardboard, 11⅝ x 8¼ in. (29.7 x 21 cm)
Kunstmuseum Bern, Paul Klee Stiftung

Outbreak of Fear III
Angstausbruch III
1939 / 124 (M 4)
Watercolor over egg ground on paper,
mounted on cardboard, 25 x 18⅞ in.
(63.5 x 48.1 cm)
Kunstmuseum Bern, Paul Klee Stiftung

Outbreak of Fear
Angstausbruch
1939 / 27 (G 7)
Pen and ink on paper, mounted on
cardboard, 10⅝ x 8⅜ in. (27 x 21.5 cm)
Kunstmuseum Bern, Paul Klee Stiftung

Intoxication
Im Rausch
1939 / 1
Tempera on paper, mounted on
cardboard, 14¼ x 20¾ in.
(36.2 x 52.7 cm)
Private collection

Fleeing UR-OX
Fliehender URCHS
1939 / 1080 (FG 20)
Brush and brown paste on paper,
mounted on cardboard, 8⅛ x 11⅝ in.
(20.8 x 29.5 cm)
Kunstmuseum Bern, Paul Klee Stiftung

UR-OX, Half from Behind
URCHS, halb von hinten
1939 / 1078 (FG 8)
Brush and colored paste on paper,
mounted on cardboard, 8¼ x 11⅝ in.
(21 x 29.5 cm)
Private collection, Switzerland

Shield-UR-OX
Schild-URCHS
1939 / 1079 (FG 19)
Brush and brown paste on paper,
mounted on cardboard, 8⅛ x 11⅝ in.
(20.8 x 29.5 cm)
Kunstmuseum Bern, Paul Klee Stiftung

Hold Out!
Durchhalten!
1940 / 337 (G 17)
Black pastel on paper, mounted on
cardboard, 11⅝ x 8¼ in.
(29.6 x 20.9 cm)
Kunstmuseum Bern, Paul Klee Stiftung

Angel, Still Female
Engel, noch weiblich
1939 / 1016 (CD 16)
Colored lithographic crayon over blue
paste on paper, mounted on cardboard,
16⅜ x 11½ in. (41.7 x 29.4 cm)
Kunstmuseum Bern, Paul Klee Stiftung

Vigilant Angel
Wachsamer Engel
1939 / 859 (UU 19)
Pen and tempera on black newspaper,
19 x 12⅞ in. (48.5 x 33 cm)
Private collection, Switzerland

The Cupboard
Der Schrank
1940 / 276 (L 16)
Colored paste on paper, mounted on
board, 16¼ x 11⅝ in. (41.5 x 29.5 cm)
Private collection, Switzerland

The Carpet
Der Teppich
1940 / 275 (L 15)
Colored paste on paper, 11⅝ x 16½ in.
(29.5 x 42 cm)
Private collection, Switzerland

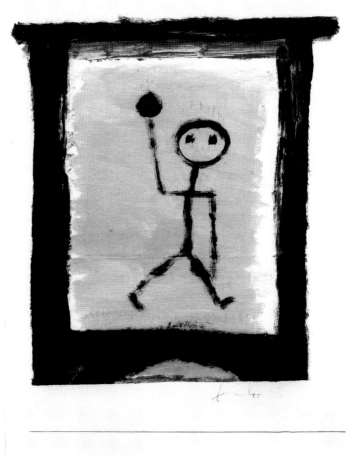

Locksmith
Schlosser
1940 / 274 (L 14)
Colored paste on paper, mounted on
cardboard, 18⅞ x 12 in. (48 x 30.5 cm)
Kunstmuseum Basel

Wandering Artist: A Poster
Wander-Artist, ein Plakat
1940 / 273 (L 13)
Colored paste on paper, mounted on
cardboard, 12⅛ x 11⅜ in. (31 x 29 cm)
Private collection, Switzerland

313

314

Double
Doppel
1940 / 236 (N 16)
Colored paste on paper, mounted on
cardboard, 20⅝ x 13⅝ in.
(52.4 x 34.6 cm)
Kunstmuseum Bern, Paul Klee Stiftung

Glass Facade
Glas-Fassade
1940 / 288 (K 8)
Encaustic on burlap, 27⅞ x 37⅜ in.
(71 x 95 cm)
Kunstmuseum Bern, Paul Klee Stiftung

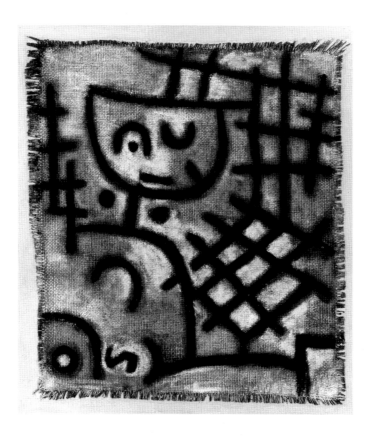

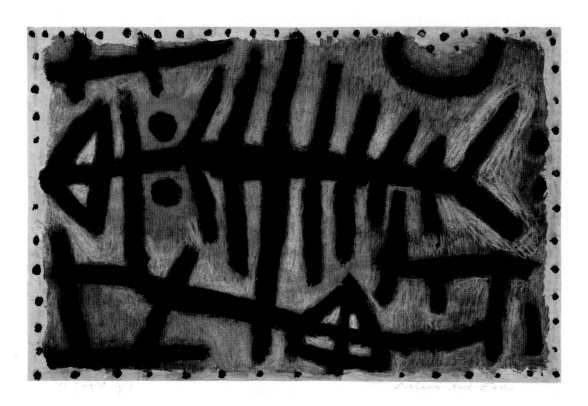

316

Here and Beyond (Captured)
Diesseits-Jenseits (Gefangen)
1940 / N
Colored paste on burlap, 21⅝ x 19⅝ in.
(55 x 50 cm)
Galerie Beyeler, Basel

Muddle Fish
Schlamm-Assel-Fisch
1940 / 323 (G 3)
Colored paste on paper, mounted on
cardboard, 13⅜ x 21 in. (34 x 53.5 cm)
Collection Beyeler, Basel

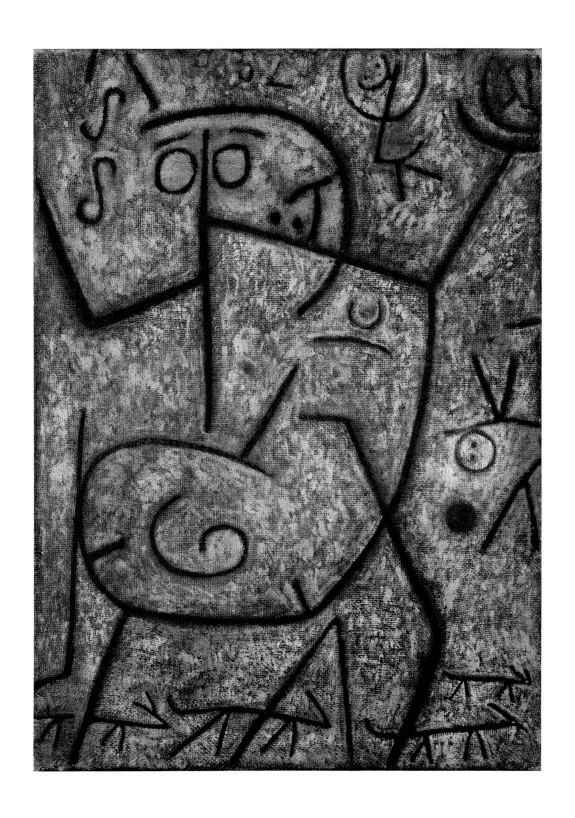

O! These Rumors!
O! die Gerüchte!
1939 / 1015 (CD 15)
Oil and tempera on burlap,
29¾ x 21⅝ in. (75.5 x 55 cm)
Collection Beyeler, Basel

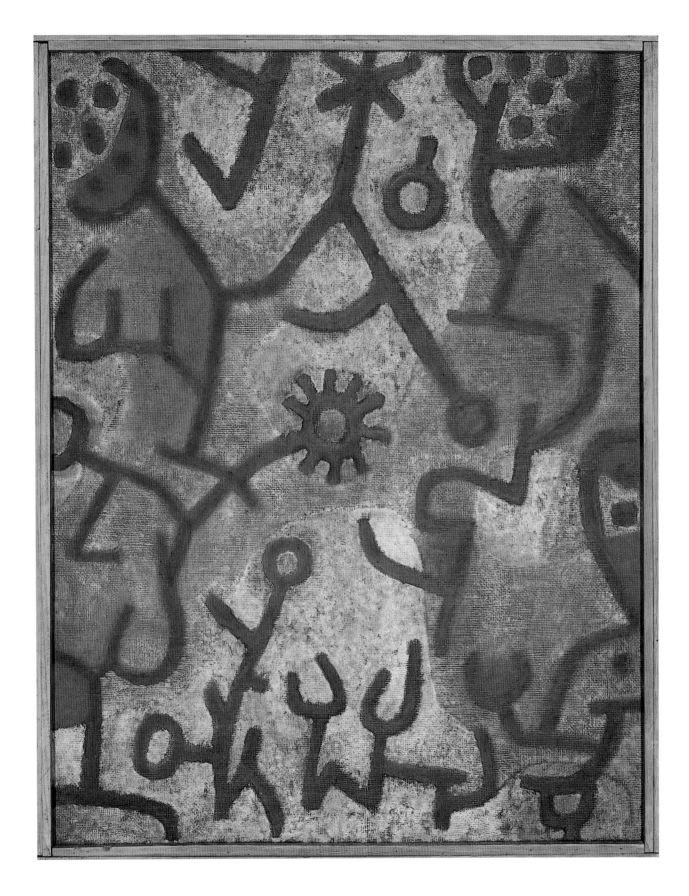

318

Flora on the Rocks
Flora am Felsen
1940 / 343 (F 3)
Oil and tempera on burlap,
35⅜ x 27½ in. (90 x 70 cm)
Kunstmuseum Bern, Paul Klee Stiftung

Untitled (Composition with Fruit)
Ohne Titel (Komposition mit Früchten)
1940 / N
Colored paste on packing paper,
40½ x 58¼ in. (103 x 148 cm)
Private collection, Switzerland

High Guardian
Hoher Wächter
1940 / 257 (M 17)
Encaustic on canvas, 27½ x 19⅝ in.
(70 x 50 cm)
Kunstmuseum Bern, Paul Klee Stiftung

Angel, Still Ugly
Engel, noch hässlich
1940 / 26 (Y 6)
Pencil on paper, mounted on cardboard,
11⅝ x 8¼ in. (29.6 x 20.9 cm)
Kunstmuseum Bern, Paul Klee Stiftung

Untitled (Still Life)
Ohne Titel (Stilleben)
1940 / N
Oil on canvas, 39⅜ x 31⅝ in.
(100 x 80.5 cm)
Private collection, Switzerland

Everything Comes Running After!
Alles läuft nach!
1940 / 325 (G 5)
Brush and black paste over colored-
paste ground, mounted on cardboard,
12½ x 16⅝ in. (32 x 42.4 cm)
Kunstmuseum Bern, Paul Klee Stiftung

Death and Fire
Tod und Feuer
1940 / 332 (G 12)
Oil, drawing in black paste on burlap,
surrounded by colored-paste ground,
mounted on burlap, 18⅛ x 17¼ in.
(46 x 44 cm)
Kunstmuseum Bern, Paul Klee Stiftung

CHRONOLOGY

1879 December 18: Paul Klee is born at Münchenbuchsee, near Bern, Switzerland. His mother, Ida Marie Frick Klee, is Swiss; his father, Hans Klee, a music teacher, is German. Paul's sister Mathilde was born in 1876.

1880 Family moves to Bern.

1898 Spring: Graduates from *Literarschule* (humanities program) of Bern *Gymnasium* (secondary school).
October: Moves to Munich; studies art with Heinrich Knirr and later with Franz Stuck at Munich Academy. Begins *Tagebücher* (diaries), maintained through 1918.

1901 October: Departs for travel in Italy with sculptor Hermann Haller. In May 1902, returns to live in Bern.

1905 May 31–June 13: Trip to Paris with Hans Bloesch and Louis Moilliet.

1906 April: Trip to Berlin.
September 15: Marriage to Lily Stumpf, Munich pianist he has known since 1899. They settle in Schwabing, artists' quarter of Munich.

1907 November 30: Birth of Felix Klee.

1909 March: Felix becomes seriously ill. Klee assumes full responsibility for his care, and they spend summer in Bern.

1911 Spring: Begins oeuvre catalogue, detailed record of his work, maintaining it until his death. Retroactively records work dating back to 1883.
Autumn: Moilliet introduces Klee to August Macke and Wassily Kandinsky; soon after meets Franz Marc and Alexey Jawlensky. Becomes affiliated with *Blaue Reiter* (Blue Rider) group.
Reviews Munich cultural events for Bern newspaper *Die Alpen*.

1912 February: Takes part in second *Blaue Reiter* exhibition at Galerie Goltz, Munich.
April 2–18: Second trip to Paris. Visits Robert Delaunay's studio.

1914 April: Travels to Tunisia with Moilliet and Macke. Visits Tunis, St. Germain, Hamamet, and Kairouan.
May: Founding member of New Munich Secession.

1916 March 4: Franz Marc killed at Verdun; Klee profoundly affected.
March 11: Klee drafted into German infantry reserves in Landshut.
Summer: Transferred to Munich, then to air-force reserves in Schleissheim; paints aircraft and accompanies military transports to front.

1917 January: Transferred to flying school in Gersthofen; clerk in paymaster's office.

1918 December: Discharged from military duty.

Paul Klee, Bern, 1881

Paul Klee, Bern, 1892

Quintet at the Knirr studio, Munich, 1900. Paul Klee in right foreground

Klee and Hermann Haller at the Villa Medici,
Rome, February 1902. Photograph by Karl Schmoll

Lily Stumpf, August 1903. Photograph by Paul Klee

Gabriele Münter. *Man in an Armchair* (Paul Klee),
1913. Oll on linen, Bayerische
Staatsgemäldesammlungen, Munich

Hans, Lily, and Paul Klee, Bern, September 1906

Klee in Tunisia, April 1914. Photograph by Louis Moilliet

Klee in uniform, Landshut, 1916

1919 Spring: Rents large studio in Suresnes
Castle in Munich.
April 12: Joins artists' advisory body of
Räterrepublik, socialist government of
Bavaria.
June 11: Leaves Munich briefly after
failure of *Räterrepublik*.
Summer: Oskar Schlemmer and Willi
Baumeister seek appointment for Klee
at Stuttgart Academy; faculty refuses.
Klee signs three-year contract with
dealer Hans Goltz in Munich.

1920 May–June: Exhibition at Goltz's Galerie
Neue Kunst in Munich (362 works).
October: Invited by Walter Gropius and
Bauhaus faculty to teach at Staatliche
Bauhaus Weimar, founded previous year.
"Creative Credo" appears in anthology
Schöpferische Konfession, published by
Tribüne der Kunst und Zeit.
Leopold Zahn and Hans von Wedderkop
write first monographs on Klee.

1921 Publication of Wilhelm Hausenstein's
monograph on Klee.
January: Assumes post at Bauhaus,
commuting from Munich.
March 15: Death of Klee's mother.
September: Lily and Felix join Klee in
Weimar.

1923 August 15–September 30: First Bau-
haus festival and exhibition. Commem-
orative publication includes Klee's "Ways
of Nature Study."
Autumn: Holiday on Baltrum Island in
North Sea.

1924 January 7–February 7: First Klee exhibi-
tion in America, organized by Katherine
Dreier of Société Anonyme, at
Heckscher Building on West 57th Street,
New York.
January 26: Klee delivers lecture "On
Modern Art" to inaugurate exhibition at
Kunstverein Jena in Germany.
March 31: Klee signs agreement with
Kandinsky, Lyonel Feininger, and Alexey
Jawlensky to form "Blue Four," which
Galka Scheyer will represent in America.
Summer: Travels in Sicily.
December 26: Bauhaus Weimar of-
ficially closed.

1925 April: Bauhaus moves to Dessau.
October–November: First exhibition in
France, at Galerie Vavin-Raspail, Paris.
November: Included in first Surrealist ex-
hibition, at Galerie Pierre, Paris.
Pedagogical Sketchbook, designed by
László Moholy-Nagy, published as sec-
ond in series of Bauhaus Books edited by
Gropius and Moholy-Nagy.
Signs contract with dealer Alfred
Flechtheim.

326 1926 July: Klee family moves into two-family
house designed by Gropius; shares it
with Wassily and Nina Kandinsky.
October–November: Travels to Italy
with Lily.
December 4: Dessau Bauhaus inaugu-
rates new building designed by Gropius.

1927 Summer: Travels to Porquerolles and
Corsica.

Klee's studio in Suresnes Castle, Munich, 1920. Photograph by Paul Klee

Klee and Galka Scheyer, Weimar, 1922. Photograph by Felix Klee

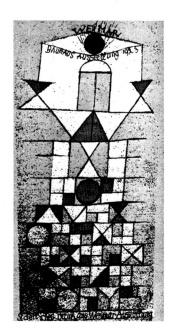

Paul Klee. Invitations to Bauhaus festival-exhibition, Weimar, 1923.
Lithographs. The Museum of Modern Art, New York,
Purchase Fund

Klee in his Weimar Bauhaus studio, 1924. Photograph by Felix Klee

Klee's studio in Dessau Bauhaus, August 1926. Photograph by Felix Klee

George Grosz, Alfred Flechtheim, and Klee, Dessau, July 1929

Wassily Kandinsky and his wife Nina, Georg Muche,
Klee, and Walter Gropius, Dessau Bauhaus, December 1926

Kandinsky and Klee posing as Schiller and Goethe
on the beach at Hendaye, France, 1929. Photograph by Lily Klee

1928 February: Bauhaus journal *Zeitschrift für Gestaltung* publishes Klee's "exact experiments in the realm of art."
July–August: Travels to Paris and Brittany.
December 17: Begins month-long visit to Egypt.

1929 January: Returns from Egypt via Italy.
Summer: Holiday in Basque country.
Will Grohmann's monograph on Klee published in Paris by Cahiers d'Art.

1930 Spring: Invited to teach at Düsseldorf Academy.
Summer: Holiday in northern Italy.

1931 April 1: Terminates contract with Bauhaus and begins to teach in Düsseldorf, maintaining residence in Dessau.
Summer: Travels to Sicily.

1932 October: Travels to Zürich, to see Picasso exhibition, and then to northern Italy.

1933 January 30: Adolf Hitler assumes power in Germany.
March: Nazi officers search Klee house in Dessau.
April 21: Klee suspended from Düsseldorf Academy by new director, Nazi appointee.
May 1: Moves from Dessau to Düsseldorf.
October: Travels to Paris and southern France: visits Picasso and signs contract with dealer Daniel-Henry Kahnweiler, Galerie Simon.
December 23: Leaves Germany. Moves to father's house in Bern.

1934 Early spring: Klees move to house at Kistlerweg 6, Bern.
Nazis confiscate Grohmann's new monograph on Klee's drawings.

1935 Onset of illness later diagnosed as scleroderma.

1936 Illness worsens; works very little.

1937 February: Kandinsky, in Bern for retrospective at Kunsthalle, visits Klee.
July: Nazi *Degenerate Art* (*Entartete Kunst*) exhibition opens in Munich; includes seventeen works by Klee.
Summer: Resumes painting.
September: Travels to Ascona.
November 28: Picasso visits Klee in Bern.
Nazis remove modern art from state collections throughout Germany, including 102 works by Klee.

1938 Summer: Holiday in St. Beatenberg.

1939 April: Georges Braque visits Klee.
Summer: Visits Geneva twice to see exhibition of works from Prado.
Produces prodigious volume of work, particularly drawings: oeuvre catalogue lists 1,253 items.

1940 January 7: Klee submits application to Bern city officials for Swiss citizenship but is never granted it.
January 12: Death of father, Hans Klee.
May: Enters sanitarium at Orselina.
June 29: Klee dies in hospital at Muralto-Locarno.

Paul Klee, Dessau, 1933. Photograph by Josef Albers

Paul and Lily Klee, Dessau, 1933. Photograph by Bobby Aichinger

Paul and Felix Klee, Bern, 1934. Photograph by Bobby Aichinger

Paul and Lily Klee and their cat Bimbo, Bern, 1935.
Photograph by F. Meisel

Lily, Hans, and Paul Klee, Bern, 1935

Paul Klee with Will Grohmann, Bern, Summer
1938. Photograph by Felix Klee

Paul Klee, Bern, December 1939

BIBLIOGRAPHY

This selected bibliography is intended as an introduction to the vast literature on Paul Klee and his work. The most comprehensive bibliography in English to date is that compiled by Bernard Karpel for *The Nature of Nature*, ed. Jürg Spiller (1973).

The first section below comprises anthologies of Klee's writings, major individual texts by Klee, and books illustrated by him. The second section lists major monographs on the artist and selected works that are relevant to the issues raised in this book. The third section lists articles and essays, emphasizing early works of historical importance, articles that appeared in American publications, and works of recent scholarship.

BY THE ARTIST

ANTHOLOGIES

Geelhaar, Christian, ed. *Paul Klee: Schriften, Rezensionen und Aufsätze.* Cologne: DuMont, 1976. Artist's writings: reviews and essays.

Giedion-Welcker, Carola, ed. *Poètes à l'écart; Anthologie der Abseitigen.* Bern-Bümpliz: Benteli, 1946. Revised edition, Zürich: Die Arche, 1964.

Glaesemer, Jürgen, ed. *Paul Klee: Beiträge zur bildnerischen Formlehre.* Basel and Stuttgart: Schwabe, 1979. Facsimile edition of lecture notes and other writings at Weimar Bauhaus, 1921–22.

Hollo, Anselm, ed. and trans. *Some Poems by Paul Klee.* Suffolk, England: Scorpion Press, 1962.

Klee, Felix, ed. *Paul Klee: Gedichte.* Zürich: Die Arche, 1960. Artist's poems.

————. *Paul Klee: His Life and Work in Documents.* New York: Braziller, 1962. Translation of *Paul Klee: Leben und Werke in Dokumenten.* Zürich: Diogenes, 1960. In French: *Paul Klee par lui-même et par son fils Felix Klee,* ed. Maurice Besset. Paris: Les Librairies associées, 1963.

————. *The Diaries of Paul Klee, 1898–1918.* Berkeley and Los Angeles: University of California Press; London: Peter Owen, 1964. Translation of *Tagebücher von Paul Klee, 1898–1918.* Cologne: DuMont Schauberg; Zürich: Europa, 1957.

————. *Paul Klee: Briefe an die Familie 1893–1940.* Vol. 1: 1893–1906; vol. 2: 1907–1940. Cologne: DuMont, 1979. Artist's letters to his family.

Spiller, Jürg, ed. *The Thinking Eye: The Notebooks of Paul Klee.* Trans. Ralph Manheim with Dr. Charlotte Weidler and Joyce Wittenborn. London: Lund-Humphries; New York: Wittenborn, 1961. Translation of *Das bildnerische Denken.* Basel and Stuttgart: Schwabe, 1956.

————. *The Nature of Nature: The Notebooks of Paul Klee, Volume 2.* Trans. Heinz Norden. London: Lund-Humphries; New York: Wittenborn, 1973. Translation of *Unendliche Naturgeschichte.* Basel and Stuttgart: Schwabe, 1970.

Watts, Harriet, ed. *Three Painter Poets: Arp, Schwitters, Klee: Selected Poems.* Harmondsworth, England: Penguin, 1974.

ESSAYS

"Über das Licht," Klee's translation of "Sur la lumière," by Robert Delaunay, in *Der Sturm* (Berlin), no. 144–45 (January 1913), pp. 255–56. Reprinted in Geelhaar 1976, pp. 116–17.

"Über den Wert der Kritik: Antworten auf eine Rundfrage an die Künstler," *Der Ararat* (Munich), vol. 2 (1921), p. 130. Reprinted in Geelhaar 1976, p. 123.

"Schöpferische Konfession," in *Tribüne der Kunst und Zeit XIII: Schöpferische Konfession,* ed. Kasimir Edschmid. Berlin: Erich Reiss, 1920. Reprinted in Geelhaar 1976, pp. 18–22; as "Creative Credo," in Spiller, *The Thinking Eye,* pp. 76–80.

"Wege des Naturstudiums," in *Staatliche Bauhaus Weimar 1919–1923.* Weimar and Munich: Bauhausverlag, 1923. Reprinted in Geelhaar 1976, pp. 124–26; as "Ways of Nature Study," in Spiller, *The Thinking Eye,* pp. 63–67.

Über die moderne Kunst. Text of lecture given at Kunstverein Jena, 1924. First edition in German: Bern-Bümpliz: Benteli, 1945. In English: *On Modern Art.* Trans. Paul Findlay, intro. Herbert Read. London: Faber and Faber, 1948.

Pädagogisches Skizzenbuch, Bauhausbücher 2. Munich: Langen, 1925. In English: *Pedagogical Sketchbook,* intro. and trans. Sibyl Moholy-Nagy. New York: Praeger, 1953. Reprinted London: Faber and Faber, 1984.

"Kandinsky," in *Katalog Jubiläumsausstellung zum 60. Geburtstag von W. Kandinsky.* Dresden: Galerie Arnold, 1926. Reprinted in Geelhaar 1976, pp. 127–28.

"Emil Nolde," in *Festschrift für Emil Nolde, anlässlich seines 60. Geburtstages.* Dresden: Neue Kunst Fides, 1927. Reprinted in Geelhaar 1976, p. 129.

"exakte versuche im bereich der kunst," in *Bauhaus: Zeitschrift für Gestaltung* (Dessau) vol. 2, no. 203 (1928), p. 17. Reprinted in Geelhaar 1976, pp. 130–32; as "Exact Experiments in the Realm of Art," in Spiller, *The Thinking Eye,* pp. 69–70.

ILLUSTRATED BOOKS

Corrinth, Curt. *Potsdamer Platz, oder die Nächte des neuen Messias: Ekstatische Visionen.* Munich: Müller, 1919 (10 illustrations).

Novalis (Friedrich von Hardenberg). *The Novices of Sais.* Preface by Stephen Spender, trans. Ralph Manheim. New York: Curt Valentin, 1949 (frontispiece by André Masson; 60 Klee drawings selected by Valentin).

Tzara, Tristan. *L'Homme approximatif.* Paris: DeNoël et Steele, 1931 (one engraving). Limited edition of ten.

Voltaire. *Kandide, oder die beste Welt.* Munich: Kurt Wolff, 1920 (26 ink drawings). English edition, trans. Tobias Smollett, New York: Pantheon, 1944.

BOOKS

Abadie, Daniel. *Paul Klee.* Paris: Maeght, 1977.

Alfieri, Bruno. *Paul Klee.* Venice: Istituto Tipografico, 1948.

Armitage, Merle, ed. *5 Essays on Klee.* New York: Duell, Sloan & Pearce, 1950. Essays by Armitage, Clement Greenberg, Howard Devree, Nancy Wilson Ross, and James Johnson Sweeney.

Ball, Hugo. *Flight Out of Time: A Dada Diary.* Ed. John Elderfield, trans. Ann Raimes. New York: Viking, 1974. Translation of *Die Flucht aus der Zeit.* Munich-Leipzig: Duncker und Humblot, 1927.

Baumgartner, Marcel. *Paul Klee und die Photographie.* Bern: Kunstmuseum Bern, 1979.

Bern, Klee-Gesellschaft. *Paul Klee, 1. Teil: Dokumente und Bilder aus den Jahren 1896–1930.* Bern-Bümpliz: Benteli, 1949. *Paul Klee, 2. Teil: Bilder und Zeichnungen aus den Jahren 1930–1940,* ed. Max Huggler. Bern-Bümpliz: Benteli, 1960.

Bernoulli, Rudolf. *Mein Weg zu Klee.* Bern-Bümpliz: Benteli, 1940.

Bloesch, Hans, and Georg Schmidt. *Paul Klee: Reden zu seinem Todestag.* Bern-Bümpliz: Benteli, 1940.

Brion, Marcel. *Klee.* Paris: Somogy, 1955.

Campbell, Sara, ed. *The Blue Four, Galka Scheyer Collection.* Pasadena, California: Norton Simon Museum of Art, 1976.

Cassou, Jean. *Hommage à Paul Klee.* Boulogne-sur-Seine, France: L'Architecture d'Aujourd'hui, 1949.

Cheney, Sheldon. *A Primer of Modern Art.* New York: Boni and Liveright, 1927.

Chevalier, Denys. *Klee.* New York: Crown, 1971.

Cooper, Douglas. *Paul Klee.* Harmondsworth, England: Penguin, 1949, 1950, 1952.

Crevel, René. *Paul Klee.* Paris: Gallimard, 1930.

Düsseldorf, Kunstsammlung Nordrhein-Westfalen. *Paul Klee Bilder-Aquarelle-Zeichnungen.* Text by Werner Schmalenbach. Düsseldorf: Kunstsammlung Nordrhein-Westfalen, 1977.

Duvignaud, Jean. *Klee en Tunisie.* Lausanne-Paris: Bibliothèque des Arts, 1980.

Ferrier, Jean-Louis, et al. *Paul Klee: Les Années 20.* Paris: DeNoël, 1971.

Forge, Andrew. *Klee (1879–1940).* London: Faber and Faber, 1954.

Geelhaar, Christian. *Paul Klee and the Bauhaus.* Greenwich, Connecticut: New York Graphic, and Bath, England: Adams & Dart, 1973.

———. *Paul Klee: Life and Work.* Trans. W. Walter Jaffe. Woodbury, New York: Barron's, 1982. Translation of *Paul Klee, Leben und Werk.* Cologne: DuMont Schauberg, 1974.

Geist, Hans-Friedrich. *Paul Klee.* Hamburg: Hauswedell, 1948.

Giedion-Welcker, Carola. *Paul Klee.* New York: Viking, 1952. Published in German: Stuttgart: Gode, 1954.

———. *Paul Klee in Selbstzeugnissen und Bilddokumenten.* Hamburg: Rowohlt, 1961.

Glaesemer, Jürgen. *Paul Klee: Handzeichnungen I: Kindheit bis 1920.* Bern: Kunstmuseum Bern, 1973.

———. *Paul Klee: Handzeichnungen II: 1921–1936.* Bern: Kunstmuseum Bern, 1984.

———. *Paul Klee: Handzeichnungen III: 1937–1940.* Bern: Kunstmuseum Bern, 1979.

———. *Paul Klee: The Colored Works in the Kunstmuseum Bern.* Trans. Renate Franciscono. Bern: Kornfeld, 1979. Translation of *Paul Klee: Die farbigen Werke im Kunstmuseum Bern.* Bern: Kornfeld, 1976.

———, and Max Huggler. *Der pädagogische Nachlass von Paul Klee.* Bern: Kunstmuseum Bern, 1977.

Goldwater, Robert J. *Primitivism in Modern Painting.* New York: Harper, 1938. Reprinted as *Primitivism in Modern Art.* New York: Vintage, 1967.

Grohmann, Will. *Paul Klee.* Paris: Cahiers d'Art, 1929. Texts by Louis Aragon, René Crevel, Paul Eluard, Jean Lurçat, Philippe Soupault, Tristan Tzara, Roger Vitrac.

———. *The Drawings of Paul Klee.* Trans. Mimi Catlin and Margit von Ternes. New York: Curt Valentin, 1944. Translation of *Paul Klee: Handzeichnungen 1921–1930.* Berlin: Müller und Kiepenheuer, 1934.

———. *Paul Klee.* New York: Abrams, 1954. Translation of *Paul Klee.* Stuttgart: Kohlhammer, 1954.

———. *Paul Klee: Drawings.* New York: Abrams, 1960. Translation of *Paul Klee: Handzeichnungen.* Cologne: DuMont Schauberg, 1959.

———. *Paul Klee.* New York: Abrams, 1967.

Grote, Ludwig, ed. *Erinnerungen an Paul Klee.* Munich: Prestel, 1959.

Guggenheim, Peggy. *Art of This Century.* New York: Art Aid, 1942. Reprinted New York: Arno Press, 1968.

Haftmann, Werner. *The Mind and Work of Paul Klee.* New York: Praeger, 1954. Translation of *Paul Klee: Wege bildnerischen Denkens.* Munich: Prestel, 1950.

———, ed. *The Inward Vision: Watercolors, Drawings, Writings by Paul Klee.* Trans. Norbert Guterman. New York: Abrams, 1958.

Hanover, Kunstmuseum Hannover mit Sammlung Sprengel. *Paul Klee Bestandskatalog.* Hanover: Kunstmusem Hannover, 1980.

Hausenstein, Wilhelm. *Kairuan, oder eine Geschichte vom Maler Klee und von der Kunst dieses Zeitalters.* Munich: Kurt Wolff, 1921.

Haxthausen, Charles Werner. *Paul Klee: The Formative Years.* New York: Garland, 1981.

Herbert, Robert L., Eleanor S. Apter, and Elise K. Kenney. *The Société Anonyme and the Dreier Bequest at Yale University: A Catalogue Raisonné.* New Haven, Connecticut, and London: Yale University Press, 1984. Reprints statement on Klee by Marcel Duchamp from catalog of Société Anonyme Collection, Yale University Art Gallery, 1950.

Hofmann, Werner. *Paul Klee: Traumlandschaft mit Mond.* Frankfurt-am-Main: Insel-Verlag, 1964.

Huggler, Max. *Paul Klee: Die Malerei als Blick in den Kosmos.* Frauenfeld and Stuttgart: Huber, 1969.

Hulton, Nika. *An Approach to Paul Klee.* New York: Pitman, 1956.

Jaffe, Hans L. *Klee.* London and New York: Hamlyn, 1971.

Jordan, Jim M. *Paul Klee and Cubism.* Princeton, New Jersey: Princeton University Press, 1984.

Kagan, Andrew. *Paul Klee: Art and Music.* Ithaca, New York: Cornell University Press, 1983.

Kahnweiler, Daniel-Henry. *Klee.* Paris: Braun; New York: Herrmann, 1950.

Kandinsky, Wassily, and Franz Marc, eds. *The Blaue Reiter Almanac.* New documentary edition, Klaus Lankheit, ed. New York: Viking, 1974. Translation of *Der Blaue Reiter.* Munich: R. Piper, 1912.

Klee, Felix, ed. *Paul Klee: 22 Zeichnungen.* Stuttgart: Eidos, 1948.

———. *Paul Klee Rosenwind.* Basel and Vienna: Herder Freiburg, 1984.

Kornfeld, Eberhard W. *Paul Klee: Bern und Umgebung—Aquarelle und Zeichnungen, 1897–1915.* Bern: Stämpfli, 1962.

———. *Verzeichnis des graphischen Werkes von Paul Klee.* Bern: Kornfeld und Klipstein, 1963.

Lynton, Norbert. *Klee.* London and New York: Hamlyn, 1964. Reprinted Memphis: Castle Books, 1975.

Masson, André. *Eulogy of Paul Klee.* Trans. Walter Pach. New York: Curt Valentin, 1950. Translation of "Eloge de Paul Klee," *Fontaine* (Paris), vol. 10, no. 53 (June 1946), pp. 105–08.

Mehring, Walter. *Klee.* Bern: Scherz, 1956.

Naubert-Riser, Constance. *La Création chez Paul Klee.* Paris: Klincksieck, 1978.

New York, The Museum of Modern Art. *Paul Klee: Three Exhibitions—1930, 1941, 1949.* New York: The Museum of Modern Art and Arno Press, 1968. Catalog reprints. Texts by Alfred H. Barr, Jr., James J. Sweeney, Julia and Lyonel Feininger, and James T. Soby.

New York, The Solomon R. Guggenheim Museum. *Klee at the Guggenheim Museum.* New York: The Solomon R. Guggenheim Museum, 1977. Texts by Dr. Louise Averill Svendsen and Thomas M. Messer.

Nierendorf, Karl, ed. *Paul Klee: Paintings, Watercolors, 1913 to 1939.* New York: Oxford University Press, 1941.

Osterwold, Tilman. *Paul Klee, ein Kind träumt sich.* Stuttgart: Gerd Hatje, 1979.

Paul Klee: Puppets, Sculptures, Reliefs, Masks, Theatre. Preface by Pierre von Allmen and intro. by Felix Klee. Neuchâtel: Galerie Suisse de Paris, 1979.

Petitpierre, Petra. *Aus der Malklasse von Paul Klee.* Bern-Bümpliz: Benteli, 1957.

Pfeiffer-Belli, Erich. *Klee, eine Bildbiographie.* Munich: Kindler, 1964.

Pierce, James Smith. *Paul Klee and Primitive Art.* New York: Garland, 1976.

Plant, Margaret. *Paul Klee: Figures and Faces.* London: Thames and Hudson, 1978.

Ponente, Nello. *Klee: Biographical and Critical Study.* Geneva and Lausanne: Skira, 1960.

Read, Herbert. *Klee (1879–1940) with an Introduction and Notes.* London: Faber and Faber, 1948.

Roethel, Hans Konrad. *Paul Klee.* Wiesbaden: Vollmer, 1955.

———. *Paul Klee in München.* Bern: Stämpfli, 1971.

Rosenthal, Mark. *Paul Klee.* Washington D.C.: The Phillips Collection, 1981.

San Lazzaro, Gualtieri di. *Klee: A Study of His Life and Work.* Trans. Stuart Hood. New York: Praeger; London: Thames and Hudson, 1957, 1964.

Schmidt, Georg. *Ten Reproductions in Facsimile of Paintings by Paul Klee.* Trans. Richard Allen and Douglas Cooper. New York: Wittenborn, 1946. Translation of *Zehn Farbenlichtdrucke nach Gemälden von Paul Klee.* Basel: Holbein, 1946.

———. *Paul Klee: Engel bringt das Gewünschte.* Baden-Baden: Woldemar Klein, 1953.

Soby, James Thrall. *The Prints of Paul Klee.* New York: Curt Valentin, 1945.

Thürlemann, Félix. *Paul Klee: Analyse sémiotique de trois peintures.* Lausanne: L'Age d'Homme, 1982.

Tower, Beeke Sell. *Klee and Kandinsky in Munich and at the Bauhaus.* Ann Arbor, Michigan: UMI Research Press, 1981.

Verdi, Richard. *Klee and Nature.* New York: Rizzoli, 1985.

Walden, Herwarth, ed. *Paul Klee: Sturm Bilderbuch 3.* Berlin: Verlag der Sturm, 1918.

Walterskirchen, Katalina de. *Paul Klee.* New York: Rizzoli; Paris: E.P.I. Editions Filipacci, 1975.

Wedderkop, Hans von. *Paul Klee.* Leipzig: Klinkhardt & Biermann, 1920. Published also in *Jahrbuch der jungen Kunst* (Leipzig), vol. 1 (1920), pp. 225–36, and in *Der Cicerone* (Leipzig), vol. 12, no. 14 (1920), pp. 527–38.

Werckmeister, O. K. *Versuche über Paul Klee.* Frankfurt-am-Main: Syndikat, 1981.

Zahn, Leopold. *Paul Klee: Leben, Werk, Geist.* Pots-

dam: Kiepenheuer, 1920.

———. *Paul Klee: Im Lande Edelstein*. Baden-Baden: Woldemar Klein, 1952.

ARTICLES AND ESSAYS

Adler, Jankel. "Memories of Paul Klee," *Horizon* (London), vol. 6, no. 34 (October 1942), pp. 264–67.

Aichele, K. Porter. "Paul Klee's Operatic Themes and Variations," *The Art Bulletin* (New York), vol. 68, no. 3 (September 1986), pp. 450–66.

Artlover (New York), ed. J. B. Neumann (Spring 1959). Special issue on Klee. Texts by Klee, Hugo Ball, Clifford Odets.

Arts Magazine (New York), vol. 52, no. 1 (September 1977). Special issue on Klee.

Ashton, Dore. "The Function of Unreality: Klee," and "The Organic Imagination: Klee and Goethe," in *A Reading of Modern Art*, pp. 40–44 and 45–52. Cleveland and London: Case Western Reserve, 1969.

Bataille, Georges. [Statement,] *Cahiers d'Art* (Paris), 20e–21e années (1945–46), p. 52.

Bauhaus: Zeitschrift für Gestaltung (Dessau), vol. 4, no. 3 (December 1931). Special issue on Klee. Texts by Will Grohmann, Ludwig Grote, Christof Hertel, and Wassily Kandinsky.

Bloesch, Hans. "Ein moderner Grafiker Paul Klee," *Die Alpen* (Bern), vol. 6, no. 5 (January 1912).

Boretz, Naomi. "On the Symbolism in Paul Klee's Painting 'Um den Fisch,'" *Leonardo* (Oxford, England, and Elmsford, New York), vol. 9, no. 4 (Autumn 1976), pp. 295–300.

Bousquet, Joë. "Paul Klee," *Cahiers d'Art* (Paris), 20e–21e années (1945–46), pp. 50–51.

Burnett, David. "Paul Klee: The Romantic Landscape," *Art Journal* (New York), vol. 36, no. 4 (Summer 1977), pp. 322–26.

———. "Klee as Senecio: Self-Portraits 1908–1922," *Art International* (Lugano, Switzerland), vol. 21, no. 6 (December 1977), pp. 12–18.

———. "Sense of Quality in Paul Klee," *Art International* (Lugano, Switzerland), vol. 22, no. 6 (October 1978), pp. 10–14.

———. "Paul Klee: From Symbolism to Symbol," in *The Turn of the Century: German Literature and Art, 1890–1915*, ed. Gerald Chapple and Hans H. Schulte, pp. 237–48. Bonn: Bouvier Verlag Herbert Grundmann, 1981.

Cahiers d'Art (Paris), 20e–21e années (1945–46), pp. 9–74. Special issue on Klee.

Char, René. "Secrets d'hirondelles," *Cahiers d'Art* (Paris), 20e–21e années (1945–46), p. 27.

Comini, Alessandra. "All Roads Lead (Reluctantly) to Bern: Style and Source in Paul Klee's Early 'Sour' Prints," *Arts Magazine* (New York), vol. 52, no. 1 (September 1977), pp. 105–11.

Courthion, Pierre. "Paul Klee," *XXe Siècle* (Paris), no. 4 (Christmas 1938), p. 36.

Crevel, René. [Statement,] *Cahiers d'Art* (Paris), 20e–21e années (1945–46), p. 60.

Damisch, Hubert. " 'Equals Infinity,'" *20th Century Studies* (Canterbury, England), December 1976, pp. 56–81.

Däubler, Theodor. "Paul Klee," *Das Kunstblatt* (Weimar), vol. 2 (January 1918), pp. 21–27.

DeLamater, Peg. "Some Indian Sources in the Art of Paul Klee," *The Art Bulletin* (New York), vol. 66, no. 4 (December 1984), pp. 657–72.

Du (Zürich), vol. 8, no. 10 (October 1948). Special issue on Klee. Essays by Carola Giedion-Welcker, Arnold Kübler, Max Huggler, Felix Klee, Rolf Bürgi, Alexander Zschokke, Camilla Halter, Walter Ueberwasser, René Thiessing, and Marguerite Frey-Surbek.

Duthuit, Georges. "A Paul Klee," *Cahiers d'Art* (Paris), 20e–21e années (1945–46), pp. 20–22.

Franciscono, Marcel. "Paul Klee in the Bauhaus: The Artist as Lawgiver," *Arts Magazine* (New York), vol. 52, no. 1 (September 1977), pp. 122–27.

———. "Paul Klee's Italian Journey and the Classical Tradition," *Pantheon* (Munich), vol. 32 (January 1974), pp. 54–64.

Geelhaar, Christian. "Paul Klee," in *Vom Klang der Bilder*, pp. 422–29. Staatsgalerie Stuttgart, 1985.

Greenberg, Clement. "On Paul Klee (1879–1940)," *Partisan Review* (New York), vol. 8, no. 3 (May–June 1941), pp. 224–29.

Grohmann, Will. "Paul Klee, 1923–1924," *Der Cicerone* (Leipzig), vol. 16, no. 17 (August 1924), pp. 786–96.

———. "Paul Klee," *Cahiers d'Art* (Paris), 3e année (1928), pp. 295–302.

———. "Paul Klee in New York," *Der Cicerone* (Leipzig), no. 22 (1930), p. 11.

———. "Un Monde nouveau," *Cahiers d'Art* (Paris), 20e–21e années (1945–46), pp. 63–64.

———. "L'Humour goethien de Paul Klee," *XXe Siècle* (Paris), no. 8 (January 1957), pp. 33–38.

———. "Kandinsky et Klee retrouvent l'orient," *XXe Siècle* (Paris), no. 17 (December 1961), pp. 49–56.

Harms, Ernest. "Paul Klee as I Remember Him," *Art Journal* (New York), vol. 32, no. 2 (Winter 1972–73), p. 178.

Hayter, Stanley W. "Paul Klee: Apostle of Empathy," *Magazine of Art* (Washington, D.C.), vol. 39, no. 4 (April 1946), pp. 126–30.

Henniger, Gerd. "Paul Klee und Robert Delaunay," *Quadrum* (Brussels), no. 3 (1957), pp. 137–41.

Henry, Sara Lynn. "Form-Creating Energies: Paul Klee and Physics," *Arts Magazine* (New York), vol. 52, no. 1 (September 1977), pp. 118–21.

Hugo, Valentine. "Le Verger de Paul Klee," *Cahiers d'Art* (Paris), 20e–21e années (1945–46), pp. 66–69.

Jollos, Waldemar. "Paul Klee," *Das Kunstblatt* (Potsdam-Berlin), vol. 3 (August 1919), pp. 222–34.

Jordan, Jim M. "The Structure of Paul Klee's Art in the Twenties: From Cubism to Constructivism," *Arts Magazine* (New York), vol. 52, no. 1 (September 1977), pp. 152–57.

Kadow, Gerhard. "Paul Klee in Dessau," *College Art Journal* (New York), vol. 9, no. 1 (Autumn 1949), pp. 34–36.

Kagan, Andrew. "Paul Klee's Influence on American Painting," *Arts Magazine* (New York), vol. 49, no. 10 (June 1975), pp. 54–59; vol. 50, no. 1 (September 1975), pp. 84–90.

———. "Paul Klee's 'Kettledrummer,'" *Arts Magazine* (New York), vol. 51, no. 5 (January 1977), pp. 108–11.

———. "Paul Klee's 'Ad Parnassum': The Theory and Practice of Eighteenth-Century Polyphony as Models for Klee's Art," *Arts Magazine* (New York), vol. 52, no. 1 (September 1977), pp. 90–104.

———. "Paul Klee's 'Hommage à Picasso,'" *Arts Magazine* (New York), vol. 53, no. 5 (January 1979), pp. 140–41.

———. "Paul Klee's 'Polyphonic Architecture,'" *Arts Magazine* (New York), vol. 54, no. 5 (January 1980), pp. 154–57.

———, and William Kennon. "Fermata in the Art of Paul Klee," *Arts Magazine* (New York), vol. 56, no. 1 (September 1981), pp. 166–70.

Kessler, Charles S. "Science and Mysticism in Paul Klee's 'Around the Fish,'" *Journal of Aesthetics and Art Criticism* (New York), vol. 16 (September 1957), pp. 76–83.

Klein, Jerome. "Line of Introversion," *New Freeman* (New York), vol. 1, no. 4 (April 5, 1930), pp. 88–89.

Knott, Robert. "Klee and the Mystic Center," *Art Journal* (New York), vol. 38, no. 2 (Winter 1978–79), pp. 114–18.

Laude, Jean. "Paul Klee," in *"Primitivism" in 20th Century Art*, ed. William Rubin, vol. 2, pp. 487–501. New York: The Museum of Modern Art, 1984.

Lhote, André. "Klee," in *La Peinture, le coeur et l'esprit*, pp. 199–202. Paris: DeNoël et Steele, 1933. Reprinted from *La Nouvelle Revue Française* (Paris), vol. 26 (February 1936), pp. 247–49.

Limbour, Georges. "Paul Klee," *Documents* (Paris), no. 1 (April 1929), pp. 53–54.

Mabille, Pierre. "Azimuths Terrestres," *Cahiers d'Art* (Paris), 20e–21e années (1945–46), pp. 28–32.

Marsh, Ellen. "Paul Klee and the Art of Children," *College Art Journal* (New York), vol. 16, no. 2 (1957), pp. 132–45.

Mizue (Tokyo), no. 586 (June 1954). Special issue on Klee.

Museum of Modern Art Bulletin (New York), vol. 17, no. 4 (Summer 1950). Texts on Klee by Marcel Breuer and Ben Shahn.

La Nouvelle Revue Française (Paris), vol. 206 (February 1970). Tests on Klee by Dora Vallier, Jean Guichard-Melli, and Jean Clair.

Pierce, James Smith. "Pictograms, Ideograms, and Alphabets in the Work of Paul Klee," *Journal of Typographic Research* (Cleveland), vol. 1, no. 3 (July 1967), pp. 219–43.

———. "Paul Klee and Baron Welz," *Arts Magazine* (New York), vol. 52, no. 1 (September 1977), pp. 128–31.

———. "Paul Klee and Karl Brendel," *Art International* (Lugano, Switzerland), vol. 22, no. 4 (April–May 1978), pp. 8–10.

Pour l'Art (Lausanne), no. 37 (July–August 1954). Special issue on Klee. Texts by Paul and Felix Klee, Marcel Arland, André Tanner, Alexander Zschokke, René Berger, and Paul Eluard.

Prévert, Jacques. "Parfois le balayeur," *Cahiers d'Art* (Paris), 20e–21e années (1945–46), p. 39.

Read, Herbert. "Klee: Imagination and Fantasy," *XXe Siècle* (Paris), no. 4 (Christmas 1938), pp. 31–33.

Reise-Hubert, Renée. "Writers as Art Critics: Three Views of the Paintings of Paul Klee," *Contemporary Literature* (Madison, Wisconsin), no. 1 (1977), pp. 75–92.

Ringbom, Sixten. "Paul Klee and the Inner Truth to Nature," *Arts Magazine* (New York), vol. 52, no. 1 (September 1977), pp. 112–17.

Rosenberg, Harold. "Art as Thinking," in *Artworks and Packages*, pp. 41–57. New York: Horizon; London: Thames and Hudson, 1969.

Rosenthal, Deborah. "Paul Klee: The Lesson of the Master," *Arts Magazine* (New York), vol. 52, no. 1 (September 1977), pp. 158–60.

Rosenthal, Mark. "Paul Klee's 'Tightropewalker': An Exercise in Balance," *Arts Magazine* (New York), vol. 53, no. 1 (September 1978), pp. 106–11.

———. "The Myth of Flight in the Art of Paul Klee," *Arts Magazine* (New York), vol. 55, no. 1 (September

333

1980), pp. 90–94.

———. "The Prototypical Triangle of Paul Klee," *The Art Bulletin* (New York), vol. 64, no. 2 (June 1982), pp. 299–310.

Roskill, Mark. "Three Critical Issues in the Art of Paul Klee," *Arts Magazine* (New York), vol. 52, no. 1 (September 1977), pp. 132–33.

Scheewe, L. "Klee," in *Thieme-Becker: Allgemeines Lexikon der bildenden Künstler*, ed. Hans Vollmer, vol. 20, pp. 424–26. Leipzig: Seemann, 1927.

Schiff, Gert. "René Crevel as a Critic of Paul Klee," *Arts Magazine* (New York), vol. 52, no. 1 (September 1977), pp. 134–37.

Shapiro, Maurice L. "Klee's 'Twittering Machine,'" *The Art Bulletin* (New York), vol. 50 (March 1968), pp. 67–69.

Soupault, Philippe. [Statement,] *Cahiers d'Art* (Paris), 20e–21e années (1945–46), p. 56.

Stern, Lisbeth. "Bildende Kunst," *Sozialistische Monatshefte* (Berlin), vol. 52 (1919), p. 294.

Sydow, E. von. "Paul Klee," *Münchner Blätter für Dichtung und Graphik* (Munich), vol. 1, no. 9 (1919), pp. 141–44.

Sylvester, A. D. B. "Auguries of Experience," *The Tiger's Eye* (New York), vol. 1, no. 6 (December 1948), pp. 48–51.

———. "La Période finale de Klee," *Les Temps Modernes* (Paris), vol. 6, no. 63 (January 1951, pp. 1297–1307.

Teuber, Marianne, L. "'Blue Night' by Paul Klee," in *Vision and Artifact*, ed. M. Henle, pp. 131–51. New York: Springer, 1976.

Thwaites, John A. "Paul Klee and the Object," *Parnassus* (New York), vol. 9, no. 6 (November 1937), pp. 9–11; vol. 9, no. 7 (December 1937), pp. 7–9, 33–34.

Tzara, Tristan. "Paul Klee, ou l'apprenti du Soleil," *Cahiers d'Art* (Paris), 20e–21e années (1945–46), pp. 36–37.

Verdi, Richard. "Musical Influences on the Art of Paul Klee," *Museum Studies* (Chicago), vol. 3 (1968), pp. 81–107.

———. "Paul Klee's 'Fish Magic': An Interpretation," *Burlington Magazine* (London), vol. 116, no. 852 (March 1974), pp. 147–54.

———. "The Late Klee," in *German Art in the 20th Century*, pp. 457–59. London: Royal Academy of Arts, 1985.

Veronesi, Giulia. "Paul Klee e la sua influenza," *L'Arte Moderna* (Milan), no. 53 (1967), pp. 281–312.

XXe Siècle (Paris), no. 4 (Christmas 1938). Special issue on Klee. Texts by Herbert Read and Pierre Courthion.

Vishny, Michele. "Paul Klee and War: A Stance of Aloofness," *Gazette des Beaux-Arts* (Paris), vol. 92, no. 1319 (December 1978), pp. 232–43.

———. "Clocks and Their Iconographical Significance in Paul Klee's Works," *Arts Magazine* (New York), vol. 54, no. 1 (September 1979), pp. 138–41.

———. "Paul Klee's Self-Images," in *Psychoanalytic Perspectives on Art*, vol. 1 (1985), pp. 135–68.

Vitrac, Roger. "Le Regard de Paul Klee," *Cahiers d'Art* (Paris), 20e–21e années (1945–46), pp. 53–55.

Werckmeister, O. K. "The Issue of Childhood in the Art of Paul Klee," *Arts Magazine* (New York), vol. 52, no. 1 (September 1977), pp. 138–51.

———. "Walter Benjamin, Paul Klee, and the Angel of History," *Oppositions* (Cambridge, Massachusetts), no. 25 (Fall 1982), pp. 102–25.

Willats, John. "On the Depiction of Smooth Forms in a Group of Paintings by Paul Klee," *Leonardo* (Oxford, England, and Elmsford, New York), vol. 13, no. 4 (Autumn 1980), pp. 276–82.

Zervos, Christian. "Paul Klee" (exhibition at Galerie Georges Bernheim et Cie.), *Cahiers d'Art* (Paris), 4e année (1929), pp. 54–55.

———. "Paul Klee, 1879–1940," *Cahiers d'Art* (Paris), 20e–21e années (1945–46), pp. 10–19.

EXHIBITION
HISTORY

MUNICH. *Secession: Internationale Kunst-Ausstellung.* June 1906. (10 etchings.)

MUNICH. *Secession: Internationale Kunst-Ausstellung.* May 15–October 1908. (3 works.)

BERLIN. *Secession: XVI. Ausstellung, zeichende Künste.* December 1908. (6 works.)

BERN. Kunstmuseum Bern. *Paul Klee.* August 1910. Traveled to Zürich, Kunsthaus Zürich; Winterthur, Kunsthandlung zum Hohen Haus; Basel, Kunsthalle Basel, 1910–11. (56 graphic works.)

MUNICH. Galerie Thannhauser. *Paul Klee.* June 1911. (30 drawings.)

MUNICH. Galerie Hans Goltz. *Der Blaue Reiter* (second exhibition). February 1912. (17 graphic works.)

MUNICH. Galerie Hans Goltz. *V. Kollektiv-Ausstellung.* March 16–April 4, 1912. Traveled to Berlin, Galerie Der Sturm. *Moderner Bund, Schweiz.* April 26–May 31, 1912. (9 works.)

MUNICH. Galerie Thannhauser. *Sema.* April 1912. Traveled to Dresden.

LEIPZIG. Verein LIA. *LIA: Leipziger Jahre Ausstellung 1912.* April 7–June 1912. (4 works.)

COLOGNE. *Sonderbund internationale Kunstausstellung.* May 25–September 30, 1912. (4 works.)

ZÜRICH. Kunsthaus Zürich. *Moderner Bund.* July 7–31, 1912. (8 works.)

MUNICH. Galerie Hans Goltz. *Neue Kunst: Erste Gesamtausstellung.* October 1912. (11 works.)

BERLIN. Galerie Der Sturm. *Paul Klee* (with Alfred Reth and Julie Baum). February–March 1913.

BERLIN. Galerie Der Sturm. Group Exhibition (with Hans Arp, Wilhelm Gimmi, Walter Helbig, Herman Huber, Oskar Lüthy, and Albert Pfister). May 1913.

MUNICH. Galerie Hans Goltz. *II. Gesamtausstellung.* August–September 1913. (3 paintings.)

BERLIN. Galerie Der Sturm. *Erster deutscher Herbstsalon.* September 20–December 1, 1913. (22 works.)

DRESDEN. Galerie Ernst Arnold. *Die neue Malerei (Expressionistische Ausstellung).* January 1914. (2 works.)

BERLIN. Galerie Der Sturm. April 1914.

MUNICH. *Neue münchener Secession* (inaugural exhibition). May 30–October 1, 1914. (8 works.)

BERLIN. Galerie Der Sturm. Group Exhibition (with Fritz Baumann, Heinrich Campendonk, Franz Marc, Conrad Felix Müller, and Oswald Herzog). June–July 1915.

BERLIN. Galerie Der Sturm. Two-Man Exhibition (with Albert Bloch). March 1916.

BERLIN. Galerie Der Sturm. *XXXXIII. Ausstellung: Expressionisten / Futuristen / Kubisten.* July 1916. (10 works.)

BERLIN. Galerie Der Sturm. Group Exhibition. August 1916.

ZÜRICH. Galerie Dada. *Sturm-Ausstellung I. Serie* (inaugural exhibition). March 17–April 7, 1917. *2. Serie.* April 9–30, 1917.

BERLIN. Galerie Der Sturm. Group Exhibition (with Gösta Adrian-Nilsson and Gabriele Münter). December 1917.

FRANKFURT-AM-MAIN. Zinglers Kabinett für Kunst-und-Bücherfreunde. *Paul Klee, Fritz Schaefler, Th. C. Pilartz.* 1919. Text by Theodor Däubler. (35 works.)

BERLIN. Galerie Der Sturm. Group Exhibition (with Johannes Molzahn and Kurt Schwitters). January 1919.

COLOGNE. Kunstverein Köln. *Bulletin D.* November 1919. (2 works.)

HANOVER. Kestner-Gesellschaft. *Paul Klee / Lyonel Feininger.* November 30, 1919–January 1, 1920. Text by Paul Erich Küppers.

DÜSSELDORF. Galerie Alfred Flechtheim. *Paul Klee.* March 17–April 4, 1920. Text by Theodor Däubler.

MUNICH. Neue Kunst–Hans Goltz Galerie. *Paul Klee.* May–June 1920. Special issue of *Der Ararat* as catalog. (363 works.)

BERLIN. Galerie Der Sturm. Two-Man Exhibition (with Reinhard Goering). September 1920.

BERLIN. Galerie Der Sturm. Group Exhibition. July–August 1921.

WEIMAR. Staatliche Bauhaus Weimar. First International Exhibition of the Weimar Bauhaus. August 15–September 30, 1923.

BERLIN. Kronprinzenpalais. *Paul Klee.* 1923.

NEW YORK. Anderson Galleries. *A Collection of Modern German Art.* October 1923. Organized by William Valentiner.

JENA, GERMANY. Kunstverein Jena. January 7–February 7, 1924.

NEW YORK. Société Anonyme (Heckscher Building). *Paul Klee.* January 7–February 7, 1924.

NEW YORK. Daniel Gallery. *The Blue Four.* 1925.

MUNICH. Galerie Hans Goltz. *Paul Klee: 2. Gesamtausstellung. 1920–1925.* May–June 1925.

PARIS. Galerie Vavin-Raspail. *39 aquarelles de Paul Klee.* October 21–November 14, 1925. Introduction by Louis Aragon, poem by Paul Eluard.

PARIS. Galerie Pierre. *La Peinture surréaliste.* November 14–25, 1925. (2 works.)

OAKLAND, CALIFORNIA. The Oakland Gallery. *The Blue Four.* May 22–August 31, 1926.

BROOKLYN. The Brooklyn Museum. *An International Exhibition of Modern Art Assembled by the Société Anonyme.* November 19, 1926–January 9, 1927. Traveled to Anderson Galleries, New York; Albright Art Gallery, Buffalo; Toronto Art Gallery, 1927. (8 works.)

DÜSSELDORF. Galerie Alfred Flechtheim. *Paul Klee: Olgemälde und Aquarelle.* April 1927.

BERLIN. Galerie Alfred Flechtheim. *Paul Klee.* March 18–Easter 1928. Texts by Alfred Flechtheim and René Crevel. (56 works.)

BRUSSELS. Galerie Le Centaure. *Exposition Klee.* December 22–30, 1928. (42 works.)

PARIS. Galerie Georges Bernheim et Cie. *Exposition Paul Klee.* February 1–15, 1929. Text by René Crevel. (40 works.)

DRESDEN. Galerie Neue Kunst Fides. *Paul Klee.* February–March 1929. (105 works.)

335

BERLIN. Galerie Alfred Flechtheim. *Paul Klee*. October 20–November 15, 1929.

DÜSSELDORF. Galerie Alfred Flechtheim. *Paul Klee: Aquarelle, Zeichnungen, und Graphik aus 25 Jahren.* February 15–March 10, 1930.

NEW YORK. The Museum of Modern Art. *Paul Klee.* March 13–April 2, 1930. Introduction by Alfred H. Barr, Jr. (63 works.)

CAMBRIDGE, MASSACHUSETTS. Harvard Society for Contemporary Art. *Modern German Art.* April 18–May 10, 1930. (10 works.)

BERLIN. Nationalgalerie. *Klee.* Spring 1930. (50 drawings.)

CAMBRIDGE, MASSACHUSETTS. Harvard Society for Contemporary Art. *Bauhaus.* December 1930–January 1931. (15 works.)

HOLLYWOOD, CALIFORNIA. Braxton Gallery. *Paul Klee.* May 1–15, 1930.

NEW YORK. New School for Social Research (Société Anonyme). *Special Exhibition Arranged in Honor of the Opening of the New Building of the New School.* January 1–February 10, 1931. Traveled to Buffalo, Albright Art Gallery under title *International Exhibition . . . Recent Development in Abstract Art.* February 18–March 8, 1931.

HANOVER. Kestner-Gesellschaft. *Paul Klee.* March 7–April 5, 1931.

NEW YORK. The Museum of Modern Art. *German Painting and Sculpture.* March 13–April 26, 1931. (5 works.)

SAN FRANCISCO. California Palace of the Legion of Honor. *The Blue Four: Feininger, Jawlensky, Kandinsky, Klee.* Kandinsky, Feininger, April 8–22, 1931; Jawlensky, Klee, April 23–May 8, 1931.

DÜSSELDORF. Kunstverein für die Rheinlande und Westfalen. *Paul Klee.* June 14–July 6, 1931. Text by Will Grohmann.

BERLIN. Galerie Alfred Flechtheim. *Paul Klee: Neue Bilder und Aquarelle.* November 5–December 10, 1931.

LONDON. The Mayor Gallery. *Paul Klee.* 1934.

PARIS. Galerie Simon (Daniel-Henry Kahnweiler). *Paul Klee.* June 12–25, 1934.

LONDON. The Mayor Gallery. *Paul Klee.* 1935.

BERN. Kunsthalle Bern. *Paul Klee.* February 23–March 24, 1935. Text by Max Huggler. (273 works.)

NEW YORK. Contempora Art Circle (J. B. Neumann). *Paul Klee.* Paintings, March 2–16; watercolors, March 18–30, 1935.

OAKLAND, CALIFORNIA. Oakland Art Gallery. *Paul Klee.* October 1935.

BASEL. Kunsthalle Basel. *Paul Klee.* October 27–November 24, 1935. (191 works.)

HARTFORD, CONNECTICUT. Wadsworth Atheneum. *Paul Klee.* January 21–February 11, 1936. (50 works.)

NEW YORK. The Museum of Modern Art. *Cubism and Abstract Art.* March 2–April 19, 1936. Text by Alfred H. Barr, Jr. Traveled 1936–37. (7 works.)

LONDON. New Burlington Galleries. *The International Surrealist Exhibition.* June 11–July 4, 1936.

NEW YORK. The Museum of Modern Art. *Fantastic Art, Dada, Surrealism.* December 7, 1936–January 17, 1937. Organized by Alfred H. Barr, Jr. Traveled 1937. (20 works.)

LOS ANGELES. Putzel Gallery. *Pictures by Paul Klee.* November–December 1937.

NEW YORK. East River Gallery (Marian Willard). *Paul Klee.* 1937.

SAN FRANCISCO. San Francisco Museum of Art. *Paul Klee.* January 12–February 25, 1937. (69 works.)

MUNICH. Haus der deutsche Kunst. *Entartete Kunst* (Degenerate Art). July–November 1937. (17 works.)

PARIS. Galerie Simon (Daniel-Henry Kahnweiler). *Paul Klee: Oeuvres récentes.* January 14–February 5, 1938. (40 works.)

NEW YORK. Buchholz Gallery (Curt Valentin). *Paul Klee.* March 23–April 23, 1938.

PARIS. Roland Balaÿ et Louis Carré. *Paul Klee.* July 7–28, 1938. (23 works.)

NEW YORK. Nierendorf Galleries. *Paul Klee.* October 24–November 1938. Text by Perry Rathbone.

NEW YORK. Buchholz Gallery (Curt Valentin). *Paul Klee.* November 1–26, 1938.

NEW YORK. The Museum of Modern Art. *Bauhaus 1919–1928.* December 7, 1938–January 30, 1939. Traveled 1939.

LONDON. London Gallery. *Paul Klee.* March 3–16, 1939.

NEW YORK. Neumann-Willard Gallery. *Paul Klee.* May 15–June 10, 1939.

CHICAGO. Katharine Kuh Gallery. *An Exhibition of Paintings by Paul Klee.* December 1939.

NEW YORK. Art Students League. *Paul Klee.* January 3–11, 1940 (continued at Nierendorf Galleries). Text by Clark Mills.

ZÜRICH. Kunsthaus Zürich. *Klee.* February 16–March 25, 1940. Text by W. Wartmann.

CAMBRIDGE, MASSACHUSETTS. Germanic Museum, Harvard University. *Paul Klee.* February 28–March 27, 1940. (37 works.)

NEW YORK. Buchholz and Willard Galleries. *Paul Klee.* October 9–November 2, 1940. Texts by James Johnson Sweeney and by Lyonel and Julia Feininger. (100 works.)

BERN. Kunsthalle Bern. *Gedächtnisausstellung Paul Klee.* November 9–December 8, 1940.

LONDON. Leicester Galleries. *Paintings and Watercolors by Paul Klee.* 1941.

BASEL. Kunsthalle Basel. *Paul Klee: Memorial Exhibition.* February 15–March 23, 1941.

NEW YORK. The Museum of Modern Art. *Paul Klee.* June 30–July 27, 1941. Essays by Alfred H. Barr, Jr., James Johnson Sweeney, and Julia and Lyonel Feininger; 2d, rev. ed., 1945, edited by Margaret Miller, including writings by Klee; 3d. ed, 1946. Traveled to Northampton, Massachusetts, Smith College, Museum of Art; Chicago, The Arts Club of Chicago; Portland, Oregon, Portland Art Museum; San Francisco Museum of Art; Los Angeles, Stendahl Art Galleries; City Art Museum of St. Louis; Wellesley, Massachusetts, Wellesley College, 1941.

NEW YORK. Nierendorf Galleries. *Paul Klee.* November 1941.

NEW YORK. Nierendorf Galleries. *Fifth Selection of Works by Paul Klee.* March–June 1942.

WASHINGTON, D.C. The Phillips Memorial Gallery. *Paul Klee: A Memorial Exhibition.* June 2–October 4, 1942. Text by Duncan Phillips.

NEW YORK. Reid Mansion (Coordinating Council of French Relief Societies). *First Papers of Surrealism.* October 14–November 7, 1942.

BALTIMORE. Museum of Art. *Paul Klee.* March 16–April 25, 1943.

NEW YORK. New Art Circle (J. B. Neumann). *Paul Klee.* October 4–30, 1943.

NEW YORK. Nierendorf Galleries. *Works by Klee.* March 8–April 8, 1945.

PHILADELPHIA. The Philadelphia Art Alliance. *Paul Klee: Paintings, Drawings, Prints.* March 14–April 9, 1944.

LUCERNE. Galerie Rosengart. *Paul Klee zum Gedächtnis.* July 15–September 15, 1945. Text by Georg Schmidt.

NEW YORK. The Museum of Modern Art. *Prints by Paul Klee.* Traveled to 14 cities, 1945–47.

DENVER. Denver Art Museum. *A New Way to Paul Klee.* March 1–April 13, 1946. Text by Otto Karl Bach.

LONDON. National Gallery. *Paul Klee* (organized by The Tate Gallery). December 1946. Traveled.

NEW YORK. Nierendorf Galleries. *Paul Klee.* June–July 1947.

BERN. Kunstmuseum. *Ausstellung der Paul Klee-Stiftung.* November 22–December 31, 1947.

PARIS. Musée National d'Art Moderne. *Paul Klee* (Klee-Gesellschaft Collection). February 4–March 1, 1948. Text by Henri Hoppenot.

BRUSSELS. Palais des Beaux-Arts. *Paul Klee* (Klee-Gesellschaft Collection). March 1948. Text by Georges Limbour.

NEW YORK. Buchholz Gallery. *Paul Klee.* April 20–May 15, 1948.

VENICE. 24th Biennale. May 29–September 30, 1948.

AMSTERDAM. Stedelijk Museum. *Paul Klee* (Klee-Gesellschaft Collection). June 1948.

BEVERLY HILLS, CALIFORNIA. Modern Institute of Art. *Klee: 30 Years of Paintings, Drawings, and Lithographs.* September 3–October 6, 1948.

ZÜRICH. Kunsthaus Zürich. *Ausstellung Paul Klee-Stiftung.* September 22–October 17, 1948. Text by W. Wartmann. (300 works.)

NEW YORK. Buchholz Gallery. *Fifty Drawings by Paul Klee.* October 26–November 13, 1948.

BASEL. Kunsthalle Basel. *Aus der Stiftung Paul Klee.* October 27–November 21, 1948.

DÜSSELDORF. Hetjens Museum. *Späte Werke von Paul Klee.* November–December 1948.

NEW YORK. The Museum of Modern Art. *Paintings, Drawings, and Prints by Paul Klee from the Klee Foundation . . . with additions from American Collections.* December 20, 1949–February 14, 1950. Text by James Thrall Soby. Traveled to San Francisco Museum of Art; Portland, Oregon, Portland Art Museum; Detroit Institute of Arts; City Art Museum of St. Louis; New York, The Museum of Modern Art; Washington, D.C., Phillips Memorial Gallery; Cincinnati Art Museum, 1949–50. (202 works.)

NEW YORK. New Art Circle. *Paul Klee.* May 1–31, 1950.

NEW YORK. Buchholz Gallery. *Paul Klee.* May 2–27, 1950.

BASEL. Kunstmuseum. *Paul Klee, 1879–1940: Ausstellung aus schweizer Privatsammlungen.* Summer 1950.

NEW YORK. New Art Circle. *Paul Klee.* December 18, 1950–January 31, 1951.

NEW YORK. Buchholz Gallery. *Klee: Sixty Unknown Drawings.* January 16–February 3, 1951.

PALM BEACH, FLORIDA. Society of the Four Arts. *Paintings by Paul Klee.* March 9–April 1, 1951. Text by F. C. Schang.

PARIS. Berggruen & Cie. *Paul Klee: Gravures.* February 14–March 8, 1952.

NEW YORK. New Art Circle. *Paul Klee.* Easter–May 1952.

PARIS. Berggruen & Cie. *Paul Klee: Aquarelles et dessins.* 1953. Text by Will Grohmann.

NEW YORK. Curt Valentin Gallery. *Paul Klee.* September 29–October 24, 1953.

LONDON. Institute of Contemporary Arts. *Paul Klee, 50 Drawings: Collection of Curt Valentin, New York.* No-

vember–December 1953.

SÃO PAULO. Museu de Arte Moderna (2d Bienal de São Paulo). *Paul Klee*. November 1953–February 1954.

LAUSANNE. Château de la Sarraz. *Paul Klee*. 1954.

NEW YORK. Saidenberg Gallery. *Paul Klee*. March 8–April 26, 1954.

NEW YORK. The Museum of Modern Art. *Prints by Paul Klee*. July 7–September 19, 1954.

PARIS. Berggruen & Cie. *L'Univers de Klee*. 1955.

NEW YORK. Kleemann Galleries. *Paul Klee*. March 5–31, 1955.

NEW YORK. Curt Valentin Gallery. *Paul Klee: Sixty Unknown Drawings*. April 11–23, 1955.

LONDON. The Tate Gallery. *Works by Paul Klee from the Collection of Mrs. Edward Hulton*. May 4–June 5, 1955. Traveled to York City Art Gallery; Chicago, The Arts Club of Chicago, 1955–56.

NEW YORK. Saidenberg Gallery. *Paul Klee*. October 10–December 14, 1955.

BERN. Kunstmuseum Bern. *Paul Klee*. August 11–November 4, 1956. Traveled to Hamburg, Kunsthalle; Amsterdam, Stedelijk Museum; Oslo, Kunstnernes Hus, 1956–57.

HAMBURG. Kunstverein Hamburg. *Paul Klee*. 1956–57.

NEW YORK. Saidenberg Gallery. *Third Bi-Annual Exhibition of Paintings and Drawings by Paul Klee*. November 11–December 14, 1957.

PARIS. Berggruen et Cie. *Klee et Kandinsky: Une Confrontation*. 1959.

DÜSSELDORF. Staatliche Kunstsammlung des Landes Nordrhein-Westfalen. *Paul Klee* (works acquired from the G. David Thompson Collection, Pittsburgh). 1960.

NEW YORK. World House Galleries. *Paul Klee*. March 8–April 2, 1960.

GRENOBLE. Musée de Peinture et Sculpture. *Paul Klee*. June 11–July 15, 1960. Text by Felix Klee.

PARIS. Berggruen & Cie. *Klee lui-même: 20 Oeuvres, 1907–1940*. 1961. Text by Claude Roy.

TOKYO. The Seibu Department Store. *Paul Klee*. October 14–November 14, 1961.

NEW YORK. Saidenberg Gallery. *Exhibition of Paintings and Drawings by Paul Klee*. January 8–February 16, 1963.

AMSTERDAM. Stedelijk Museum. *Paul Klee*. September 20–November 4, 1963.

LONDON. Arts Council of Great Britain. *Drawings and Watercolors from the Felix Klee Collection, Bern*. Text by Norbert Lynton. Traveled throughout Great Britain, 1963–64.

FRANKFURT. Städelsches Kunstinstitut. *Paul Klee*. 1963–64. Text by Max Huggler.

BADEN-BADEN. Staatliche Kunsthalle. *Der frühe Klee*. April 18–June 21, 1964. Text by Leopold Zahn.

LONDON. Marlborough Gallery. *Paul Klee*. June–July 1966.

NEW YORK. The Solomon R. Guggenheim Museum. *Paul Klee, 1879–1940: A Retrospective Exhibition*. February–April 1967. Texts by Thomas M. Messer, Felix Klee, and Will Grohmann (see also: *Paul Klee Exhibition at the Guggenheim Museum. A Post Scriptum*, by Thomas M. Messer). Traveled to Cleveland Museum of Art; Columbus, Ohio, Gallery of Fine Arts; Kansas City, Missouri, William Rockhill Nelson Gallery of Art.

NEW YORK. Saidenberg Gallery. *Paul Klee*. February 1–March 25, 1967.

BASEL. Kunsthalle Basel. *Paul Klee 1879–1940: Gesamtausstellung*. June 3–August 13, 1967.

NEW YORK. Saidenberg Gallery. *Paul Klee*. October 14–

November 29, 1969.

PARIS. Musée National d'Art Moderne. *Paul Klee*. November 25, 1969–February 16, 1970. Texts by Jean Leymarie, Françoise Cachin-Nora, and Isabelle Fontaine.

BERN. Kunstmuseum Bern. *Paul Klee*. 1970.

ROME. Galleria Nazionale d'Arte Moderna. *Paul Klee (1879–1940)*. April 16–May 17, 1970. Text by Werner Schmalenbach.

MUNICH. Haus der Kunst. *Paul Klee*. October 10, 1970–January 3, 1971.

CHICAGO. Art Institute of Chicago. *Paul Klee: Etchings and Lithographs*. October 15–November 29, 1970.

LONDON. Roland Browse and Delbanco. *60 Watercolors from the Collection of Felix Klee*. 1971.

WINTERTHUR, SWITZERLAND. Kunstmuseum Winterthur. *Paul Klee und seine Malerfreunde: Die Sammlung Felix Klee*. February–April 1971. Traveled to Duisberg, Wilhelm-Lehmbruck-Museum, May 25–August 22, 1971.

BASEL. Galerie Beyeler. *Paul Klee*. September–November 1973. Text by Reinhold Hohl.

DES MOINES, IOWA. Des Moines Art Center. *Paul Klee: Paintings and Watercolors from the Bauhaus Years 1921–1931*. September 18–October 28, 1973. Text by Marianne L. Teuber.

ADELAIDE. The Art Gallery of South Australia. *Paul Klee*. 1974. Traveled to Sydney, The Art Gallery of New South Wales; Melbourne, National Gallery of Victoria. Texts by Werner Schmalenbach, Margaret Plant, et al.

DUISBERG, WEST GERMANY. Wilhelm-Lehmbruck-Museum. *Paul Klee—Das graphische und plastische Werk*. 1974. Directed by Jürgen Glaesemer. Texts by Glaesemer, Mark Rosenthal, Marcel Franciscono, and Christian Geelhaar.

THE HAGUE. Haags Gemeentemuseum. *Paul Klee*. February 9–May 5, 1974.

LONDON. Arts Council of Great Britain. *Paul Klee: The Last Years*. Traveled to Edinburgh, Scottish National Gallery of Modern Art, August 16–September 16, 1974; Bristol, City Art Gallery, October 10–November 23, 1974; London, Hayward Gallery, December 13–January 12, 1975.

LONDON. Fischer Fine Art Limited. *Paul Klee: 1879–1940*. 1975.

STUTTGART. Württembergischer Kunstverein. *Paul Klee: Die Ordnung der Dinge*. September 11–November 2, 1975. Text by Tilman Osterwold.

SAINT-PAUL, FRANCE. Fondation Maeght. *Paul Klee*. July 9–September 30, 1977.

NEW YORK. Serge Sabarsky Gallery. *Paul Klee: The Late Years*. Autumn 1977.

NEW YORK. Saidenberg Gallery. 1979. *Honoring the Centenary of Paul Klee*. March 22–May 19, 1979.

OTTAWA. National Gallery of Canada. *A Tribute to Paul Klee 1879–1940*. March 2–April 15, 1979. Traveled to Toronto, Art Gallery of Ontario, April 28–May 26, 1979. Text by David Burnett.

NEW YORK. The Museum of Modern Art. *Paul Klee Centennial: Prints and Transfer Drawings*. January 8–April 3, 1979. Text by Howardena Pindell. (70 works.)

COLOGNE. Kunsthalle Köln. *Paul Klee: Das Werk der Jahre 1919–1933, Gemälde, Handzeichnungen, Druckgraphik*. April 11–June 4, 1979. Directed by Siegfried Gohr. Texts by Marcel Franciscono, Christian Geelhaar, Eva-Maria Triska, Gohr, Placido Cherchi, Per Kirkeby, Wolfgang Wittrock.

ROME. Palazzo Braschi. *Paul Klee: The Private Life*. May 24–June 22, 1979. (93 photographs.)

STANFORD, CALIFORNIA. Stanford University Museum of

Art. *In Celebration of Paul Klee 1879–1940: Fifty Prints*. September 25–November 4, 1979.

MUNICH. Städtische Galerie im Lenbachhaus. *Paul Klee: Das Frühwerk 1883–1922*. December 12, 1979–March 2, 1980. Directed by Armin Zweite. Texts by Marcel Franciscono, Jürgen Glaesemer, Charles Werner Haxthausen, R. Suter-Raeber, O. K. Werckmeister, Jim M. Jordan, Christian Geelhaar, Marianne L. Teuber, M. Droste.

STUTTGART. Württembergischer Kunstverein. *Paul Klee: Ein Kind träumt sich*. December 14, 1979–January 22, 1980. Text by Tilman Osterwold.

HANOVER. Kestner-Gesellschaft. *Paul Klee: Sammlung Felix Klee*. June 27–August 17, 1980.

DARMSTADT. Hessischen Landesmuseum. *Paul Klee: Gemälde, Aquarelle, Zeichnungen aus dem Besitz von Felix Klee*. October 16–November 16, 1980.

CARACAS. Muséo de Arte Contemporáneo. *Paul Klee*. 1981.

MADRID. Fundacion Juan March. *Klee: Oleos, Acuarelas, Dibujos y Grabados*. March–May 1981.

MÜNSTER. Westfälisches Landesmuseum für Kunst und Kulturgeschichte Münster. *Die Tunisreise: Klee, Macke, Moilliet*. 1982. Directed by Ernst Gerhard Güse.

MILAN. Galleria del Milione. *Paul Klee: L'Annunciazione del segno: Disegni e acquareli*. February–March 1982. Galleria Marescalchi, March–April 1982. Text by Achille Bonito Oliva.

ANNANDALE-ON-HUDSON, NEW YORK. Edith C. Blum Art Institute, Bard College. *The Graphic Legacy of Paul Klee*. 1983. Texts by Christian Geelhaar, Jürgen Glaesemer, Jim M. Jordan, and Felix Klee.

HÖCHST. Jahrhunderthalle Höchst. *Paul Klee*. January 9–February 6, 1983.

NEW YORK. Marisa del Re Gallery. *Klee: 1914–1940*. April 1983. Text by Carmine Benincasa.

DRESDEN. Staatliche Kunstsammlungen Dresden Kupferstichkabinett. *Paul Klee*. November 6, 1984–January 9, 1985.

BERLIN. Bauhaus-Archiv. *Paul Klee als Zeichner 1921–1933*. May 5–July 7, 1985. Traveled to Munich, Städtische Galerie im Lenbachhaus, August 8–November 3, 1985; Bremen, Kunsthalle, November 17, 1985–January 5, 1986.

MARTIGNY, SWITZERLAND. Fondation Pierre Giannada. *Klee*. May 24–November 3, 1985. Text by André Kuenzi.

HOVIKODDEN. Henie-Onstad Kunstsenter. *Klee og Musikken*. June 23–September 15, 1985. Traveled to Paris, Musée National d'Art Moderne, *Klee et la musique*. October 10, 1985–January 1, 1986. Texts by Dominique Bozo, Ole Henrik Moe, Marcel Franciscono, Karl Loebe, Jürgen Glaesemer, Walter Salmen.

STUTTGART. Staatsgalerie Stuttgart. *Vom Klang der Bilder: Die Musik in der Kunst des 20 Jahrhunderts*. July 6–September 22, 1985.

LONDON. Royal Academy of Arts. *German Art in the 20th Century: Painting and Sculpture 1905–1985*. October 11–December 22, 1985. Traveled to Staatsgalerie Stuttgart, February 8–April 27, 1986.

HIMEJI, JAPAN. City Museum of Art. *Paul Klee in Exile: 1933–1940*. Text by O. K. Werckmeister. Traveled throughout Japan, 1985–86.

SAN FRANCISCO. San Francisco Museum of Modern Art. *Paul Klee: Figurative Graphics from the Djerassi Collection*. January 23, 1986–June 4, 1987.

VENICE. Museo d'Arte Moderna, Ca' Pesaro. *Paul Klee nelle collezioni private*. June 21–October 5, 1986.

LENDERS TO THE EXHIBITION

Kunstmuseum Basel
Nationalgalerie, Berlin
Kunstmuseum Bern
Musées Royaux des Beaux-Arts de Belgique, Brussels
Museum Ludwig, Cologne
The Denver Art Museum
Scottish National Gallery of Modern Art, Edinburgh
Sprengel Museum Hannover
The Trustees of the Tate Gallery, London
Milwaukee Art Museum
Bayerische Staatsgemäldesammlungen, Munich
Städtische Galerie im Lenbachhaus, Munich
The Brooklyn Museum, New York
The Metropolitan Museum of Art, New York
The Solomon R. Guggenheim Museum, New York
Centre Georges Pompidou, Musée National d'Art Moderne, Paris
Philadelphia Museum of Art
San Francisco Museum of Modern Art
Staatsgalerie Stuttgart
Ulmer Museum, Ulm, West Germany
Munson-Williams-Proctor Institute Museum of Art, Utica, New York
Graphische Sammlung Albertina, Vienna
The Phillips Collection, Washington, D.C.
Kunstmuseum Winterthur, Switzerland
Von der Heydt-Museum Wuppertal, West Germany
Kunsthaus Zürich

Mr. and Mrs. James W. Alsdorf, Chicago
Ernst Beyeler, Basel
Galerie Beyeler, Basel
Helen Keeler Burke, Illinois
Carl Djerassi, Stanford, California
Isidore Ducasse Fine Arts, Inc., New York
Mr. and Mrs. James Foster, Chicago
Stephen Hahn, Inc., New York
Mr. and Mrs. Stephen Kellen, New York
Michael Kellen, New York
Felix Klee, Bern
E. W. K., Bern
Morton G. Neumann Family Collection, Chicago
Angela Rosengart, Lucerne
Mr. and Mrs. Daniel Saidenberg, New York
Stiftung Sammlung Bernhard Sprengel, Hanover
Ian Woodner, New York
Richard S. Zeisler, New York
Several anonymous lenders

TRUSTEES OF THE MUSEUM OF MODERN ART

PHOTO CREDITS

Photographs reproduced in this volume have been provided, in the majority of cases, by the owners or custodians of the works, as indicated in the captions. The following list, keyed to page numbers, applies to photographs for which an additional acknowledgment is due. Individual works of art appearing here may be additionally protected by copyright in the United States of America or abroad, and may not be reproduced in any form or medium without the permission of the copyright owners.

© Gilberte Brassaï: 32, fig. 40
© A.C.L.–Brussels: 208 top.
Jörg P. Anders, Berlin: 189.
Myles Aronowitz, New York: 238.
Benteli-Verlag, Bern: 72, fig. 11; 123, upper left.
Gertrud Bingel, Munich: 155.
Ben Blackwell: 154.
Ken Brown: 29, fig. 34; 166 bottom; 268 top.
Rudolph Burckhardt, New York: 224 right.
Geoffrey Clements, New York: 19, fig. 14.
Colten, New York: 28, fig. 31.
© Cosmopress: 136 top and bottom; 139; 303 right; also: all works from Kunstmuseum Bern and Bildarchiv Felix Klee.
Walter Dräyer, Zürich: 38, fig. 32; 202; 203.
P. Richard Eells: 206 left.
G. R. Farley, Utica, New York: 276.
Galerie Beyeler, Basel: 211.
Georg Hartinger, Munich: 132 bottom.
David Heald, New York: 151; 170 top; 174 top.
Henzi AG, Bern: 171; 240 left and right; 242; 287; 292; 305; 318.
Hickey & Robertson, Houston: 72, fig. 11; 219.
Fenn Hinchcliffe, Sydney: 143 upper left.
Hans Hinz, Allschwill-Basel: 133 top; 134; 169 bottom; 214; 245; 254; 277; 281; 283; 313 left.
Gerhard Howald, Bern: 72, fig. 12; 78, fig. 24; 114 upper right; 122; 124 bottom; 129; 162 right; 183; 185; 198; 201; 209; 215; 218 bottom; 246 right; 251 top; 258; 268 bottom; 282; 288; 289; 295 top; 301; 311; 315.
Jacqueline Hyde, Paris: 279.
Michael Katz: 308.
Bernd Kegler, Ulm, West Germany: 136 top.
Kate Keller, The Museum of Modern Art, New York: 168; 173; 205; 253.
Gary Kitchen: 147 bottom.
Bildarchiv Felix Klee: 35, fig. 45; 52, fig. 15, 16, 17; 53, fig. 18, 19, 20; 54, fig. 21; 70, fig. 7; 72, fig. 10, 13; 73, fig. 14; 76, fig. 20; 114 upper left; 115 upper left; 121; 124 top; 126; 127; 130 top; 140 lower left; 146 left and right; 147 top; 149; 152; 164; 169 top; 170 bottom; 168; 184; 227; 266; 285; 286; 324 upper left and bottom; 325 upper left, middle

right, lower left and right; 326 middle; 327 lower right and middle left; 329 lower left.
Ralph Kleinhempel, Hamburg: 67, fig. 2; 140 top; 144; 226 top.
© Ute Klophaus, Wuppertal: 77, fig. 23a.
Bob Kolbrener, St. Louis: 229; 256; 298.
Peter Lauri, Bern: All black-and-white illustrations of works in the Kunstmuseum Bern, Paul Klee Stiftung; also: 142; 232; 243; 255; 267; 307 left; 323.
Endrik Lerch, Ascona: 300.
Marlborough Gallery: 18, fig. 12.
Robert E. Mates, New York: 57, fig. 25; 194; 247; 269; 273.
James Mathews, The Museum of Modern Art, New York: 15, fig. 3; 16, fig. 6; 25, fig. 24; 76, fig. 21.
Allan Mitchell, New Canaan: 231; 252.
Eric E. Mitchell, Philadelphia: 221.
O. E. Nelson, New York: 107, fig. 31.
Mali Olatunji, The Museum of Modern Art, New York: 173; 261.
Paltrinieri, Breganzona: 280.
Rolf Petersen, New York: 97, fig. 14; 217; 228 left.
Eric Pollitzer: 32, fig. 39.
Pollitzer, Strong & Meyer: 297.
Quiriconi-Tropea: 148; 212 bottom.
Sandak: 217; 233.
Sayn Wittgenstein Fine Arts, Inc.: 195.
John D. Schiff, New York: 19, fig. 13; 159.
Foto-Siegel, Neu-Ulm: 136 bottom.
Photo Stebler: 181; 236.
© S.P.A.D.E.M.: 15, fig. 2.
Adolph Studly, New York: 34, fig. 43; 71, fig. 8; 116 top and bottom; 117 bottom.
Soichi Sunami, New York: 16, fig. 7; 18, fig. 10; 20, fig. 15, 16; 23, fig. 20; 24, fig. 22; 27, fig. 28; 28, fig. 33; 40, fig. 1; 84, fig. 1; 118 right; 119; 172.
Caroline Tisdall: 77, fig. 23b.
© V.A.G.A.: 25, fig. 25.
Malcolm Varon, New York: 239.
Rolf Willimann, Kriens: 20, fig. 17; 158 top; 187; 190; 191; 207; 208 bottom; 244; 264.
Zeis: 295 bottom.

WORKS NOT IN EXHIBITION AT
THE CLEVELAND MUSEUM OF ART

Numbers refer to pages.

123 right, 132 bottom, 133 top and bottom, 134, 135, 137, 138, 139, 158 bottom, 162 right, 169 top and bottom, 170 top, 175, 176 left, 177 left, 180 top, 186, 197, 199, 200 right, 201, 204 top, 206 left, 208 top, 210, 214, 218 top, 224 left, 225, 230, 231, 236, 238, 240 right, 241, 243, 245, 247, 254, 271, 273, 277, 280, 281, 283, 287, 289, 302, 313 left, 314, 315, 322.

INDEX

Numerals in italics indicate an illustration. References to works by Paul Klee are cited alphabetically under the title of the work; works by all other artists are cited under the individual name.

343